EPOCHS OF CHINESE AND JAPANESE ART

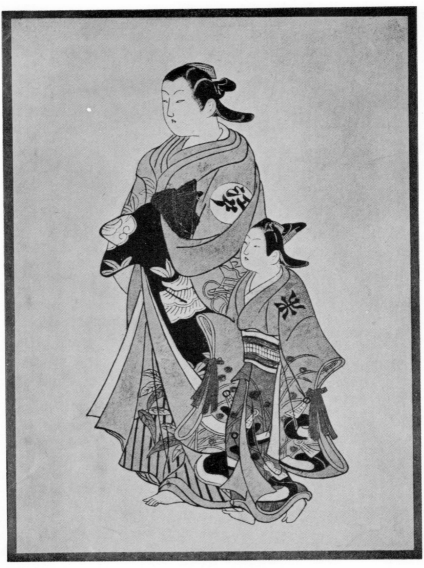

MASÁNOBU: COURTESAN WITH A SERVANT. *Hand-tinted
with red, yellow, brown, black, and gold-dust. On a mica
ground.* Medium size.
Royal Print Room, Dresden.

EPOCHS *of* CHINESE
& JAPANESE ART

AN OUTLINE HISTORY OF
EAST ASIATIC DESIGN

By

ERNEST F. FENOLLOSA

*Formerly Professor of Philosophy in the Imperial University
of Tokio, Commissioner of Fine Arts to the Japanese
Government, Etc.*

NEW AND REVISED EDITION,
WITH COPIOUS NOTES BY PROFESSOR PETRUCCI

VOLUME II

DOVER PUBLICATIONS, INC.
NEW YORK

This new Dover edition, first published in 1963, is an unabridged republication of the second (1913) edition of the work first published by Frederick A. Stokes Company and William Heinemann in 1912.

The following illustrations in Volume Two were reproduced in color in the 1913 edition: double-page illustration between pages 32 and 33 and illustrations facing pages vii, 59, 62, 95, 111, 179, 193, 197, 200 and 201.

Standard Book Number: 486-20365-4
Library of Congress Catalog Card Number: 63-5655

Manufactured in the United States of America
Dover Publications, Inc.
180 Varick Street
New York, N. Y. 10014

CONTENTS

VOLUME II.

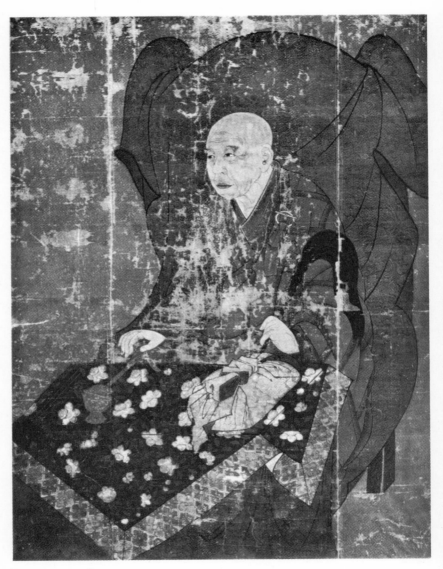

PORTRAIT OF A PRIEST.
 Old Tosa School.
 In the Gillot Collection, Louvre.

LIST OF ILLUSTRATIONS.

VOLUME II.

LIST OF ILLUSTRATIONS.

LIST OF ILLUSTRATIONS.

LIST OF ILLUSTRATIONS.

XII LIST OF ILLUSTRATIONS.

TO FOLLOW PAGE

EPOCHS OF CHINESE AND JAPANESE ART

CHAPTER X.

IDEALISTIC ART IN CHINA.

Northern Sung.

WE return now to the Art of China after a long interval in which we have devoted our attention solely to Japan, an interval which should enforce upon the reader's mind the almost complete severance of the two cultures during the Middle Ages. In China too, coming back after this interval, we plan to enforce attention upon the great spiritual gap involved in the change from what I have called mystical art to what I now call Idealistic art.

For this significant change—that which makes the epochs—is no less than a complete transition from Tendai Buddhism to Zen Buddhist ; not a sudden transition, for the two were always running parallel even through Tang, but a definitive transition. Such a transition is naturally ignored by those official Chinese historians for whom all Buddhist disputes in their far west are matters of small moment. The absolute uniformity of Confucian polity from Han at least down to the year of the writer (1906) seems to be their deceptive bias. It is like the bias of Christian sects who write European history from the point of view of their own pet controversies. This revolution in Chinese feeling, and in art, was, however, as great a one as if our earth should roll over and project its axis in the neighbourhood of Panama, thus driving all remaining cultures to build their sky-scrapers on the Antarctic continent, for it implied no less a change in Buddhist and in social contemplation than the substitution of the natural for the supernatural. If I call it Idealistic contemplation, it is because it regards nature as more than a jumble of fortuitous facts, rather as a fine storehouse of spiritual laws. It thus becomes a great school of poetic interpretation.

It may be objected that, in Poetry, the school lies partly in Tang, and I should have to admit that fact. But I should also admit, nay, assert, that it lies as far back as Southern Liang and Sung in their Nanking capital, and that Toemmei was the founder of it. It was then that the Indian Daruma transplanted the germs of this doctrine, germs carefully watered by the Chinese priest Yeyan and his composers of the White Lotos Club. It was then that Taoism joined hands with the budding Zen to enforce individuality as opposed to Confucian conformity. All this was detailed at some length in Chapter III. When North and South re-united with Tang in the seventh century, something of this Zen spirit, but really overweighted with Taoist thought and image, came to unite itself temporarily with the best in Confucian tradition. The union is best exemplified in the Genso poetry of Rihaku and Toshimi, where imagery from nature is used to enforce social criticism. The pure landscape poetry of Tang, like Omakitsu's, is much more Taoist in spirit than Zen. The admixture of Esoteric Buddhism at this time rather turned away from Zen Buddhism. If a critic could have analysed the tendencies of the eighth century, he would probably have enumerated them as Confucianism, Taoism, and Tendaism. Zen was a real thing, only it did not blossom into full fruition, and take the whole idealistic field for itself until the more self-conscious days of Sung.

The striking note in the Zen thought of Northern Sung is its open and contemptuous opposition to all that Confucians hold dear. Whether this union of extremes was in 730 a real union, or only a patched up truce, it had broken away into self-conscious conflict by 1060. The truth is that the narrow sect of Confucianists, the moment that they were to become self-conscious puritans, could never have tolerated any substantial comparison or real union with anybody. They are a set of Sadducees and Pharisees who hold with the tenacity of bull-dogs to the letter of the law. We have seen in Chapter VII. how they broke out into bitter persecutions of Buddhism before the end of Tang. Tang critics themselves were hardly able to analyse the situation ; they were rather open-mouthed spectators of a violence which they could not understand. The Confucian element in early Tang culture, such as in civil service examinations and university organization, had been a healthful one. People could hardly judge whether to condemn or to admire its partisanship.

But by the advent of the Sung dynasty this state of confusion and doubt had blown away. During the fifty-five years of the five short dynasties intermediate between Tang and Sung in the tenth century, a relative kind of independence had grown up in the severed provinces, a premium set upon local genius, a stage of decentralization and individuality reached which just gives a hint of the sort of change that was later to transform Japan into the Kamakura period. And when the parts came together again with the opening of Sung in its new capital of Kaifongfu in 960 and the budding geniuses rushed up from the provinces to add their lustre to the new court, there was almost immediately a cleavage of parties between the individualistic and the anti-individualistic. It was the former, however, that at first clearly prevailed, and that is what makes the art of early Sung so brilliant, even that which helped make possible such a supreme genius as Ririomin. But the Confucians, tireless as usual, insisted upon re-opening the same sort of institutions that had been current under Tang. In their handling of the educational system particularly they savagely discouraged all attempts to feel newly or to think freely, insisting upon the rigid morality of even pre-Han conventionalities. Liberal methods of taxation and government appointment for real efficiency, even projected institutions for the benefit of industry, they resented as an infringement of their prerogatives. Some day the worked out history of all this is going to furnish us with the greatest conflict for intellectual freedom that the world has seen, a conflict too many of whose details are not different from that which is accompanying the awakening of China in the twentieth century. In early Sung keen intelligence had driven China toward scientific method in reasoning and in industry ; she was on the verge of ante-dating European invention of the Renaissance. But the check upon it everywhere was subtle, quiet and deadly. It lay at the base of the Chinese brain, in the educational system itself.

The strong minds and the reformers of Northern Sung were face to face with a supreme tragedy, and they knew it. The degeneration of Tang was a symptom of what was about to stifle the vitality of all Chinese, and apparently for ever. The real situation is seen in the tenuity of the graphic curve which I have given in Chapter I., where the softening of the Chinese brain and a kind of social locomotor ataxia were really about to begin. The peculiar civilization of the whole Sung dynasty, Northern and Southern, was a desperate

protest against the insidious disease, the only clear realization of its dangers in all Chinese history. This is what makes the Sung dynasty a kind of anathema to modern Chinese annalists, that is, all in it that is not pure analytic criticism. The creative quality of the Sung mind they positively hate, and have done their best to bury under the rubbish of misrepresentation. Sung art is only known to the moderns in malformed and alleged copies which utterly travesty it. It is almost as if some one were to assert the mosques of Cairo to have been built by Rameses.

It will certainly be a strange thing for European scholars and a public who have been accustomed to regard Chinese culture as a dead sea level of uniformity for three thousand years, to read the words of men who wrote hopefully in Northern Sung ; such words as those of the artist critic Kakki, who alleges that " it is the very nature of man to abhor all that which is old and cleave to that which is new." The whole round of Sung culture is an immense storehouse of records that show Chinese humanity for three centuries building upon everything which we are disposed to disregard as un-Chinese.

In these great movements of Northern Sung, Zen Buddhism began to play a conspicuous part. Neither Taoist nor Tendai mysticism appealed to the university scholars. " Back to nature" was the cry, whether of incipient scientists or of pious Buddhists. How Buddhism can possibly become a contemplation of nature will remain, I presume, a mystery to those Pali scholars who suppose there never can have been a real Buddhism that did not keep maundering on about "the five noble truths." Metaphysical Buddhism was already dead in China, even before the mystic. Certainly the most æsthetic of all Buddhist creeds is this gentle Zen doctrine, which holds man and nature to be two parallel sets of characteristic forms between which perfect sympathy prevails. In this respect it is not unlike the Swedenborgian doctrine of " correspondences." But it goes much further than any European has ever done in carrying out the details of the correspondence, and in freeing them from a narrow ethical purism. It has something of the openness and humanism of the Renaissance, without its somewhat empty Paganism.

An extreme principle of Zen is that books are injurious, especially in the educational stage. Therefore it discards even scripture reading, and cuts itself away from the literature of its order. This is enough

to condemn it with Chinese scholars, who regard the written word as a sort of sacred talisman. Yet it was partly to break up the deadness of this very conceit that turned Zen teachers to the value of a more vital writing, namely, the Book of Nature. The neophyte was to see for himself how animals and birds, and rivers and clouds, and mountains and rocks are built up and discharge specific functions. It is an attempt to reconstruct the categories of thought *de novo*, and that on the basis of nature's organization. This is why the writer Kakki leaps out with the first words of his joyous preface, " Why do men love landscape ? Because it is the place where *life* is perpetually springing !" Life, that is it ; not a Confucian cupboard-full of dead weights and meters, and the bones of social orders, ranged rank upon rank, and ticketed in analytical order. The trouble with Confucius is that he had acted as if the skeleton were indeed the life. He was probably better than his practice, and took narrow ground as the only policy to convert the feudal spendthrifts of his day. Had he foreseen that he was defining an Imperial China for all time, we may well believe that he would have propounded freer doctrine. But his overzealous disciples had for ages intensified his defects ; and now they were openly clamouring that the very way to learn how to live was not by watching the heart beat and the lungs expand, but to count the number of ribs. Such antithesis was one ground of the Zen educational policy.

Another great point of the Zen scheme was that, in taking for his book the characteristic forms and features of nature, the student should have no guidance but his own unaided intelligence. The wise teacher set him down before rocks and clouds, and asked him what he saw. The priest was examiner, if not preceptor. It was his very purpose to let the mind build up its own view of the subtle affinities between things ; to construct an organic web of new categories. In short, education must develop *individuality !* This is why the great portraits of the Zen priests—such as that of the Louvre, which is described in the last chapter—are so powerful of head and keen of eye. For individuality, though a means, is really not an ultimate end, since behind the way of approach will loom something of a common great spiritual system underlying both man and nature. In this sense it is a sort of independent discovery of Hegelian categories that lie behind the two worlds of object and subject. Possibly, the telepathic power of the teacher, and of the whole Zen enlightenment, worked through the perceptions of the neophyte, to bring him to this general unity of plan.

That such a doctrine should become a powerful adjunct of poetry, from Shareiun,* of Liang, to So-Toba, of Sung, is due to its keen perception of analogies. All real poetry is just this underground perception of organic relation, between which custom classifies as different. This principle lies at the very root of the enlargement of vocabulary in primitive languages. Nature was so plastic and transparent to the eye of early man, that what we call metaphor flashed upon him as a spiritual identity to be embodied at once in language, in poetry and in myth. Zen only tried to get back to that primitive *éclaircissement*. A word, like a thing, means as much as you can see into it, and therefore lights up with a thousand chameleon-like shadings, which, of later days, only the poet knows how to use with a hint of the original colour. So in Chinese poetry every character has at least two shades of meaning, its natural and its spiritual, or the image and its metaphorical range. In Chinese poetry we find extreme condensation, for every word is packed with thought. Hence, also, the parallelism goes on to couplets or stanzas, contrasted in their apparent, yet alike in their real meanings.

It is clear, too, that such a doctrine must have a still more powerful influence over art. When Sung went to nature with Zen, it practically declared for landscape painting, a form that before had been used in art only sporadically. Sung and Tang are, *par excellence*, the epochs of landscape art, not only in China, but for the world. No such apotheosis of landscape has ever been vouchsafed to the West. Even in landscape poetry we ought to note the lateness as well as the thinness of the stream that began to flow with Wordsworth. The Wordsworths of China lived more than a thousand years ago, and the idealistic " intimations " to which the English bard somewhat timidly gave a platonic form only hinted at, instead of unfolding a system. The sounding cataract " haunted him like a passion," but what did it say to him ? In our landscape art we were long satisfied with pretty backgrounds for saints ; and even in Dutch landscape it was rather the peaceful suburbs of cities, or the rustic life of farms, that greets us, not the free forms of nature in its violence and creative motion. The truth is that all through the Middle Ages the dualistic view of nature—wild nature—was essentially evil ; the horror of grand rocks and lonely valleys, the hostility of matter to the heaven-directed human spirit, delayed European perception of beauty in mountains and storms until the nineteenth century. This,

* In Chinese Hsieh Ling-yün and Su Tung-p'o.

too, the desire of man to surround himself with formal gardens, as far removed as possible from nature's compositions. And even yet, in much of our pretended love for summer rambles and seaside outings, there lingers, I fear, a sort of personal pampering, or a sort of fetish collection of facts, rather than any noble passion of interpretation ; rather than any Zen-like recognition that something characteristic and structural in every organic and inorganic form is friendly to man, and responds gladly to the changing moods and powers of his spirit. When Wordsworth declares, as his belief, that "every flower enjoys the air it breathes," he humanizes nature a little in the direction of the Zen perception. Say in every new stratification or crystalline structure of rocks of close likeness to the marks and proportion of typical character in the faces of old men. To compare children with flowers is obvious enough ; but to make every visible form, and through the very visual peculiarities, the anti-type of human character ; to make, in short, nature *the mirror of man*—this is completed Zen system ; this gives a vast vitality to landscape art.

To pass, now, to the visible history of this landscape art we must begin with the little that is left us of Omakitsu's (Wang Wei) and Godoshi's (Wu Tao Tzu) landscapes from middle Tang. The So critics continually refer to these as the origin. Of the two, Omakitsu's are described as the more peaceful, Godoshi's as rough and striking in lines, but deficient in notan. The one great landscape of Omakitsu which has come down in Japan is the waterfall among rocks of Kotaiji, Higashi-yama.* This, however, is very powerful. The strange scratchy lines that cover the rocks, like strange veinings in marble, are quite incalculable in their pen forms. It is as if they had been drawn with a bunch of sticks and leaves for brush. This style has absolutely no relation to the mushy "bunjinga" style which the late Ming and early Sei pedants tried to father upon him. The chief landscapes of Godoshi are the two on silk in Daitokuji. These are splendid and worthy of his reputation ; utterly unique in composition, being unlike the Sung types that were more or less fixed by Risei and Kakkei. Mountains rise like a great screen over the whole tall picture, so that almost no sky appears in the grouping. It is all mountain gorge filled with plunging streams and cold mists. But the

* This splendid landscape now at Kotaiji Higashi-yama is not recognized as being undoubtedly genuine by modern Japanese criticism.—M. F.

utmost splendour of drawing has been thrown into the trees; the tall pines with angles and twists of mighty character, as strongly worked out as a portrait. The depth of tone varies greatly on the nearer and the farther trees.

Landscape painting was not very widely practised throughout Tang, which ran rather to human and religious subjects. But in the very last years of Tang interest in Zen revived, and led to such men as Taisu, who are the real link with Sung. Taisu loved to paint nature scenes of cow-herds, riding on bullocks, playing flutes, rejoicing in the cool fans of waving willows, or gazing off at strong mountain forms. The illustration is from a copy of Kano Isen (probably), in the Freer collection.

The ante-room, so to speak, of Sung art is formed by the five short dynasties that intervene between it and Tang. It must be remembered that, though the dynastic recognition of these follow in succession, the truth is that during the whole fifty-five years China was broken up into many provinces that remained all the time in a state of semi-independence. The father of landscape art in the North-East was Keiko, who lived as far back as Tang, but flourished under Liang (907-922). His landscape was free and broad, with striking passages of soft notan. Hankwan (Fan K'uan) and Kwando, who studied under him, became the great landscape painters of the early tenth century. Of Hankwan it was said that "his landscape seems continuous from where the spectator sits." He probably lived far into Sung, and even enjoyed the influence of Risei (Li Ch'eng). We can judge this whole transition school from the specimen of Hankwan here given. It follows Godoshi in its tree-forms, and in making the tones of the trunks rather thin as compared to the dark of the leaves. It was this quality, perhaps exaggerated in Kwando, which led the Sung critic, Beigensho (Mi Yuan-chang), to say caustically of him, "His trees have branches but no trunks." Kwando's work was "rough and simple," *i.e.*, broad, and he often worked in vast effects of mist and rain. We can probably guess what the critic means by comparing the background of this little Hankwan. What doubtless gave the Tsing pedants a cue to carry their traditions back to early Sung men, was such a method as this of Hankwan's in drawing distant misty cedars with a broad side-stroke. This is what is technically called "batsu-boku" by even the early Sung critics. But the rocks and leaves of the foreground are

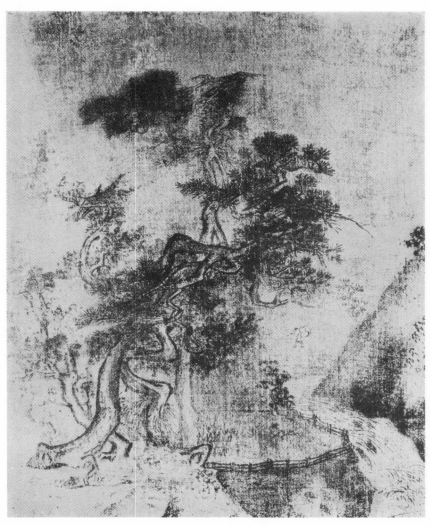

Lower Portion of one of the alleged Godoshi (Wu Tao-tzu)
Landscapes, kept in the Temple of Daitokuji.

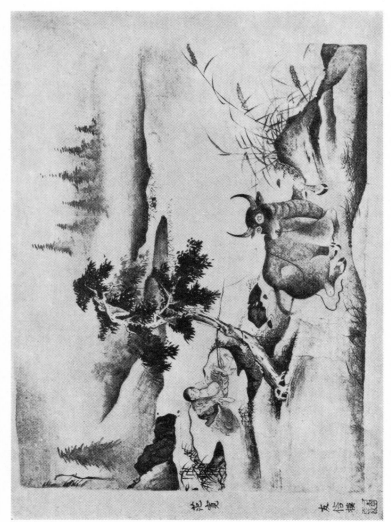

李成筆

LANDSCAPE WITH COW.
By Hankwan (Fan K'uan).

sharp and real and utterly unlike the modern bunjinga, which smothers everything near and far, with a soft buttery mass of formless batsu-boku.

In the picturesque neighbourhood of the Yangtse, in the province called Southern Tang, lived one of the greatest geniuses of the transition, Joki (Ch'u Hui), painter of birds and flowers, who was most highly honoured by his prince. His work was much admired in the capital of early Sung, and he is reckoned the great father of *Kwacho* (bird and flower compositions) in all Chinese art. Several examples are in Japan. We have his small bird on the branch of an apple tree, done in full colour. He was especially successful in his paintings of herons, a fine example in what is perhaps a Ming copy being here shown. The poise of the bird on one foot and with extended wing is notably fine. He liked to use a coarse silk, so that Beigensho remarked, " Yo's silk is like cotton." Some of his greatest work was done in lotos, no doubt much like that splendid painting of growing lotos at Horiuji, which long tradition has ascribed to his Japanese contemporary, Kanawoka. Two most beautiful paintings of lotos, and surely of his design, have come down to us in copies at Horiuji. Each flower is outlined and tipped with a lovely crimson. The foliage leaves are malachite and blue-green, according to their presentment of under or over surfaces. It was such work that became a model for Yuen and Min artists of later eclectic times.

In the picturesque West, too, Szechuan, many artists arose : one of whom, Chosho (Chao Ch'ang), is a rival to Joki. But the critic, Risen, rightly says of Chosho that his flowers are merely pretty, " looking like embroidery." Another was Kosen (Huang Ch'uan), also celebrated for *Kwacho*. The fine painting of a peony, in Mr. Freer's collection, is probably a copy of his design by Shunkio of Yuen. Thousands of purplish-pink tones play up through the billowy petals of this peony. He called himself Shesei, that is, " nature-copyist," and loved to paint detached branches of flowers.

We come now to the artists of Sung proper. One of the first acts of the founder was to make literary men, graduates of the literary examinations, provincial governors. This, which had not been done under Tang, was the beginning of the present civil-service abuses, and doubtless led to that scholarly arrogance which awakened the antagonism already spoken of. But it also led to a greater familiarity with the whole empire, governors being often transferred from post to post, and

it encouraged a universal influence of landscape art as a record of local beauties of scenery. This the poet Toba did much for the improvement of that Seiko * Lake near Hangchow, which later became China's greatest Southern capital. It also led to a wide diffusion of critical scholarship, and it led to the quick discovery of local artistic geniuses, who were quickly introduced at the capital.

In this way Risei was brought up from the Yeikei† province far down the Hoangho, Risei who followed much the style already described under Hankwan. " The trunks of his trees are in thin ink, accented with large spots." He was fond of drinking, and composed some of his finest work when a little intoxicated. He cared especially about the painting of tree effects, thick forests, blurred in smoke and mist. He is the centre of the early Sung landscape style. He worked probably between 980 and 1020 A.D. He had greater reputation among the early Sung Confucians than men like Kakki, who were doubtless finer artists. Kokokumei, one of his pupils, flourished after Ninso's accession, 1023.

But the great outcome of all this preparatory landscape work, from Taisu and Keiko to Hankwan and Risei, was Kakki (Kuo Hsi), the best pupil of Risei, whom he surpassed. He was a native of Honan, and so loved to paint its broad plains, of vast extent, soaked and softened with varying tints of stratified mist. He is the greatest painter of distance in Chinese art. It is said of his brush strokes that they were " quaint, and full of implied meanings." By this we understand great power of suggestion through unusual handling. There are no dark spottings or strong contrasts, but wonderful misty impressions of rock, tree and roof. " He is most famous for forests in winter," say the biographers. Here the deciduous trees stretch gaunt fingers toward wide plains of snow. The little caravan about to cross the bridge sets the vast scale. The anchored boat beyond is disappearing in the low valley mists. The distant hills are typical of quiet Sung drawing. It is said of Kakki that " his ink looks wet."

Kakki's great work was done on the wide white walls of temples and palaces. He was probably the first to use pure landscape for solid mural work. We read of his enormous pine trees many feet in height shooting up against broadsheets of mist, and hanging over deep crevasses, while through the branches shine glimpses of mountain peaks shrouded in clouds. He died

* In Chinese Ta-hu. † In Chinese Ghen-si.

probably in the Genko period (1078-1085) from which his latest work—
enormous landscapes on silk—dates. He could have known Risei only in
early youth. He somewhat overlapped the youth of Ririomin, and must
have been one of the dying sages who moulded the thought of that
transcendent spirit. It is on record that Kakei, the greatest landscapist of
Southern Sung, studied Kakki deeply, and often copied his pictures.

But perhaps the greatest service Kakki has done us, and one of the
greatest which anyone in the Chinese world could do for the whole
world, is the writing of his great Essay on Landscape, which he says
was first projected as a set of precepts for his son, Jakkio. In fact,
the essay was edited by Jakkio after his father's death. It is hardly
too much to say that, with the exception of some relatively dry por-
tions, it is one of the greatest essays of the world. It does more to
convince us that an enormous change had come over the face of the
Chinese world than all the Confucian annals put together. It proves
to us what an integral part landscape had come to play in Chinese
culture and imagination ; and it shows us just why the Zen symbolism
of nature gave such a splendid insight into characteristic forms. It
is indeed true that the utmost dominance of Zen had not yet super-
vened, and that it is the landscape essayists of Southern Sung who
complete Kakki's picture. It is true that Taoism had a considerable
part to play in nature-loving, and that there were all sorts of mix-
tures in men's minds between Buddhism, Taoism, and Confucianism,
mixtures which were destined to be hardened into a splendid synthesis
by later Sung philosophers.

I propose here now to include a few striking extracts from this
essay as the best account which can be given of Chinese virtuosity
and insight at this important period. It shows well how every charac-
teristic form of things may be held to correspond to phases of the
human soul ; how, for instance, the wonderful twisted trees, mighty
mountain pines and cedars, loved by these early Chinese and later
Japanese, which our Western superficial view first ascribed to some
barbarian taste for monstrosities, really exhibit the deep Zen thinker
in their great knots and scaly limbs that have wrestled with storms
and frosts and earthquakes—an almost identical process through which
a man's life-struggles with enemies, misfortunes, and pain have stamped
themselves into the wrinkles and the strong muscular planes of his fine
old face. Thus nature becomes a vast and picturesque world for the

profound study of *character*; and this fails to lead to didactic over-weighting and literary conceit, as it would do with us, because *character*, in its two senses of human individuality and nature individuality, are seen to become one. The very beauty of the natural side counteracts any latent moral formalism, and this is the very antithesis to the later bunjinga—"literary man's art,"—which, indeed, as its name might imply, swallows up beauty in pedantry. The pure modern Confucian recoils with horror from all taint of Buddhist thought and feeling, and in so doing, renounces and ignores the very greatest part of what makes China and Chinese art great in the great Sung. To be pure as a plum-blossom, free as a bird, strong as a pine, yet pliant as a willow, was the lovely ideal of the Chinese Sung gentleman, as of the later Ashikaga Japanese, and it is permeated through and through with Zen thought. It might, perhaps, be asserted that the Japanese, or my own enthusiasm, had invented these advanced thoughts (and it has been so said), which seem to have nothing in common with what modern Chinese scholars or their European pupils have to say about China, were it not that, fortunately, we have this great essay to reinforce what the finer Sung pictures tell us.

EXTRACTS FROM THE FAMOUS ESSAY BY KAKKI (KUO HSI) ON PAINTING.*

KAKKI OF SO (KUO HSI OF SUNG) ON THE HIGH TASTE OF FOREST AND FOUNTAIN. COLLECTED BY HIS SON (FROM FRAGMENTARY NOTES) LAICHI LAIFU, COM-MANDER-IN-CHIEF OF INFANTRY, KAKUSHI JAKKIO (KUO SZE).

PREFACE.

The sage said :—"It is well to aim at the moral principle (Tao), to derive authority in everything from virtue, to regulate our conduct by benevolence, and to let the mind play in the sphere of Art.

* EDITOR'S NOTE :—The following extracts are taken from the entire translation made many years ago in Japan for Professor Fenollosa by Japanese scholars. This essay has always been kept among the most valued papers of the writer of this book, and has been by him frequently quoted and referred to in lectures. The extracts are, for the most part, those paragraphs and isolated sentences which have been marked by Professor Fenollosa. Wherever there is a marginal note by him it has been given.

"I, Kakku Jakkio, from boyhood, followed my revered friend (meaning his father, Kakki); travelling with him among streams and rocks, and every time he painted the actual scene, he said, 'In sansui (landscape) painting there are principles, and thoughts that cannot be expressed roughly and hurriedly.' And so every time he said any word to be remembered, I took up my pen and recorded it. The records having now amounted to several hundreds without any loss, I publish them for the sake of those who love the art.

"It is to be added that my father, while young, studied under a Taoist master, in *consequence of which he was ever inclined to throw away what is old, and take in what is new.** He was thus a man who moved outside the regular region (meaning the Confucian world of strict and conventional forms); and there having been no painters among his ancestors, what was in him was derived purely through intuition. During the whole career of his life, he wandered about in the sphere of art, and thereby acquired its fame. In his private character he was virtuous in conduct, pious to parents, benevolent to friends, and deeply so. Thus it is incumbent upon his descendants to bring these things to light."†

A little later, Jakkio, in explaining some terms used by his father, writes again, in his own person, thus charmingly :—

"Some years ago I saw my father painting one or two pictures, which he left unfinished for ten or twenty days at a time, probably because he was not disposed toward them. That is what he called the idle mind of a painter. Again, when he was much disposed towards his painting, he forgot everything else. But even if a single thing then disturbed him he left the painting unfinished, and would not look at it. Such was what he meant by a dark mind. Whenever he began to paint he opened all the windows, cleared his desk, burned incense on the right and left, washed his hands, and cleansed his ink-stone; and by doing so his spirit was calmed and his thought composed. Not until then did he begin to paint.‡ To sketch out the picture once, and then try to reconstruct it, to increase some quality or portion, and then to wet it again, to do twice what could have been once, to do thrice what could have been twice, to trace again every curve, and thus be always trying to improve, but finally ending in dissatisfaction, such is what he meant by painting with a proud heart."

* EDITOR's NOTE :—The italics are Professor Fenollosa's. He considered this statement important.

† End of Preface.

‡ The writer's marginal note against this is the one word "Whistler."

Wherein do the reasons lie of virtuous men so loving sansui (landscape)? It is for these facts : that a landscape is a place where vegetation is nourished on high and low ground, where springs and rocks play about like children, a place which woodsmen and retiring scholars usually frequent, where monkeys have their tribe, and storks fly crying aloud their joy in the scene. The noisiness of the dusty world, and the locked-in-ness of human habitations are what human nature, at its highest, perpetually hates ; while, on the contrary, haze, mist and the Sennin sages (meaning, poetically, the old spirits that are supposed to haunt mountains) are what human nature seeks, and yet can but rarely see. But if there be great peace and flourishing days in which the minds, both of the ruler and subject, are high and joyous, and in which it is possible for one to regulate his conduct with purity, righteousness and honesty during his whole career ; then what need or motive would there be for the benevolent man to hold aloof, shun the world, and fly from the common place ? Rather would he join the people in the general jubilee. But since this is not the case what a delightful thing it is for lovers of forests and fountains and the friends of mist and haze, to have, at hand, a landscape painted by a skilful artist ! To have therein the opportunity of seeing water and peaks, of hearing the cry of monkeys, and the song of birds, without going from the room ! In this way a thing, though done by another's will, completely satisfies one's own mind. This is the fundamental idea of the world-wide respect for sansui (landscape) painting ; so that if the artist, without realizing this idea, paints sansui with a careless heart, it is like throwing earth upon a deity, or casting impurities into the clear wind.

In painting sansui it should be remembered that each has its own form ; so that if a sublime picture fills the whole expanse of a large silk ground, there need be nothing superfluous ; or, if a small scene is painted on a small ground, there need be nothing wanting. The critics of sansui (landscape) usually give to the scene represented such qualities as are suitable to walk in, suitable or pleasant to look at, suitable to ramble in, and suitable to live in. The sansui that is supreme combines the four qualities. However, if it should be that only two can be given, then that which is suitable to live in and to ramble in are preferable.

Man, in studying painting, is under the same condition as in studying writing. If, as in writing, one makes Sho-o, or Gurinku, his master, then, at most, his work can resemble that master and

PAINTING BY THE CHINESE ARTIST TAISO (TAI SUNG)
Copied probably by Kano Isen.
Collection of Mr. Charles L. Freer.

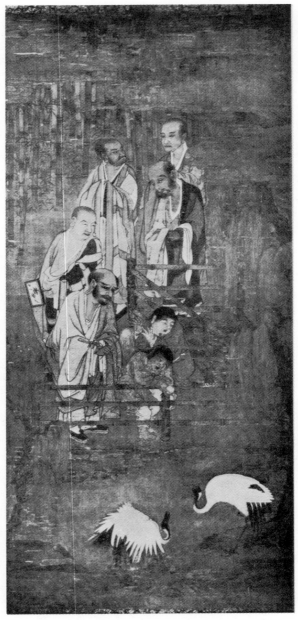

GROUP OF RAKAN (OR ARHATS) WATCHING STORKS.
School of Ririomin (Li Lung-mien).

be nothing more. So also is it in painting. A great thorough-going man does not confine himself to one school; but combines many schools, as well as reads and listens to the arguments and thoughts of many predecessors, thereby slowly forming a style of his own; and then, for the first time he can say that he has become an artist. But nowadays men of Sei and Ro follow such men as Yeikiu only; and men of Kwankio follow Hankwan only. The very fact of following one master only is a thing to be discouraged; added to which is the fact that Sei, Ro, and Kwankio are confined regions and not the whole empire. Specialists have from the oldest times been regarded as victims of a disease, and as men who refuse to listen to what others say.

He that wishes to study flower-painting should put one blossoming plant in an earthen pot, and look upon it from above. He that studies bamboo painting should take one bamboo branch, and cast its shadow on a moonlight night upon a white wall.

ON CLOUD PAINTING.

The aspect of clouds in sansui is different according to the four seasons. In spring they are mild and calm; in summer thick and brooding (melancholy); in autumn they are rare and thin, in winter dark and grey. And in painting clouds, if one does not try to carve out every minute detail, but will paint only the great total aspect of the thing, then the forms and proportions of the clouds will *live*. Among clouds there are returning-home clouds. There are strong winds and light clouds; a great wind has the force of blowing sand, and a light cloud may have the form of a thin cloth stretched out.

ON MOUNTAINS AND WATER.

Mountains make water their blood: grass and trees their hair; mist and cloud their divine colouring. Water makes of mountains its face, of houses and fences its eyebrows and its eyes, and of fishermen its soul. Therefore mountains are more beautiful by having water, bright and pleasant by having houses and fences, open and free by having fishermen.* Such are the combinations of mountains and water.

A mountain is a mighty thing, hence its shape ought to be high and steep, freely disposing itself like a man at ease, or standing up with

* Note by E. F. F.—Chinese sages often became fishermen. The constant allusions to them in such essays are to these retired scholars rather than to actual fishermen.

grandeur, or crouching down like a farmer's boy; or as having a cover over it, a chariot below it, seeming as if it had some support in front to lean over, or something behind to lean against, or as gazing down upon something below; such are some of the great form-aspects of mountains.

Water is a living thing, hence its form is deep and quiet, or soft and smooth, or broad and ocean-like, or thick like flesh, or circling, like wings, or jetting and slender, rapid and violent like an arrow, rich as a fountain flowing afar, making water-falls, weaving mists upon the sky, or running down into the earth where fishermen lie at ease. Grass and trees on the river banks look joyous, and are like beautiful ladies under veils of mists and cloud, or sometimes bright and gleaming as the sun shines down the valley. Such are the living aspects of water.

MOUNTAINS.

Mountains are some high and some low. High mountains have the blood-range (an old Chinese expression) lower down; its shoulder and thigh broad and expanded, its base and leg vigorous and thick. Rugged mountains, round-backed mountains and flattened mountains together, always appear forcible, grasping and embracing one another with their bright, continuous girdle. Such are the forms of high mountains, and these are not solitary. Lower mountains have their blood-circulation higher up, with short, stunted neck and broadened base.

If a mountain has no mist or cloud, it is like spring-time without flower or grass.

Mountains without cloud are not fine, without water not beautiful (the word beautiful used here is that applied generally to women), without a road or path not habitable (or suitable), without forests not alive. If a mountain is not deep and far it is shallow, and without being flat and far it is near, and without being high and far it is low.

In mountains there are three sorts of distance, that of looking up to the top from below is height, that of looking toward its back from its front is called depth, and that of looking from near mountains at distant mountains is called the *distance of flatness*. The force of the distance of height is pushing up; the idea of the distance of depth is being thick and folded; the idea of the distance of flatness is that of mildness in grandeur, as of the ocean.*

* NOTE BY E. F. F.—The term for foreground here means that part of the picture which is just in front of the eye, and which, therefore, is to receive the main attention; not the whole foreground from side to side. Thus, the other parts may mean not only the upper distance, but the space at the sides, and also at the bottom.—The italics are by E. F. F.

In mountains there are three largenesses. A mountain is larger than a tree, and a tree is larger than a man. A mountain at a certain distance, but not farther, becomes in size like a tree; the tree at that certain distance becomes the size of a man. Thus the mountain and the tree are not large. The comparing of a tree with man begins with its leaves, and the comparing of man to a large tree begins with the head. A certain number of tree-leaves should match with a man's head, and the man's head is composed of a certain number of leaves. Thus the largeness and smallness of man, tree and mountain, all go out of this middle ratio. These are the three sorts of largeness.

A mountain, though intended to be tall, cannot be tall if every part of it is shown. It can be tall only when mist and haze are made to circle its loins. Water, though intended to be distant, can be distant only through visibility and invisibility interrupting its course. Nay, a mountain shown in all parts is not only without beauty, but is awkward, like the picture of a rice-mortar. And water shown in every part is not only without the grace of distance, but resembles a picture of a serpent.

Though valleys, mountains, forests and trees in the foreground of a picture bend and curve as if coming forward, as if to add to the wonder of the scene, and though it is done with great detail, it will not tire the beholder, for the human eye has the power to grasp all detail that is near. And, in other parts, though they have flat and far expanse, folded peaks that are continuous like ocean waves receding off into distance, the beholder will not weary of the distance, because the human eye is capable of seeing far and wide.

ON ROCKS.

Rocks are the bones of heaven and earth; and, being noble, are hard and deep. Dews and water are the blood of heaven and earth; and that which freely flows and circulates is noble blood. . . . Rocks and forests (in paintings) should pre-eminently have reason. One big pine is to be painted first, called the master patriarch, and then miscellaneous trees, grass, creepers, pebbles and rocks, as subjects under his supervision, as a wise man over petty men. . . . If a sandy mountain have forests that are thick and low, the rock bearing mountain must have them lean and high. . . . Great rocks and pines should always be painted beside great banks or tablelands, and never beside shallow, flat water. Some water runs in streams, some rocks are level at the top, or again, waterfalls fly about among tree-tops, and strangely shaped rocks crouch beside the path.

THOUGHTS ON PAINTING.

The men of the world know only that they use their brush, and therefore they paint; but they do not realize that painting is a difficult thing (with the meaning that it lies below technique, in a man's character). A true artist must nourish in his bosom mildness, kindness and magnanimity; also he should possess pleasant thoughts and ideas, such as Ichokushi called "oil-like" thoughts; and be capable of understanding and reconstructing in his own mind the emotions and conditions of other human beings, both in pointedness and obliqueness, and in the "standing-side-by-side-ness" of things.* Having accomplished this understanding of others, he should let them out unconsciously through the tip of his brush. Kogaishi of Shin (Ku K'ai-chih of Tsin) builded a high-storied pavilion for his studio, that his thought might be more free. Or if the thought becomes depressed, melancholy and clogged even upon a single point, how can the artists be able to manufacture from such thought, or to feel the mental characteristics of others? . . . unless I dwell in a quiet house, seat myself in a retired room with the windows open, table dusted, incense burning, and the ten thousand trivial thoughts crushed out and sunk, I cannot have good feeling for painting, or beautiful taste, and cannot create the "yu" (the mysterious and wonderful). After having arranged all things about me in their proper order, it is only then that my hand and mind respond to one another, and move about with perfect freedom. . . . To always make one kind of stroke, is to have no stroke at all; and to use but one kind of ink is not to know inking. Thus, though the brush and ink are the simplest things in humanity, yet few know how to manage them with freedom. . . . It is said of Ogishi (Wang Hsi-chih) that he was fond of geese, his idea being that the easy and graceful bend of its long neck was like that of a man holding a brush, with free motion of the arm.

With regard to brushes, many kinds may be used—pointed, rounded, coarse, delicate, needle-like, and knife-like. With regard to inking, sometimes light ink is to be used, sometimes deep and dark, sometimes burnt ink, sometimes preserved ink, sometimes receding ink (that is drying rapidly from the ink-stone), sometimes ink mixed with Ts'ing-lü (blue), sometimes dirty ink kept in the closet. Light ink retraced six or seven times over will make deep ink, whose colour is wet, not dead and dry. Dark ink and burnt ink are to be used in making boundaries, for unless it is dark the form of pines and rock angles will not be clear. After making sharp outlines, they are to be retraced with blue and ink. Then the forms will seem to come out of mist and dew.†

* This is evidently a literal translation of some telling Chinese phrase.

† Editor's Note.—There are pages of such technical instruction, but it was thought best not to add more.

ON POETRY.

Here in my leisure days I read old and new poems, and make extracts of such good stanzas as I feel to be completely expressive of the soul. The ancient sages said that a poem is a painting without visible shape, and a painting is poetry put into form. These words are ever with me. I will now record some of these verses of old masters that I am accustomed to sing.

To understand the whole play and range of the rich life that underlay Northern Sung at Kaifung-fu at this, its culminating, period, we must go beyond this strong presentation of the Zen problem, and touch for a moment on some of the other phases of the great blood-less, tragic struggle which had the fate of all Chinese culture in its issue. If we could get a concrete picture of the seething, the indi-vidualistic, the idealistically poetic China of this day, say from 1060 to 1126—less than the normal life of a man,—we should witness the greatest illumination of the whole East, the whole Asiatic world, with but two exceptions—the culminating of Tang under Genso, at Singanfu (713 to 755), and the *éclaircissement* of Southern Sung at Hangchow (1172 to 1186). The first, of Tang, was a larger movement in that it was on an international scale, Tang being in close relation with half of Asia. The second, of Northern Sung, was relatively con-tracted and the most purely Chinese, the eclecticism of all the vital infusions of local Chinese spirit. The third was peculiarly Southern Chinese, and still more contracted in scope, the whole north half of China being held by hostile Tartars. Another interesting difference between the first two is that Tang culture probably found its supreme expression in poetry, while the Sung culture found its supreme ex-pression in pictorial art. Without the one unrivalled genius of Godoshi, Tang art could hardly compare with Sung—surely not in scope, variety, and taste. In strength and spontaneity, perhaps, even as a mass, it stood higher. Accordingly, as one takes one point of view or the other, Godoshi ranks Ririomin or Ririomin Godoshi. It is quite a maintainable thesis that, though in all the elements of civili-zation taken together the Tang reaches the acme, in pictorial art alone the Sung reaches it. Some day a true account of the pitting of the enormous party forces of Kai-fung-fu against each other will make one of the most romantic episodes in literature.

Just a sketch of this wide movement must here be included. That

the Confucians who had captured Tang at its close, were bound to make a supreme effort to Sung at its beginning is shown in the following events. They influenced the Emperor to appoint them as local governors in 963. They made the nine Confucian classics the chief curriculum in provincial schools (1001), and in what were now civil service examinations. They had a lofty title given to Confucius, "Bunsen, or Wen-chen, King of Letters," as if he were the source of all Chinese intellect (1008).

Yet a strongly counteracting force was at hand. In 984 Kwazan Inshi,* a Taoist hermit, came to the court, and insisted upon residing and preaching there. He undertook even to work miracles, and won the attention of the Emperor. In 1012 a second imported Taoist came. These men were supposed to be *sennin*, that is, men in the flesh, who, by pure communication with nature, and subordination of personality, had won a kind of power over things, and might even circumvent death. It is clear how such a doctrine might fall into close harmony with Buddhism, particularly Zen. Both went to nature for their inspiration. It must be remembered, too, that many of the most influential courtiers had come from southern and western provinces, which had been more closely under Buddhist tradition, the South being the very scene of Daruma's life, and a centre of Zen dispersion. In 1023 the Emperor Ninso came to the throne, destined to a long reign of forty-one years. That he was reputed by his own non-Confucian courtiers to be a sennin, shows what a hold the Taoist doctrine, in its semi-Zen form, had already acquired at the capital. With the Emperor now, not only a Taoist, but a *living Taoist God*, the Confucian party was put to straits. This reign of Ninso became the great preliminary battle-ground of the forces which were trying to free or fetter the Chinese intellect for ever. Kakki's father, to whom he refers in his preface, was a man of this day, and Kakki was brought up in the midst of the controversy.

But the Confucian party had a great leader, Oyoshi, a refined and able scholar, statesman and writer, who sought by peaceful and philosophical means to convince the nation that its hope lay in a stern and ceremony-restricted life, that free personality carried in its heart a mighty danger. It was the same sort of a position that the Sophists took against Socrates, the same campaign waged in the last century against Emerson. Toward the end of Genso's reign, a much younger man, Oanseki, arose to take official leadership of the

* In Chinese, Ch'en F'uan.

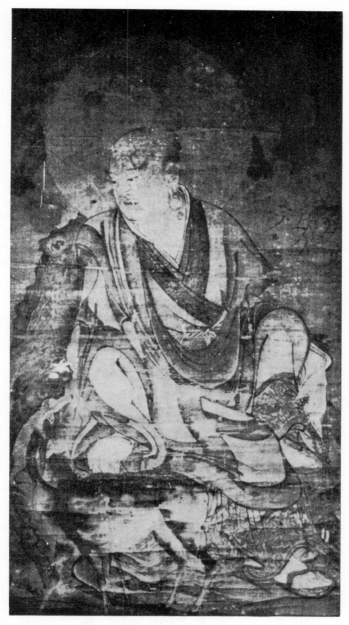

ONE OF THE RAKAN (IN ARHAT).
From the set owned by Mr. Charles L. Freer.
By Ririomin (Li Lung-mien).

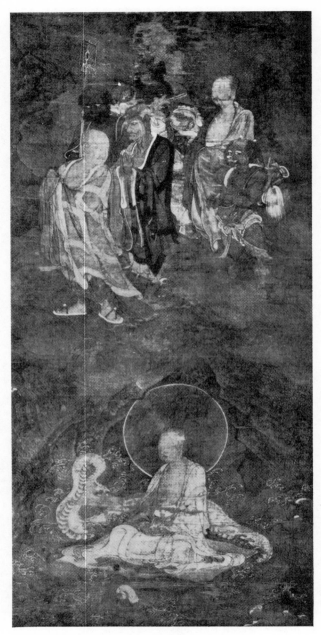

RAKAN (OR ARHAT) IN TRANCE UPON WATER.
School of Ririomin (Li Lung-mien).

individualistic party. It was not enough to ignore the scholars in private practice ; they already had in their hands the machinery of education, provincial government, taxation. Most of all, the effect of the century-long conformity was in danger of producing a deadening in the Chinese intellect. Chinese industry and warfare were both backward, because not based on a study of nature. It was necessary to show that scholarship was not confined to pedants, necessary to snatch its very elements, by organized opposition, away from the Confucian danger. The battle was on.

Oanseki (Wang An-shih) was one of those extraordinary men who, like Roger Bacon, reach a clear insight of truth hundreds of years ahead of time, at a day when such radicalism means extreme misunderstanding and danger. He has, of course, been denounced by all subsequent historians as the arch traitor to Chinese ideas ; yet he was the first great Chinese rationalist of a universal, a European, a Non-Confucian, type. He clearly distinguished between that part of the knowledge of his day which was science, from what was not. He was no special partisan of either Tao or Zen, though ready to utilise their support. His base was reason and observation ; he regarded formalism as a far more insidious danger than even superstition. If he were living at the present day (1906)* how eagerly he would be seeking the good in Western influence ! Such a reformer as Kang Yü-wei, who had the ear of the young Emperor in 1898—just before the *coup d'état*—would have been regarded as a new Oanseki, had he really possessed Oanseki's scholarship and breadth of mind. Former minister Wu, now high in court circles, is a sort of young Oanseki ; but the breadth of his grasp is now unfortunately scattered through the brains of a thousand only half effective scholars. Of course it is a harder test than Oanseki's to construct a working synthesis of the best in Chinese and European ideas ; and seven hundred added years of hard-baked Confucianism makes a denser opposition. The Empress Dowager proscribed Kang Yü-wei in 1898, and cut off the heads of his colleagues. To the credit of the Sung Confucians be it said that no one advocated the assassination of Oanseki.

Four years before Ninso's death he came to the point of summoning Oanseki as chief adviser, and to draft a working scheme for reconstructing the civil service. While this was only a scheme, the

* Note.—It was during the summer of 1906 that the entire draft of these two volumes was hastily written.—The Ed

Sennin Emperor died ; and the hopes of the Confucians, under Oyoshi and Shiba the historian, arose. Yeiso, however, was occupied with internal wars, in which matters the scholars had never shone as brilliant advisers. Did not Confucius deprecate all war and violence? Here was one of the weak points in the armour of the *literati ;* when things went wrong, and work was to be done, they folded their hands and advocated but the one abstract remedy "virtue." Oanseki saw that they in time would become the screen for a gigantic hypocrisy.

But in four years more a new Emperor Shinso was on the scene ; and Oanseki was given carte blanche to promulgate his new laws in the great year 1069. Oanseki's power lasted, with the exception of brief intervals, to his death in 1086. It is just this critical period, Kirei, from 1068 to 1078, that witnessed the brunt of the conflict. Oanseki's reform included a return to something like the Tang system of taxation, a fair rental for land, not to be left to the tender mercies of governors but administered by a vigorous central bureau. But his greatest innovation was, not to abolish the school system and the examinations, but to purify them by throwing out the Confucian classics altogether. Think of a great Chinese minister daring to propose and to *do* this. But Oanseki found himself with the much more difficult task of construction than of destruction. What could be substituted as a basis of education? He made a splendid effort to try to formulate the learning of his time upon a practical basis. He insisted that officials must be taught the elements of their trade. He introduced studies in economy, taxation, book-keeping, law, and the routine of administration morals. But Oanseki was a scholar also, a fine prose writer, and no mean poet ; and so he undertook to compose for himself a whole new series of text-books that should in some sense supply the place of the deposed classics. It will be a great study for some future humanitarian scholar to translate and analyse the writings of this great publicist.

In 1074 Oanseki was temporarily deposed. Oyoshi, his most bitter enemy, a Confucian leader for nearly forty years, had died two years before. Shiba Onko,* the historian, now became his successor, but with less force. Shiba presented his great history of China to the Emperor in 1084, a work written with the purpose of proving that national health had always rested upon ethics and ritual. In 1086

* In Chinese Ssü-ma Kuang.

both Oanseki and Shiba died ; a new Emperor, Tesso,* came in ; and, weary with disputes, the new administration ordered a truce between the parties, which practically resulted in the sliding back into their old places of the *literati*. Even so, the whole Sung dynasty never quite lost the lesson of freedom ; the Confucians kept their ambitions in the background ; and the great individuals of the dynasty, including the Zen priests and the artists, lived their great lives out in peace.

It was in the very midst of this great intellectual ovation that Kakki died, and Ririomin (Li Lung-mien) arose into prominence. We can see from Kakki's essay what the new free spirit was like, how it instinctively turned toward a poetic idealization of nature. The great Confucian poets, too, such as So-toba, could not help taking an interest in this movement, and themselves becoming painters. It was a wonderful grouping of men that met each other at the Emperor's receptions, or in the humbler haunts of scholarship—on the Confucian side, Oyoshi the minister, Shiba the historian, Bunyoka the prose-writer, Toba the poet, and Beigensho the critic : on the liberal side, Oanseki the reformer, Kakki the essayist, Ririomin the artist, and the young prince Cho Kitsu, who was later to become the great æsthetic emperor Kiso Kotei.

The place of Ririomin (Li Lung-mien) in this double grouping is probably the most interesting of all, since he is one of the world's greatest geniuses. We have already seen how prominent he was in the painting of Buddhist images and the miracles of the Rakan. In his later years he became a firm believer in the doctrines of Shaka (Buddha) and lived a life of pious insight in his villa " Ririomin-zan." † It is interesting to see how such great friends as the Confucian poet Toba, and Ririomin, could live together, tolerate and even sympathise with each other's ideals, and yet in fact be strong partisans of principles as far apart as the poles. Ririomin had taken his final examinations during Kiñen,‡ the very period in which Oanseki's new laws and standards were in force. We may infer that he readily adapted himself to the new texts, and breathed in a special freedom unknown to all other Chinese painter-scholars. In 1076 he tells us himself that he bought the villa at Ririomin-zan as a place for future retirement, yet for twenty-four years after this he served faithfully at

* In Chinese " Cheh Tsung."
† This name, Ririomin-zan, means " Mountain of the Dragon's brightness."
‡ In Chinese " Hi-ning."

court as reader and censor of new books, and later as court historian. He was calm and undogmatic in temper, beloved and respected by men of all parties, yet holding his own comprehensive position with an easy air of freedom. No doubt he made his own personal combination of Confucianism, Taoism, mystical Buddhism, Zen Buddhism, and Oanseki's scientific rationalism. He was a poet, well-known in his day as Michael Angelo was. He loved, even during his period of service, to take walks into the country and brood over the beauty of scenery. Toba sometimes accompanied him, and has left records of their experiences. He was also a master of prose, and had a fine hand at written characters. He was regarded by his more formal friends as a good - humoured eccentric ; one of his friends openly regretting that he did not put more " moral purpose " into his pictures. " But he was a lover of Tao ! " the critic sighed. It was quite Confucian to condemn pictorial beauty as such for triviality. Hence the first Bunjinga absence of beauty. He was a connoisseur and collector, and also made drawings for books. He is perhaps the most " all-round " man in Chinese history.

Yet, as in the case of Leonardo da Vinci, it is as an artist that the world best preserves his fame. I intend to say no more here of his supremacy as a Buddhist painter. It is rather as a painter of secular subjects that we here want to think of him, and a man of the same line and tendency with Risei and Kakki before him, with Rito his contemporary, and with Kiso, Riteiki and Rianchu after him. Ririomin spent his youth in a part of the country where horses were bred, and especially loved their freedom of wild motion. So that his earliest predilection was for the painting of horses. In this narrow line some critics have ranked him above the great Tang horse-painter, Kankan. But it was also in the fine attitudes of the riders of the horses that Ririomin excelled. A good example has come down to us in a copy by the Japanese Okio ; we do not know whether the original still exists. Here the same supreme imagination for line freedom in drapery, which his Buddhist work displayed, is conspicuous. The synthesis of the man turning with the Tartar behind him is specially fine. Again and again the comments of writers upon his pictures refer to his likeness to Kogaishi. The same thing was said during Tang of the pictures by Godoshi. We can see well what the sort of force is that is common to Ririomin and Godoshi. " The force of Kogaishi " is the very phrase used.

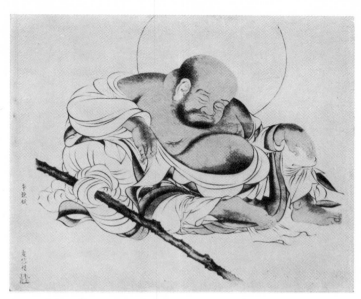

SLEEPING HOTEI. By Ririomin
(Li Lung-mien).

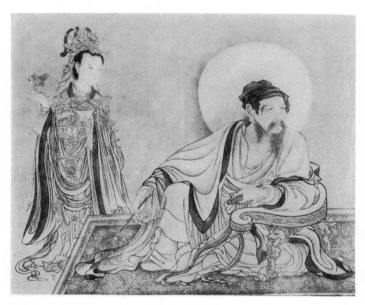

THE FAMOUS YUIMA OR VIMALAKIRTI (*Copy*).
By Ririomin (Li Lung-mien).

THE PAINTING BY RIRIOMIN (LI LUNG-MIEN)
OF HIS OWN VILLA, "RIOMIN-ZAN."

DRAWING—HEAD OF A CHINESE LADY.
 By Ririomin (Li Lung-mien).
 Owned by Mrs. H. O. Havemeyer, of New York.

BLACK BAMBOO.　By Bunyoka.

Apart from his altar-pieces Ririomin was fond of using paper rather than silk for his grounds, and of painting in ink only. Yet his colour in Buddhist pieces is praised as "divine," and in landscape his style is compared to the general Rishikin's of Tang, which was a coloured style. It is therefore an ignorant assertion of one scholar that Ririomin used colour only when he copied. This was perhaps a pious attempt to reclaim Ririomin as a scholar in good standing, by insinuating that his great Buddhist work was merely copying. It is true that he specially loved to copy the great accessible works of earlier masters, and it is declared in his biography that he so loved to copy Kogaishi, Chosoyo and Godoshi, his splendid bias for line being surely here derived. He loved to paint the Ubasoku Yuima visited by Ananda, a subject which we may remember was created by Kogaishi. Kogaishi's Yuima was one of his few pictures that was known to exist as late as Sung. It is a fair inference that Ririomin's Yuima was more or less based upon the ancient model. In the Yuima of Ririomin, of which we present a copy, the work is entirely done in ink line, and has an archaic flavour. The princess figure of a young girl attendant is like a Buddhist statue. There is relationship between this line, and the single figure of Kogaishi given in the Kinsekiso. On the other hand the line is inferior to Ririomin, less sure of itself and consistent. Another work of Ririomin's upon paper, this time Taoist and slightly coloured, is of a fine fat Hotei sleeping. This is far superior to the Hoteis of Sesshu and Motonobu, much less abstract in line and modelling. I have also seen Ririomin's portrait of the poet Rihaku overcome by drink, of his Daruma, and of his standing white Kwannon. I will not attempt to refer here to the elaborate descriptions of some of his famous paintings which Chinese critics have left us, only to say that we can understand the force of his crowded compositions of figures by studying the early Kano copy of his fight among the blind musicians. This too shows that he was not lacking in humour; but the mingled humour and pathos of the scene where the sightless antagonists beat the air and smash heads with their "biwa" is swallowed up in the magnificent passages of the lines.

Ririomin, as a landscapist, seems rather to have gone back to Tang, than merely yielded to the new Kakki style. He could paint minutely and with rich colour. The studies that he made of his own Ririomin-zan were long famous. Only one piece is known in Japan, namely, the

bamboo grove at the back gate of his villa, where stone steps lead down to the river. Here there is slight tinting of colour, and the style is not so different from what is soon to follow of the Senkwa age, Kiso himself the Chos, and the ancestors of Bayen. There is a naive charm about its composition, however, which is quite unique. It is so quiet and homely. We can feel every detail of flower, grove, walk, and ornamental stone, even the wild white peach blooming amid the dark bamboo. The bamboo grove on the farther bank of the stream is thinner, and toned down into mist.

Another thing that shows Ririomin's fine feeling for rusticity and quiet life is his love for the ancient poet Toemmei. He often painted Toemmei. He definitely retired from public life in the year 1100, the very year before the accession of his young friend, the prince Cho Katsu. Though Kiso Kotei could not have Ririomin's direct influence at his own academy, it was reflected through himself, and doubtless pictures found their way up to the court from Ririomin-zan.

But a last interesting feature of Ririomin's thought and work that we must mention, is his supreme respect for the great and domestic virtues in women. It was one of his favourite subjects to paint in all the splendour of their rich beauty and moral nature the great ladies that he had known at court, and the noblest wives and mothers of Chinese biography. This is reckoned by his contemporaries as one of his finest traits. Fortunately one most beautiful specimen in thin ink on paper has come down to us. It is a lady, evidently of youth and delicate nature, whose luxuriant hair is caught back into three heavy coils by a single rough wooden hairpin. Her garment is a single robe wrapped round her slender body. This must either represent some famous noble lady living in lofty calm though reduced to penury, or more probably a widow who has dedicated her gentle life to her husband's memory. In any case the face is extraordinarily sweet, high-bred, and beautiful, and well worth comparing with Raphael's sweetest Italian types of mother. It shows how such a great Chinese as Ririomin appreciated " the eternal feminine."

We do not know the year in which this admirable spirit passed to its Nirvana.

Of Ririomin's contemporaries, the men about whom the biographers make most fuss are the scholars, Bunyoka, Toba, and Beigensho ; but we can read between the lines that the high praise given their art is rather reflected from the fame of their literary achievements. The

truth is that they were rather narrow and amateurish at painting ; though Beigensho was, as we have seen, something of a caustic critic, Bunyoka was celebrated chiefly for his " black bamboo," and Toba the same. From the example here given we can see that there was nothing of bunjinga carelessness in their work, every stroke being as clear and crisp as a Bayen. Beigensho, on the other hand, seems really to have originated a kind of sloppy style, out of the suggestions of Hankwan, which may be called the ancestor of bunjinga. It is fine and striking in its notan, but almost childish in its drawing. It may be suspected, however, that this has been falsely fathered upon Beigensho by some Yuen enthusiast.

In 1001 Kiso Kotei (Hiu-tsung) came to the throne, and what is sometimes called the brightest era of Asiatic art came in. There were no geniuses as supreme as the retiring Ririomin. The Emperor himself came nearest to this high standard. Most imperial attempts at art are only flattered mediocrity ; but Kiso's work really rises to the heights. He proceeded at once to collect about him all the able painters he could lay his hands on, organize them in a more special way than as mere courtiers, compose a great art academy in fact, with definite studies, exhibitions, and rank for prizes. The Confucians have always sneered at this organization, and its successor in Southern Sung, as the prostitution of talent to officialdom. No doubt danger would lie along this line if the standard were not kept extraordinarily high. This Kiso attended to by collecting the most complete Art Museum of masterpieces that China ever saw. This was the famous Senkwa* collection (Senkwa period 1119 to 1125), of which an account was published in printed form.† To illustrate its scale we may mention that it owned more than a hundred of Ririomin's pictures.

The Emperor graciously took his associates through the Museum, pointing out the characteristic beauties, and urging the influence of the best models. He himself set subjects for the artists, presided at the symposium where the experiments were compared, and passed personal criticism upon them. Our own little " Kangwakwai," in Japan, from 1880 to 1886, modelled its procedure on that of Kiso's Academy— (see Chapter I.). But in his day the whole Chinese world was under the eye ; in our day but the shadow of the shadow.

Foremost among the artists stands out the Emperor Kiso. It is

* Senkwa, in Chinese " Hsüan-ho."
† It is still to be obtained in Japan, where it is known as the " Haibunsai Shogwafu."—Ed.

openly said in his biography that his style is based upon Ririomin's later manner. We can understand this well from his splendid Buddhist picture of Shaka, Monju and Fugen, in colour, kept in one of the smaller temples near Kioto. The figure of the youthful Monju, a girlish boy, wrapped in long twisting folds of mantle, is one of the most Grecian figures in art. Its lines are more effeminate than Ririomin's. The Senkwa art, indeed, often ran to minuteness, and sometimes rather than strength. Kiso's white hawk and iridescent pigeon among peach blossoms show how he could create in the manner of Joki. But perhaps his greatest in landscape, the two fine pieces kept at Daitokuji, Kioto, being enough for the fame of any man. One shows a poet—likely enough Ririomin himself—who has climbed to a great ledge among the mountains, where he has thrown himself down at the root of a cedar tree almost torn to pieces by the storms that have swept over its conspicuous site. A great rock buttresses the foreground. Far below are seen the ridges of adjacent spurs. White clouds, done in solid white, sail away into the melting air. A wild stork, flying, seems to lose itself in infinity. The careless pose of the poet is fine, with one arm thrown up against the rough tree-trunk. The torn branches are done with a power that resembles Zengetsu Daishi.

The other scene is of a mighty foreground rock tipped with bamboo trees that nod to a waterfall springing across a cleft. A monkey sits gibbering from a tree above the waterfall. Among the broken rocks below a standing figure with hood and staff looks back and down into the wild abyss. It is early morning, and the frosts of a wintry night still tingle unmelted upon rock and leaf. The drawing of the figure is wonderfully fine, simpler even than Ririomin. We can see from these that Kiso's style in landscape is no imitation of either Godoshi or Kakki. It uses lines with great force, but they are elegant and few. It does not attempt to render space and glow by great patches of light and dark; nor does it blur its masses into impressionistic effects. Every detail is drawn with utmost crispness, yet the effect is large, due to the perfection of the drawing. The grandeur lies in the spacing. The dark is local colour, spotted upon things sparingly. The style and strokes foreshadow the incisiveness of Bayen. Here is a line of cleavage between the early landscape of Northern Sung and the landscape of the Southern.

Associated with Kiso in his long æsthetic reign, from 1101 to 1126,

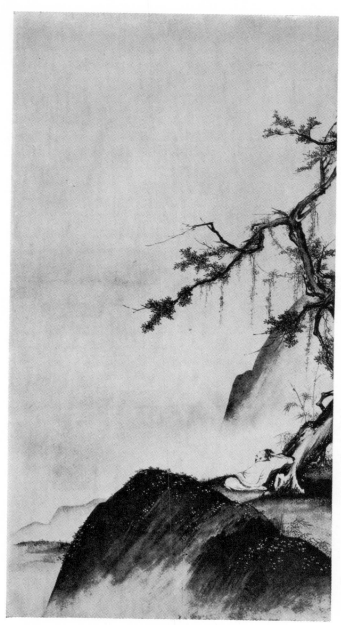

PAINTING BY KISO KOTEI (HUI-TSUNG).
 Daitokuji.

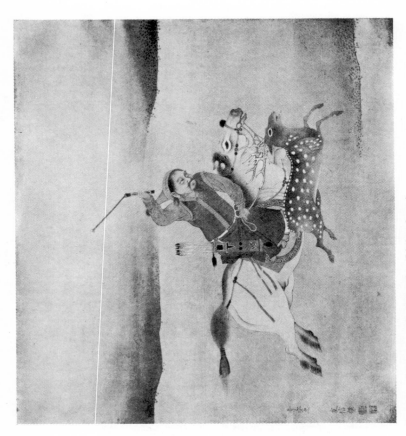

TARTAR HUNTING. By Rianchu (Li An-chung).

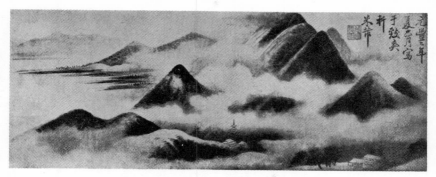

CLOUD LANDSCAPE. By Beigensho (Mi Yuan-chang).

GENRE SKETCH OF A CHINESE PEDDLER OF TOYS.
 By Jinkomi (Kao K'o-ming).

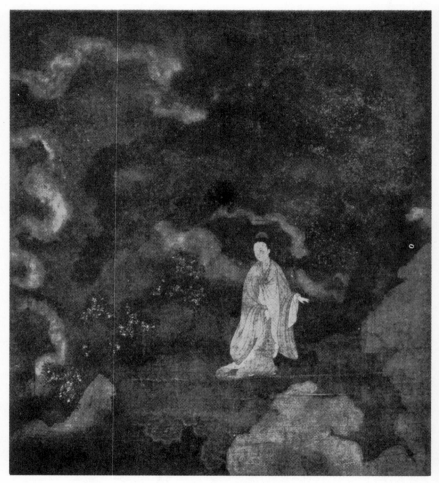

PAINTING : SUNG LADY LEANING AGAINST A PINE
TREE. Attributed to Chosenri (Chao Ta-nien).
Mr. Charles L. Freer.

were several other members of the imperial clan of Sung, especially Chotainen (Chao Ta-nien), the painter of delicate impressionistic landscapes in colour, and Chosenri (Chao Ch'ien-li), whose work is more like Kiso. Rito has left us fine drawings of landscape, and particularly of cows, in which he was hardly inferior to Taisu of Tang. He was especially famous about 1111, and died somewhere near eighty years of age, about 1130. Riteiki (Li Ti) was a Senkwa man who essayed both land-scape and figures. Rianchu (Li An-chung), also of Senkwa, put the finest touch into birds and running horses. He it is who has left us vivid drawings of the Kin Tartars, who were even then, because of Kiso's vacillation, threatening the Northern Empire with destruction. A Tartar on horse-back, killing a wild deer with a weight wielded by a string, is reproduced. Jinkomi has left us a fine *genre* scene of country life, where many children and a nursing mother are attracted by the wares of a moustached pedlar. It is in the style of Ririomin modified by Kiso. The many seals upon it are believed to be of the several imperial collections in which it has been treasured.

But perhaps the most beautiful picture of this age, next to Kiso Kotei's, is the Sung lady leaning upon the great chocolate trunk of a twisting pine tree, owned by Mr. Freer. This, too, has imperial seals. It is tinted in most delicate colour, and the tree is drawn with wonderful force of crouching branches. The masses of the leaves are broad, though executed with hair lines. They are of a wonderful bluish-olive in tone. Rocks of pale bluish malachite are at the bottom ; a blossoming tree, the fragrant " wild olive," rises at the left. Clouds of low, smothered opaque creams boom through the composition. The figure is most delicately drawn, and tinted in soft, warm yellows. The whole forms an impression of incomparable peace and beauty. I am inclined to ascribe this gem to Chosenri (Chao Ta-nien) himself, the cousin of Kiso.

The accessories of life at this day must have been very rich. The splendour of pattern, working into the rhythms of living forms, dragons, lions, and birds, can be seen in the robes of Ririomin's Rakan. The palaces were gorgeous, more like what Kimura painted for us in 1880 ; the Emperor constructed a beautiful lake near the palace grounds.

We may add that book-printing probably began at this day. The sudden tragic cataclysm that destroyed this idyllic peace and æstheticism, and caused the change to Southern Sung, must have its story deferred to the next chapter.

CHAPTER XI.

IDEALISTIC ART IN CHINA.

Southern Sung.

K ISO KOTEI'S (Hui-Tsung's) wonderful twenty-five years of æsthetic illumination at Kaifongfu on the Southern bank of the Hoangho River, and therefore close to the most ancient centres of Chinese civilization, was rudely threatened and broken up by a tragedy more national than the somewhat private feuds that destroyed Genso of Tang. It was the capture of the city and the whole of North China by the Kin Tartars in 1126. The responsibility for this stupendous misfortune has been laid by all chroniclers at the door of Kiso's impious æstheticism. He has been represented as a Chinese Nero, fiddling away his soul ecstasy with brush and pen, while Kaifong burned. Yet some of those ministers who gave him the very worst advice were the Confucians. When have Chinese scholars made great generals ?

These Tartars, the most civilized of their race, had been in touch with China for some time. Something of Sung culture had penetrated to them. In 1114 they were pressing so hard upon the province of Liang that the latter, without the consent of Sung, attacked the Tartars and defeated them. The Tartar chief, however, prevailed upon Kiso's weak government to aid him in this attack of a rebellious province. In a bitter campaign of seven years the valiant Liang was extinguished. Then the Kin chief turned upon his imperial allies, demanding land and recognition as an equal. Sung was in no position to withstand this powerful Goth, and after some violence was forced to make a disgraceful peace which virtually surrendered all North China, including the person of Kiso himself to the Kin, and allowed the Chinese court peacefully to retire to some new capital far in the south. This episode of 1127 is spoken of regretfully in Chinese history as "the crossing," meaning the crossing of the Yangtse River below which they chose in 1138 as their capital upon the coast the already picturesque city of

Hangchow. No doubt its beauty, with a neighbouring lake surrounded by fine mountains, played considerable part in the choice. Here Toba the poet had been governor only a few years before, and had repaired the causeways which intersected the lake, and rebuilt many bridges. Now the city was laid out on a larger scale, with heavy walls of masonry facing the lake, through which walls lofty gates gave egress to the shipping on the canals. For Hangchow was a sort of splendid Venice, crossed by many waterways and enriched by hundreds of fine arched bridges of a type which still remains throughout that part of the south. The palace was built upon a rolling tongue of land which separated the lake from the great Sento river that was here becoming an estuary before it emptied into the sea.

Marco Polo saw this city a few years after its greatest growth, about the year 1300. When it fell in 1279, it had been the most brilliant and intellectual capital that China ever saw for only one hundred and fifty-two years. I would refer the reader to Polo's description of it as being far ahead of anything in Europe at that day, the bridges, the public buildings, the universal supply through leaden pipes of hot water for bathing, the refinement of the people ; the crowded villas, temples and pleasure houses set in picturesque nooks about the shores of the lake. Many of these architectural splendours actually remained until the terrible destruction of Hangchow by the Taipings in 1860. That, indeed, was like the explosion of the Parthenon by Austrians in the seventeenth century. To-day we should understand the real ancient heart of China far better but for that misfortune.

One cannot help pitying poor Kiso in his long captivity among the Kins, who now established their capital near the present Peking. Though it was nominal captivity, yet we may be sure that he was in the midst of millions of his own countrymen, in his country's ancient seats, and, though shorn of all power, that he spent a dignified decline in æsthetic pursuits, and undoubtedly did much to civilize his captors. When the Kin empire itself fell before the all-conquering Mongols, a century later, it was already the seat of advanced culture. The study of this Kin art and literature will some day be very interesting, and some painting executed by Kiso in his retirement may yet turn up. He died among his captors in 1135.

But, so far from being discouraged by Kiso's æsthetic " excesses," the new government at Hangchow plunged into the delights of art with a new ardour. The Imperial Art Institute became now an organic part of the Court Service, with examinations and court rank of almost equal importance with the institutes of literature. The later Chinese have never forgiven the great court artists of Hangchow, such as Bayen (Ma Yuan) and Kakei (Hsia Kwi), for being " professional artists," "at the beck of monarchs," etc., etc. They look back with praise to Enriuhon (Yen Li-pen), of Tang, who was " ashamed of being a painter." It is much as in English fiction that a hearty Saxon aristocrat looks down on a " tradesman." We can see that the scholars in their own hearts had little real love for an art they would so demean. Its moral uses were what saved it, according to their idea, and its " literary freedom." It is one of the anomalies of Chinese civilization that these pedants raised the standard of " freedom " to cloak the most narrow creed and tyrannical conformity. In this they were not so much unlike their New England fellow-Puritans. On the other hand, under the magnificent system of training of the Sung academy, genius found its fullest means of expression. No French impressionist could be more " free " and picturesque and æsthetic in his methods than Kakei. The state of things was much more like that of Phidias under Pericles, or the Florentine artists under the Medici. In that fervour of magnificent work which electrified the beautiful Italian city under Lorenzo's wise patronage, a thousand competing artists found their ranking upon a scale of absolute merit. Where a public as well as a court is a-thrill with the highest taste, there is no room for official favouritism. So tremendous was the spiritual momentum of Hangchow art, and so high its standard, that it succeeded in maintaining itself, like a wedge, far into later alien bodies of Yuen and Ming work.

That the passionate love of landscape should come to dominate this new art, even more absolutely than it had done under Northern Sung, is due to the fact that the court was once more in its native South. Not far away up the river lay in pathetic desolation the very site where Butei * of Rio had held Buddhist services in his ancient Nanking. Not far away to the north-west rose those grand chains of mountains, jewelled with lakes, which Toemmei and Shareiwun had

* In Chinese, Wu Ti of L'iang.

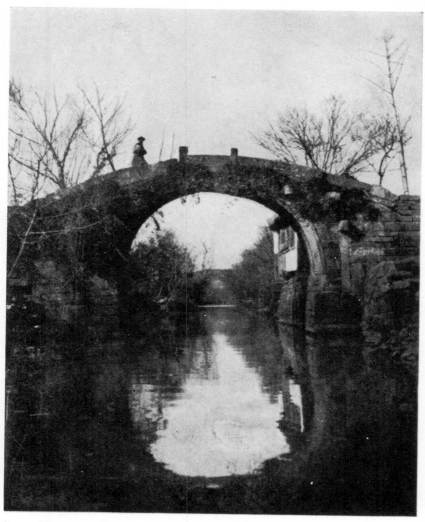

STONE BRIDGE IN GARDEN NEAR HANGCHOW,
AT THE PRESENT DAY.

THE EARTHLY PARADISE.
 Artist unknown; Ming Dynasty.
 British Museum.

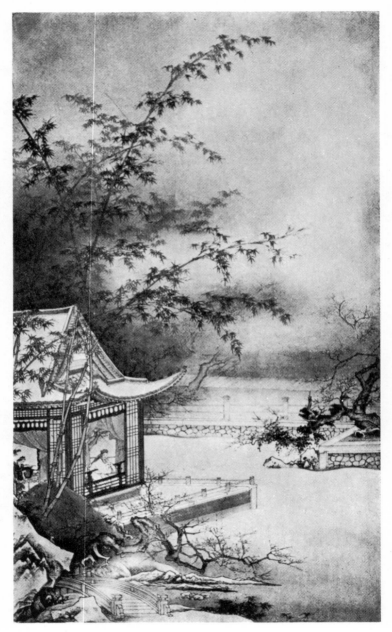

BAMBOO AND VILLA IN WINTER.
By Bayen (Ma Yuan).

celebrated in their first landscape poetry. It was the "Lake Country," the home of the Chinese Wordsworths. The great Northern landscape poetry of Tang had been but a reflection of this passionate South into the whole mirror of the Chinese mind. So again in early Sung, it had been the artists of the South, who coming up to Kaifong, had again breathed their love for nature into the same great mirror. The whole landscape school of Northern Sung was but an imported South. And now the capital was once more set in that blessed South, after five centuries of absence. Landscape should be no longer an imported ideal. The very mountains and waters, of which its name is made up, could paint themselves on the sensitive fabric of every heart. Never in the world, before or since, and nowhere but in Hangchow, has there been an epoch, an illumination, in which landscape art could give vent to a great people's passion, intellect, and genius. What Christian emotion was to the early Italian cinquecento, what Buddhist emotion was to the over-cultured Fujiwara at Kioto, that now landscape emotion became for the Chinese of Hangchow. Fra Angelico and Yeishin Sozu, so much alike, must now make a strange companion of the absorbed Mokkei (Mu Ch'i).

Here, too, we put our finger upon the fact that it was this very South that had been the original and continued seat of the Zen sect of nature contemplators. Already before "the crossing," its sombre temples and mighty pine-trees of the temple yards had covered many a lofty site about Seiko Lake. All that Kakki says of symbolism and poetical interpretation in his great essay was now more than realised in Zen philosophy. The Taoist interpretation becomes quite overshadowed by the Zen. Every Zen monk and abbot in Southern Sung becomes a landscape painter, or introduces figures that seem to melt down into the very substance of the landscape. Many successors of Kakki arose as writers on landscape, some of whose works I shall shortly quote. Poetry did not reach the heights of earlier times. Genius was absorbed in painting.

It is worth while now to ask what had become of the valiant protests of Oanseki, fifty years before, against the encroachments of Confucian formalism upon the Chinese intellect. The most conservative wing of the scholars' party had never been able to reinstate themselves in imperial favour. The new Emperors in the South were far from

allowing themselves to be recaptured by an ascetic ritualism. But the problem had to be faced in a new form. To have Chinese polity based upon two bitterly antagonistic philosophies augured weakness for the future. The Confucian danger might be eliminated once for all, not by opposing, but by transforming Confucius himself. It augurs much for the nobility of the Sung intelligence that it could clearly put to itself such a problem. The problem, in its large range, as it worked itself out through three generations of great Chinese metaphysicians, was how to fuse Confucianism, Taoism and Buddhism (Zen) into a single working system. I suppose that this is the greatest intellectual feat accomplished by Chinese thought during the five millennia of its existence. It is as when a Leibnitz, a Kant, a Hegel arose to reduce dry European formulas with scientific and idealistic solvents.

The great philosopher Teishi had already begun the work at the end of Northern Sung. The Confucianists of the South tried in vain to proscribe his doctrines in 1136. The central work was done in 1177 by the still greater Shushi, in his most original commentaries on the Analects of Confucius and on Mencius. In 1193 Shuki had extended the system to the whole round of Confucian literature. But in 1196 another temporary decree, procured by the unregenerate Confucians, prohibited the reading of all this work as " false philosophy." Yet in 1241 his tablet was placed in the Confucian temple.

To an outsider it must appear as a matter of infinite thanks, must appear as a spectacle of unique grandeur, this last effort of the great Chinese mind to raise itself into a plane of universal human thought — to make itself the fellow of Plato in the ancient world and of Hegel in the modern. For the tragedy was at hand ; the last chance was about to be cut off. That Scourge of the World, Genghis Khan, became chief of the Mongols in 1206, only six years after the death of Shuki, and inaugurated that policy which eventually swept down before his fanatical tribe all of Asia and half of Europe, like fields of wheat before a mowing machine. With the final destruction of Sung fell the real creative ability of the Chinese race. After the Yuen debauch, it is true, the Ming tried to revive art, literature and thought ; but it was too late. The brain was ossifying. Stereotyped categories were supplanting the free play of ganglia—" Freedom is beauty " had become mere words, incapable of translation into deeds.

The nation was already virtually dead, in that no reconstruction from within was possible. Thus we watch the last flare up of Chinese genius at Hangchow with a melancholy and tragic interest.

The Philosophy was a splendid one ; but this is hardly the place to expound it. Enough to say that it substituted for the hard classes, the fixed categories, the ritualistic forms of the old Confucianism, a doctrine of inner evolution, by which the fixed points became fluid, and passed into each other by a logical order, akin to historical order in human affairs. A thought is what it becomes ; so is an institution. The "mean" of Confucius is no abstract compromise nor mere grammatical genus, but a healthy elastic working in a sort of spiral. The true spiritual type is individuality ; not a negative freedom to abandonment, but the place in which the needs of readjustment must find room. Moral discipline, but not asceticism, is its privilege. There is no natural inferiority in human souls, not even of children or women. If we had the full texts of Confucius, we should have found him the bitterest enemy of the formalism founded upon him. In the Analects we find the germ of a doctrine of individuality. In the more ancient Y-King, evolution is clearly stated. Laotze's idealism is only a derivation from the Y-King. The Taoist magicians travesty the power of soul, but do service in calling attention to nature. As we should say, they are the alchemists of their world. Buddhism, too, in its later forms, is evolutionary, and holds to the integrity of the soul, even through the possible superstition of reincarnations. Zen Buddhism particularly inculcates that fresh spontaneity which nature and life and normal society exhibit. In an evolving individuality, therefore, an individuality which takes its place with others in the harmonic circle, we have a working union between the three Chinese religions. They are only partial expressions for one and the same thing. Over all is Heaven ; through all is harmony and beauty ; nature and man are brothers ; the soul is but a child growing more and more into the stature of its parent, Heaven. Surely this is well nigh up to the most advanced Christian philosophy ; and goes far to solve the eternal antinomy between the individual and society.

The sort of life that came upon Hangchow with the practical cessation of party strife may be called the most idyllic illumination of all human experience. Statesmen, artists, poets, Zen priests, met upon a basis of spiritual equality, were close friends interested in each

other's works, and often combined functions in one and the same person. They spent their mornings at work in the city; but their afternoons, evenings and holidays on the lakes, at the terraces on the causeways or the rocky islands, among the Buddhist temples that invited them by winding inclines up every steep, in the countless villas that dotted the edge of every bay and creek. Great two-storied pavilions looked down upon the lake from above the city walls, or from the bastioned rocks, where parties might congregate, and in conviviality enjoy the beauties of sunsets or discuss poetry. These lovely villas surrounded themselves with gardens in which cool terraces, and graceful marble bridges, and lotos ponds walled in with stone and overhung by swaying trees, played necessary part. And some of these exquisite gardens remain yet, overgrown perhaps, but with strange latticed windows and circular doors opening from cool interiors, in Hangchow itself, or in the great neighbouring city of Fuchow, and in the country retreats of the whole vicinity.

A photograph of one of these gardens, kindly lent me by a recent traveller, an American lady and an artist, I reproduce here side by side with a similar scene painted contemporaneously by the Sung artist, Bayen. Still to-day the great pagoda of the six warriors dominates the hills, rising from the river, where the Sung palace stood. But it was in the still cooler recesses of the Zen temples in their secluded groves that the finest thought and art were brewed, by choicer spirits who rarely came to the metropolis, human beings as free and wild and impressionable as mountain deer and graceful herons. Such were the priestly artists of the Mokkei class.

Besides history, philosophy and painting, the art of these happy idealists cared specially for pottery. They are indeed the inventory of that creamy-brown and mottled warmth of greys, and suggestions of cool purples and milky-blue in the opaque glazes that overlay the tawny clays of the ground. The very way in which the glaze runs, like the play of semi-transparent thin waves hurling their light lassoes over the warmth of wet sand, is also like the play of opaque pigment in a fine painting that finds telling place over the depths of prepared grounds. The work of Whistler, both in water and in oil, particularly exhibits this effect of scumbling, which is like Sung glazes. The fine painting of Chosenri (see page 29) exhibits, in photograph, almost the same law of spotting as the Kioto square vase, based upon Sung colour.

It is because of this subtle influence of pottery upon painting that Mr. Freer has made his collection consist of its three famous parts.

We come now to those leading artists of Southern Sung, whether teachers of the academy or retiring priests, who form the glory of Sung art, who became the models of later Japanese art, and who have still much of surprising beauty to reveal to the Western world.

The first generation of Southern Sung men had been trained in the great Senkwa school of Kiso, and participated in "the Crossing" to the South. Among these men were the Riteiki and Rianshu already mentioned, and the aged Rito. Riteiki was made vice-director of the new academy. With them came Sokanshin ; but Yohoshi (Yang Pu-chih), who had been one of the geniuses whom Kiso had tried to train, refused to come at Kiso's invitation. He had a wild talent which painted only in great feeling, and confined himself largely to painting sprays of plum, orchid, bamboo and pine, all in ink of several tones. One of the very last things that Kiso had done was to criticize a painting of plum branches by Yohoshi as a "village plum," and ask him to paint it over again with "few branches and cold leaves," "whose purity shall seem to be human." Shortly after, before the new work could be finished, Kiso was in captivity.

Of the earlier men who probably began work in the South itself under the first Emperor, were Bakoso,* the most famous critic of the new academy, and Bakwashi,† a native of Hangchow, who painted a set of three hundred pieces illustrating all the ancient odes compiled by Confucius. A poetical comment which existed, on one of his pieces, and is quoted in Chinese literature, shows us such a picture of individual character, that it throws light for us not only on the painter's work, but on Chinese poetry. "The night water-clock has already stopped, and the frozen stork has fallen asleep. The dark-headed servant is warming himself by the fire, with his two knees crossed in front of him. Before the napping old man stands a mouth-cracked jar holding a branch of blossoming plum."

It was very common for Chinese poets and critics to write upon the free spaces of pictures, and the habit was imitated by the Japanese of Ashikaga. So universal did it become in Southern Sung, that a scholar was asked to dedicate a painting as soon as made. This was carrying out

* In Chinese, Ma Hsing-Tsu.
† In Chinese, Ma Kung-hsien.

the old dictum, that poetry and painting are only varying forms of each other. It thrilled the Chinese connoisseur to see two such supreme beauties presented as one. A third art, namely, the beauty of the handwriting, was often added, when the poet happened to be a noted chirographer.

Bakoku, the son of Bakoso, rose high in the artistic examinations, and received the badge of the golden order, which Riteiki had held. He and his younger brother Bakeisei worked for the second Emperor down to 1190. It is interesting to note that the first Emperor Koso, who crossed with his Court in 1127, built his palace at Hangchow in 1138, and ruled for the most part peacefully as a great patron of arts until 1162—although he then resigned in favour of the second Emperor, he still lived on in a ripe old age of æsthetic enjoyment until 1187. This great period of sixty years saw two generations of artists rise and pass away.

Other artists of this great Koso period were Mosho, a painter of animals, and his son Moyeki (Mao Yih), a still more famous painter, who took his artists' degree in the period Kendo (1165-1173). Moyeki particularly loved to paint cats and tigers, with the fine crouch, and the soft gleaming fur. In power and delicacy he is far ahead of those later realistic animal painters of China, whose works we mostly see ; and also ahead of such Japanese Shijo men as Ganku and Sosen. The small painting of a crouching tiger which we here reproduce shows the So method of painting in its most perfect original form. In both form and colour it might be compared with a Rembrandt or a Rubens. It is perhaps the finest original of Moyeki now remaining, and is one of the gems of Mr. Freer's collection. Moyeki probably lasted on into the next great period.

That the reign of the fourth Hangchow Emperor, Neiso (Nin tsung), is the very centre of Sung genius and illumination must be recognized. It lasted from 1195 to 1224 ; but with it we may well include the end of the reign of the second Emperor and the short reign of the third—that is from 1187 to 1224. In this way we can divide the great Hangchow movement, in all but its very latest struggling years, into three clear portions :—

The life of Koso—1127 to 1187.
The age of Neiso—1187 to 1225.
The reign of Riso—1225 to 1264.*

* These important dates do not correspond exactly with other printed versions of them, but since these were verified in Japan, in the spring of 1910, by several well-known Chinese scholars, I think they had better remain as they are.—M. F.

REMAINS OF AN OLD HANG CHOW GARDEN
at the present day.

SMALL CROUCHING TIGER. By Moyeki (Mao Yih).
In the collection of Mr. Charles L. Freer.

The first is the preparation, based upon the work of Senkwa ; the second is the culmination, realizing the new Hangchow genius in both philosophy and painting, the third is the persistence, with a slight weakening in art, and troubled by the rising Mongols.

That the age of Neiso was the very flowering of Hangchow is seen from many indications. It saw the supreme philosophical work, the death, and the posthumous triumph of the great thinker Shuki. It was an age of great refinement and learning among women. And it was the chief seat of the labours of the greatest painters of the South, Bayen, Kakei (Hsia Kuei), and Mokkei (Mu Ch'i).

Bayen (Ma Yuan) came of a family many of whose members were artists as far back as Senkwa, and before. His grandfather was Bakoso, one of the founders, and chief critic, of the Southern Academy. His father was Bakeisei, a respectable associate of the time of the second Emperor. His uncle was the great Bakoku who held the golden badge. He probably took his degree about 1180, and, his extraordinary genius being at once recognized, soon became the greatest professor and the most famous member of an Academy rich in prominent geniuses. Many of his pictures, famous in imperial collections, are described for us by Sung and Ming commentators. By the last of Sung his fame had already passed into a proverb.

One would judge that Bayen was the first to paint the subject of the three founders—that subject which Professor Giles mistook for a portrait of Christ and His disciples ! It reveals Sakyamuni (Buddha—also called Shaka), Confucius and Laotze, the founders of China's three religions and schools of philosophy, in harmonious inter-course, and thus typifies the new great Southern Sung philosophy of the contemporaneous Shushi and Shuki* which had in theory united them. It is quite possible that the fine painting of this subject by Kano Masanobu (shown in Chapter XIII.) has its figures copied from this design by Bayen. At least the composition is just like that described by a Sung critic, who speaks of the Shaka as walking ahead and turning back to Laotze and Confucius, who advance together. This beautifully typifies the fact that Buddhist influence was from outside Indian sources. The strong head of Confucius

* EDITOR'S NOTE.—Dr. N. Ariga, of Tokio, assures me that these two names, Shuki and Shushi, belong to one person ; the latter, Shushi, being his " philosopher name."—M. F.

betokens individuality, the smiling face of Laotze brotherly love, thus seeming to exchange, or intermingle positions.

Bayen was the second to paint the eight famous scenes of Shosei Lake, which only Sobunshi had done before him, a few years earlier. Bunshin had done it on a picturesque journey ; and the synthesis of his choice was probably an accident. Bayen's, which were probably far finer, really established the type as a recognized set for all later Chinese and Japanese art.

It is also most interesting to be informed that whenever Bayen painted for the Emperor (Neiso) his picture was commented upon by the Emperor's youngest sister, Yokei, who was most celebrated for her literary skill and handwriting. This shows both Bayen's familiarity with the palace inmates, and the advanced place of women in education—all of which is of course non-Confucian.

The strictures passed by a Ming commentator upon both Bayen and Kakei, that they are poor and unworthy in style, is a bit of pure Confucian misconception. Though the greatest masters of ink style, they are the farthest removed from anything like Bunjinga taint. They are the most " Northern " of the later class, " The Northern School !" No such distinction, however, was made in their day. Extreme Confucians did not like them ; but all Chinese artists and critics of any power have regarded them as standing at the top.

Of Bayen's pictures known in Japan there are a large number, mostly belonging to former daimio collections (often since dispersed) or occasionally to temples. From these it seems clear that Bayen's style goes back to Kiso Kotei, and so remotely to Ririomin. Or rather we may say that he relates more to Ririomin in figures, but more to Kiso in landscape. There is little in him of the grand sweep of moor or misty blur of cloud and foliage, such as distinguished the early Sung landscape of Kakki and Risu. His touch is rather clear, hard and firm, not getting effects by accident, but by complete mastery over design. He gave his trees a clear, though not thick outline in firmly penned ink. His colour is generally thin, consisting of a few transparent tints that just modify the prevailing warm monochrome of ink and paper. In this he is the forerunner of the coloured landscape of the Kano school in Japan.

Bayen loved to paint the beautiful villas that surrounded the western lake, or were set like gems into the valleys that ran back into the mountains. One of the most beautiful of these shows a one-storey pavilion, open at the sides, but screenable by roll-up bamboo curtains, and edged with an irregular stone facing that dips into the waters of a river or pond. Behind a finely carved railing sits a Chinese gentleman with a round-bodied lute in his hand. We can trace the tiled floor and the solid cylindrical columns of the pavilion far back through the opening. There are beautiful tones of soft mauve and yellow in the hanging decorations. The roofs are beautifully tiled, and are without that Tartar exaggeration in curve which modern Chinese drawing gives ; in fact, they are roofs of exactly the type of the Japanese temples of Ashikaga. Water-worn rocks painted in fine crisp outline, not unlike those of the Ririomin landscape, edge the pond. Graceful sprays of bamboo cut springing curves across the roof-lines, and soft trees, of the oak or beech order, are spotted out into the mist at the back. In this fine stippling of leaves, which perfectly gives the silhouette of branches, we have a method very different from the cloudy mesh of Kakki, and also utterly unlike the modern Chinese bunjinga, which draws with a certain formal touch the leaves on all trees, no matter how distant.

But the finest thing in the picture, and the most salient, is the large green pine-tree—greens and soft browns—that rises from the foreground, and springs high up in the air over the roofs, with the spirally resisting and tapering force of a rocket. Here individual pine needles are drawn, but so softly that you can hardly see them without a special focus. The branches have a firm but not exaggerated twist and reach. The counter-point of the crossing pine and bamboo lines is magnificent ; we cannot help recalling the Sung gentleman's idea of manliness, " firm as a pine, yet pliant as a willow." Here both trees, while contrasting, partake each of the quality of the other. The bamboo, like a great lady, has a gentler character that will be found stronger when it comes to emergencies. The pine, though tough in fibre, as beseems a statesman's ability, has a perfect grace of finish in accordance with lovely manners. The feeling of life in this place is full of that subtle charm which we find a reflection of in Ashikaga gardens.

Another beautiful Bayen villa shows a similar pavilion in winter, but drawn at an angle. The bent strings of the bamboo are here

thicker and most beautiful, although a storm has recently torn away some of the thinning leaves. The foreground rocks here are more angular and splintery. A beautiful marble bridge, drawn in fine perspective, crosses a creek. A great leafless plum, of the " dragon " shape, crouches behind the bridge. The gentleman, thickly muffled and wearing a white cap, gazes out thoughtfully into the snow. The combination of rustic beauty and classic elegance in such pictures is almost beyond belief. It is indeed the new classic, new to us Westerners, but the fine old classic atmosphere of the Eastern world, a thing to set side by side with Greek and Renaissance conditions.

An extraordinary composition of Bayen's shows a deep mountain road, seen from above, and leading off toward a military gate barrier in the distance. A large tree with spiky leaves, and covered with mountain frost, crosses the picture from the elevated foreground. Against its powerfully outlined branches the hill-bounded road is drawn in soft ink, really appearing to lie some five hundred feet below. Here is a masterly perspective, not only of proportion, but of *texture ;* a quality which Whistler often has used.

Drawn in freer manner, and on silk now very dark with age, is the great spiky pine, with mountain background familiar to readers of Kokkwa. Here the style becomes consciously more like that of Kakei, as full of sweep and motion, though of non-human elements, as a Greek frieze. Here is a veritable portrait of a tree into which a Zen priest would read the analogies of an individual human soul. Here, too, are the kinds of rock which the Ming eclecticists attempted to revive two hundred years later, but succeeded only in coarsely travestying. Here the power of angle is as great (though so much freer) as in an Arabic mosaic ; and the *notan,* the actual gleam of the wet black against luminous mists, a new beauty which Kakki could hardly lay claim to.

We come now to Kakei, whom we must judge to be taken, all in all, the greatest landscape artist of China, yes—of China and Japan, if not of the world. He held the golden badge under Neiso.

Though it is said that Kakei studied Kakki—and, indeed, he did introduce more misty effects than did his friend Bayen—yet he made a decided change in Chinese landscape style : the "In " style that the Confucians specially scoff at—in that he introduced the utmost

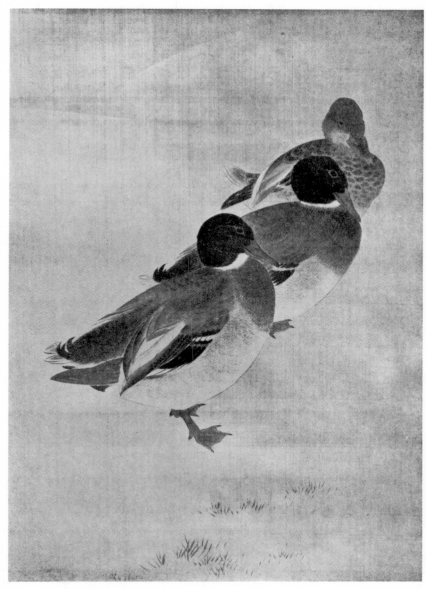

THREE DUCKS. By Manju.

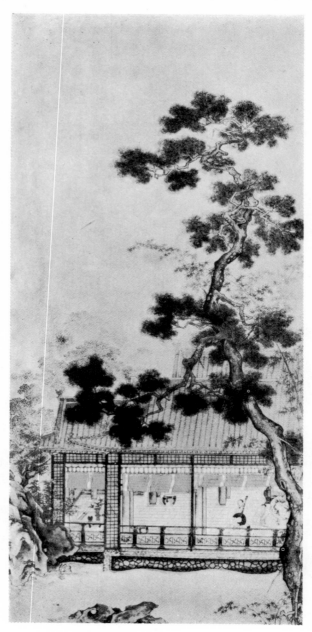

VILLA WITH PINE TREE.
By Bayen (Ma Yuan).

DETAIL OF COAST SCENE. By Kakei (Hsia Kuei).

WATERFALL IN A CIRCLE.
By Kakei (Hsia Kuei).
Copied by Kano Tanyu.

LANDSCAPE BY KAKEI (Hsia Kuei).
" Where my pathway came to an
 end by the rising waters covered,
 I sat me down to watch the shapes
 in the mist that over it hovered."

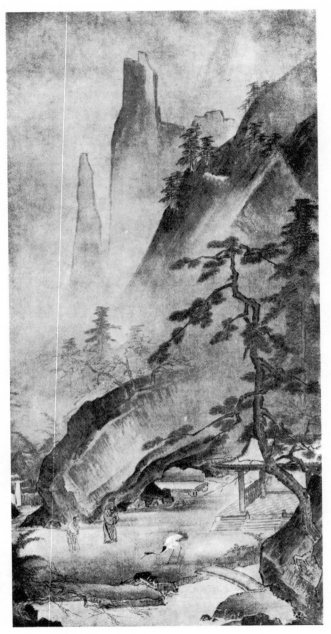

PAINTING OF THE POET RINNASEI (Lin Pu).
By Kakei (Hsia Kuei).

decorative splendour of *notan*, or dark and light beauty. He made the strong shapes of his touches of glowing ink "look as if they were falling in drops." This is "suiboku," or wet ink, such as Bayen also used in his mountain tree. Even the rocks and the hills crumble away into these gleaming touches, where the contrast of light and dark spots is inconceivably splendid. All that is involved in our finest modern black-and-white work, particularly for illustration—the charcoal of Millet, and flashing darks of Manet, the almost lawless strokes of Whistler, making tone of their very hatching—all this is only experienced along the road where Kakei is past master. Therefore Kakei seems to us splendidly modern, as if he were a hitherto obscure member of the Barbizon school and Whistler's secret teacher. Kakei seldom did figures, and so he is more of a landscape specialist even than Bayen. There are times when he introduced a certain rough outline, like Bayen's pine. But for the most part his work is either in "wet" masses or in dry touches like the most splendid etching. His fellow critics expressed this by saying that his ink "ferments." They also said that his ink alone looks as if it had real colour, which is generally true of a fine piece of *notan*. They said, too, "his wrinkles are rough," by which they mean that the transitional markings on rocks and trees are drawn not with fine hair lines, as even in the rocks of landscape villas, but in vivid masses, as in his panorama of the river. Yet form was not neglected, only made less hard. This very point which the Chinese scholars condemn, which they say has "killed painting," is the very point in which he is so modern, which brings him into contact with Western art, with all that is best in modern Europe.

It is on record that Kakei loved to paint the coast views of the tide flowing into the Kientang estuary, just beyond the city of Hangchow. One piece of this kind has come down to us, representing a pavilion bridge over a foreground creek, and the mountains melting away into mist on the other side of the bay. Very fine groups of trees, pines, oaks, and willows rise in juicy masses from both foreground banks, while some old huts lie along the shore to the right. The tall pines are just like those which we see about all the Ashikaga temples, such as Miyoshige and the Tokugawa palaces and tombs, as at Shiba and along the road to Nikko. It is the Chinese "male" pine, as particularly contrasted with the short

spreading Japanese "female" pine drawn in Tosa landscape. The whole left side, backed with nearer mountains, is typical of Kakei's silvery *notan*. Sesshu has studied this picture.

Another sketch in a circle shows Kakei himself watching the tide steam up over the flats. It comes in great boiling masses; the distance is blurred out into mist. The splendid twisted tree above is typical of Kakei's *notan*. This well illustrates the poem which Kakki quotes as a poem especially liked by a painter—

> "Where my pathway came to an end by the rising waters covered
> I sat me down and watched the shapes in the mist that over it hovered." *

Another of his celebrated pictures was a long roll (probably makimono) showing the whole panorama of the Yangtse river, its rise from small streams, its passage through gorges, and its mouth filled with commerce. It is probably an old copy of a portion of this which we here reproduce. It is a grand geologic panorama of precipitous peaks, and great torn sides of gravelly hills. It is like an alpine study by Turner. The river curves gracefully between two groups of agitated hills, passing around a fine low rounded hill in the distance which it has partly worn away. The breaks and twistings of the strata are finely rendered on the right. The drawing of trees that top the ridges on the

* EDITOR'S NOTE.—In the original, pencil-written manuscript, Professor Fenollosa has put a small marginal note beside this poem. It says "Explain inner meaning, then repeat."

I have heard him, more than once, in lectures, give this "inner meaning," and shall now attempt to render it from memory.

The human figure sitting and gazing out into a distance that is blurred with mist typifies the sage—the thinker, the philosopher,—who does not blind himself to the social and political discords of his day, but can gaze on them calmly, knowing them to be, after all, just a little less ephemeral than mists or rising water. The word "pathway" is intended to be taken in its moral sense, as the path of virtue, or, less conventionally, that pathway through the world, which, in all ages, the sane, strong soul will take. This shimmering road—in the picture given—winds out through the middle distance, and is obliterated by the incoming tide of haze,—perhaps of actual rising water,—for floods have, at all times, been a scourge in China.

The seer, gazing outward, sees that his onward progress is temporarily obscured. There is no use plunging forward into oblivion. He knows that it is a phase which must have its brief day of existence; so, instead of attempting a hopeless combat, he "sits him down to watch the shapes in the mists that over it hover."

By "shapes" he doubtless means those spectres of greed, oppression and injustice that always accompany a period of unwise administration. There will be other forms and visions, too, less terrible. Indeed, the philosopher is able to find something of interest, if not of amusement, in all such forms of mist. This is a type of mind that has been for centuries an ideal one to both Chinese and Japanese thinkers.—M. F.

left is so splendidly generalized into middle distance scale as to give us the very scratchy fringe which a photograph of a similar natural formation near Kamakura reveals. See how perfectly the silhouettes correspond, and how incredible and unconventional are Kakei's magic brush-drives for rendering them with demoniac power.

Kakei also painted wonderful waterfalls with mist drifting across the mountains, waterfalls for all the world like Kakki's word description in his account of the element " water." One of the finest has been copied by Tanyu. The gleam of sunlight through mist and from water can hardly go further.

Kakei's fine painting of the poet Rinnasei, wandering with his familiar stork over the pine-clad upper hills is magnificent in its angular spacing. His central clump of black trees sheltering a half-decayed tea-house over-looking a river, may be a part of his original Yangtse roll. The hills on the right climb like the steps of a gigantic ladder. In another piece, a similar clump of trees, but more curving, dominates a pearly valley filled with mist. But the largest panorama that has come down to us, in what is probably a Yuan or an early Ming copy, is a splendid scene along the coast of China, where a walled city opens upon a little bay behind a cliff. The whole coast for several miles is thrown back into, misty distance by a bit of dark etched foreground, showing a great prickly pine and the anchorage of laden boats. There, a mile away over the water, we can watch every detail of the water-gate, the city rising in misty terraces behind to the dominant roofs of the Yamens, the boats drawn up in the harbour, the rustic temple with an ancient grove opening to the left. The finest passage, perhaps, is the bit of magnificent detail in a little outlying suburb where the mud huts of a few fishermen crouch beneath great leaning willows. The enlargement of this low marshy hamlet, with its varied suggestions of character in trees, shows a magical scratchy touch, almost as dry, but far more pliable in stroke, than a modern Whistler etching. Indeed, here is a passage of land-scape impression in line that goes beyond anything that Europe has ever done.

Among the many associates of Bayen and Kakei under Neiso, are several whose works are very familiar to us. Moyeki, the great painter of tigers, we have already noticed. Then there was Baki, the elder brother of Bayen ; and Barin and Karin, sons of Bayen and Kakei. Many Barins are extant in Japan ; his great Fugen

at Miyoshige being already ascribed as design, to some great Tang painter of Godoshi influence, possibly Ririoka. Rinshonen was famous for his scenes of farming and weaving, which the Kanos have closely followed. He used rich colour, blue, green, and red, evidently the source of the more violent and commonplace colouring of degenerate Ming. His pictures of Chinese children are known in Japan.

Then there is Risu (Li Sung), who was once a carpenter, but who rose to high rank in the Academy, showing how truly democratic, how genuinely artistic, was the competition that led to æsthetic success. He was famous for painting scenes of Seiko Lake. Also Enjihei (Yen Tz'u-p'ing), whose work resembles Kakei, but is squarer and more angular. Kameiyen (Hsia Ming-yuan) is the great painter of architectural masses beautifully set in coloured landscape. We show here a small work of this type, which somewhat exaggerates the steepness of mountains. The splendid landscape-architecture scenes in full colour done by our Kangakwai artist Kimura in 1880-85 are chiefly based on the work of Kameiyen. Lastly we must speak of Riokai (Liang Ch'ieh), whose more violent style points to a later tendency. He painted figures and landscapes whose parts seemed to fly asunder in great splinters wedged off by lightning strokes. In this he was a free impressionist, and called himself " Rio, Son of the Wind." He represented an extremely inspired type of artist, also known to Japan, which Mrs. Fenollosa has attempted to depict in her young artist, Tatsu, in " The Dragon Painter." Offended with some formality at the palace, probably criticism of one of his own escapades, he hung up his badge on the door of the Academy, and decamped.

Of those artists in the third sub-period, the reign of Riso, who followed the In style of Ba and Ka with success, we know many ; such as Oki (Wang Hui), who has given us villa landscapes like Bayen's, but coarser in feeling, halfway between Bayen and Son-kuntaku, of Ming, and Hannanjin (Fan An-jen), the painter of fishes. Barin (Ma-lin) and Karin (Hsia-lin) lived into this age. Renshiren has left us the magnificent painting, at Shokokuji, of a stork flying downward across the face of a mountain. This most magnificent soaring bird, with spread curves of wing as fine as Greek sculpture, has been one source of Japanese bird-painting. Barin and Karin also worked into this age.

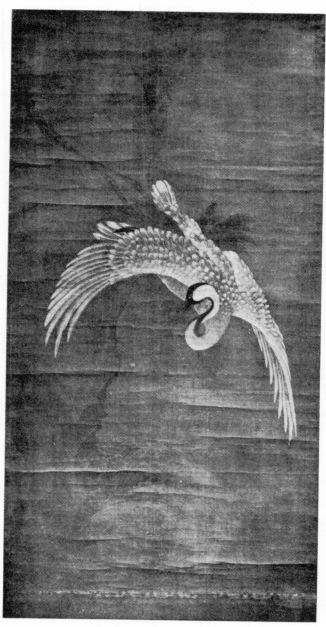

FLYING STORK. At Shokokuji.
Renshiren.

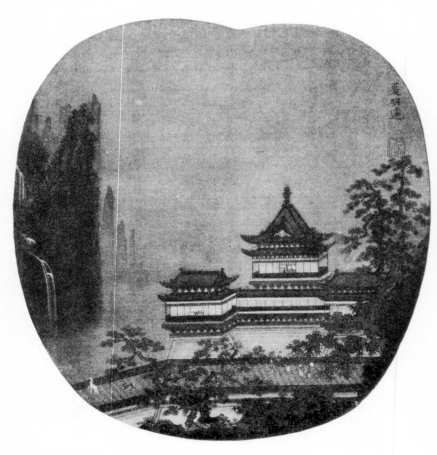

PALACE IN CIRCLE.
By Kameiyen (Hsia Ming-yuan).

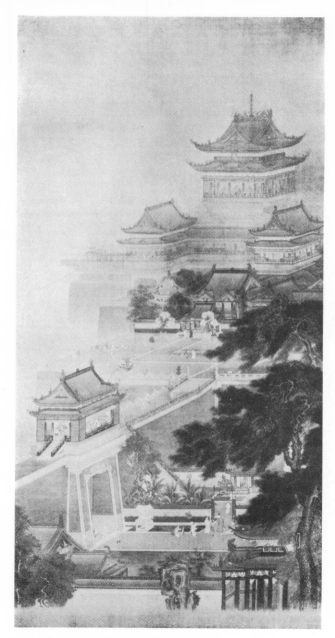

IDEAL STUDY OF CHINESE PALACE.
By Kimura.

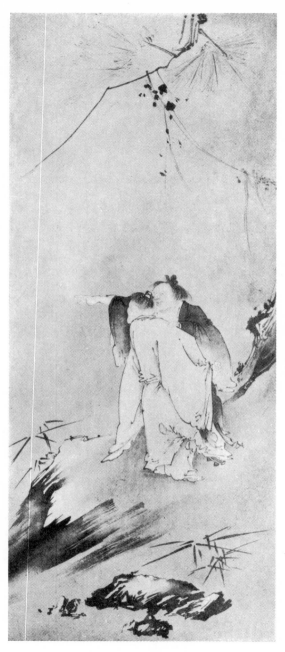

Copy of Painting. By Riokai (Liang Ch'ieh).

But the most characteristic work of this third sub-period is the priestly style of Mokkei (Mu Ch'i) and his followers, the Zen priests, who were not members of the Academy, but who carried the passionate impression of Riokai to greater, but less violent and exaggerated, heights. These men lived in the picturesque temples, set on every peak of vantage, where superb prospects swept away under their eyes, and they could work undisturbed among rustic suburbs for the whole day. The date of Mokkei is not given in the Chinese books, which treat him cavalierly as a rough unworthy artist; this, of course, because he was that abomination of ritualistic scholars, a Buddhist priest. We suppose that he must have overlapped from the Neiso period into the Riso. There is not much trace of such work under the former, except Riokai's.

Of Mokkei personally we know almost nothing. But his work speaks eloquently for him. He is the arch-impressionist of impressionists in ink—he never used colour—he does magnificently the very things which the decadent Confucians of Ming and Tang try to do clumsily and with "literary taste." His mist effects are far finer and saner than Beigensho's—his outline strokes are few, and "softly-splintery," if such a term is not a contradiction. They are never angular like Riokai's, rather curving in outline, much more blurry than Kakei's, line and clouding mix up together by a real wash-out of the brush; and the accents of dark are made by rapid oval-shaped spots dropped upon the silk by a vertical side touch of the soft brush. It does not have the superb silvery *notan* of Kakei; its *notan* is even sometimes a little weak. But for poetical impression of nature, pure, flowing, as the Chinese say "river-like," there is nothing to surpass him. His work came in with the great inrush of Zen in early Ashikaga days. All the great Japanese artists, including Sesshu and Noami, have built upon him. Kano Motonobu, in his softer style, grows out of him. The whole Kinkakuji school of Kioto follows him. The absence of almost all literary account of this whole priestly school, of which Mokkei was the centre, must not be taken as proving its lack of importance—but only that it was a supreme Hangchow importance which all later Confucians have resented or ignored. It is only among the few great Buddhist circles in China, like the Island of Kwannon, that his work will be understood. The white porcelain statues of Kwannon are sculptures based upon his pictorial design. The Japanese, being fortunately free

from the Confucian bias, in Ashikaga days at least, could adopt his school at its real worth, as the very core of Zen feeling.

Among Mokkei's well-known works in Japan are a small group of sparrows on a spray, and a set of herons with lotos, of which are shown a heron in flight beating downward against a heavy slant of rain that bends over the lotos plants, and tears away their petals. Another is a fine moist drawing of a hen and chicks, done in a soaking touch upon sized paper, in the very style which the later Bunjinga have abused. It is quite interesting to see that the man whom they have abused most is technically far more like them than those, like Omakitsu, whom they have claimed as their exemplars. The *notan* of these chicks—white, black and grey—as they nestle among their mother's feathers, is charming. So is the *notan* of the grapes upon the vine hanging from above. A very striking figure piece with landscape accompaniment is an old wizened Rakan, wrapped in a single white blanket, who sits in trance high on a rocky ledge upon the side of a mountain. Obedient to his will, a great snake has crept out of the crevices, encircling the figure in its coils, and now raises its head with open mouth in the saint's lap. The valley below is hidden by clouds, but the figure seems to bask in warm sunlight. Altogether the impression of such work is like Millet's fine monochrome studies in charcoal. This effect is still more given in Mokkei's drawing of Daruma's first Zen followers in the garb of woodmen bearing axes and faggots. We have one pure landscape by Mokkei, a range of misty mountains, which far surpasses in softness and condensation any bunjinga piece. There is not a separate touch or accent in it, nothing but an outlined wash, melting out into clouds.

The largest paintings by Mokkei are a set of five on silk, which are the chief treasures of the Daitokoji temple in Kioto. One is of two great storks and bamboo pipes. Another of a tiger scowling defiance at the rain. A third shows the head of a huge dragon mingled with cloud. A fourth shows a mother and baby monkey of the long-armed hairy Chinese species, perched near the top of a great vine-hung tree that seems to overhang an abyss. The foliage of the tree, as also the vine leaves, are done in the softest blurry scratches, more irregular and "abandoned," as the Chinese say, than Kakei. In comparison with the characters of handwriting, Bayen's style conforms more to the square formal character which has hardened into printing,

Mokkei's to the running hand of free, connected words used in episto-lary composition, the so-called "grass-hand." Kakei stands between the two. These four paintings have been an important source of much in the early Ashikaga styles, including the work of Sesshu.

But the fifth of these Mokkei paintings at Daitokuji merits a para-graph to itself ; for it is probably the greatest Chinese composition that has come down to us, with the exception of Godoshi's and Ririomin's. This is the great white Kwannon, seated in a rocky cave, with an inflow of water washing at her feet. A crystal vase with a sprig of willow (both sympathetic with the elements of water and ether, which Kwannon symbolizes) stands on a rock at her left. From the overhanging roof of the cave rough weeds droop. The space is blurred with thin white vapours. The silvery water swells up to the rock, lazily and without sound. The one strong note of accent in the picture is given by a small spray of black bamboo near the seat at her right, bamboo drawn with the force of the earlier Yohoshi. The most beautiful portion, however, is Kwannon's gracious figure, sweetly bending forward, as if listening with inner ear to the voices of mariners in distress that come in over the sea. For Kwannon is especially the Mother of Waters, the Providence who guards the travellers upon ships. Here the goddess is plainly feminine, of the white type from which come the later porcelains. And, in the all-comprehensive Zen symbolism, we may say that she here typifies, in a general way, the great human and sub-human category of "motherhood." Indeed it is true that millions of Chinese and Japanese have for seven centuries looked up to, and prayed to, such superhuman types, with the same sort of passionate confidence in the divine motherhood that the millions of European believers have to the Holy Virgin, Mother of Christ. The early Jesuit missionaries took advantage of this analogy, and readily established for Chinese converts a spiritual identity between the two, just as they did between "God the Father" and the Chinese " Emperor of Heaven." The analogy between Christ and Buddha has impressed the imagination of travellers in all ages. The Arabs, who believed in neither, carelessly identified them. These analogies should, to a broad mind, whether Catholic or Protestant, be beautiful illustrations of how the highest truths find natural adumbration in all pure souls. Especially is it beautiful to find an Asiatic nation joining in the worship of the spirit of womanhood.

And æsthetically the realization is worthy of the conception. The purity and weakness of the form, the beautiful lines like a marble statue, the splendid dominance of the hood and crown, and the sweetness of the face, stand as high for a world's æsthetic type as do the great Madonnas of Italian work, say the sweet half-length Bellini at the Venice Academia. In 1886 I took our own John LaFarge to Daitokoji to see this work. The old priest was delighted to have it specially brought out for such a sage. Mr. LaFarge, devout Catholic as he is, could hardly restrain a bending of the head as he muttered, " Raphael." Indeed, the Mokkei Kwannon challenges deliberate comparison with the sweetest mother types of the great Umbrian. It is a revelation to see photographs of the two side by side.

How original a thing the great Kwannon really is may be seen by comparing the Enriuhon and Godoshi types, and even the Ririomin female Rakan. There the dignity is masculine, cosmic, the might of Providence in general. The lines of Ririomin even are rather splendid than tender. This for the first time in art realizes the utmost beauty of condensation and impression in pure line used to express the most tender divinity of womanhood. The subject was attempted by many followers of various dates, both Chinese and Japanese, but never equalled.*

* EDITOR'S NOTE.—Among the things which the writer of this book had intended to supply, during his eagerly anticipated " next visit to Japan," was a complete account, from the lips of the venerable Kano Tomonobu, of the methods of copying which had been used by the noble-artist race of Kanos—old Tomonobu being the last. When I reached Japan in the spring of 1910, I made the attempt to get this material, and was given all possible aid both by Tomonobu and the scholar who interpreted his words, Dr. Ariga Nagao. I feel it to be but a shadow of the thing which Ernest Fenollosa, with the same opportunities, would have written. But here I give it as best I may :

" There are two ways in which my ancestors have copied masterpieces," old Tomonobu began, " and I will first speak of the best and the most difficult. It is called ' Age Utsu-shi ' (freely translated this would mean, the honourable, uplifted way of copy-painting), and was applied only to pictures which could be rolled, such as kakemono and makimono. The copying was done usually upon the floor, or a very low desk. The masterpiece to be copied was rolled quite tightly, showing only a few inches at the bottom. In the same way the kakemono to be painted, though still a rectangle of untouched silk, was rolled, exposing the same width of space. Little by little the artist copied,

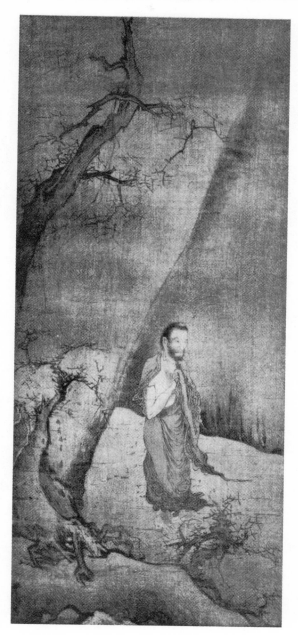

PAINTING OF A MOUNTAIN HERMIT.
By Riokai (Liang Ch'ieh).

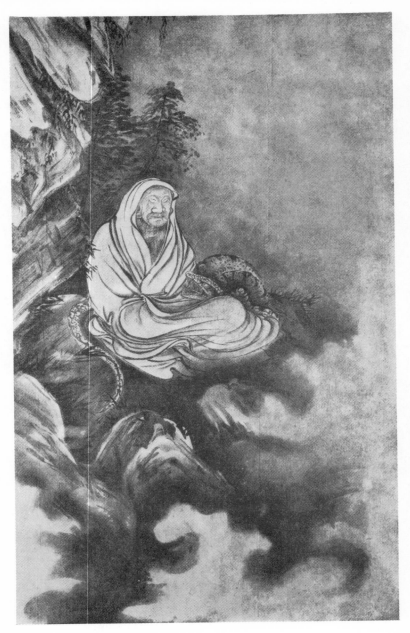

RAKAN (OR ARHAT) WITH SNAKE.
By Mokkei (Mu-Ch'i).

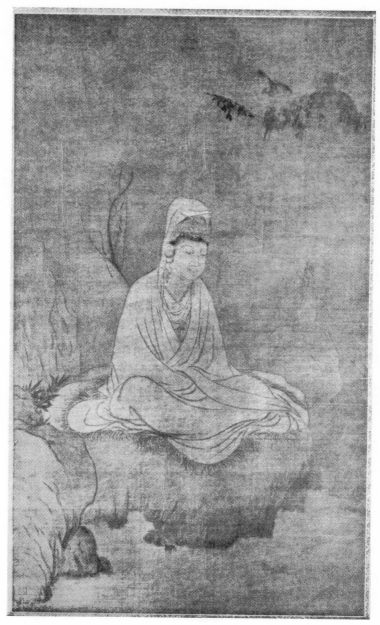

THE FAMOUS KWANNON. By Mokkei (Mu Ch'i).
Temple of Daitokuji.

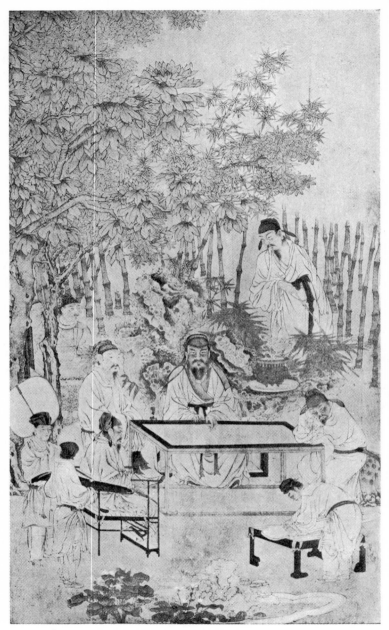

" Music without Instruments."
By Gessan (Yüeh San).

A host of priestly Zen artists followed Mokkei to the end of Sung, and even later. Of these one of the greatest is Mokuan (Mu An), whose lines are thicker and more crumbly. Mommukan gives us almost ghastly impression with the paleness of his washes. Indara continues the wildness of Riokai with the softness of Mokkei. His human hair is a soft washed blur, without lines, but he uses sharp black touches on eye and mouth. Other followers, who may not have been priests, and some of whom were members of the Academy, are Konenki, whose touch upon his misty landscapes technically foreshadows bunjinga (though hated by Bunjin and Chin Shoo, the great painter of dragons, who was probably an Academic contemporary of Mokkei, about 1250. Shoo took his degree in Tanpei, 1234-6). He painted wonderfully, in the soft ink style, the motions of turbulent water and clouds, and their familiar spirit, the dragon. One of his many pieces, owned in Japan, shows a dragon coming head-on out of a dark cave to join his mate, who is already disporting outside, in a storm-cloud on the right.

If this pretended to be a complete history of Chinese art, it might be considered requisite, for form's sake, to interpolate separate chapters upon the art of the two dynasties that followed Sung, the short Yüän (Gen), and the long Ming (Ming). But this would be to throw their æsthetic values quite out of proportion. It is true that much worthy Chinese art was produced in the fourteenth and the early fifteenth centuries, but almost nothing that

and it was not only mechanical, but 'thought' copying, requiring both intelligence and skill. This was one of the chief ways of training a beginner, though, of course, he wasn't given difficult masterpieces to copy. As long as Kano Tomonobu was retained as a teacher in the Tokyo Fine Arts School, he insisted upon enforcing this practice. Now, he says, it is discarded. The pupils use modern transparent paper, 'killing the force.'

"The second way, called 'Suki-Utsushi' or 'dark-copying,' is used chiefly for very old, discoloured paintings, and for flat-mounted panels. The paper on which the picture was to be transferred was soaked in a weak lye water, which made it slightly translucent. It is then laid upon the painting, and only the boldest outlines traced. It is then taken away, and all the smaller details filled in by the eye alone. The famous Mokkei Kwannon, a splendid copy of which is in the Boston Museum, was transcribed in this way, and the process took many weeks."

is epochal. The greatest days of Chinese creation are over ; the intensity of occasional flashes, in poetry and painting, does not quite take the place of form, now decaying. If art were a Vasarish chronicling of names and popular stories, one artist-life might seem to be as good a fact to record as another, and so down to the end. But that is not a history of *Art*. Art is supreme beauty, and thus is essentially epochal. The long weak periods, especially those of imitation and decay, merit only passing notice, except for the special historical student. Art is like a great island world, of which all but the tall peaks are submerged below a very useful sea of oblivion. Below the level marked by strong creation the million facts are tiresome and unimportant, and to be visited only by the diver well equipped with apparatus to keep him from stifling. Those who love to parade mediocrity as meriting equal notice with genius, have their æsthetic perception already stifled.

The most important use of a study of Yuän, and especially of Ming art, is to trace the line of connection between Sung art in China and Ashikaga art in Japan—both highly creative. And therefore I have decided to include these intermediary arts, but only in the form of appendix, as it were, to this Thirteenth Chapter.

The end of Sung formed part of the most wide-spread tragedy in human history —the Mongol Conquest. It was not, like Alexander's Conquest, on the whole human and constructive. It devastated the world for the time being, from the shores of the Danube and the Baltic to the China Sea. And yet it did one great thing which neither Han nor Tang had been able to do : it brought China into direct contact with Europe. During the short Mongol dynasty in Han (1280 to 1368) Chinese princes were received by the papal court at Rome, and Franciscan missionaries had established some forty bishoprics in the Celestial Kingdom. In this brief wave of overlapping waters, Marco Polo visited China, saw Hangchow, and has left us the one great and precious account of mediæval China that is at all trustworthy. After the Yuan days, no European penetrated China again for two hundred years, and during that interval the last traces of Sung feeling had been destroyed.

Ghengis Khan, the Scourge of the World, had become chief of the restless Mongols in 1206. By 1213 he had already attacked the Kins, the inveterate enemies of Hangchow, now long entrenched in

Northern China. By 1227 Ghengis had begun to conquer the Saracens on the West. In 1234, the successors of Ghengis had destroyed Kin, and begun to invade Southern China. It shows the extreme toughness of even this æsthetic Hangchow civilization that it was able to stave off the world scourge for fifty years. Slowly the Mongols, blasted away from the main body, walled city after city. One is hardly proud of the fact that the European Polo directed the ordnance of the besiegers. The civilization of ages was burned up by Venetian powder. In 1276 the Imperial family had to flee from Hangchow. In 1280 all semblance of a separate government had ceased, and the Mongol conqueror, called by the Japanese Seiso, and by us Kublai Khan, reigned as the first Emperor of Yuän.

And now happened a significant act. As ever, when barbarians had seized the reigns of government, the literary Confucians flocked to their Court with offers of help. And, indeed, services were needed by native officials who understood the machinery of administration. The Mongols had less organizing capacity even than the Kins. It was hardly the native Hangchow patriots, idealists and reformers who would offer or be accepted. No, the unregenerated Bourbon Confucians seized their opportunity, and in the very next year, 1281, the books of all the " heretical " Hangchow philosophers, Teishi, Shishi and Shukei, were proscribed and burned. This, of course, meant a return to the deadliest formalism, and Chinese variability, or power of reconstruction, was lost for ever—at least down to the twentieth century.

Chinese art of the Yuän dynasty must be briefly described as falling under three separate categories, schools, or movements. One is a diverting of the technical powers of professional artists trained in the historic schools to purveying to their Mongol masters the only phase of art they could well understand, namely *realism*. To copy in bright colours the trees and flowers of the Mongol gardens, the animals they loved, particularly the horses, and the details of coarse, material life among the Mongols themselves ; these were their two main categories. And in this they brought little originality into play. The more realistic masters of late Tang and early Sung were the deserted quarries in which they picked up old stones. No one denies the beauty of their execution, but all trace of Zen idealism has become lost. It was the horse pictures of Soba,

Kankan, and Ririomin that they imitated : the figure work of the secular styles of Seikinkoji and Ganki, and especially the flower work of Joki, Kosen and Chosho. The great masters of this school are such as Chosugo (Chao Tzu-ang),* Sen-shunkio (Chien Shun-ch'ii), and Gessan, who may be called "eclectic realists." Their figure work is often very fine in line, and shows groups of men and women enjoying themselves in gardens, the women doing all the serving. The figures of these women have become traditional and doll-like, with far less freedom and considerably less sweetness than the women of Sung. The lines become almost as fine as a hair, but the proportions of the body are mostly less anatomical and sculptural than the earlier work. It was not only material scenes they painted, but such biographical and historical scenes as the Confucians recommended by way of example or warning. Gessan's great scene, for instance, where a group of gentlemen listen rapturously, with shut eyes, to imaginary music, which the central figure seems to play upon a table, where the lute, non-existent, is merely understood, is almost a mockery of idealism. The figure with the bamboo rod is finely typical of Yuen work, but is a weakened Ririomin. Shunkio's and Sugo's portraits are delicate and fine, but are simply realistic. Two aristocratic ladies walking in a garden make us think of the courtly school of Van Dyck. The great supper scene by Fujo, the brother of Sugo, which recalls the feats of degenerate Roman days, is so splendid in the line composition of its four main figures, in spite of the hair lines, as to lead us to believe it a weakened copy from Ririomin, with a screen in the background, whose fine early Sung landscape was probably taken by Ririomin from Risei. I have already given this in Chapter XII. In landscape Sugo sometimes tries the freer ink form of Sung, but with no real spirit.

It is still fine, but lacks the ultimate inspiration. Shukei in landscape mostly follows the colour style, descended in long line through Rishikin, and indeed with a conscious imitation of Tang awkwardness, rather than the Sung perfection of a Kameiyen. These artists were in good part antiquarians. But in flowers and detached branches they did their best work. Here, however, they were little more than imitators of Joki and his fellows. There is greater hardness about their style,

* Chao Tsu-ang is another name for Chao Meng-fu. Chien Shun-ch'ii is another name for Chien Hsuan.—PROFESSOR PETRUCCI.

A Supper Scene.
Attributed to Tchao Meng-fu.

CRUMPLED CAMELLIAS.
By Chien Hsüan (Yüan).

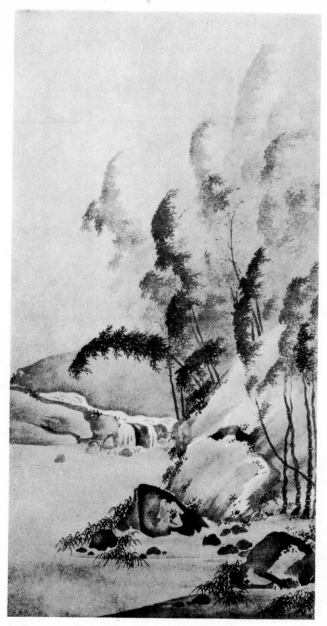

A GROVE OF BAMBOO SWAYED BY A PASSING
STORM. By Gen. Danshidzui.

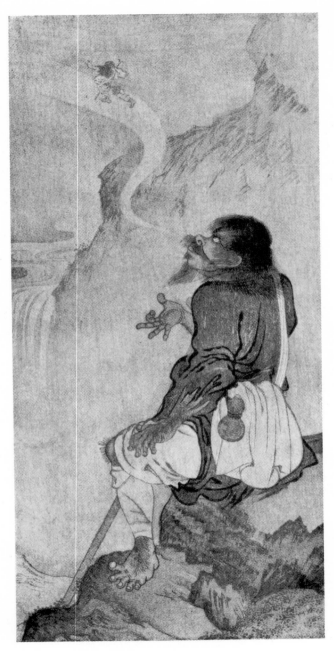

TAKKAI SENNIN. By Ganki (Yen Hui).

like a coloured photograph—witness the fine camellia of Shunkio. The herons by Chokuboku is probably based on a Sung original. There is always the doubt whether their best work is not almost always a thin copy. One must add that in this day, design upon porcelain utensils begins, as in raised relief of clouds and dragons. The fine pottery of Sung is becoming neglected.

The second notable school of Yuan is a Confucian revolt from the hard realistic *In* style of the court painters to the Mongols. There still lingers among the Confucian artists, particularly in the provinces, the tradition of great Sung scholars who were also poets and painters, like Toba and Beigensho—men of high individuality and independence, who could never be made slaves to a system. This was the better element in the Confucian ranks, the provincial element ; the salt of independence, savouring the insipid Mongol feast. They took for their model the work of Beigensho himself, who had left soft, landscape, cloudy effects in a mannered touch. These new men, of whom Mogiokkan, Choyen and Randenshuku are three geniuses, took their hint from the *literati* artists of Sung, but out of it developed a far more pictorial form, and therefore came nearest to making an epoch. They made a point of working upon soft silk, or even satin, where there could be no sizing to manipulate their ink upon, and could rely only upon manual dexterity to overlap, soaking touch upon touch until softness and gradation should arise from the many superpositions. This dryer technique, combined with Beigensho's formal stroke and its modifications, make up what is peculiar in their method. But, beyond this, they have magnificent conceptions, albeit in a narrow range. They show great mist-soaked sides of mountains, gleaming in the sun, where accuracy of form becomes of slight importance compared to *notan* of mass. The masses themselves, too, are as far as possible from the angular masses of a mosaic, being hardly traceable in curve, suggested outline, or shape. So that the style becomes largely limited to the impression of the formlessness of strong light gleaming through mist. Within these limits it is really beautiful, even grand. This is the only school of bunjinga that was ever creative. It accompanied a new mild school of landscape poetry. But the names, " bunjinga " * or " Southern

* " Bunjingwa " is a Japanese transcription of the Chinese term "wenjen-hua," or literary painting. These caligraphic paintings should not be confounded with the style called " The Southern School."—Professor Petrucci.

School," were not yet used. This school did not become known to Japan until the eighteenth century.

But it was neither of these schools that forms the proper transition from Southern Sung to the Japanese Ashikaga. The bridge lay in the persistent work of the Zen temples, still scattered chiefly throughout Southern China and along the Eastern coast of Go, then, long before, in pre-Tang times, in closest maritime relations with Japan. Here, the technical knowledge and fine spirit derived by priest and In painters from Hangchow could not be wholly lost, and two or three great Zen painters can be regarded as one extension of creative Hangchow into the fourteenth century. This spirit was also preserved in the far central West (Shoku or Szechuan).

One of the greatest of these men is the landscapist and bamboo painter, Danshidzui, whose *notan*, Mokkeish, is almost as brilliant as Kakei's. His grove of bamboo, swayed by a passing storm, through which sunlight sifts are like pure silver to the gold of Sung. The line is just a little more mannered and violent than that of Sung. The other great man is the figure painter Ganki. His powerful pieces share in a somewhat thickened Sung line. His great Zen works comprise the wild hermit genius and the wild servants of Buddha's temple, Kanzan and Jittoku. His great portraits of the last are owned by Mr. Kawasaki, of Kobe. His great Takkai Sennin blowing his own likeness out of his mouth in the form of breath ("projecting the double") is at Daitokuji of Kioto. Here we have a splendid rich suggestion of purplish colour in the flesh. It is like a combination of Mokkei and the great Zen painter of Tang, Zengetsu Daishi, only with less volcanic intensity than either. There is something of distorted imagination about it which becomes a matter of course in Ming.

The Dynasty of the Mongols was finally extinguished by a great native Chinese uprising, not unlike that which was attempted against the Manchus in the nineteenth century by the Taipings. The disturbances began as early as 1348, but gathered headway when Gensho, a military genius who had risen from humble origin, took command in 1355. A bitter struggle of thirteen years put him in control of Peking in 1368, when Gensho was proclaimed Emperor and founder of the new Ming dynasty. The revolt had come from the South, and Gensho decided to keep his capital at Nanking, the old famous seat of Southern Chinese power of the Liang in the sixth century.

Now Nanking became capital for a second time after eight centuries, the third Southern capital counting Hangchow. No dynasty ever began with more enthusiasm and prospects, for it was a clear reaction of Sung ideas toward re-establishment. Everyone believed that a second Hangchow had come, and that poetry would again rise to divine heights. But, alas, the disillusion! It was too late! The Gen debauch had stiffened and hardened the Chinese mind. The Sung philosophy could hardly be re-established, and there arose no transcendent genius to inaugurate a new one. It was either anarchy or Confucianism; nothing else short of European science could be conceived, and Europe was shut off by a terrific hatred due to the Mongol's patronage of Marco Polo and Christian missionaries. Unfortunately, these had always shown themselves pro-Mongol and anti-Chinese. Polo, who lived in China some eighteen years, never took the pains to speak or read the Chinese language. So Ming was a purely Chinese reaction which went to its doom because the very evil foreseen by Oanseiki in early Sung had come to pass. He knew the Chinese must then decide whether to be scientific or formalistic, and he knew that formalism would eventually reach a point so far down that thought would become incapable of reconstructing itself. Such indeed it became in later Ming.

The first fifty, or even the first hundred years of Ming, however, produced some art consciously based upon Bayen and Kakei. The fourth generation from these men was still living; and from the remote provinces the successors of the *In* style came to the Southern capital. It was these men, trying with all their might to be as free and genial as the old masters of Hangchow, that the Japanese of early Ashikaga struck. For the new Chinese dynasty was as friendly to Japan and hostile to Europe as the Mongols had been hostile to Japan and friendly to Europe. In this change lay the transition from Sung to Japan; the future of Japanese art, and the whole possibility of men of our day understanding in the least what the art of China had been at its great period.

Great landscapists in the style of Kakei and Bayen, now pretty much rolled into one, are Taibunshin and Sonkuntaku . . . Kuntaku especially essayed Bayen's villa style. But their lines at best are awkward. There is a chronic lack of proportion, as in all products of the Chinese mind. The boldness of angle and freedom of stroke became little better than

coarse exaggerations. Compositions are not placed finely in their frames.
It is a weak classic renaissance. In flower compositions Rioki follows the
hints of Joki and Chosho, but reacts rather violently from the minuteness
of Gen (Yuan) execution. Stroke is everywhere coarse, where Gen
was fine. Colour, too, is coarse. No doubt an immense amount of poor
copying was done from old masterpieces, now so dark that their true tone
could not always be made out. In figures the lines were somewhat
fine, but the proportions of body less classic than those of Yuan. The
heads became too large and top-heavy, particularly of women, where the
neck becomes too small, and the shoulders sometimes so drooping that
they hardly seem to exist. Here the better painters are such as Kinyei
and Torin. Kinyei has left this charming garden piece of Mr. Freer's,
nice in colour and feeling, but of impure proportion. In general the
colour is much harder than in Sugo and Shunkio, running now to harsh
Chinese contrasts of vermilion, blue and green. Such pieces as the
ladies painting and writing by Torin, also in Mr. Freer's collection,
possess a certain charm, but the faces are becoming more doll-like,
so that they look almost as childish as the paper-doll women on Tsing
porcelain and embroidery. Ming architecture, too, overloaded with
colour, has less dignity and splendour of developed proportion than Sung.
But the early Ming porcelain shows some charming delicacy of flower
design in symmetrical arrangement of monochrome lines drawn upon
a single tinted ground.

Among the earliest Ming painters, however, were several whose
positive genius rose above the mediocre talent of their fellows. Such was
Rinno (Ch'uan Shih) the Mokkei of his day, whose wet sweeping strokes
are full of demoniac fire, in spite of participating in Ming awkwardness.
His great Hoo, or phœnix, in Sokokuji at Kioto, is really a thrilling thing.
Another is Shubun, who seems to have been almost a Ming rehabilitation
of Kakei. We know of him chiefly from Japanese sources, to which
country it seems probable that he came as an immigrant, and was
naturalized as a Japanese subject under the family name Soga, about
1420. He lived and painted at Daitokuji, in the North of Kioto,
founding there the great Soga school of Ashikaga. He is thus in a
special sense a connecting link between Hangchow and Japan. His
history rather belongs to that of Japanese art, and we shall consider his
work at the outset of the next chapter.

But by the end of the fifteenth century, that is, a little more than

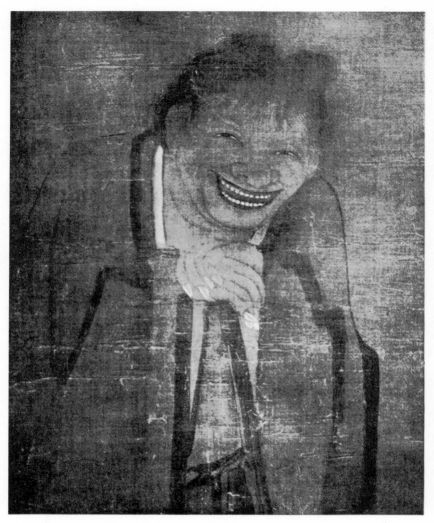

PORTRAIT OF THE WILD HERMIT-LAD KANZAN. By Ganki (Yen Hui).
Collection of Mr. Kawasaki, Hiogo, Japan.

A Fair Hermit in Mount Lo-Fou.
Attributed to To-in (Tang Yin).

one hundred years after the founding of Ming, this renaissance school had not only gone to pieces, but was almost wiped out of the national memory. This was due to changes which I shall speak of again summarily at the commencement of Chapter XV. . . . The old predicted danger, creeping nearer, had shown itself as early as 1386, with a special summons of the Confucian scholars to Court. Under their advice the third Emperor of Ming transferred the capital again to the North (1421), that is, to the same Peking which had been the seat of Mongol and of Confucian party. This was really decisive, for the whole strength of Buddhism and Taoism still lay in the south. The field was fairly free for the Confucians. It is a matter of the most extraordinarily good fortune that Sesshu, the greatest artist genius of Japan, and a Zen priest, got over to Ming about 1466, before the Confucian change became complete. In a few years later it was as if a veil had shut down over the ancient world, and Chinese art and thought became as different as if upon another planet.

Chapter XII.

IDEALISTIC ART IN JAPAN.

Ashikaga.

THE position of Japan toward the close of the fourteenth century is one of the most interesting in the whole history of art. With the break-up of the Fujiwara oligarchy in the twelfth had vanished the last trace of that early Chinese influence that had come in from the Tang dynasty. During the feudal age of Kamakura Japan had developed her own rude democratic institutions and her peculiar dramatic taste. Her dominant art, as we have seen in Chapter IX., had become purely national in form and matter, owing nothing specific to her contemporary and neighbour, the Southern Sung of China. This long breach with the mainland, so significant for the freedom of the Japanese spirit, had been due to internal disturbances upon both sides : feudal warfare and local rivalry on the part of the Japanese, a precarious position with regard to Kins and Mongols on the part of the Chinese. Finally the Mongol wave had broken itself in vain against the wall of Japanese Feudal chivalry, with a result of mutual hatred.

But when the Ming dynasty was finally established, in 1368, the situation became profoundly changed upon both sides. In Japan, as we have seen (Chapter IX.) Ashikaga Takanji, taking up arms with the ostensible object of freeing the Emperor Godaigo from the tyranny of the Kamakura Shoguns and of their court guardians the Hojo, had eventually declared himself the founder of a new dynasty of Shoguns, with the whole administrative power of the Empire in its hands. Takanji himself had died in 1358, during the very crisis of the struggles between Yuan and the native Chinese revolution ; and his successors had been forced to maintain a desultory civil war with the thinning partisans of the "Southern Emperor" until the formal peace

LADIES WRITING. By Torin (Ming).
Mr. Charles L. Freer.

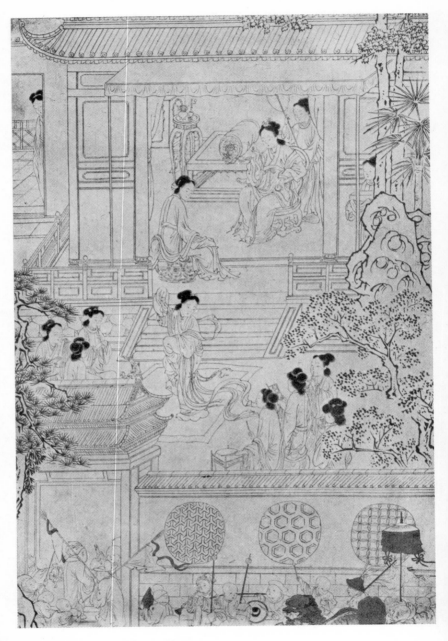

OUTLINE PAINTING—WOMAN DANCING.
Kiuyei.

of 1392. But the accession of the third Ashikaga, Yoshimitsu, in 1368, had brought enough substantial peace to allow this able administrator to devote his attention to internal reforms. He might have chosen to continue the Kamakura *régime*, removing his capital as far as possible from the Mikado, and resting content with the somewhat anarchical and superstitious state in which two centuries of violence and localization had left the Japanese people. But Yoshimitsu was a true statesman, who saw that Japanese society needed some new strong spiritual remedy for its atomicity, and that nothing new could come without the decided break of changing the Shogun's capital back to Kioto, where the two courts, imperial and military, could be made to work side by side in a common cause.

On the other hand, on the side of China, it happened—most dramatically!—that the very year of proclamation of the new Ming Emperor, 1368, coincided exactly with the advent in Japan of Ashikaga Yoshimitsu. The Ming empire was indeed shorn of all China's former north-western possessions, the whole of Turkestan, Mongolia, and Manchuria ; but it was all the more glad to strengthen itself with friends upon the east, particularly men who, like the Japanese, had so deeply hated Ming's former enemy, the Mongols. There was also the question to settle amicably of the ambiguous states of Corea. A special mission from Japan went over from Nanking in the third year of the new dynasty.

It was, indeed, a unique historical crisis, this re-opening of intercourse, after such a long cessation, between the two great Asiatic empires. For it was a new China that now came to the issue, and an equally new Japan. The Japanese had known practically nothing of the stupendous problem of liberating the Chinese mind in Sung, nothing of the new inclusive philosophy, almost nothing of the Zen contemplation, and practically nothing of the great Kaifong and Hangchow academic schools of landscape art. On the other hand, here was a Japan, worn out with generations of barren struggle, local aggrandizement that involved no principle, an almost complete cessation of social discipline, education, and uplifting art—in short, a Japan heartily sick of too much blood-letting. And the necessity and desire for a new organizing principle came at the very moment when a new China, enthusiastically bent on recruiting the sum of Sung glories within itself, had just the most vital principle of all Asiatic

culture to offer the isolated island world. The only opportunities at
all like it had been the marvellous moment when the whole primitive
youth of Japan had fermented at the first touch of Chinese esoteric
Buddhism under Shotoku in the seventh century, and the less
marvellous moment when the Fujiwara nobility of young Kioto
had responded to the stimulus of Chinese esoteric Buddhism in the
ninth.

But this new chemical reaction of the fourteenth and fifteenth
centuries was to be a far more marvellous affair than either of those,
in that on the one hand, the fresh individuality of the Japanese
mind no longer implied the weakness of unformed youth, but a ripe
character built into generations of individual variation and natural
selection ; and that, on the other, the Sung culture was the ripest
expression of Chinese genius, a gospel of nature idealization and of
the divinity of art.

A more profound contrast between two such ideals of feudal man-
hood and Zen contemplation can hardly be imagined. It would imply
a Japan jumping out of the former extreme into its opposite, and
doubtless this is just what Ashikaga Yoshimitsu had in mind. A
wholesale importation of the resurrected Sung ideals from Ming would
be exactly the antidote for the intolerable disintegration into which
Japanese society had fallen. It is the greatness of Yoshimitsu that he
saw the peaceful Sung culture to be a far different and less dangerous
experiment than Tang military centralization. It should be still indi-
vidualization, but rather the spiritual than the military development
of the individual. It is Yoshimitsu's greatness to have refused, though
replacing his capital at Kioto, to revive anything like the Fujiwara
oligarchy (as Taira Kiyomori had done), but to rely, for the unifica-
tion of society, upon a common passionate devotion to the ideal. The
great Muromachi palace of the Ashikaga at Kioto was built in 1378,
and the importation of Chinese books, philosophy, Zen religion, Sung
poetry, and Hangchow art was zealously begun. The whole round
of Sung culture was soon pouring into Japan in a stream of intoxi-
cating cargoes. It was then and in the next two generations that the
great bulk of its original Tang and Sung paintings, which Japan owned
in Tokugawa days, and still owns to-day (including, doubtless, the con-
siderable number of Yuen and Ming copies, to say nothing of the
best Ming originals), was imported. The transmission of force was

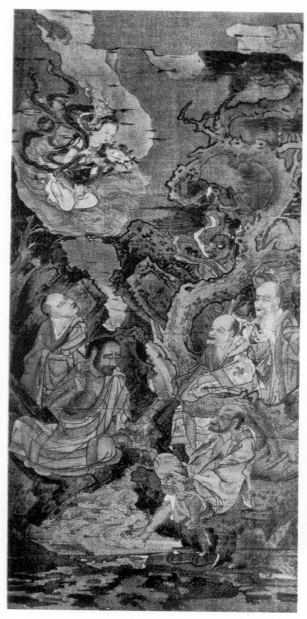

PAINTING SAID TO BE BY RIN TEIKEI (LIN TING-KUEI).
At Daitokuji.

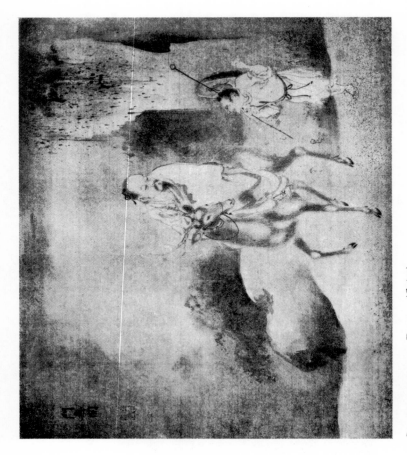

SENNIN RIDING ON DEER. (*Copy.*)
Mommukan.

made at the very last moment of Chinese heat, before the Sung
fervour and taste had quite died out of China's mind for ever. And,
though Ashikaga fell, and was followed by a different policy of the
Tokugawas, yet, as we shall see, enough of the magic *virus* remained
in the blood to make of Japan, down to the year 1894 at least, the
real living exponent, with unbroken continuity, of the great Hangchow
illumination. But the greatest creative epoch and art of this new great
Japanese movement was to come on at once.

The career of Ashikaga Yoshimitsu is to be divided into two
portions, the twenty-six years from 1368 to 1394 in which he ruled as
actual Shogun, and the fourteen years from 1394 to his death in 1408,
in which, although he had deposed himself in favour of Yoshimochi,
he ruled with all the more power as a great retired Zen priest, at his
beautiful villa temple of Kinkakuji in the extreme north-west of Kioto.
The significance of this division is also that the earlier portion, inter-
rupted by constant warfare with the dauntless Kusunoki faction, could
only as it were make preparation for the great Chinese policy that his
brain was building ; but that, in the second portion, peace being just
declared, he was free fully to realize and execute this policy. The
first part is, then, the age of inception, the second, including the later
portion of Yoshimitsu's reign down to 1428, the age of accomplish-
ment. It was in the second that the importations from China became
the most copious and deliberate ; in the second that Japanese art began
to respond to the new stimulus with a large force of creative painters
educated at well-established schools.

It is not quite true that Sung art and Zen influence were abso-
lutely unknown throughout the whole Kamakura period of Japan.
The dominant truth is what we have stated, but we must make our
minds elastic enough to recognize a minor parallel truth without losing
grasp of the main one. We have some reason to suppose that as
early as the tenth century, the Japanese painter Kose Kanawoka may
have been influenced by the pre-Sung Joki (Ch'u Hui). It is more
clear that, in the early days of Kamakura, Zen priests, driven from
the eastern provinces of Northern Sung by the Kin troubles, and of
Southern Sung by the Mongol troubles, had found their way over
to Japan and had begun to found Zen temples, especially at Kamakura,
where Kenchoji was built in 1253. It is even true that the feudal
Court of Kamakura had been in some sense the patron of this new

thin stream of art, in opposition to the pure Tosa art which tended
to concentrate at the court of the Kioto Emperor, thus superficially
considered, making the Zen predilection of Ashikaga seem no such
completely original a device. And yet the truth remains as I have
stated, and no less credit attaches to the plan of Yoshimitsu in that
the hint which he seized was already before his eyes. How could he
have foreseen the value of Sung culture if he had had no taste of
it ? The most violent reactions in nature and society are always
mediated by transitions that at first seem insignificant. It is quite
true that the rude violence of the Hojo policy could have had no
real sympathy with the Zen movement, that the Hangchow culture
could not have been seriously studied before the advent of the
friendly Ming, and that the new landscape art could not have been
naturalized and grafted on to the national genius without such wide-
spread and deeply organized study as only the new *régime* of Yoshimitsu
could have founded. The great Zen episcopates of Kioto were all
founded, or greatly strengthened, during these two periods of
Yoshimochi.

That a hint of the mystical art of Northern Sung, the Ririomin
school of Zen Arhat painting, came in with the Kenchoji Buddhism,
we have also seen. We there said explicitly that the family school
of the Takuma specially devoted itself to a style of painting to
which the Ririomin Zen influence, or what little then came in
of it, furnished a key. The style of Takuma Shoga in Yoritomo's
time may be said to be a reminiscence of the Tang style as seen
through Kanenobu's eyes reinforced with the partially-understood style
of Ririomin. But outside of the Zen temples of Kamakura, and the
Shingon temples that evidently considered the change hardly more
than a Kose revival, Takuma work had little influence upon the first
feudal age. By the early fourteenth century the Takuma tradition
had been so blended with Tosa and Kose influences as practically to
disappear. But by the later fourteenth century the new policy of
Yoshimitsu, and the founding of powerful Zen temples at Kioto, had
converted the contemporary Takuma, Yeiga, both to Zen service, and
to a more pure and intelligent study of Ririomin and his great Sung
followers than was possible to his ancestor two hundred years before.
It is thus true, as I said in Chapter IX., that the Takuma school
forms a certain weak link between China and Ashikaga, even down

through the almost complete severance of Kamakura. But it would be very easy to exaggerate the importance of this statement.

The artists in Japan, who began to work in the first flash of the new Sung ideas, *i.e.*, in the earlier portion of Yoshimitsu's life, are of two classes—these very Takumas who specially perpetuate and revive a Ririomin tradition, and the Japanese Zen priests who had been trained with more or less of success under the Yuen refugees, such as Giokuanshi and Nen Kao, who almost universally follow the Mokkei tradition, and whose very names betoken a desire to imitate the poetic *noms de plume* of Sung scholarship.

The work of Takuma Yeiga is chiefly known through its influence upon his great pupil, Cho Densu, in the next generation. Yeiga was a fine colourist, though more awkward in form than Ririomin, and has left some fine Zen portraits. In his later days he began to introduce monochrome landscape background for his coloured figures, in a sort of semi-Ming style. A few pure ink landscapes of his exist, which hardly look up to a higher source than Yuen, proving that Kakei, Bayen, Kakki, and the whole great round of Sung landscape geniuses were nearly unknown in the Japan of his day.

The work of the Zen priests lies nearer to its Chinese source, the Mokkei style lasting with fresher power into the Yuen of Danshidzui's day, and even to the Ming of Rinno's. Giokuanshi aspires to work in the very kind of orchid, rock, and black bamboo that the poet Toba loved, and which the Zen priests absorbed from their Hangchow alliance with the advanced Confucians. Nen Kao is a greater man, and can hardly be distinguished from the Hangchow Indara and Mokuan. Although there is something a little amateurish about these original early efforts, it still remains true that the Japanese soul was taking hold of the movement with a vitality and zeal that could hardly be found in Ming.

Meanwhile a younger generation of artists, like Cho Densu and Noami, were studying from what originals and personal instructions they could find in the Zen temples, and rapidly familiarizing themselves with the new importations. Japanese private gentlemen, not priests, went out to study philosophy, poetry, and Sung music in the Zen monasteries that skirted Kioto, just as their Hangchow predecessors had frequented the lovely haunts across the Suiko Lake. To be in favour with the Ashikaga one must become a Sung scholar, and

witness to the new life by the simplicity and æsthetic refinement of his household. Architecture suddenly lost much of its florid carving, and its bizarre colour and gilding, and inlaying, and accommodated itself to the large, severe masses of Sung and Ming model. Costume, too, became simple and severe, as we see in the Ashikaga portrait statues, and the rigour of the new tea ceremonies soon enforced a taste for Sung pottery and exquisite utensils of silver and bamboo. Chinese poetry was composed on every hand, and in a more fluent form than Michizane had tried it five hundred years earlier. The Zen priests taught handwriting in a new free style that looks like Mokkei's strokes.

But it must not be supposed that everything Japanese could be at once abrogated by the new movement, or that such abrogation was desired by Yoshimochi and the Zen priests. Japan was too individual and patriotic quite to forget her past, her great record of military and romantic achievement. The incipient epochs that had grown up about the careers of certain Fujiwara poets like Narihira and Komachi, about the fame of the warriors Yoshitsune, the Soga brothers, the clash with the Mongols, and other Kamakura romantic episodes ; these were still on every tongue, and a special problem of the priests was how to utilize them by giving them a force and consolidation through a decided turn into the direction of moral precept. The merely romantic appreciation of these episodes must be quickened into a passion for greatness of character as such. Now it happened that a form of secular drama had already arisen in China among the Mongols, and the germs of a comic Kamakura drama had been engrafted upon the Fujiwara Court dances in Japan. Now, if these weak but healthy roots could be made to grow up into a serious tragic drama, which should include the national subjects of the balladry and prose epics, it would be possible to invest such dramatic form with a moral purpose, not didactically enforced, but cunningly enwoven with the very vividness and passion of the representation. Hence the invention of the *Japanese Nô drama* as the greatest literary product of Ashikaga, under the supervision of Yoshimochi himself. For the text of this drama pure Japanese versification was employed, not in the short stanzas of the old lyrics, but with lines repeated in the sonorous continuity of blank verse. Instead of English iambic pentameter they used a compound line of twelve syllables, divided by a cesura into

Painting of Rock, Orchid and Bamboo in Circle. By Gokuanshi (Chokuan).
Buffaloes Swimming. By Kawo (Nen Kao).

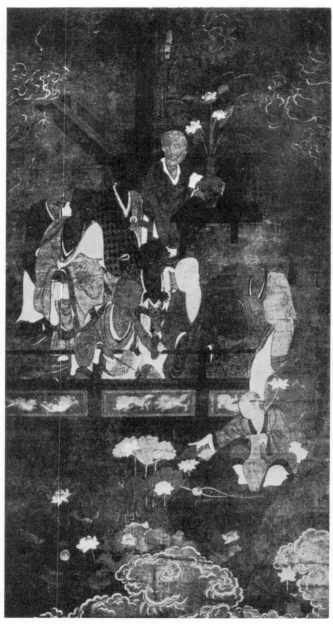

RAKAN (OR ARHATS). By Cho Densu.
At Tofukuji.

parts of seven and five. In this Zen idealism, which adapted Japanese romance to its dramatic purposes, was laid the foundation for the great Samurai code of honour.

It was in these many ways that Yoshimitsu was gradually transforming Japan, at first tentatively, during his Shogunate, at last passionately, during his retirement. It was his age of culmination that witnessed the writing and acting of the first Japanese Shakespeare and the inauguration of the tea ceremonies. But the intercourse between Yoshimitsu and the Court of Ming became far closer after his retirement, and it is this very closeness which has at once succeeded in transfiguring Japan and in casting a slur upon his memory. The Japanese have never forgiven Yoshimitsu for seeming so far to truckle to the Chinese Emperor as to acknowledge Japan hardly more than a Ming vassal. It had always been the policy of the Middle Kingdom to regard the outlying nations of the world as normally tributary, and it might well interpret the special mission which the retired Yoshimitsu sent over in 1399, specially sent for study and the collection of manuscripts, books, and pictures, as a *quid pro quo* acknowledgment of Chinese sovereignty. In 1402 the Ming Emperor solemnly issued letters patent to the old shaved-head monk at Kinkakuji as " King of Japan." This was a double insult, first to the Mikado and second to the actual Shogun, Yoshimochi. But Yoshimitsu literally *was* " King of Japan," in spite of both, and it did not greatly trouble him what interpretation the Ming Court might put upon the term. Yearly, down to 1409, and again as late as 1420, deputations of Ming officials came over to Kioto to wait upon Yoshimitsu, who took care that they brought with them a goodly stock of old Sung treasures. Here the mingled work of criticism, study, and creation went on upon a scale and with an enthusiasm which recalls the academy of the first Southern Sung Emperor Indeed, Yoshimitsu was fired with zeal to do for Japan what Koso and his successors had done for Hangchow. He would superintend the critics, poets, and artists in person, leaving the disagreeable details of administration to Yoshimochi. That is why he built the great palace temple of Kinkakuji in 1397, portions of which, with its beautiful garden, still remain to witness to the marvellous closeness of the imitation. " The Golden Storied Pavilion," Kinkakuji, still remains, stripped indeed of the Chinese gilding of its tiles, but raising its three finely-proportioned terraces in sombre Chinese state

above the pine-walled waters of its miniature Seiko Lake. This pavilion was an imitation of such as Kublai Khan had built for his garden villa at Shangtu ("the Upper City") which our Coleridge, following Marco Polo, calls Xanadu. And such Yuen architecture had been closely based upon others in Hangchow, and more remotely upon the finest one which Kiso Kotei had erected in his artificial lake near Kaifong, in Northern Sung. Here then the traveller in Kioto to-day can witness a real bit of belated and transplanted Sung in the very heart of the material present. Here, indeed, was concentrated a branch of Ming with a spirit more appreciative of the highest culture than Ming itself.

The first great creative outburst of the new art in Japan lies between 1394 and 1428. And how completely it is subject to the Zen influence which was dominating the land, and Kioto especially, with new religious fervour, can be seen from the fact that the great "quadrilateral" of Kioto art schools lay in four great Zen temples : Kinkakuji in the north-west, Tofukuji in the south-east, Daitokuji at the north, and Shokokuji near the centre.

Kinkakuji, Yoshimitsu's special erection, was not only a villa and palace, but a temple, with specially officiating priests, who mingled with lay scholars like former priests at Hangchow. The great school of art at Kinkakuji, however, was not directly under a priestly painter, but a great lay scholar, like the "golden badge officials of the Hang-chow academy, who in company with the Shogun himself, directed the work of critics and students." This was Noami, who had already studied under Zen priests, in the earlier age, and was best prepared to criticize the splendid mass of old Chinese works which were making of the Oyei era a new Senkwa. What a wonderful revelation it must have been, to stand with Yoshimitsu, Noami, and the Zen priests, watch the opening of the precious invoices, and join in the discussion as to whether the unclassified creations of Godoshi, Zengetsu, Ririomin, Kiso, Boyen, Kakei and Mokkei were to be called genuine, or only Sung, Yuen, and Ming copies ! The treasures brought over to other Zen temples also were submitted to the same board of experts. It is upon their decision, handed down to us through the traditions of the early and late Kano schools, that the world's knowledge of the greatest Chinese art will have ultimately to rest. The data for a substantial revision of their view will never be forthcoming ; for they had thousands of examples to inspect where we can know but a few tens.

But Noami was not only a critic: he was a great painter who did not merely copy Chinese originals, but, breathing in their spirit, poured it out again in fresh creation—a feat the Ming artists found quite impossible. It is significant of Zen origin that Noami based his style entirely upon the traditions of the Mokkei school. A man of the widest culture and the freest genius, he penetrates closer to the great fountain of inspiration than his priestly teachers. His brush is wilder and freer in touch, yet more grand and massed in its notan richness, than any but the greatest Sung followers of Mokkei. There is a wonderful softness about his wet ink, its subtly blended spreading with the lightest touch of hair, that is quite original. With the old cream parchment papers of his day gleaming through it, this monochrome wash according to its thickness takes on mingled tones of warm sepia and dull violet. His simplicity of style may be judged from the pine promontory (Miyo no Matsubara, near the port of Tiji) taken from one of his screens. The misty hill-side villa, one of a set of three kakemono in Boston, shows him to be a landscapist of greatest breadth. In another of these pictures, clefts in the top of a palisade actually catch the sunlight. The great dragon and tiger screens in Boston, though stamped with the seal of Yeitoku, were judged by myself, Kano Yeitoku third, and Kano Tomonobu, to be examples of Noami's later manner, in which his style grows more splintery. No finer waves than these which dash against the rock in feather-light foam have ever been painted. Compared with them, even the great waves of the Kano school look like heavy machinery. (Note: These screens came directly from one of the greatest of the old daimio families.) They stand clearly between Hangchow and Kano. Noami painted some fine figures also, and there are mural paintings of flying birds in the reception rooms of Kinkakuji.

Under Noami was his son Geiami, whom we must consider among the leading geniuses of the next age, and Geiami's son, Soami, will figure among the prominent Court painters of Yoshimasa toward the last of the century.

The second corner of the quadrilateral is at Tofukuji, which lies upon low terraced hills far south upon the Fushimi road, where Higashi-yama is about to break down into the passes to the Yamashnoi valley. When I first saw Tofukuji in 1880 it was an enormous

monastery intact, with a massive gateway at the south, and two colossal halls between it and the famous hanging causeway over the maple valley. These halls were faced externally with gigantic pillars, set antistyle, and made of single trunks of Chinese cedars five feet in diameter at the base, and some fifty feet in height, that had been floated, it is said, from the head waters of the Yangtse and across the China sea. No vestige of colour stained the solemn silver of their weather-worn granite. Within, the high space was dominated by a central circular panel, some thirty feet in diameter, painted with a single colossal twisted dragon from the pen of Cho Densu. Great statues of the four guardians, descended from Wunkei's time, stood upon the great raised altar. In the great corridor that ran behind the altar could be raised with pulleys three immense kakemono, of which the centre was a colossal Daruma * some twenty feet in height. This was executed in savage ink brush strokes, some of which were as wide as the straw of a floor broom. Both of these great central halls were destroyed by fire in 1882. The hanging bridge is still left, the gateway, the reception and living rooms of the priests, and fortunately the treasure houses with their unique store of Zen masterpieces. I have lived with these kindly Zen priests of Tofukuji for weeks at a time, and have had my artists privileged to copy for months many of these wonderful relics. No visit which does not imply residence can give a tithe of the solemn-sweet impression—particularly at night and morning—of cool sanded courts crossed irregularly with granite steps, and banked with Sung compositions of ancient shrub and mossy stone, and trickling stream ; of the nobly proportioned refectory with its low square tower and cool, tiled interior ; and of the beautiful high, light rooms, set cornerwise between the courts and overlooking the lower wards of the city, where the kakemono were brought out for inspection. In those sweet days of the early eighties, and accompanied by Kano Tomonobu and Sumiyoshi Hirokata, with either my student, Mr. Okakura, or the now famous Mr. Miyaoka of the diplomatic service for interpreter, I felt like an unworthy, degenerate Noami privileged to revise the very treasures that had delighted his eyes 450 years before. For Tofukuji could still boast of possessing the great Shaka, Monju, and Fugen of

* The Japanese appellation for Bodhidharma.

Godoshi, and the Nehan (death of Buddha) which, though attributed to Godoshi, is by some later Tang artist.

The great living genius of Tofukuji, and master of its school in Yoshimitsu's day, was the same Zen priest, Cho Densu, who had learned the fourteenth century Sung tradition from the last great artist of the Takuma family, Yeiga. Like Yeiga, Cho Densu occasionally painted in soft ink landscape, but in general his style was broad, heavy and powerful, as if his brush was overcharged with restless ink. His great dragon and Daruma, in the hall afterward burned, was of this style. But his strongest work was clearly based upon Ririomin's colour work; that is, upon his sixteen Rakan* (the identical set now forming the greatest single treasure of the collection which Mr. Freer is to leave to our national Museum), and upon the 500 Rakan of Daitokuji, which have always been ascribed to Ririomin in the records of the latter temple, but whose relation to Ririomin has already been fully discussed It was one of Cho Densu's greatest ambitions to paint a similar set of 100 paintings, larger in size, of similar figure composition, but with some variations of landscape background. These he first worked out in a set of outline ink drawings on paper, and then finally finished a second set in full colour upon silk. Both sets still remain at Tofukuji, and are most interesting to compare with the parent Sung set. They are, as might be expected, less splendid in drawing and proportion, less startling in notan effects, than the set that lies so much closer to Ririomin himself. The sketches show well Cho Densu's heavy, splintery stroke. Many Kwannons by Cho Densu remain ; but one of the most exquisite is a small one, sitting front face, with delicate line, and soft iridescent colouring, that is one of the treasures of the Fenollosa collection at Boston. The drapery is arranged not unlike the supposed Godoshi original shadowed in Yeiga's and Motonobu's front Kwannons ; but with a full variety and colouring that recalls the Enriuhon early Tang type. In this case the small Chinese boy below the Kwannon's throne, typifying man, is actually attacked by a gold-scaled dragon, instead of by a sinister cloud as in the Godoshi standing Kwannon. It is not at all improbable that this is based upon a Kiso copy of a great Tang original. John Lafarge has specially studied this Cho Densu Kwannon in preparation for some of his Oriental types.

* Rakan is the Japanese name for the Chinese "Lo-han." In Sanscrit "Arhat."

Cho Densu had many Zen pupils, among whom the most impor-
tant is the priest Kan Densu, and the most famous the Shogun
Yoshimitsu himself. Yoshimitsu is not a great painter, but his style
shows a sort of compromise between the traits of Noami's and of
Cho Densu's monochromes.

The third of the four Zen academies was the great monastery of
Daitokuji in the fields to the north of the present Kioto, facing the
Kamo river and the bulk of Hiyeizan. This, though falling into sad
dilapidation, remains intact as to the great number of main and smaller
affiliated temples, filling with their low cement walls, mossy stone
paths, and lichen-patched pines, a good part of a good half-a-mile
square. More than fifty great halls of the Ashikaga age remain
standing. The broad, two-storied gate has its fine rectangular spaces
enriched with natural pillars of freely growing pine, and fine bases of
granite ponds and bridges. The central *do's*, smaller than Tofukuji's,
occupied the centre of the vast sanded court. Behind this stretch,
right and left, separated shaded courts of the living rooms of priests,
each with its sonorous name, until we come to the massive pavilions
of Shinjuin at the north-east. In the centre lie the enormous rooms
of the refectory and the great beamed corridors that lead to the
kitchen, where meals for 1,000 monks could once have been cooked
under the eight-foot aperture of the chimney. Near by, set in a great
cool terrace of stone slabs, rises a well as large as a small pond, held
within the smooth facing of a single granite block. Far to the west, along
dark avenues rarely visited, lie range after range of subordinate *ins*
and *ans*. Here, too, I have spent many a long series of days examin-
ing the wonderful Chinese paintings at my leisure, and questioning
the friendly abbot concerning the principles of Zen, or the traditions
concerning authorship that had descended from his forbears. Here is
still kept Mokkei's grandest set of five, centred with his marvellous
Kwannon, the remains of the so-called Ririomin 500 Rakan, and the
largest Kwannon of the Enriuhon type (called Godoshi). The unri-
valled Japanese collection of early Ashikaga and Kano examples I shall
mention as we come to their authors.

The great founder and teacher of this school in Yoshimitsu's day
was that same Shubun whom we have noticed as an extraordinarily
fine Ming artist at the end of the last chapter, and whom the most
probable tradition represents as coming over to Japan about the

REFECTORY AND GARDEN OF TOFUKUJI.

TWO BIRD PANELS FROM A SCREEN BY JASOKU.

beginning of the century, and accepting Japanese naturalization under the family name Soga. (Note : Chinese family name Ri-Shubun.) Doubtless, he found the flavour of this new experiment of Japanese converts more stimulating than the somewhat deliberate formalism of Ming pretenders. Being Chinese himself, he is a closer link with the parent genius than Noami or Cho Densu. We do not know his Chinese history, but he must have been trained in some southern or western seat by old lovers of Kakei's work who may have known in their youth old personal pupils of Kakei's son Kashin. That is, we may conjecture Kashin to have lived down to about 1280 at Hangchow, and Shubun to have been born about 1360 in later Yuen. That the stream which flowed from Kakei and Bayen to him was fresher than the muddy waters from which men like Taibunshin drank is clear from the almost Sung genius of his work, which properly belongs to the history of Japanese art. He lived to a ripe old age, not a priest, yet retired like a priest, in the lovely moss-grown court of Shinju-an of Daitokuji, not far north of the Kondo, where he painted upon three sides of both of his connected living rooms. These paintings were upon the original sliding doors, where they had formed a sombre mural decoration for 450 years, when I saw them in 1880, 1882, and 1884. They gave one the very feel of Hangchow life at a day when every palace and pavilion had its walls finished in stately landscape monochrome. But in the summer of 1886, before special laws against the alienation of temple property could be passed, they were added to the large private collection of Count Inouye.

Both rooms faced south upon an ancient garden ; the paintings were upon the eastern, northern and western walls. Of the room farthest east, the designs, some six feet in height and thirty-six in total length, were of pure Chinese landscape on a scale that we never see in the daimios' kakemono, a scale which Kakei must have often used for mural work at the Sung capital. Great knotted pines rose in counterpoint against steep cliffs, while at their roots nestled Chinese pavilions with pointed roofs, and poets seated on picturesque rocks. The paper was considerably defaced, but a portion of the design can be understood from the accompanying illustration photographed in 1882. This seems to be in a style half way between Bayen and Kakei. The other room was finished in more cloudy designs of wild birds flying, or seeking food among reedy marshes ; these were clearly in the style of Mokkei, and of a freedom and force seldom realized by Ashikaga artists.

Another great work, judged by Kano Tomonobu and myself in 1882 to be by this same Shubun, the judgment based of course upon comparison with the Daitokuji originals, is the splendid pair of landscape screens in the Fenollosa collection at Boston. I am not at liberty to say from which one of the famous daimio collections I bought this treasure. The screen with the great central pile of mountains is doubtless the grandest landscape ever produced in Japan, with the exception of a few by Sesshu, and comes the nearest to Kakei in ripeness of feeling of any large landscape that we possess. In some respects it is like the early work of Sesshu himself; but the great splintery black touches on foreground rocks and the foliage of nearer trees is almost pure Ming in style, being quite unlike the awkwardnesses of such Japanese as Toga, which at first sight it seems to resemble. In richness of atmospheric effect nothing but Kakei surpasses it. In noble massy composition it is less mannered than Sesshu's, being comparable to the great Rhine landscapes of old Dutch artists like Berglener, or the magnificent groups of cliff and lake that Turner builds into his Swiss scenes. But it is more ripe and finished than any monochrome of the Liber Studiorum; and much less thin in composition than the finest etchings and lithographs of Whistler. The centre is occupied by a great pyramid of splintered cliffs, within whose broken angles are set the picturesque roofs of Chinese Zen monasteries. Enormous oak trees and fallen boulders give firm foreground to this middle distance. On the left the central mountains break away into a valley filled with soft feathery trees, beyond which is a great rounded hill, touched with the accent of a lone tree, the value of which hill is so cunningly shaded that it comes absolutely unbroken by line or tint against the equal glow of distant sky, and yet is perfectly felt as a great solid bulging mass. No such magic of atmospheric notan is found anywhere in Sesshu. On the right the central mountains break down into the rounded breast of a long alluvial hill, whose thinning gleams of tinted ink, unoutlined at the top, pass gradually back behind the veil of a golden mist-soaked distance. A strip of water, reflecting the hazy blurs of the sky, separates the semi-distant hill from the strong bit of accent in the lower right-hand corner. This, which quite corresponds to Kakei's corner accent in his coast panorama, shows a low promontory half veiled in river grasses where small boats cower, backed with a few low plastered huts, and bounded with a large rock

and tree nearly identical with one found in Kakei's tide at Suitang. This corner piece alone exhibits the very ultimate law of notan, a dozen clearly mosaic spaces of separate tint standing severally for mud, grass, boat, plaster, tile, rock and tree. The beauty of the atmospheric effect is heightened in the original by the addition of very soft tints in orange and blue-green. This we know to have been one of Kakei's favourite methods, although few of his existing pieces show it.

Another stupendous work evidently by the same Shubun who did this preceding scene, and which came to notice as late as 1905, when it was added to Mr. Freer's collection, is a powerful pure ink landscape thrown across a screen of four broad folds. This is more condensed and broader in effect, continuing the touches of Riokai and Mokkei with a notan peculiarly Kakei-ish. Mr. Freer strongly thinks that no Sesshu which he has yet seen approaches it, and that it ought to be regarded as the supreme landscape masterpiece of the Ashikaga schools. For lustrous splendour of ink contrasting with broad silvery gleams of light, and for demoniac power of stroke (this like Riokai) it may be set side by side with the great Sung masterpieces.

The greatest pupils of Shubun at Daitokuji, were his son, Soga Jasoku, who lived and did mural painting at Shinjuan, and Nara Kantei, who also worked at Daitokuji. Jasoku is rougher than his father, and more awkward in spacing. His notan schemes are powerful, but more bizarre. He did some landscapes, as on the walls of Shinjuan, but his special bent was toward painting birds of prey, great eagles and hawks upon craggy branches. In this he formed a school which descended to his Soga successors for four generations. Fine examples of such work are upon a pair of screens at Boston, signed with an official name which Kano Tomonobu recognised to be Jasoku's. Jasoku's figure pieces are fine, like his Sakyamuni in the Wilderness, in which there is purity of naïve feeling. His set of three Zen priests, also at Shinjuan, are probably copied from Ganki's originals.

The fourth great Yoshimitsu school was at Sokokuji, which occupies part of the site of Kwammu's original Kioto palace. This temple has been much injured by fire ; and the larger part of its ancient collections have been destroyed or dispersed. Here worked the great teacher Josetsu, who has, by some tradition, but with less certainty than Shubun, also been regarded as an immigrant Chinese. His work, awkward and strange if compared to accepted Ashikaga canons, seems

certainly like the work of an eclectic Ming artist, rather than of a Japanese Zen priest. There are several specimens in Boston, of which a large landscape in the Fenollosa collection shows an interesting confluence of two Chinese rivers, with a low, rocky and marshy tract between, passing off into the distance through layers of mist that half conceal the roofs of bannered terraces. This is not the pure Ming style that imitates, but half travesties, the peculiar Northern Sung touch of Risei and Kakki. From the variety of styles in the alleged and sealed Josetsus, it may be inferred that he was a prolific copyist rather than a great creator like Soga Shubun.

Among Josetsu's many pupils, by far the greatest, and one far greater than himself, was a Zen priest whose identical name Shubun had better be distinguished from the preceding, by Romanizing it into Shiubun. The Japanese make the distinction by calling one Ri-Shubun or Soga Shubun, the other So-Shubun—i.e., Priest-Shubun. Shiubun was the first artist of Ashikaga, not of Chinese blood, to rise to the full power and grasp of Hangchow art. To do this he studied all artists, but particularly Kakei. In his earlier work he is especially like Kakei, as is shown by a Boston example. Here the free wetness of the ink masses fairly crumbles against the gleams upon the tree trunk and stone. The world is bathed in thick damp mist through which golden sunlight sifts and shifts. In his later work Shiubun invented a harder manner, in which great mounted masses pile up, trees and roofs are executed in a fine nervous touch that looks like the burr of "dry-point," and the dark passages upon rocks tend toward triangular shaped shadows. A very pale tinting of orange and blue adds to the liveliness of this effect, as in the case of Mr. Freer's fine example. A number of good screens by Shiubun are in daimios' collections. He also did figure pieces, particularly of Taoist Sennin. His copy of Gankui's Zen priest is in Mr. Freer's collection, and his splendid Taoist in tones of opaque white, which realizes Whistler's thought of painting as akin to the light of opaque glazes. One of Shiubun's greatest claims to our interest is that he was the early teacher of Sesshu.

The end of this period of *the establishment* may be reckoned at 1428, the date of Yoshimochi's death. The next period, that of *the inheritance*, may be considered to comprise the broken reigns of several intervening Shoguns before Yoshimasa, and the earlier part or the

reign of Ashikaga Yoshimasa himself, down say to the Onin war which began in 1467, or to the return of Sesshu from China in 1469, after a period of confusion and revolt. In spite of his military weakness, and his absorption in æsthetic pleasures, he may be said to have been the ruling mind of Japan for forty-one years down to 1490. On an even more pronounced devotion to the Chinese cause of a revived Sung than his ancestor Yoshimitsu, he may be regarded as the great successor of the latter, the two dividing between them some ninety most significant years of Ashikaga rule. The Chinese culture of Japan in Yoshimasa's day was on a higher level of refinement and accomplishment, indeed the latter part of his life we must call the culmination of Ashikaga art. He came in a turbulent age of revolting barons and local quarrels which the virtues of æsthetic ecstasy had not been able to quell. In this respect his misfortunes are much like those of Kiso Kotei, the cultured side of whose career he seems consciously to have emulated. His weakness was the same kind of weakness and similarly punished ; but not so severely, since Yoshimasa did not die in hopeless banishment—rather he outlived his temporary misfortunes, to the realization of absolute æsthetic triumph.

Of the middle age, down to 1467, the artists or whom we have already spoken as pupils under Yoshimitsu, take the full lead :— Geiami at Kinkakuji, Jasoku at Daitokuji, and Shiubun at Sokokuji. In the latter place is also growing up the young priest, Sesshu, who bids fair to outstrip all his predecessors. Jasoku's and Shiubun's work we have already described. Geiami's is like his father, Noami's, but less robust in form. It has splendid notan, however, and in the treatment of blurry foliage it comes to have an atmospheric breadth like that of the modern Frenchman, Corot. His planes of mountain in mist are well given in the Boston landscape ; his Corot-ish trees are shown in the extract taken from Mr. Freer's splendid pair of screens.

This middle age, however, did not seem to get on as fast as it wished. The impulse given by Yoshimitsu's earnest study perhaps had passed away. Perhaps it was too difficult to draw enough nourishment from alien soil, for it is noticeable that with the exception of Noami's Miyo no Matsubara, all the paintings I have mentioned have been purely Chinese in subject. It had almost got to the point where a domestic subject seemed inartistic and vulgar. Classicism was as rampant in this renaissance as in the contemporary one of Italy, though in the

former Chinese landscape took the place of Venuses. The real depth of the movement lay, of course, in Zen idealism. But technical soundness demanded deeper study. Yoshimasa accordingly undertook to send new messengers to Ming with fresh appeal for assistance in collecting masterpieces. By this time the movement in Ming was weakening, and the artists had become poorer. They cared less about preserving their masterpieces; their perpetrated copies were more discernible. So Yoshimasa reaped a new crop, which Geiami criticized; and from this source new spirit could be derived. It was not enough, however, for several of the artists, among whom Sesshu was the most earnest. Possessed of a divine genius, nothing could satisfy him short of Chinese reality. So about 1465 he went over, some say with his fellow-students Sesson and Shuko,*and remained for several years in Ming, where he tried not only to copy all the Kakeis he could find, but especially to travel to all the famous scenes where Kakei and the other great Sung landscapists had painted from nature. His style of sketching was so rapid and incisive that he brought back to Japan in 1469 thousands of fresh impressions of all the most noted places in Chinese scenery or history, with accurate studies of costumes worn by famous individuals, and of portrait types. This enormous accession to Japan, not only of raw material but of personal vigour and genius, gave the final push of Ashikaga art toward its apex.

Meanwhile, Yoshimasa had undergone the horror of the Onin civil war, which set Kioto again in ashes, as the Hogen Heiji war had done in the twelfth century, destroyed many Zen monasteries and famous palaces, and led to the loss, doubtless, of many of the most precious originals already imported, including, perhaps, some of the Godoshis, whose copied anti-types we recognize. It was all due to strife between two rival daimios, as to which should control the succession to the Shogunate. As a result Yoshimasa abdicated in 1472, and was left free to repair the loss, if possible, by renewed æsthetic work. By 1479 he had built his lovely new pavilion of Ginkakuji, " the silver terraces," in the far north-east of the city, where he retired with the greatest artists of his day to carry Yoshimitsu's personal experiments to purer triumphs. Soami, the son of Geiami, and his leading critic, planned the laying out of the garden. Sotan, the successor of Shiubun at Sokokuji, painted on the walls with his pupil Kano Masanobu. Sesshu was for a time at

* Shuko, or, as it should be, Shukei, is another name for Sesson.—PROFESSOR PETRUCCI.

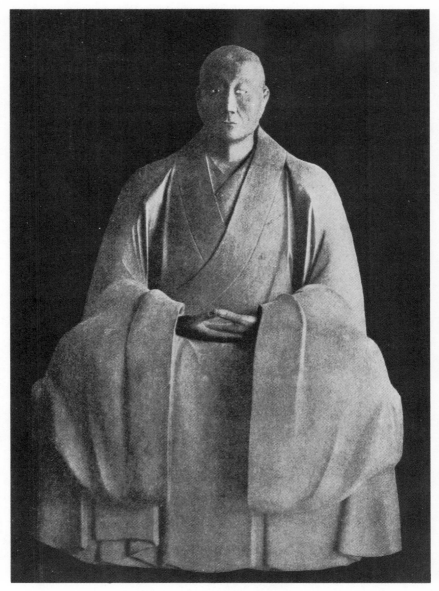

Wooden Portrait Statue of Ashikaga Yoshimasa,
" The Lorenzo de Medici of Japan," at Ginkakuji,
near Kioto.

PAINTING. By Sesshu.

hand to give advice of infinite value, though most of his later life he spent as priest in Choshu. Again a last attempt was made to import masterpieces from Ming, and those would be the last, for the Ming movement was fast succumbing to the pedantry of the Confucians. Here Yoshimasa lived and worked, indeed, as a second Kiso, down to his death in 1490. This was his triumph, for he had been spared to see Japanese art really rivalling all but the greatest masterpieces of any Chinese period. His tomb is in the group of buildings, comparatively modern, that adjoins the land-garden of Ginkakuji. There the great Shogun sits in splendid dark wood statue, as if alive ; the single lines of his priest-like garment, the sweet, sad smile on his face, the pathetic dignity of his fine clasped hands bringing a strangely interesting personality before us. Here indeed is the very Lorenzo di Medici of Japan, who had done for his great contemporaries, by his purely democratic interest in art, *primus inter pares*, what the great Florentine banker had done for his supreme generation. Yes, if Yoshimitsu had been the Cosmo di Medici of Japan, Yoshimasa was the Lorenzo, and each pair, by mere accident, were exactly contemporary. The analogy goes on even to the degenerate Medici and Ashikaga of the sixteenth century.

Among the crowd of artists who arose through two generations in the four schools of the quadrilateral, there was one Sesshu, so central, so sane, so masterful, so versatile, finally of such a fiery genius, that he easily overmarks them all, focuses the whole work of the Ashikaga school into himself, and stands up for ever as their central peak. He does more : he goes back to China, reproduces in imagination the great China of Hangchow, makes of himself a living museum of mingled fact and reminiscence, and then goes back to Japan to make it see that wondrous past as clearly as he sees it, by projecting it through the marvellous lens of his own creative genius. Without him Chinese art would have lacked, as late as the fifteenth century, a supreme interpreter. Through him—his knowledge, his criticism, his art—not only Japan, but the whole world, shall know it for ever, and even some reconstructed China of another century will have to peer back upon its own dim past through Sesshu's eyes.

Of the career of Sesshu before he went to China we know little enough, but he had strongly impressed his friends, including Yoshimasa.

He went as a great Zen priest, and that opened to him the Chinese monasteries. He came with the credentials of the Japanese " King," and that opened to him the courts of the Imperial Palace. He was recognized by a failing generation of Chinese artists as easily their superior. They marvelled to see the unconscious ease with which he dashed off spirited sketches, while they, with their utmost labour, could produce only mannered distortions. He was to them—and will be for ever to the world—like a Kakei come again in the flesh. It was not that he tried, or needed to try, to imitate Kakei, or anybody else. He created afresh in his own right, in his own manner, as if he were a new Hangchow genius of the first rank, only a little belated. He stood—and stands —side by side with Bayen, Kakei and Mokkei ; yet is different from either of them, as they are from each other.

His range led him through every variety of Chinese subject : figures, religious, historical, symbolical, biographical ; the crowded life of the people, in cities, palaces, temples, farms and mountain valleys ; the lovely mirrors of the human soul to be found in feathered and furry life, great storks stepping like lords through their gardens of wild plum, timid herons hiding under the lotus of the church from predatory hawks, the domestic chatter of hens and ducks, the gorgeous poise and arrow-flash of wrens and jays and doves, mild-eyed deer, suspicious rabbits, monkeys crying for their dimly-perceived humanity, tigers who can bask in hurricanes as snakes in sunlight, dragons who realize in their natures the liquid boil of earth's life-blood—water. But it was in landscapes—meet for the great Zen seer— that he realized supreme height. Here no mood escaped him, no character-soaked nook. He brought back vast panoramas which record the continuity of coast scene, with inlet, island, junk, and castled town ; the jagged steps of inland ranges, which stop in their dizzy climb to gaze at themselves in silver lakes ; the startled leap of waterfalls that find themselves pursued to a granite brink ; the frosty upland forests that shiver under their blanket of perpetual mist ; the lonely walk of Zen priests through menacing ravines ; the sunny stretches of chequered rice-fields fighting for room amidst tumbled volcanic *débris* ; cliff-perched temples, preening themselves like resting birds.

Sesshu painted in the palace of the Ming Emperor, did there great mural work, as he did later in Japan, and doubtless left behind him in the Chinese archives many a kakemono, of which only one

or two have strayed to light in recent years. When he returned to Japan, it is said that artists and nobles accompanied him to the vessel, showering upon him such masses of white silk and paper, to be returned at his leisure as finished paintings, that they there gave him the pen-name, "Sesshu," "Ship of Snow." It is probable, however, that the name was already in use, and this origin of it a myth. It is clear that the landing of Sesshu in Japan was hailed as a national event, and that he proceeded to train, under his personal supervision, such men as Sotan, Sesson, Shiugetsu, Kano Masanobu, and the young Kano Motonobu. He refused, however, all permanent emoluments of Yoshimasa's court, and retired as Zen priest to his country parish of Unkoku-an, in Choshu. There, for years before his death in 1506 or 1507, at the ripe age of eighty-four or five, he became an object of pilgrimage, the great and the poor alike seeking for a token from his brush. He painted the walls of many monasteries long since destroyed, and hundreds of six-fold screens, of which many have moulded away in damp godowns, or been burned in conflagrations. An enormous amount of his work remains, however, though it is so zealously prized and guarded that few, even of living Japanese scholars, have seen many of his greatest masterpieces. The large number of copies formerly made by the Tokugawa Kanos, and owned during the eighties by my master, Kano Yeitoku, proved a unique field for studying his design.

The style of Sesshu is central in the whole range of Asiatic art, yet unique. Its primary vigour lies in its line. Sesshu's conceptions are more solidly thought out in terms of line, and line is more dominant in his work than is the case with any of the other great masters of monochrome, except possibly Ririomin. In landscape Bayen comes the nearest to this quality. The execution of Sesshu's line, however, is quite unique. It is rough, hard and splintery, as if his brush were intentionally made of hog bristles irregularly set. He evidently wished to emulate Mokkei in his broad freedom of strokes, yet to eschew their softness and roundness. Sesshu is the greatest master of *straight line and angle* in the whole range of the world's art. There is no landscape so soft that he cannot, if he wills, translate it into terms of oaken wedges split with an axe! As contrasted with Ririomin, his line, while feeling for the grandeur of spaces, scornfully rejects the perfect polish of the taper and of the edge. Ririomin's

line is like perfect chirography, as strong as steel, as flexible in temper, as finished in surface. The abstract edges of its thickening and thinning curves would make two excellent interrelated hair-lines. But Sesshu's line, even where, as in its large Buddhist images, it aims at Ririomin's grandeur and modulation of flow, almost brutally hacks the traditions and sinuosities into unrelated shivers and passionate scratches. It is not unlike the difference between polished antique marbles and the deliberately coarse chiselling of Rodin's burghers. And it has its reward in the same sort of nervous picturesqueness that comes with modern European draughtsmanship—the masculine breadth of Rembrandt and Velasquez, and Manet, the brush magic of Sargent and of Whistler. Still more closely is it like the work of a great penman or an etcher, only with the splintery burr and the split edge carried to a far greater scale of flexibility and thickness. The nearest actual touch to it in Western work is the roughest split quill drawing of Rembrandt. We may say that Sesshu's line combines the broken edge and the velvety gloss of a dry-pointist's proof, with the unrivalled force and resource of a Chinese caligrapher's brush— Godoshi and Whistler rolled into one.

But though Sesshu's line dominates mass and colour, his notan taken as a whole—that is, notan of line as well as notan of filled space—is the richest of anybody's except Kakei's. In Kakei, line is continually breaking down into crumbly masses, as elements disintegrate through radial loss. The light plays into these masses like sunlight through young leaves, and warm mists join in the dance, and wet rocks glisten, and middle greys spray coolness, until we know how the world would look if it were made of silver. But Sesshu is more " spare of flesh, " as the Chinese would say ; the structure is the architecture. Nevertheless his lines are so thick that they carry great notan value in their masses, which thus serve as something more than salient accents. By cunningly varying his strokes as dark and light, more than half the splendour of Kakei's notan is achieved, though with a harder glitter. The interstices can now be spread with a scale of greys or shot with dazzling laminæ of light, without sacrificing the claims of either delineation or sparkle. It is true that Sesshu often disdains to avail himself of obvious notan prettinesses, and becomes as austere and daringly monotonous in tone as Whistler in his most esoteric etchings, or—to take a sister art—as Brahms in

Sᴇssʜᴜ's Jᴜʀᴏᴊɪɴ, ᴏʀ "Sᴘɪʀɪᴛ ᴏꜰ Lᴏɴɢᴇᴠɪᴛʏ."
The chief treasure in the collection of Marquis
Hachisuka.

DETAIL OF STORK AND PLUM SCREEN.
By Sesshu.

his *caviare* "grey passages." Kakei or Bayen never do this; they are as universally "decorative" as a Greek frieze. Mokkei sometimes does it; but then *notan* is the point in which he is temperamentally most deficient. Ririomin, too, though he had notan of line, treated notan of mass in his monochrome work with scant interest.

One other greatest quality Sesshu possesses in large measure, and that is "spirit." By this first of the Chinese categories is meant the degree in which a pictured thing impresses you as really present and permeated with a living *aura* or essence. The men you meet on the street are only tactually real, their personality spreads not a hair's breadth beyond their coats. But now and then you meet such a great man that you cannot nail him to an outline, but find him diffusing himself into a rich atmosphere or halo of character, so that he carries a *pungent reality for the soul.* This is the kind of force with which Sesshu presents his figures, his portraits, even his birds and his landscapes. They seize upon the impressionable side of the soul, and thus become far more real than could a world of photographs. Their "mentality" burns like an acid; you are held before them as if that etcher's needle were holding live wires to your heart; you rise from their presence breathless and purified as if you had learned to breathe some new ether. Such is the highest quality of Chinese art—"Ki-in." Doubtless all things in nature, even bad men, can be seen to be iridescent with this aura, if only the vision be sharp enough. It is this elixir through which poets in all ages have transmuted the world. This is why even the rocks and trees of Sesshu strike you with a sort of unearthly force, as if more real than reality. In such quality Sesshu stands with Godoshi, Phidias, Ririomin, Michel Angelo, Nobuzane, Velasquez, Kakei, Manet and Mokkei.

Why, then, if he has such transcendent line, notan and spirit, should we not put Sesshu first among the artists of Eastern Asia? It is hard to answer that: and yet we do not so place him. Is it not because, though what we have called the brutality gives him transcendent force, in the more delicate, internal and infinitely subtle balances of taste lies a more spiritual strength of tissue that Sesshu lacks? Sesshu is no great colourist, for instance. Though his soft tints that sometimes modify the monochrome help the liveliness, he cannot make them brilliant without becoming repulsive. Even in the

very power of his line and notan we miss a certain infinite withdraw-
ing that conscious power lacks. Can we help recognizing that in the
ultimate classic, whether of Greece or China, in Phidias and perhaps
to a less degree in Ririomin, the infinity of the balances just requires
a certain perfection of polish? Where informing essence penetrates
to the very finger tips, strength does not lower but completes itself
through grace. Sesshu, one might say, is over-masculine ; even
perhaps as Rembrandt is over-masculine. Were he to have com-
bined a little more of the bi-sexuality of a Bodhosattwa, he might
have reached such a height that, as in Godoshi's Kwannon, we should
hardly care to inquire as to the sex in his soul. Sesshu probably
stands sixth on the list of Asiatic masters, but not first.

It is useless to attempt here any exhaustive enumeration of the
existing masterpieces of Sesshu ; we shall have mostly to confine our-
selves to the all too few which we illustrate. Among his finest
Buddhist figures are the large Shaka, Monju and Fugen, belonging
to Mr. Kawasaki, the set of Rakan at Daitokuji, and the several
Rakan owned by Mr. Freer. The three deities may be said to
combine the qualities of Ririomin and Mokkei. The Rakan that we
reproduce from Mr. Freer's has a softer, less splintery stroke than
usual. Sesshu's Kwannon saving a victim from a robber has a similar
composition to the striking Vittore Pisano in the National Gallery at
London. Of the portraits his Daruma, formerly owned by Count
Saisho, the governor of Nara, is the most intense. He has drawn
every detail of hair and beard with his most nervous, etching-like
touch. In some of the Central Asian types which he sketched in China
he has given us photographic impressions of modern Russian tartars.
Some of his roughest works are executed in hardly more than two
strokes. On the other hand, his finest figure piece is a most elaborate
Jurojin in colour upon silk, which apparently he executed for the
Ming Emperor in China. At least, this great painting, which is now
the chief treasure of Marquis Hachisuka's collection, has a romantic
history. It was brought back from the palace of the Corean King by
Kato Kiyomasa, after his troops had occupied Seoul about 1595. The
supposition is that it had been presented to the king by the Chinese
Emperor. On the other hand, we know that Yoshimasa was in close
correspondence with the King of Corea about the time that Sesshu
went to Ming. The picture bears the signature " Sesshu," so that if

it ante-dates the return from Ming it disproves the legend concerning the name. The description of this picture merits a separate paragraph.

It represents an old, old man with long grey eyebrows and beard, and with bent back, walking amid a tangle of leafy pine and bamboo, and of the flowering plum. He wears on his head a tall purple horse-hair cap, and carries in his hand a long heavily-knotted stick. His pet deer smells about his feet for the magic mushroom that is growing out of the rocks. His long yellow garment trimmed with brown fur contrasts with the variable-plum lining of his mantle. This is Sesshu's most elaborate figure piece, both in minuteness and fulness of line, and in colour. Its symbolism, too, is mostly of the setting, giving the spirit of Longevity its least abstract meaning and its most poetic potency. For here, we may say, is nature personified, the same old, mysterious, kindly nature, thousands, nay, tens of thousands, of years old, the spirit of life, young too though it be old, blossoming anew every spring into eternal freshness and beauty. It is Merlin entangled with the very enchantments he weaves ; the incredibly old face smiling like a wise St. Nicholas ; *Natura naturans.* I have compared and contrasted it with Botticelli's idea of Flora, Vitality as a gay young maid, decked with and embowered in the rose nature she exhales ; but in this Chinese conception we have added the elements of eternity, and of the kindly wisdom of the happily aged. Artistically, the complexity of line is not inferior to the large figures of Ririomin, though different in spacing and rhythm. The far-away smile seems almost worthy of Da Vinci. Here indeed is a supreme artistic flowering of Zen thought.

In bird and flower pieces also Sesshu ranges from the extreme of suggestion and condensation, as in the Boston blackbird poised upon a stray, to the complication of the great stork entangled in the wild plum tree and the river grasses which was copied by Yasunobu in the 17th century from a Choshu screen. Here the lines are as many and as carefully constructed from point to point, as in a Greek frieze. In European flower work we leave much of the effect to chance ; but this is a cunning piece of pictorial architecture. Apparently as tangled as nature's luxuriance, at no point is there a trace of confusion. The great bird with its feathers radiating like the folds of an archaic Greek *chlamys*, steps proudly like a lord through his demesne. Frost crisps the edges of the large, sparse " plum-coins." A wild camellia

bursts into a single note of scarlet streaked with snow. It is hardly less mysterious than the Jurojin. A great screen of Sesshu in the Fenollosa collection, which came from the collection of the Tokugawa princes of Kishu, is a more rounded and frankly Mokkei-ish piece of Zen symbolism. The centre explodes branches of pine and rains leafless willow, the male and female principles from which worlds are built. Iron bands of spiral parasite curb the huge limbs, quite as the habits which we allow to build upon us turn about and choke us. In this world, the Soul, typified by a white heron, is pursued by cosmic and personal enemies, the wild hawk which turns to strike, belly upwards. Other hawks wait with glaring eyes upon the branches. The waters of a stream roll down, even as tears and time flow. The timid soul seeks shelter, as a religious, under a roof of lotus leaves, or flies away to some fairy world on the wings of conjugal love, like the mandarin ducks in the upper left-hand corner. Meanwhile the old philosopher owl sits blinking on his twig at the right, quite oblivious of the tragedy that is being perpetrated beneath him. What a symbolic picture of life, illustrating Kakki's words, not pedantic, but perfectly fused into a fine natural picture!

In landscape Sesshu's finest remains are on screens, or in the form of panoramic rolls of Chinese scenery. The finest of these latter are in the great collection of Prince Mori of Choshu, by whom I was allowed to photograph them. Here variety of subject and composition is endless. Among the finest passages are the monasteries perched on cold rocks and fanned by pines, and the forests where the leafless trees actually disappear into the west without our knowing where. There is no hocus-pocus about this, the lines, frank as if etched, growing fainter and thinner and sparser till, as imperceptibly as in nature, they are lost altogether. Sesshu loves old decayed posts, whose rotting hulks lie half concealed by river grasses, and roofs sag under their weight of tiles. Some of his simple rustic scenes, relying chiefly on scratchy lines, remind us of charcoal studies by Millet. Again he is tempestuous, treating mountains like tossing waves, as in the great screen formerly owned by Mr. Waggener of Washington, but now in Mr. Freer's collection. Here, deliberately discarding sensuous notan, he makes cliff-planes succeed each other for thousands of feet in almost identical tone, yet clearly distinguished by some subtle veiling of texture—quite as Brahms plays a thousand variations on a central theme. The sharper

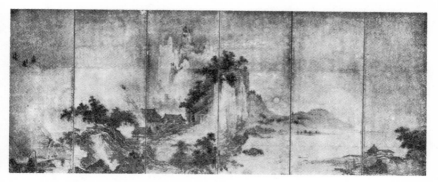

ONE OF THE PAIR OF SHUBUN LANDSCAPE SCREENS.
Fenollosa-Weld Collection, Boston.

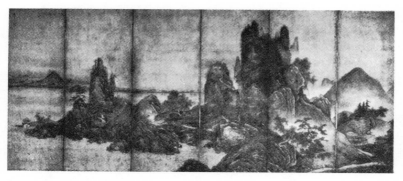

GREAT SCREEN BY SESSHU.
Formerly owned by Mr. Waggener, of Washington,
now in the collection of Mr. Charles L. Freer.

Detail of the famous Mori Roll. By Sesshu.

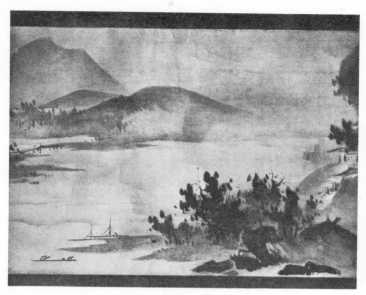

EXAMPLE OF HIS " ROUGH STYLE "
IN LANDSCAPE WORK. By Sesshu.

DETAIL OF VANISHING TREES. By Sesshu.
From the Mori Roll.

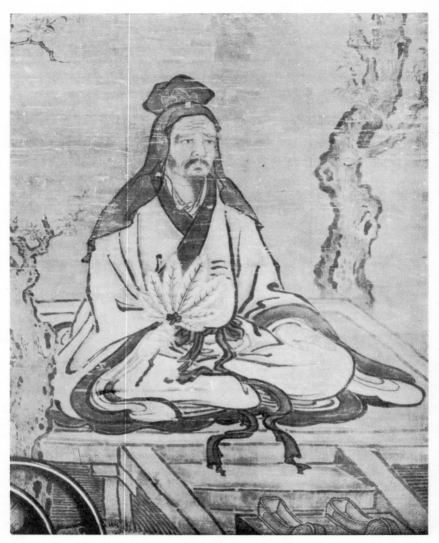

PORTRAIT OF CONFUCIUS. By Kano Masanobu.
 Copy by Kano Tanyu.
 Fenollosa-Weld Collection, Boston.

etching of a brick temple at the top focuses the eye. Great trees find root in the interstices of the rocky valleys below. Small dark ranges of distant mountains play against each other like tumbling waves on a twilight horizon. Four great mountain landscapes on silk form a treasure in Marquis Kuroda's collection. All this, of course, is Chinese scenery, of which Sesshu is the greatest interpreter after Kakei.

Sesshu was the centre of a great host of pupils, mostly Zen priests, of whom the greatest is Sesson. The fine Sesson screens in my former collection, now at Boston, are of monkeys and black bamboo, in the touch of Mokkei. Another set of screens in Mr. Freer's collection shows a subtler study of white and black monkeys stealing wild grapes from a vine. Here the values go beyond the breadth of the wildest Whistler. But the greatest of all Sesson's is the superb snow landscape scene, also owned by Mr. Freer, done with pale colour in Sesshu's pure *shin* (square) touch. A giddy road to a monastery cuts a huge cliff into a natural bridge. Below in the centre nestles one of Sesshu's river villages, enlarged from a passage in a Mori panorama ; which is not overpraised by saying that, if it were by Sesshu himself, we should reckon it his masterpiece. Nothing more sunny, crystalline, pictorially full of basic balance between line and notan, can be conceived in Kakei, Sesshu or Turner. What infinite suggestion such transcendent work will have for future American Whistlers !

Shiugetsu was another great personal pupil of Sesshu's ; also Shukō, Unkei, Yogetsu and Soan, all exemplified in Boston. Of Sesshu's greatest contemporaries, Soami and Keishoki came out of Geiami's Kinkakuji school, Tobun and Sotan had been pupils of Shiubun at Sokokuji. Soami is more effeminate than his ancestors, reducing the softer sides of Mokkei's work to a kind of formula. Keishoki, who often worked for Kamakura, went over to something like the square style of Sesshu. Tobun has luminous brown ink like his teacher. But Sotan is probably the greatest landscapist, and nearest to an original Sung genius of all, after Sesshu and Sesson. His great landscape screens, showing views of the Shosei Lake in China, are in my former collection. He reaches the greatest height in coloured sprays of flower and bird, recalling rather Joki, Kose and Choso, than the weaker work of Shunkio. A perfect example is in Mr. Freer's collection in Detroit.

We are conscious of having rushed too fast over this great Ashikaga

period ; and, by good rights, we ought to lead it to its finish by appending a long note upon the great artists who followed Yoshimasa in the sixteenth century. Yoshimasa had died in 1490, Sesson in 1494, Sesshu as late as 1507. After 1500 the whole power of Kioto painting in the Hangchow style may be said to have been gathered up into the genius of a single professional family, the Kano. But these Kanos are so prominent, so all-subduing, such vital links with the following Tokugawa age, that we are constrained to give them now, the earlier generations of them, a short chapter to themselves.

IDEALISTIC ART IN JAPAN.

The Early Kano.

HOW deeply the Hangchow Zen germ had rooted itself in Japan, and especially in Kioto, can be seen by the firmness and luxuriance of its growth, long after the artificial soil of Ashikaga strength had been removed from it. After Yoshimasa the prestige and wealth of his family is wasted away in an almost continuous succession of local wars, Shogun against Shogun, daimio against daimio. Any man might take who could. The hegemony of the Ashikaga remained hardly more than nominal. And yet, throughout their whole decay, down to their final deposition by the freebooter, Nobunaga, in 1573, the China-nurtured genius of their Kano Court painters, shed a much-needed light upon their reigns. Indeed, Kano Motonobu, head of the second generation, is often reckoned by modern native artists as the greatest of Japanese geniuses, Sesshu alone excepted. While we may not quite concur in such an estimate, it is true that the vigour and quantity of his work literally hold back the decay which it would be high time to expect in such an exotic school of art— even as his great European contemporary, Michel Angelo, is holding back, single handed, like a grand promontory half submerged by storms, the mediocrity due to a flippant and corrupt *cinquecento.*

The external history of the century is lurid; yet in its latter half it is romantic, and in a minor sense epochal. We need not follow the rude ambitions of soldiers who refused to be tamed by poetry. Red blood flowed in Japanese veins, and demanded spilling. Japan should return to herself, after two hundred years of Chinese dreaming, in the nightmare of war. But in the year 1542, two significant things happened—Tokugawa Iyeyasu, the man destined to found Japan's last and greatest dynasty of Shoguns, was born,

and more important, Japan's first contact with Europe came with
the landing of Portuguese upon the island of Kiushu. The
problems of the coming age are to be complicated with the romance
of Christian intrigue. It is all a part of Jesuit expansion in Asia.
In the next year the daimio of Bungo sends an ambassador to
Portugal, as if he were an independent king. European records call
him "King of Bungo." He does on a small scale what Ashikaga
Yoshimitsu had done on a large. In 1549 "Saint" Francis Xavier,
one of the original incorporators of the Society of Jesus, lands in
Japan as missionary. By 1573 a great Catholic Cathedral is being
built in Kioto. Many of the daimios would like to import the new
spiritual savour from Europe, as Yoshimitsu had imported the Zen
from China. Powerful Buddhist monasteries, especially the old Tendai
seat on Hiyeizan, take a hand at once in the dynastic disputes and
against the new religion. In short, the nation is falling into anarchy.

Yet in this very year, 1550, out of the anarchy is stretched the
hand of a powerful captain and administrator. Ota Nobunaga, a small
daimio living near Owari, commences to conquer his turbulent peers
and take a decisive hand in the Ashikaga wars. In 1559 he first enters
Kioto. In 1568 he sets up Yoshiaki for Shogun. In 1573, making
friends with the Christian party, he destroys the Buddhist by burn-
ing Enriakuji. In 1580 the Honganji priests submit to him. With-
out being entitled Shogun he now wields supreme administrative
power. The resident missionaries and the European monarchs are in
ecstasies at the prospect of immediately christianizing Japan through the
patronage of their daring general. But in 1582 he is assassinated, and
his power is assumed by one of his generals, Hideyoshi, who had
originally been a stable-boy. Tokugawa, another of Nobunaga's generals,
remains in the north, a quiet spectator of Hideyoshi's triumph. In
1583 one of the daimios sends an ambassador to the Pope. In
1586 Hideyoshi takes a higher title than Shogun—*i.e.*, regent or
administrator, an officer of the Emperor's household. The great problem
is what Hideyoshi, having the Buddhists crushed, will do for the
Christians. In spite of one of his ablest generals, Konishi, being leader
of the Christians, he decides to expel the missionaries as disturbers of
national loyalty. It is a decisive moment for the history of the whole
East, and for the world. For had those arrogant and corrupt European
Courts then succeeded in subverting Japan to their nominally religious

exploitation, the great past of both China and Japan would probably have been crushed out of sight, the art certainly ; the contact of East and West would have come before East was ripe for self-consciousness or West capable of sympathetic understanding. It would have been Cortez and the Aztecs over again. The great Japan that we know to-day, heading a peaceful reconstruction of Asiatic culture, would have been impossible. In all reverence, I would see the hand of Providence in the raising of a great barrier between Europe and Japan, with just a peep-hole at Deshima—a barrier which enabled the Tokugawa Samurai to concentrate forces of culture, and the Tokugawa populace to rise to that measure of national self-consciousness and self-government which have guaranteed Japan equal competition, equal exchange, equal world building with the West in 1853, 1868, 1898, and 1905.

Hideyoshi established himself in imperial state at Osaka, and in his golden palace of Fushimi. He would rival the gorgeous surroundings of ancient Tang Emperors, quite as his analogue, the French Napoleon, later conceived his Court as a renaissance of the Cæsars. His great ships are in close touch with Siam and the Philippines. He invades Corea in 1592, and defeats the army of Ming that comes to the rescue. Hideyoshi snubs the decaying Ming dynasty, partly because it is now given over to literary pedantry, partly because it is already harbouring the Jesuit missionaries. In 1597 Hideyoshi issues a second severer edict against the Japanese Christians, conquers Corea for a second time, and prepares to march his armies over the Yalu to Peking. It is interesting to realize that some of the great battle-grounds of the Japanese against the Chinese in 1894, and against the Russians in 1904, had been first explored by their warriors 300 years earlier. But Hideyoshi dies in the following year. His son Hideyori succeeds. English and Dutch ships arrive in 1600, ready to assist the Japanese in destroying Portuguese and Spanish. Then comes the crash, with Tokugawa Iyeyasu on top !

From this brief sketch it is seen that we may divide the 16th century, or rather the 110 years after the death of Yoshimasa, into three sub-epochs :—(1) the utter decay, from 1490 to Nobunaga's supremacy —about 1560 ; (2) the Nobunaga period from 1560 to his death in 1582 ; (3) the Hideyoshi period from 1582 to the overthrow of Hideyori in 1600. It is during the first sub-period that Kano

Masanobu and Kano Motonobu are the great Court painters to the Shoguns; during the second that Kano Shoyei succeeds to similar function with Nobunaga and during the third that Yeitoku becomes the master decorator for the palaces of Hideyoshi. Their work, and that of their pupils, is the special subject of this chapter.

The position of lay Court painter was not absolutely a new thing with the Kano. In a sense Noami, Geiami and Soami had been closely attached to the persons of earlier Ashikaga. But their status was not quite yet recognized as an organic part of the Shogun's officialdom. That a Shogun should have a Court painter—as a European monarch should have a Court jester—was rather a matter of taste. But after the passing of Yoshimasa, with the painter favourites, Soami and Sotan, the pupil of the latter and companion of both, who had worked for Yoshimasa in painting Ginkakuji, Kano Masanobu, succeeded in making himself indispensable to the succeeding Ashikaga dilettanti. The great geniuses were mostly dead; the aged Sesshu had retired to his far South; the inflowing stream of Chinese painting and culture had entirely ceased. Only Kano Masanobu and his young sons combined in themselves enough knowledge and creative power to preserve as a living reality the Hangchow culture which their predecessors had won. It is interesting to note that these men no longer represented a great vital movement common to two nations. The movement was absolutely dead in China, as we shall see more specifically in Chapter XV. It was practically dead in Japan, also outside of the Kioto and a few local camps. It was held as a lonely and precious specialty by the Kano, who sailed along under the impetus acquired by Kakei and Sesshu, like great birds soaring lazily from a rapid flight. This is especially why they became eclectics in style, since they have the whole universe of idealistic art to choose from and incorporate in themselves.

Kano Masanobu, the founder, rose from a family that had won respectable notice as courtiers of literary culture. He had begun work as a painter under Oguri Sotan, probably at Sokokuji. Though the founder of the Sokokuji school had been nominally Josetsu, we must trace a still more powerful influence upon Sotan's master from the Chinese Shubun at Daitokuji. Sesshu also, though a fellow-pupil with Sotan, must have drawn from the same source. It was Sesshu who had introduced Masanobu to Yoshimasa; and therefore we may infer that Kano derived much from his priestly patron also. This Masanobu may be said to have absorbed

remotely from the two Shubuns, directly from Sotan, Soami, and Sesshu. The old quadrilateral became a single solid fortress in itself.

Masanobu's style may be regarded as a type about as high as Sotan's, with a prevailing squarishness of touch, and an architectural structure of mounting lines that suggests Bayen rather than any other of the Hangchow men. The lines of his inking are rather straight and formal, and in this respect he creates a Kano touch. His notan is rich and full, getting about as far toward Kakei's as Shubun had done. In colour he uses only thin tint, but a little heavily, and in this respect seems to have borrowed from Geiami and Keishoki. His strongest point it probably conception ; for he can at his best present us with spirits almost as powerful as those of Sesshu. There is little of the demoniac in him however ; he soars calm, and sane, and clear, on sufficient but not superhuman inspiration. He painted almost equally well in all three categories of human figures, birds and flowers, and landscape. Nothing of his great mural work, except a few screens, now remains.

Lest it should seem that I have somewhat belittled Masanobu's genius, let me at once defer to the high testimony of his work. In figures we have his Fukurokujin and boy attendants in the Bigelow collection at Boston, which is probably a late work, and done in a glossy flowing line derived from Mokkei through Sesshu and Keishoki. His great painting in colours, also at Boston, of the three founders was very celebrated in Tokugawa days, and has already been referred to as a possible copy from Bayen. The Monju, reproduced here, is a beautiful and gracious figure. But finer than all is his portrait of Confucius in the Ashikaga University, based upon an important Sung statue, and of which Kano Tanyu's careful copy we reproduce from the Boston treasures. This great heirloom in the family of Tanyu's successors I bought from the last artist of the line, Kano Tambi, in 1882. The face is of such a high intellectual type that in spite of its disadvantages in eschewing modelling and shadow, and of relying on delineation in thick ink, it owns its own for powerful individuality even when photographed side by side with such a finished portrait as that of Leonardo da Vinci by himself.

In birds and flowers, his kawagarasu bird on a bamboo spray, in ink, from the ancestral collection of Marquis Hachisuka, is very noble. The

famous screen of Shinjuin at Daitokuji shows a great stork stepping among grandly-spaced rocks and trees. Doubtless he did flowers in colour, also, like Sotan.

In landscape he came fairly near to Bayen. The beautiful little landscape on silk, of the banished Chinese general, Osho, feeding his sheep, in the Fenollosa collection, also bought in 1882 from Tambi's treasures, is very probably a copy from Bayen or one of his contemporaries. Yet it already foreshadows Motonobu's composition of mountains. Perhaps his greatest work in landscape was the screen with a Chinese terrace supermounted with an enormous pine, which belonged in early Tokugawa days to Prince Kinoshita, and was then copied by Kano Yasunobu. The great zig-zag pine, like a triumphant Bayen creation, cuts in magnificent counterpoint the vertical columns of distant mountains. The law of *spacing* in this composition is supremely illustrated. It is hardly inferior to Sesshu at his best.

Masanobu died in 1490.

Kano Masanobu, whose Chinese name was Yusei, had two sons, Motonobu, also called Yeisen, and Utanosuke, whose *nobu* name was Yukinobu. This use of a *nobu* name, which may be translated either " having faith in," or more appropriately " narrator of," descends as a custom down through sixteen generations of Kano patriarchs to the present day. From Motonobu onward the leading line also had a literary or priestly name beginning with Yei—" eternal." Thus Motonobu Yeisai may be read " Faith in the Ultimate, Eternal Magician," and " Yeishin Yasunobu," his great-great-grandson, may be supposed to mean " Eternal Truth sweet tale-teller of peace." The latter's niece, " Yukinobu," could be prettily called " Whisperer of the Snow," and my teacher " Tomonobu " is " one who talks of friendship." *

Kano Masanobu still held about his person and style the flavour of Ashikaga greatness. But Motonobu, who must have been born about 1480, found himself at an early age practically alone, the sole embodiment of artistic insight and power. He spans, with a long bridge of fifty years, the gap between Sesshu and Nobunaga. He was sole critic, sole creator (barring the brother) of his day. All that Kaifong

* EDITOR'S NOTE.—During these years of great activity among the yet remaining artists of Japan, Ernest Fenollosa was formally adopted into the Kano family, and given the name " Kano Yeitan "—the latter, a personal name having the significance of " Eternal research "—or " Endless seeking."

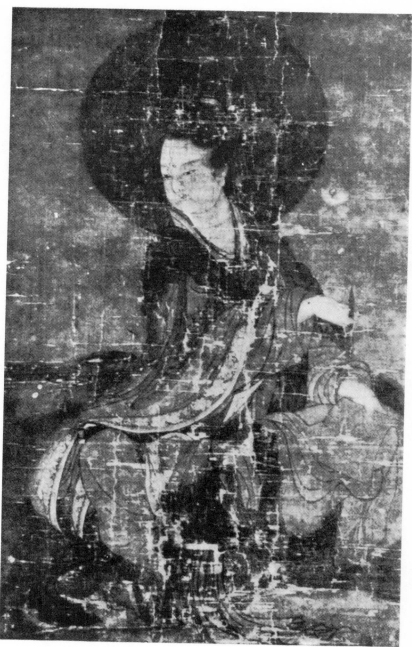

MONJU. In the Boston Museum.

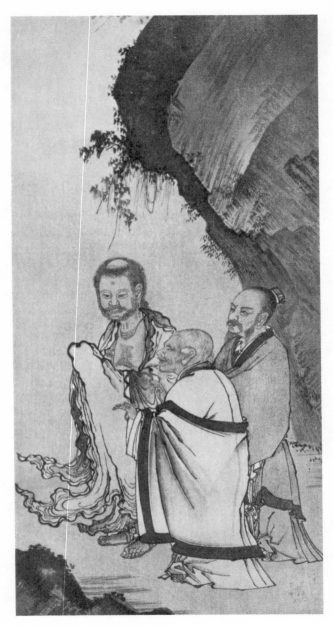

THE THREE FOUNDERS.
 By Kano Motonobu.
 Fenollosa-Weld Collection, Boston.

and Hangchow has been, all the Kinkakuji and Ginkakuji had
fostered, or as much of it as could be held in a single brain, was
summed up in him. His styles are a final consolidation of its leading
styles. In his squarer touches (*shin*) he touches Bayen through the
mediums of Sesshu, Sotan, and his father. In his softer touch (*so*) he
absorbs Mokkei through the avenues of Noami and Soami. In his
colossal birds and flowers he derives from Joki through Sotan. In
his scratchiest style he consolidates Riokai, Giokkwan, and Sesshu.
In his lay figures he mounts almost to Bayen and Kiso, giving us
the most normal views of Sung gentlemanly life. In his Buddhist
figures he almost touches Ririomin and Godoshi, but with the helpful
finger of Cho Densu. Along all these lines he selects, he confirms, he
consolidates. His style is almost as solid, personal, and flexible as
Sesshu's. It is perhaps a little mannered, but the number and variety
of his manners are so great that we hardly feel the limitation. It is
the perfection of technique ; never a bit of awkwardness intrudes, as
sometimes in Yoshimitsu's day ; the composition is always dignified,
scholarly, full. It is really through him chiefly that the early Kano
school merits such special notice. We can say of his life-work
as compared with previous Ashikaga painters, that, while the men of
Yoshimitsu's and Yoshimochi's day were climbing to Hangchow, and
while the men of Yoshimasa's day, especially Sesshu, had got there,
and sat on the same bench with the Chinese, Kano Motonobu, aim-
ing neither to climb nor to share, simply establishes a Neo-Hangchow
universe where he chooses to reign alone. Whatever be the absolute
merits of his work—and they are great—his service to posterity in
making of himself an open door to the great past of two nations is
incalculable. Unfortunately the enormous collection of copies from
Chinese originals accredited to him and to his pupils was destroyed by
a Kioto conflagration early in the seventeenth century. If Motonobu is
epochal, he alone defines the epoch.

Going a step further into generalization, we may say that three
men—Soga Shubun, Sesshu and Motonobu—literally span with their
lives the ages of Ashikaga creation. Here is the ultimate line of
descent from Sung, far more legitimate and genuine than the bastard
Ming or the pretended " Bunjinga " copies of Tsing. Finally, Sesshu
is the perfect air that Motonobu, in his youth, breathed. Though he
never went to China, China is a reality to him, because he can wear

without strain on Sesshu's glasses. The infinity and locality of Sesshu's myriad sketches are at his disposal. He holds all Ashikaga scholarship in his memory. The whole round of Zen symbolism permeates his work.

But there is another root of Motonobu's vividness ; though intent on Chinese subjects and basing his technique on copying masterpieces, he refreshed his elementary knowledge of form by sketching from Japanese nature. It is a pity that all such sketches made before Tanyu are destroyed. It is true that all his passages of rock, tree and waterfall fit perfectly into a Chinese mosaic, and do not look much like anything in Japan except nooks of gardens built in the Hang-chow manner ; yet we have record that he tested by vision the rocket-spiral of his pines and the notan truth of his mists.

A typical example of Motonobu's figure work in monochrome is afforded by the three Chinese gentlemen of Sung owned in Boston. The perfection of touch and spacing is notable ; not a quiver of the impression is left to chance ; it is all as perfect as sculpture. His version of the " Three Founders," owned by Mr. Dwight Davis, of St. Louis, is equally perfect, though less " cuneiform " in manner. The drawing and copying of the faces shows Motonobu's finest works. Many great figure screens were copied by Yasunobu—large groups of Chinese gentlemen, philosophers and sennin with wild landscape background. His great white Kwannon in Godoshi style has been noticed. In 1882 I visited, in company with Kano Tomonobu, Miokakuji of Kioto, where we paid our respects at Motonobu's tomb, and colossal coloured Nehango by him, which rivalled the great " canvasses " of Cho Densu at Tofukuji. In his earlier work his strokes are like wedges, but more carefully split than Sesshu's. In his later work the angled wedges of garments become executed in a smaller, more careless running stroke, exemplified in Mr. Freer's fan of the sages.

Motonobu's " square " bird and flower passages on silk were often quite brilliantly coloured, though on paper screens they were generally only tinted. In his softer Mokkei-ish style he loved to enrich landscape backgrounds with splendid groups of birds, leaves and petals in glowing ink. Supreme examples of such work were exhibited at the first Tokio loan exhibition in 1882, in two six-panel screens, which I photographed. There exists one panel where a lovely notan contrast is afforded by the white herons on the willow and the blackbird on the

rock. The "colour" is enhanced by the general presence of snow, which is not painted with our impasto, but "left" by tints that surround, with incredible skill, its many-formed masses. The snow is therefore in tone with all the local lights. Here, too, the perfect spray of the black bamboo leaves lead thought back to the early experiments of Toba and Bunyoka. How boldly the retiring of the middle distances is effected through texture alone!

Typical ink *shin* landscapes of Motonobu on silk are the twelve fine scenes painted on panels of screens owned by Prince Mori; these retain something of Masanobu's manner. A fine glossy example of his Mokkei mannerism in landscape is shown in one of Mr. Freer's kakemono. Here, as so often in fine ancient works, the golden quality of the old paper throws forward the melting ink into a sort of violet atmosphere. The great set of landscapes held at Mioshinji, Kioto, formerly mural decorations of reception rooms, exhibits quite a range from the Ming *shin* lines to the scratchy impressions that suggest Giokkai. These have been reproduced in rather poor process printing by the Shimbi Tai Kwan Company. A specially fine "scratchy" example is Mr. Freer's large square paper kakemono. There are no screens by Motonobu at Boston, for in all the twenty-eight years of my collecting and studying I have been in vain on the look-out to obtain a large mural piece by this artist, whom the Tokugawa Japanese prized next to Sesshu.

Other more highly-coloured manners by Motonobu, used for effective mural decoration in palaces, were inventions of his own, though remotely based on coloured Sung work. Such were particularly his great compositions of Tartars hunting, in wild yellow landscapes, where the oak trees bristle with clumps of spiky leaves that recall chestnut burrs. The rocks are touched in little flaky dots that form straight lines. The colouring here vibrates between violet and warm yellow, throwing up the Tartar costumes and tents of bright red and green. There are two fine panels of this style in Boston. The later Yeitoku school of Hideyoshi partly grows out of such experiments. Sometimes he carried the mural style farther, to the point of encrusting the masses in solid chalk, powdered azure, and gold; as if they were a Buddhist subject. Examples were the screens of waves and wild ducks formerly owned by Mr. Yamanaka of Osaka. This was a kind of impressionism which later had its weight upon *both the panoramas* of Yeitoku and the Tokugawa school of Korin.

We come now to a phase of Motonobu's life and work—I had almost said of Ashikaga life and work—which I have deliberately omitted up to this point in order not to confuse the true impression of the main epochs. Yet things are never so simple as we have to make our description of them. The student cannot take in masses of divergent fact, and relate them in a true scale of values, without proceeding by successive steps. In the words of a good teacher, or in the chapters of an educational book, the layers of truth have to develop for the mind one behind another, quite as the strata of distances do to the eye in a good painting. Now it is seldom true that, though we divide the history of Chinese, Japanese, or European art into separate creative epochs, the pungent life of one age entirely disappears in the new phases of its successor. Rather does a thin parallel stream of earlier influence trickle down through the ages, unnoticed in its day ; or, to use a different figure, a smouldering fire which may some day be blown up into rekindling, refuses to be extinguished. In this way some traditions of Roman mural art persisted in obscure Italian churches side by side with the triumphant Byzantine, until the genius of Giotto at a less prejudiced day unlocked it. So we have already seen the original sculptural talent of the Japanese, that best expressed itself in the early Tempei style of Nara, never quite eliminated, but ready to spring into a modified life under the touch of Jocho in the tenth century, and Wunkei in the twelfth. Its few drops of influence had not quite dried up in the ateliers of Kioto in 1882. So Kose religious painting of the second period persisted in a precarious and secondary life side by side with the ruling Tosa of the third. So, too, a trickle of Zen influence, in essence spiritually subvertive of the whole feudal structure of the dominant Hojo, kept Zen temples and Zen art moist in mossy nooks during the fiery fever of Kamakura feuds and Tosa battle-pieces.

Now, too, we have to see how the consolidated Tosa-Kose-Shiba art of the end of the third Japanese period fared, though in a most meagre minority, in its efforts to perpetuate itself by sheer force of habit through the dense, revolutionary and Chinese mass of Ashikaga idealism. It is seldom that new legislation can utterly annihilate an opposition. And so, though Japanese life and art under the Kioto Shoguns literally underwent that most stupendous transformation from violent individvalism to ecstatic absorption in the brotherhood of

nature loving—from ultra Japanese character to the thickest kind of Chinese veneering—which I have described in the last chapter, the obscure descendants of Tosa geniuses did perpetuate a trace of former feeling under the occasional patronage of the Imperial Court, of the non-Zen Buddhist temples, and of some unreconstructed country daimios. Thus we know, if we shall trust the Sumiyoshi genealogy, of a Yukihide, his son Hirochika, and others, who give us a still more weakened phase of their family manufacture even into the fifteenth century. Tosa and water ! In Yoshimasa's day, and in fact during the whole last half of the second Ashikaga century, the son of Hirochika, Tosa Mitsunobu, stood out alone against a Hangchow world, and won a certain measure of fame due to his long service to the Emperor, and to a certain picturesqueness in the landscape portions of his somewhat cramped style. During the sixteenth century there is a pretence in the Tosa annals of keeping up a sort of family continuity in an alleged son and grandson, variously called Mitsunori, Mitsunari, Mitsushige, and Mitsumochi. The truth is, however, that though the Tosa-ish pieces belonging to this intermediate date turn up in the junk shops, they no longer have an individual manner, and are reduced to a kind of weak manufactured illumination. It is quite probable that the Tosa family organization even ceased to exist in the interregnum, until a kind of pseudo-revival was engineered for it by Tokugawa eclecticism. Whichever of the two hypotheses prove to have documentary evidence, the central truth remains that Tosa Mitsunobu was the last Tosa artist who held in himself continuity of vital descent from Kamakura.

Now what all this has to do with Kano Motonobu is as follows : About the year 1500, the father, Masanobu, had been undisputed major-domo for art of the Shoguns' Court. At the same time the aged Mitsunobu exercised a similar function for the little toy court of the Mikado. They knew each other, greeted each other in terms of the most punctilious politeness. The Kano patriarch had a son just growing into vigorous manhood. The Tosa patriarch had a daughter of his later age who was an accomplished artist in her father's style. What could be a happier plan than for Kano Motonobu to marry Tosa Mitsuhisa, and thus to unite in a single family the traditions of two whole periods—nay, of two master races of Asia ? This is just what happened, and it is clear that from

that time onward the Kanos regarded themselves as inheriting legitimate right to paint such Japanese scenes in semi-Tosa style as might become needed for court or temple.

Kano Mitsuhisa's signed work is lacking, but I believe that we probably have a specimen of it in a painting of a temple crowd which I shall describe in a later chapter. From this and Motonobu's work it seems pretty clear that each of this finely-mated pair studied art humbly under the other, so that over the Japanese area of their work their two styles come to coalesce, though from opposite points. It was from this Tosa derivation that Motonobu has come to give us a more highly coloured style, and several large and small compositions of Japanese life in characteristic costume. One of the most celebrated of these is the set of makimono kept at Seiroji near Kioto, depicting the alleged removal from India and China to Japan of the ancient statue of Buddha which we have described in Chapter III. Here Motonobu has furnished a splendid Tosa-ish landscape background, in solid blue, green and gold, which is interestingly more like some Kose backgrounds of altar-pieces (also of favourite Chinese derivation) than from Tosa. Both he and his sons produced battle subjects of the Heike age. It is true that this phase of early Kano work does not rank of very great contemporary importance ; but we shall see that it has a notable bearing upon the origin of the later Ukiyoye.

It is in Motonobu's day, too, that other signs appear of the possible dawning of a new Japanese age. One of these is the renewed love for lacquer, which had never wholly died out, but now called for more elaborate decoration, mostly of Chinese landscape or flowers, of gold on gold, or gold on gold spotted black. Also it was about 1510 that the first fabrication of decorated porcelains in the new Ming fashion was introduced into Japan. All this should show us that, although in Motonobu's dominant art we have a most vigorous off-shoot, and, as his contemporaries believed, culminating form of Chinese Hangchow feeling — there is just an undercurrent in the air, a natural instinct of Japanese to return, after an alien debauch of two centuries, to a Japanese way of feeling and thinking. In the recognition of Mitsunobu, the marriage to Mitsuhisa, and the assumption of Tosa Court function, it seems to come without strain. The feverish wave of Zen propaganda is already broken ; there is no longer

a sort of religious bias against native art; Motonobu works less as
a Chinese than a Japanese; whatever the Ashikaga think, they wield
small force; the future will depend upon what the rude strength of
the revolting daimios may decide.

Motonobu's younger brother, Utanosuke, also called Yukinobu,
followed him with loyal closeness and high sympathetic genius
during the many phases of his career. It would be unfair to
Utanosuke to represent him as a mere shadow of his brother. It
is true that he does not produce a new style, yet he derives
with some independence from his father, and in his proportioning
of subject he is different. We must regard him as an independent
genius, related to his central sun pretty much as the work of Sesson
is related to that of Sesshu.

One of the finest figure pieces of Utanosuke is the six-panel screen
owned by Mr. Freer. This represents groups of Chinese gentlemen
in a beautiful Motonobu-ish landscape. They have been having an
out-of-door entertainment. The lines are softer than with the elder
brother. The low-toned harmony of tints on old paper gives us those
lovely " wood " colours for which early Kano screens are so noted.
A fine figure in pure black is the Chinese poet riding on a buffalo, in
the Boston Museum. For bird and flower screens Utanosuke is even
more famous than his brother. There are four in the Fenollosa collection.
His drawing and colouring of plants in these great landscape settings
is the finest of Japanese work in Chinese style. It evidently goes back,
not only to Joki and Sotan, but to nature. The greatest bird piece
now known of Utanosuke is the great eagle on a pine branch, which
was formerly one of the great pieces owned by Marquis Hachisuka,
and which is one of the greatest treasures of the Fenollosa collection.
It is possibly the most powerful bird painting in the world. This,
like the Motonobu Kwannon, I had known through a famous old copy
by Tanyu, before I found, and was able to purchase, the original.
This was among the treasures dispersed to outgoing retainers in 1872.
It most fully exemplifies the Zen ideal of a bird whose majesty makes
us think instinctively of great human qualities. It would hardly be too
much to say that this seems to be a "Buddha among birds." It, and
the Motonobu Kwannon, were the two greatest treasures of the first
historical exhibition of works by all the masters of the Kano school,
which I held at Tokio in 1885. In pure landscape we find Utanosuke's

best work upon the walls of several temples, notably of Shinjōan, in Daitokuji. Its composition is less powerful than Motonobu's.

When Nobunaga, the conquering freebooter, came and held Kioto from time to time during the 1550's, he found Kano Motonobu and Kano Utanosuke quietly at work in their studios, surrounded by a large retinue of sons and students. They were just completing that great range of works that had bridged half a century. Nobunaga entered rudely into the place made sacred by art, but Motonobu, though aware of his presence, went on working without noticing the intruder. The rough soldier rather delighted in the man's independence ; and when he began the building of a great feudal castle in Kioto, the Nijo, he summoned the Kanos to plan and execute the mural decoration. This act of Nobunaga's in surrounding his headquarters with granite walls is in striking contrast with the policy of the Ashikaga, who had lived in the midst of their capital city in unfortified palaces.

Nobunaga made Kioto his chief centre of operations from 1568 to his death in 1582. Motonobu had died in 1559 at an advanced age ; and his second son, Kano Shoyei, became the official head of the great Kano academy that the genius of his father had built up. Nobunaga promptly took him into his employ, and we can roughly estimate the Nobunaga period—from 1559 to 1582—as the period of the third generation, Kano Shoyei and his associates.

Though this school was large in numbers, there was no central genius in it to take the places of the two great brothers, Motonobu and Utanosuke. The eldest son of the former, Soshi, had died before his father. Other brothers, Yusetsu and Suyemasa, were weak in style. A son-in-law, Yosetsu, and a nephew, Giokuraku, came the nearest to the great master himself. Genya, Doan, Sadanobu, and Kimura Nagamitsu were conspicuous among a great crowd of pupils. The style of the last was original and powerful ; and he is also celebrated as being the father of the great Sanraku. Good specimens of the work of all these men are in the Fenollosa collection. But the central position fell to Shoyei by inheritance if not by genius. He was a faithful, steady worker, but without fire. The forceful lines of his father were chopped up into small and somewhat monotonous crumbly touches. His work in coloured flowers and birds was his prettiest. But it was clear that his work, and that of most

INTERIOR OF NIJO CASTLE.

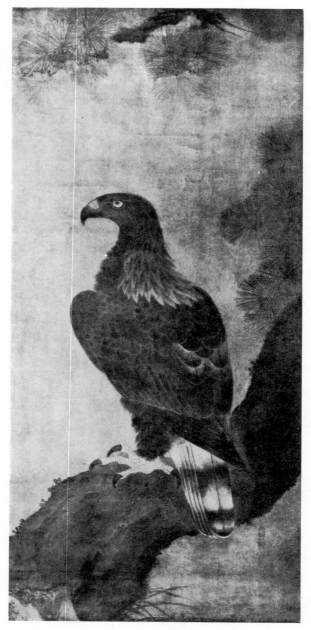

PAINTING OF AN EAGLE. By Kano Utanosuke.
Fenollosa-Weld Collection, Boston.

of his followers, was after all manufactured. There were no heart in it. It did not pretend to go back for inspiration to Chinese originals, nor even to Sesshu. The long triumph of Motonobu had overweighted it with a narrow, unbreakable tradition. His pungent style had become a wall which shut out their view. Their sole aim was to be like him, and chiefly—as always happens in such cases— like his latest and weakened phases. It would seem as if the end, not only of the Kano school but of the whole Ashikaga movement, had come. The infusion of Tosa tradition and blood, the possibility of reviving something of Japanese style, were chances thrown away. Now that the substance of Motonobu was gone, the world demanded his shadow. Shoyei's thin talent, with such a father and mother, is a strange fact of "heredity." He did a few little pieces in Tosa style. Some of the Nijo castle decorations are probably by him. There is a good "Kwacho" kakemono and a screen by him in Boston. Such was the weak ending of a powerful movement begun two centuries before with Noami and Soga Shubun.

But the Kano sohool did not at all come to an end, though the Ashikaga did. Strange circumstances arose between 1582 and 1600, and the Kano family, under the leadership of its genius in the fourth generation, just turned about and adapted itself to the new conditions. There was no longer much pretence of an interest in Zen idealism, in China, or in landscape. An upstart, Hideyoshi, was in the saddle. He had subdued the whole land to his will, by conquest or policy. His strongest rival, Tokugawa Iyeyasu, of the East, acknowledged his supremacy. The brilliant military achievements of the age, such as the conquest of Corea, fairly turned attention back to Japanese feeling and Japanese prowess. When Hideyoshi, about to invade China as well as Corea, was advised to take Chinese interpreters for his expedition, he replied patriotically, "We shall teach the Chinese to use our literature." This shows Ashikaga upside down. And yet in Hideyoshi's day as a fact there was little manifestation of a real return to Japanese subject in art. Why was this! And what could the Kano school possibly turn to—if not to Zen dreaming on the one hand or to Tosa violence on the other? The answer to these questions is, *Hideyoshi's vanity and Kano Yeitoku's genius.*

Hideyoshi indulged in no idealisms. In others he half despised and half feared them. He was foe to the supernatural pretensions of

both Buddhists and Christians. Of the two he intended to favour such part of Buddhism as he could patronize. His policy, in this respect as in every other, is like Napoleon I. in the dealings with he Roman Church. Hideyoshi knew that most of his generals—men of ancient lineage—really despised him for his plebeian birth ; and his efforts were largely directed to manufacturing for himself patents of nobility which should outshine them all. Thus he induced the Emperor to appoint him Kwambaku or Regent, an imperial office that no daimio or Shogun had ever held, one that was always reserved for a Fujiwara descendant. He built the magnificent castle of Osaka, which in scale far surpassed all precedents. But more than all, he strove to surround his Court with the externals of an almost imperial splendour. He built the great palace of Fushimi, unexampled in Japan for its size and for its gorgeous finish in colours and gold. The costume of his lords and ladies was of unparalleled richness, splendid robes of bright tint, with great patterns of still richer hue, sweeping from neck to heel. The richest carvings, not now in relief only, but perforated, were inserted into the screens of the interior finish, and covered with colours and with gold leaf. The reception rooms of all the temples that he favoured in the neighbourhood of Kioto were finished in the same gorgeous style.

Now, how could he do all this, where get the motive, the power, the ideal, the model, for such a comprehensive use of art in mural and other decorative work ? The answer is, from Kano Yeitoku, and a plan for new subjects, which probably he and his master privately agreed upon. This plan was to go—neither to Sung idealism nor to Japanese feudality— but back to the imperial splendours of the Courts of the early Tang in China, of Taiso the conqueror of Tartary, and of Genso, the world-lord ! The art that should decorate their enormous and brilliant walls should consist of great Tang Court pageants crowded with figures of Chinese lords and ladies, Emperors and their suites, in the most gorgeous costume, and backed by endless reaches of pavilions in enamelled architecture, and of gardens stocked with rare plants and animals. In this way, the Taiko—again like Napoleon —should impress his subjects with the insignia and outward magnificence of the greatest imperialism his continent had known. Napoleon the revived Cæsar, and Hideyoshi the reborn *Li*—a perfect parallel.

The man who saw just how to execute this bold and magnificent scheme was Kano Yeitoku, the second son of Shoyei. Though young,

he had succeeded to the headship of the family before 1582. He could command for the task the help of two accomplished brothers, Soshu and Kinhaku, and a vast army of pupils, whom he undertook to instruct in the new manner—and of whom the chief were Sanraku and Yusho—and, later, his young sons, Mitsunobu, Takanobu, and Genshichuro.

Kano Yeitoku, as a boy, had known the personal influence of his grandfather, Motonobu ; and during the *régime* of his father, had occasionally produced works in the old style whose vigour threatened the repose of the school. Of these, the most splendid are the vigorous mural work of pine trees and blossoming plums in ink, done on the sliding doors of Daitokuji. They have the lightning splintering of stroke that recalls the old Kano patriarch at his best, but with a new proportioning and radiation. A small painting in colour of a wood pigeon on a camellia bough (which is in Boston) rivals Utanosuke's Kwacho.* Also in the Fenollosa collection is an early impressionistic ink landscape in black which breaks up the crust of Motonobu tradition in original explosions. The bent of the young genius was already toward coarse strength. And when Hideyoshi, after his triumph of 1582, began to carve out a Court career, Yeitoku was on hand to conceive great panels of, say, forty feet in length by fifteen in height, where coarsely drawn but dignified figures of Chinese worthies should crowd a ground already largely prepared with gold. It was a revolution in Kano style, in Japanese art—in short, a brief but brilliant epoch in painting.

The sources of this art, in so far as they were external, can be partly conjectured. In subject he but borrowed certain Court groupings, generally minute, that had been painted in colours by Tang and Sung artists ever since the days of Godoshi and Roshibu. The Chinese hunting scenes—resting alternately upon remote Assyrian and Han prototypes—could be derived from Rianchu and other Sung students of Kin and Mongol. The great point was how to enlarge these groups to mural scale and make their heightened colouring correspond. Motonobu had already given some hint of a solution in his large, but more quietly coloured, mural decorations. Here he had generally not used gold leaf, though this had been done to some small extent by late Tosa's, as Mitsunobu. It was Yeitoku who for the first time conceived of expanding the gold leaf clouding until it should occupy perhaps half

* " Kwacho," in Chinese " hua-mao," signifies a painting of flowers and birds.

of the background, and should again require touches of gold paint throughout the costumes and accessories in order to force them forward into colour scale. The colours themselves of the figures were done in yellows, oranges, reds, browns, greens, and purples, most primary, and flat in hue, like great pieces of mosaic. The wooden details of the architecture, in dark chocolates and gold, should be brightened by gorgeous brocades, and by heavy-tiled roofs in purple, blue, green, and gold enamel—a barbaric scale, of which there is only a hint in ancient Chinese sketches. More direct impressions were probably derived from Chinese palace scenes of late Ming, which were worked out on great screens of raised lacquer, in colours of some brilliancy. The disposition of the Court figures in Yeitoku's and Sanraku's panoramas is often quite like the best Chinese decoration of this sort. And there was a Corean form of this decoration, more splendid still, where considerable gold leaf had been used with the lacquer. The insipidity of the late Ming figures was, however, bettered by Yeitoku's training in the splendid wedge-shaped penmanship of his grandfather, and his large feeling for proportion.

But the most original feature that Yeitoku introduced into these huge colour mosaics was the introduction in patches of very dark colour, got by glazing transparent pigments over coloured ground, as in the tempera and oil work of Europe, or by scumbling dark opaque pigment over lighter. In this way he could carry his coloured masses to a contrast and depth of notan comparable to that achieved in mono-chrome by the pure glossy blacks of ink. Thus he could darken his greens into a splendid olive, his blues into lapis lazuli soaked with indigo, his scale of oranges and reds into the glowing carmines of cochineals, and his purples into the lowest depths of plums. At times his orpiments would strengthen into the richest warm dark browns. He would apply this method, too, to the foliage of trees ; and indeed it had been already foreshadowed in the dark leafage of Utanosuke ; and he would get more glow into his blossoms by their glazing of transparent pinks and gamboge. In how far Yeitoku was influenced toward this by the many examples of European oil painting imported for the Christian daimios we can only conjecture. There is no attempt at shadow in his work, and Hideyoshi was hostile to the European propaganda ; but it may well be that Yeitoku got a hint of stronger mural power in colour from the glazed garments of pseudo-Venetian " Holy Families," or portraits of popes.

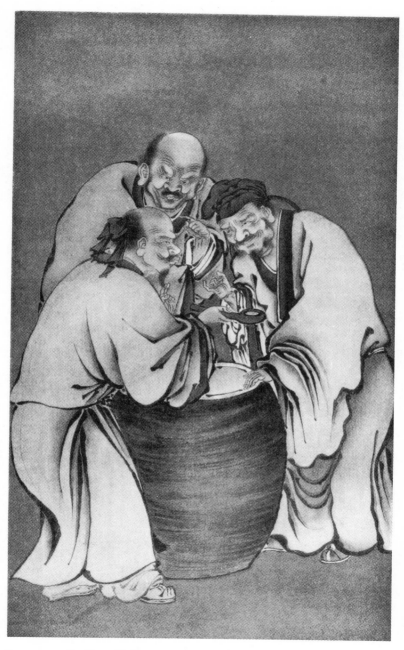

Painting. By Kano Motonobu.

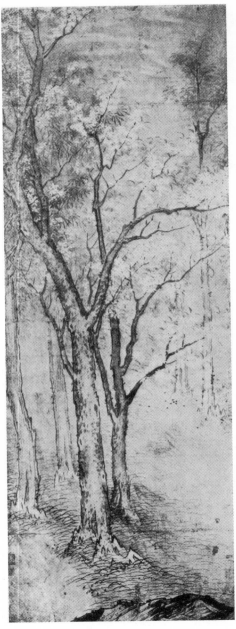

TREES.　By Kano Soshu.

It will be seen from all this that the school of Yeitoku is probably the most brilliant school of secular art that Asia ever produced, perhaps the most brilliant in the world with the one exception of Venice at its best. In actual appearance, with its presence of flat gold and absence of shadows, it is not unlike the altar-pieces of the great Italians Giotto, Orcagna, Lorenzo Monaco and Fra Angelico. It is like what these would become if expanded to a scale of yards or rods.

But our most important historical problem is to see just how this great school stands toward the movement of which it is in name the culmination. In subject it is Chinese, and therefore not out of harmony with one side of Sung and Ashikaga art. In technique of drawing, too, it is really a legitimate development of Shubun, Sotan and Motonobu. In the fact of mural decoration on a large scale it merely follows the precedents of Sesshu. It therefore clearly has strong roots in the past of Chinese feeling. On the other hand, it is almost entirely cut off from that splendid Zen spirit which had rendered the art of Hangchow and Ashikaga possible. Not a trace of any but a decorative love of nature remains ; the noble sobriety of monochrome in mural work has given way to the most "vulgar" extravagances of colour. In these respects, while we must declare it a late offshoot from the Ashikaga stem, it presents such enormous variation that it fairly becomes a type by itself, a type of transition in art—as its master was in policy—between the Shogunate of the Ashikaga and the Shogunate of the Tokugawa.

Conceived in relation to other contemporary tendencies, it holds a marvellous conservatism and balance. It is true that the seeds of a Japanese return to Japanese feeling are already in it ; we shall see in the next chapter how the Korin school partly grows out of it, and in Chapter XVII. how the Ukiyoye school of the populace does the same thing. But in itself, its great day—that is, in Hideyoshi's and Yeitoku's day—it showed no more of this tendency than is involved in its Tosa descent through Mitsuhisa, and the semi-Tosa suggestion in its colouring. Again, though face to face with Europe, and already threatened with pungent world changes that have become realities in the nineteenth century, it still holds itself aloof, and remains closely Asiatic. One more negative relation is here well worth stating. It is contemporary with the closing days of Ming, a harassed and confused

Ming, a Ming that has utterly thrown away its last trace of eclectic desire to reproduce Hangchow, and has gone over bodily to the Confucian scholars, who in their ignorance and perverted taste are transforming and travestying their natural art into the trivialities of "bunjinga." But of this movement, which we shall dwell upon at some length in Chapter XVI., not a hint crept into Hideyoshi's Court. As little cared he and his war-loving daimios for Confucius as for Buddha or Christ. Any new form of preciosity or ultra-impressionism would have been most distasteful to them. Japan was happily spared the scourge of Chinese formalism until the eighteenth century.

The greatest examples of the pure Yeitoku manner are seen to-day in the decorations of the great hall of the Nishi Honganji temple at Kioto. This was a favourite of Hideyoshi's, and he transferred to it some of his pavilions, and also some of the carved gates, and the gilded halls, it is said, from the Monoyama palace at Fushimi. Hideyoshi's great wood-carver was Hidari Jingoro, and certainly the splendid front gate of Nishi Honganji, with the fine figures on horse-back, shows that Jingoro took his designs from Yeitoku. It is also clear that the rich costumes and gorgeous lacquer utensils of the day, big and gaudy decoration with large pattern, are from Yeitoku's pen. The great hall of Honganji has a pillar-supported ceiling, cut into hundreds of square panels bordered in black and gold, and painted with coloured flower pieces by Yeitoku in the circular centre. Three sides of its walls are decorated with the gold and colour panoramas of the great artist, painted on sliding doors to right and left, but against the solid wall of the great Tokonama at the back. Beautiful gilded carvings in the ramma surmount these paintings, where forms of interlaced birds and flowers are as nobly decorative, yet naïvely real, as in the borders of Ghiberti's bronze doors.

But for the most part we have to rely upon screens to study this Yeitoku work. The finest, which came to my hands directly from Kanazawa, the capital of the rich daimio of Kaga, is a pair of six-fold screens originally presented to the Mayeda family by Hideyoshi himself. It represents the reception of the foreign envoys who are bringing world-rarities as tribute to the Court of the Emperor Taiso of To. It is in Yeitoku's richest, yet most finished and careful style of gold and colour work. The Emperor sits upon a throne, surrounded with his Court, his ministers, ladies and musicians ; upon the companion screen

the envoys are seen approaching through a rich garden. This pair is one of the treasures of the Fenollosa collection. Another two-panel screen in the same collection shows figures crossing a dark blue lake in a golden boat. The drawing of these, faces and costumes, is so careful and vigorous as to look almost like a Motonobu. The large two panel screen of Mr. Freer's, showing an Emperor and his ladies, is in the later, more rounded, style. Some of Yeitoku's most effective work, however, discarded Chinese figures, and confined itself to the most gorgeous flower and leaf decoration in solid encrusted (sometimes literally relieved) gold and silver colours. A fine example is the two-fold maple fragment at Boston. Still finer is the great six-fold screen of grape leaves falling from a trellis, owned by Mr. Freer, in which the most subtle tones of green and olive and of the dullest purple of the fruit clusters play on tarnished silvers. Less impressionistic and more crisply perfect in drawing is the same gentleman's two-fold screen by Yeitoku, painted in hanging clusters of wistaria. Here nothing is left to chance, for every line of every petal is painted in most beautiful detail, yet without distraction of the broad effect.

The greatest follower of Yeitoku, in these achievements, was Sanraku, the son of Kimura Nagamitsu, whom Yeitoku adopted under the Kano name. His ink style is scratchy and florid, though less violent than his father's. But in gold and colour mural work he comes close to his new father. His lines are a little more nervous and crumbly than Yeitoku's, his figures more suave and graceful, his colouring lovely, yet less rich in scale of pigments. There is a fine screen of Court musicians in Boston, and Mr. Freer's collection holds several noble examples. Of Sanraku's relation to the beginnings of Ukiyoye we shall speak fully in Chapter XVII.

Next to Sanraku, in pure Yeitoku execution, comes Yeitoku's two brothers, Soha and Kiuhaku. Of the former Mr. Freer has two fine screens, cut up by raised gold clouds into some twenty or more scenes of Chinese Court life with small brilliant figures. The perfect preservation of the colour shows what Yeitoku's must have been like when fresh. A fine pair of Kiuhaku Court screens is in Boston, where a great concourse of ladies upon a terrace forms a central group. Both of them are fully identified by comparison with signed works. When I first went to Japan no artist of the school was clearly differentiated from the founder. It was my interesting labour through

twenty years to identify the varying styles of some fifteen or twenty of his followers.

Kaihoku Yusho was one of the greatest of Yeitoku's pupils, and shows more individuality than the others. Much of his best work, especially in ink, belongs to the next age, of Iyeyasu. But fine colour pieces are kept at Daitokuji and Mioshinji. His screen covered with pink peonies on gold, at the latter place, marks, like Yeitoku's grapes and wistaria, one of the starting points of Koyetsu. The work of Yeitoku's sons, Mitsunobu, Takanobu and Genshichiro, chiefly appears in the Tokugawa age; though fine examples of Mitsunobu's gold and colour work exist, as in the polo-playing screen at Boston.

Yeitoku himself died at a comparatively early age, before his master Hideyoshi, and Mitsunobu became successor as head of the family. Had Yeitoku lived, he would probably have influenced the art of Iyeyasu into different channels from those it finally took. With him and his fellow-workers we close this transitional phase of Ashikaga art, though indeed the persistence of the school manner in the seventh generation is, though belonging to Tokugawa, only a late phase of the same transition. That is, we can see the feeling and accomplishment of these great days changing slowly from decade to decade, without any violent reactions. We assume the accession of Tokugawa to be the proper boundary between this chapter and the next, because all the arts of the Tokugawa epochs clearly begin to come into shape thereafter.

One of a Pair of Screens representing
Chinese Court. By Kano Yeitoku.
Fenollosa-Weld Collection, Boston.

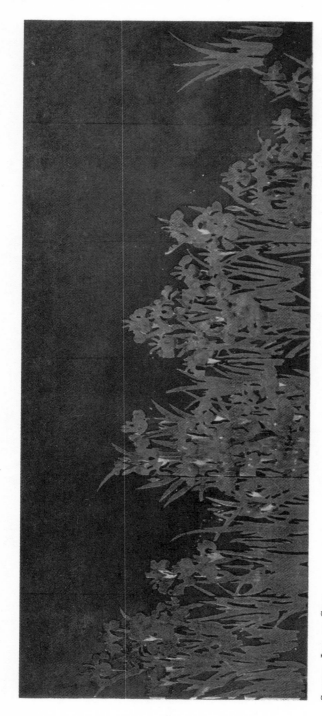

Screen—Iris on Gold.
By Korin.

MODERN ARISTOCRATIC ART IN JAPAN.

The Later Kano and the Korin School.

W E now come to that last great period of Japanese civilization and art, the Tokugawa dynasty of Shoguns, lasting practically, though Iyeyasu waited two years for formal investment, from 1600 to 1868. It is the connecting link between a rich past, whether Chinese or native, and the forceful, innovating Japan of to-day. Most writers have affected to see in it the culmination of Nippon's genius and art; but this springs chiefly from their relative familiarity with it. It is the same mere physical perspective which leads European Sinologues to place present Chinese thought in the foreground of her total picturing. The truth is that Tokugawa art in the main descends rather far into triviality and over decoration. It was this reason that induced Mr. Cram quite to omit Tokugawa architecture from his monograph. Though this long lake of peace is of deep moment for the sociologist, its strange artificial structures, built up as it were on piles from the muddy bottom of the past, savour less of culmination than of a strained balance between survival and re-adaptation. Their rapid collapse soon after the impact of Perry's foreign wave but confirms their innate weakness. So in Tokugawa art there is hardly more than one great name, Koyetsu, worthy of inscription with the great geniuses of the four preceding epochs.

Such art as exists, too, has less of a single national character, less of any solid style that betrays a widespread movement; and is cut up into a large variety of minor schools and experiments, often quite local in setting, and limited by feverish antagonisms. Some of them are indeed experiments; but some are hardly more than weak revivals of exhausted tradition. It is a period of dispersion and confusion, more than of concentration in art. We can follow the

fortunes of at least eight separate schools, parallel or overlapping in time, here ignorant of each other, there weakly compromising. But of these only four reach a breadth and height that warrant our special study in this and the following chapters.

In order to simplify this mass of material, we might first ask what is it, then, in the Tokugawa period, that makes it epochal? It is not the feudal system, for that has already characterized two epochs. It is not, as it should logically have been, contact with Europe ; because this was deliberately and violently removed from the field by the early Tokugawa policy of exclusion. It could not be any great spiritual awakening, or introduction of organizing principle, for Buddhism was exhausted and Christianity tabooed. It could not come from China, since the Manchus, who were about to overturn Ming, were regarded with suspicion inherited from Mongol days, and Chinese intercourse was included in the embargo. The Manchus, too, had nothing new to bring, even to China. No, we could hardly speak of the age as epochal, were it not for the rise of the common people, independently—the artizans, the merchants, and the farmers—to a high stage of civilization, and to the point of producing a peculiar art of their own.

It was like the rise of the industrial classes in the free cities of Europe, in those middle centuries when the old feudal system was breaking up. There, too, could be seen armoured lords of castles flourishing side by side with burghers and guilders. It is the same duality which forms the keynote of Tokugawa culture taken as a whole. And, just as the guilds of Germany and Italy underlay the possibility of modern national citizenship, so it was the growing self-consciousness of Japan's great city wards that paved the way for her constitutional life. Too often we have read that the whole brilliancy and value of Japan lay in her Samurai. Even to-day Japanese officials, who are the descendants of those samurai, only grudgingly recognize the great fermenting and self-educated growth of the masses before the restoration. The solid reefs which support present structures may be submerged, but the coral insects have done their mighty work.

The keynote of Tokugawa life and art is, then, their broad division into two main streams—the aristocratic and the plebeian. These two flowed on side by side with comparatively little intermingling. On the one side select communities of gentlemen and ladies congregated in gorgeous castles and *yashiki*, daimios and samurai, exercising, studying

their own and China's past, weaving martial codes of honour, surrounding themselves with wonderful utensils of lacquer, porcelain, embroidery and cunningly-worked bronze ; on the other side great cities like Osaka, Nagoya, Kioto and Yedo, swarming with manufacturers, artizans and merchants, sharing little of the castle privileges, but devising for themselves methods of self-expression in local government, schools, science, literature and art. The leading forms of plebeian art we shall treat in the two following chapters. This chapter we shall specially devote to the peculiar arts of the military classes.

The triumph of Iyeyasu had been only the capping of a long generation of successive wars, from Nobunaga's beginnings about 1550 to the coalition of Hideyoshi's Corean veterans in 1600. In defeating this coalition Iyeyasu not only supplanted the Taiko's son, Hideyori, but killed or removed most of his powerful rivals. He consolidated his dynasty, not only by dividing most of the land among his loyal relatives and retainers, but by devising a policy of requiring their residence in his new capital of Yedo for at least half of each year. The most conspicuous feature of Tokugawa aristocratic society spring from these regulations. Two hundred and fifty years of profound peace, with a great order of warriors favoured and consolidated, yet curbed through hostages—such is the balance of forces. A wonderful circulation between the country life of the castles and the metropolitan life of the *yashiki* carries a common civilization, as it were, from heart to periphery. A natural tendency to luxury is curbed by severe discipline and sumptuary laws. Iyeyasu, when he died in 1616, left a plan of policy which his successors mostly followed. Iyeyasu had built for himself at Yedo the great central castle on a series of hills, the site of which is covered to-day by the Mikado's palace. From it, like a camp surrounded by camps, the Tokugawa Shoguns could control the whole system.

The history of Japan would have been far different had Iyeyasu, like the Ashikaga, decided to place their capital at Kioto. The Eastern plain (Kwanto), the richest hive of life in the Empire, would have been stunted of its peculiar expression. The Imperial Court would have had to be too much deferred to. Iyeyasu could profit, too, by the mistakes of the Hojo at Kamakura. Yedo should become the real capital of the land, leaving Kioto shorn and powerless. And indeed Yedo became the Paris of the East before the end of the seventeenth

century, with the populous wards of Honjo and Futagawa far beyond the Sumida river.

The great work of realizing the schemes of Iyeyasu fell to the third Shogun, Iyemitsu, in 1620 ; quite as the detailed policy of Ashikaga had devolved upon Yoshimitsu. It was not till then that the prohibition of foreign intercourse was settled. Commerce with the Protestant English and Dutch had grown up in the reign of Iyeyasu, for it was the disintegrating power of Rome that the Japanese chiefly feared. Since 1618 the Tartar hordes of the Manchus were steadily pouring down upon the Mings at Peking. In 1637 came the great Christian revolt at Shimabara, which convinced the authorities that Europe, through religious intrigue, might yet subvert native loyalty. Thus in 1639 came the policy of exclusion, by which no native could expatriate himself, and no Japanese, then beyond the borders, might return to his native land. The Dutch were shut up in the island of Deshima, and allowed only one trading ship a year. The Chinese, too, could effect commerce only at the one port of Nagasaki. Thus Japan became an industrial and a spiritual island in the face of an advancing world. During the next hundred years, when the Jesuits were so triumphant in their policy with the Manchus, and Louis XIV. of France could exchange letters of amity with the great Kanghi, while Englishmen were colonizing the great continent of North America, and science was pressing forward unique enlighten-ment, Japan stood like a solid fortress frowning out of the past, defying the world, defying civilization, defying human brotherhood, preserving utterly artificial old-world forms and ideas. Was it a blessing or a misfortune ? I have already expressed my belief that it was the former, and providential. For how could the common people of Japan have come to study and understand the peculiar powers of their own minds and characters, how could the wonderful samurai stoicism and honour have penetrated to the national consciousness, if the problem of absorbing European ideas and customs had been prematurely forced ? This very long peace and isolation and self-study were necessary for Japan to rise into that state of self-consciousness and self-control which could stand the world shock without crumbling under it. Otherwise, the feudal system would have fallen in the seventeenth century, the Kano perpetuation and study of the Hangchow art would have ceased (as it *has* ceased since 1868), and all working knowledge

of Asia's past would have been destroyed for Europe as well as for Japan.

The one great attempt that Iyeyasu and his successors made to bring in a new spiritual force for the samurai world was the introduction of a liberal Confucianism—that is, of the moral maxims as taught in the forms descended from the Hangchow philosophers, and of the agnosticism of the Chinese learned world. This was to be the make-weight against the fanatic idealism of both Christianity and Buddhism. The enthusiasm of the daimios' Courts should be purely ethical. In 1633 the great Confucian University was built at Yedo, for the education of the samurai. But all this did not bring in the Confucian pedants, the "bunjinga," nor the stultifying monotony of actual education in China. Its Confucian tenets were made strangely to blend with such moral elements as had descended from Shinto, ancestor worship, the belief in the spirits of great national heroes, and with the samurai code of loyalty to the master. It was a strange and really inconsistent mixture of professed agnosticism with profound belief. As a moral syndicate it was effective.

It is time now to inquire what was the policy of this strange mixture toward the problems of art. We saw at the end of the last chapter that Yeitoku, and his second group of the Kano school, had developed a gorgeous and decorative mural art, which inwove Chinese imperial traditions with high colour and gold. During the days of Iyeyasu himself there was apparently no open decision to discontinue this style, though no special prescribing or expansion of it. Sanraku and the sons of Yeitoku continued to practise it; but now not so much in the line of large figures as in small compositions of richly-coloured flowers and fruits upon gold fans, or other panels sprinkled upon walls or upon screens. The Chinese figures in Tang palaces became much more minute, and spread in panoramic scenes, separated or connected by passages of landscape and cloud. In some designs, especially by Kano Mitsunobu, eldest son of Yeitoku, European ships and sailors were represented in gold and colours. Takanobu, Yeitoku's second son, has left a fine bird painting of storks in colours and gold upon a two-panel screen in Boston. Soha and Kiuhaku, uncles of these men, also lived down to this day of minute figures. The Kano artists often worked together, making a group of paintings, say, on sixty fans or square panels, without separate signature, all to

be eventually mounted on screens. Kano Sansetsu, the son of Sanraku, does beautiful gold and colour work. We must call this, down to Iyemitsu's time, a legitimate continuation of the Yeitoku school.

But already, and especially after Iyemitsu's accession, a change seemed spontaneously to take place in a partial return to more quiet monochrome painting. It is clear that the gorgeous vulgar style of Hideyoshi would not permanently suit an aristocracy whose ideal was to assume a kind of Spartan simplicity. After all, Nobunaga and Hideyoshi had not been Shoguns, and their art was no legitimate descendants of Ashikaga. When Iyeyasu succeeded to the title of Sei-tai-Shogun in 1602, after an abrogation since 1573, it might be claimed that his Court, being the legitimate successor of Ashikaga Yoshimasa's, should return to something like the dignity of fifteenth century style. But the actual tradition of Motonobu's earlier Kano work was already quite dead; new generations had not been trained in his masterly touch; where could artists look for models to study? The new daimiates had hardly yet taken inventory of what Chinese treasures had come down to them through the prolonged wars, and there was nothing like even Court museums. Moreover—and here was an important point—the Kano family was hereditarily settled in Kioto, and thus could hardly stand close to the Yedo Shoguns as Court painters, as Motonobu had done for Ashikaga. The ripe culture of old cities like Kioto and Osaka could not all at once be transplanted to the raw muddy fields of Yedo.

In this second transitional change, which we may suppose to extend roughly from 1620 to 1640, we have the remains of the Yeitoku period of the Kano school trying to work back in some experimental and original way to monochrome, and largely to landscape, and that, too, Chinese landscape. Sanruka and Sansetsu derived a rough monochrome style from their ancestor, Kimura Nagamitsu. Sansetsu had begun painting figure screens in pure ink, with long decorative lines. Mitsunobu, the head of the house (fifth generation), tried a new, very blotchy and awkward penmanship. His Kano contemporaries reviled him as unskilful. His son, Sadanobu, however, began to manifest considerable genius, working with anuglar ink touches of a new sort; but he dies in extreme youth. It was another pupil of Mitsunobu's, a man named Koi (allowed to take the Kano name), who really succeeded in striking out something new. This consisted in blurring out

DETAIL OF FLOWER SCREEN. By Korin.

DETAIL OF FLOWER
SCREEN.
By Korin.

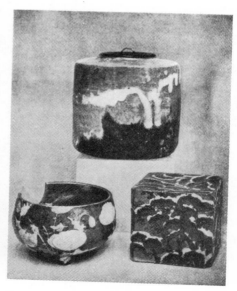

THREE PIECES OF POTTERY.
By Kenzan.

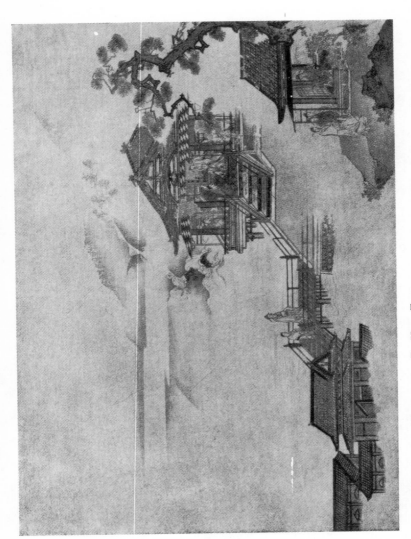

CHINESE PALACE AND TERRACES. By Kano Tanyu.

the washes of ink in places, and leaving sharp accents of line in others. It may be called a sort of mixture of Sesshu's rough and careful styles. It was quite free and picturesque, as if the world—a Chinese world—were really crumbling away. Koi has the merit of really going behind Motonobu for his own models—as far at least as Sesshu, yet without copying slavishly. After Mitsunobu's death, Kano Takanobu, the second son, came into close friendship with Koi, and worked almost wholly in his jerky, free manner. His older style, in ink, had been willowy and wavy, like grasses. Now when Takanobu died, also at an early age, he openly left by will the care and education of his three young boys to Koi. Two of these boys, Tanyu and Naonobu, were incipient geniuses ; the third, Yasunobu, had skill enough to follow them in their exercises.

Kano Tanyu, the great genius of the sixth generation of the Kano family, leaped into rapid prominence soon after 1630 by absorbing, consolidating and extending the new method of work outlined by his teacher, Koi. He made Koi's blurry passages more blurry, and at the same time less muddy. The roughest strokes which Sesshu had made upon paper with a split, hairy-edged *haké*, now became a deliberate system of beautiful clouding by washes upon silk, so clear, luminous and irregular in shape that they seemed like waving clouds. Through these soft portions shot a few large splintery passages of dark ink, not blue and blurry like Sesshu's accents, but sharp, liquid and glossy, yet so irregular and incalculable in shape, and so softened on one side by a random touch while wet, that, though carrying the suggestion of power, they dissolved into the harmonies of the cloud. Leaves, and other shapeless touches of pure accent, are like exploding bombs of ink. It was a personal style, a new technique, a manner far less careful than his great-grandfather, Motonobu's—striking and impressionistic, yet relatively superficial. In *notan* it resembled, somewhat, Kakei's roughest work ; but it was really a rough generalization of all the great early Ashikaga and Hangchow styles.

It was this personal genius of Kano Tanyu, virtually inaugurating a third vital sub-movement in Kano work, which practically settled the question of aristocratic art for the *yashiki*. Here was a man, fecund as Sesshu and Motonobu, whose impressionism recalled, without scholarship or deep belief, the refinement of the Ashikaga's, an antidote

for Yeitoku's vulgarity, a sort of marvellous idealism whose merit lay chiefly in its æsthetic charm. Tanyu has the merit, too, of going behind Sesshu, to the Chinese themselves. He began to explore the treasures of *yashiki* ; and he and his brother, after the fire in Kioto which destroyed all earlier copies, set to work to make transcripts of old masterpieces, Chinese and Japanese. It was thus a great eclectic school, a minor renaissance, translating, however, everything into the new language ; much like a library of poetic masterpieces done into English. Tanyu, too, was willing to transfer his whole atelier from the ancient seats of the Kano family in Kioto to the new capital at Yedo ; and thus to become "Court painter" of a vigorous epoch in even a closer sense than Motonobu had been to the late Ashikaga's. For, inasmuch as the Tokugawa administration involved a far wider and organic hold upon the whole list of daimios and the samurai class, the institution of Court painter would at once spread its fashion to all the minor Courts. Thus the new *entourage* of the Kano establishment at Yedo soon grew into great palaces, with hundreds of pupils and servants, an academy where young boys were to be trained from an early age, a great corps of masters ready to decorate a new palace at a moment's notice, a nest from which a whole bevy of painters for the local daimios should escape. Here criticism, already begun, could become absolute, for the Shogun requisitioned the loan of all pictorial treasures from the daimio, making an inventory of the remaining national treasures, and employing the Kanos to make careful copies of the more important. It was this enormous collection of copies, particularly those by Yasunobu, which I studied under my master, Kano Yeitoku 3rd, between 1878 and 1890. In this way critical continuity was preserved with Hangchow and its traditions ; and the chief works of the Kanos represented the same great scenes, greatly generalized, which had become familiar in Ashikaga art. Here Sesshu's sketches made in China did duty for models a third time. The whole samurai world liked those pretty Chinese poets and sages in Tanyu's transcripts, those glimpses of Seiko lake and other famous scenes, much as we like in modern poetry half-understood references to "Helian," "Pierian Springs," "Mount Ida," and "The Vale of Tempe."

Tanyu's long and triumphant life, lasting into the seventies, established for the whole subsequent Kano age not only fixed institutions

for a Kano Court paintership and a Kano academy, but almost tyrannical methods of technique. Tanyu's brother, Naonobu, was hardly his inferior, of a style just a little closer to Koi's. Tanyu used to say that Naonobu "played Bayen to his Kakei." Tanyu, though the elder, refused to inherit from his father, Takanobu, proudly declaring that he would found a new family. The third brother, Yasunobu, though less skilful, followed the Tanyu manner in the main, and was adopted to succeed Sadanobu, the lamented son of his uncle, Mitsunobu. Thus in the first great flourishing age of Tokugawa Court art, say about 1660, the situation stood thus :—

Mitsunobu.	Yeitoku.	Genshichiro.
Sadanobu.	Takanobu.	Tanyu.
Yasunobu (Yasunobu 3rd).	Naonobu 2nd.	
	Tsunenobu.	

The Kano family has thus split into three main branches (there were other minor ones descended from Masanobu), of which Yasunobu, who now took the name Yeishin, was the theoretical head, since he was, though by adoption, the successor of the great Motonobu (Yeisen). But by genius Tanyu was the real head to his death in 1675. By this time Naonobu too was dead ; but his son Tsunenobu, though far younger than the remaining uncle Yasunobu, was such a powerful genius, a second Tanyu in fact, that for the Shoguns' purposes he succeeded to the actual headship of the academy. Tanyu's sons, though employed, were weaker even than Yasunobu. Tsunenobu had been trained lovingly by his uncle Tanyu, and drank in his style with such assimilation that it is to-day at times hardly possible to distinguish an unsigned Tanyu from a Tsunenobu. Thus Tsunenobu was able to hold the brilliant Tanyu style back from degeneration far down into the eighteenth century. With him, as really fine creators in the Tanyu manner, were Tanyu's pupils To-un,* Morikage and Tanzan (Yoshinobu), and Yasunobu's pupil, Icho. The recorded professional artists whose names are on the registers of 1700, and whose style was a pure continuation of Tanyu's, number more than 200. Thus Tanyu, in absorbing all function and style into himself, imposed absolute

* Ed. Note.—To-un was an adopted son of Tanyu.

domination upon several generations of Tokugawa art. From Koi, and 1630, to Chikanobu, the inheriting son of Tsunenobu, in 1740, the whole great movement is complete in its rise and fall.

But Tanyu, like Motonobu, was not a man of one manner. Besides his regular monochromatic style, he worked in mural decoration of gold and light colour, not at all heavy like Yeitoku's, but rather derived from the pleasant light colouring upon figures of the Yuen artists or even of the early Ming. Many of the Tokugawa palaces became very gorgeous, in spite of sumptuary laws, and the mortuary chapels of the Shoguns, as at Nikko and Shiba, are overloaded with ornament mostly designed by men who had studied in Tanyu tradition. Some of Tanyu's own work is on the walls of Nikko, and the design for the great carved wooden hawks is by him.

Another of Tanyu's styles is derived from his Tosa descent, on his great-great-grandmother's side. He afterwards used Japanese subjects, both figures and landscapes, and painted Tosa makimono ; but even in these the crisp crumbling touch betrays itself, so that a Tanyu Tosa is a thing apart from all Tosa. He introduced his Chinese manner of writing even into his Japanese scenes, making the lines more curved, and the soft tinting of colours more melting. In this connection we must also speak of Tanyu's work in planning gardens. That of the late Count Katsu, at Kinegawa, near Tokio, has still growing in it ancient plum trees, nearly two hundred years old, that still shoot out single branches, and grow sparse gems of buds, exactly as Tanyu painted them on his finest silk kakemono. It should also be noted that the whole round of the decorative design of the day is based solely upon the work of Tanyu and his pupils. All the designs for wood carving, gold lacquer, engraving on brass or silver, casting and inlaying of iron or bronze implements, embroidery of garments and weaving of tapestry, decoration in black or colour upon pottery, the ornamentation for the newly-imported porcelains—all of these are purely Tanyu-ish in design, and can be recognized instantly. This fact only exemplifies the significance of my change from the usual method of classifying these industrial arts—so dear to the connoisseur collectors of to-day—into separate chapters and traditions. Regarded as art, as typical designs, they are as much an offshoot of Tanyu as the very painting of Tsunenobu. Not to go into detail here, we may say that the porcelain of Ninsei, the chasing of Somin, the lacquer of Yamamoto

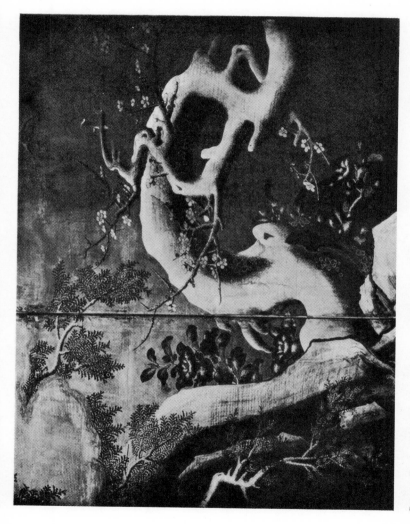

GREAT PLUM BRANCH IN SNOW. By Kano Yeitoku.

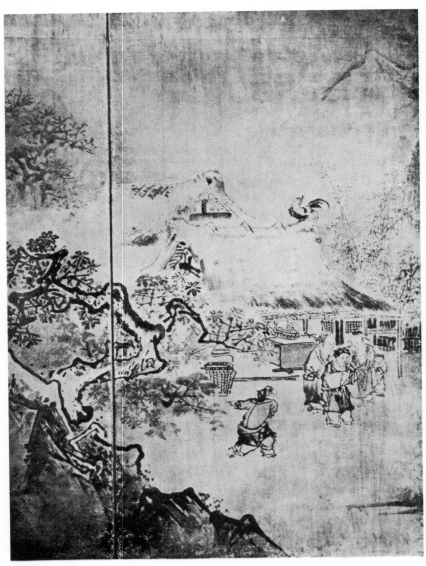

FARM HOUSE AND PEASANTS. By Kano Koi.

Shunsho, the ceramic decorations of Kaga and Satsuma, were all the work of Tanyu pupils.

Another special work of Tanyu was his elaborate study from nature. In this he differed from the Ashikaga men, and was more like an early Sung artist. He has left us thousands of wonderful studies of fish, birds, reptiles, insects, flowers, and tree branches, that for pure beauty and truth far surpass the more often lauded ones of Hokusai. Still another great work of Tanyu was his miniature translations of old masterpieces, Chinese and Japanese. Thousands of these remain, giving in minute free line his impressions (translated into Tanyu language) of a Sesshu or a Kakei. Some such impressions by Tanyu himself were later printed, and the whole range of illustrated books by his pupil, Morikuni, is only an extension of this line of work. So Tanyu stamped himself not only on all the art, but on all the arts of Japan.

Of actual examples of Tanyu we can afford room in this chapter to refer only to a few typical ones. They are scattered throughout all the collections of the world. In the Fenollosa collection at Boston alone there are more than twenty paintings, including several screens. The finest of these is the poet leaning against a great zig-zag pine tree and gazing at a waterfall. A fine example of Tanyu's early style is the Buddha seated amid clouds, also at Boston ; also the beautiful Mokkei-ish spray of sparrow and bamboo in Mr. Freer's collection. Of his middle style in landscape, Mr. Freer's square landscape with summerhouse, pine and waterfall, is typical. Of his later work, the rough snow ink landscape scene at Boston is fine, and the great snow scenes of Fujiyama and vicinity belonging to Mr. Freer. Here, too, are examples of his Japanese landscapes, and the most exquisite of his nature studies of flowers and birds, notably the branch of biwa fruit, and the great soft white spoonbill fishing. Many rolls of studies from pupils' copying have come down to us.

Naonobu's mural work is seen to great advantage on the walls of the reception rooms of Chionin temple at Kioto. A fine pair of rough figure screens bought by me at the sale of the treasures of the daimio Satake is in Boston. A very early farming scene in Koi's manner, also from a Boston screen, is here given, and a fine late blackbird on a plum branch from a Boston kakemono. Tsunenobu is sufficiently illustrated by a downward flight of geese on silk ; Morikage by two wild geese under grasses.

It was during the great period Genroku, at the end of the seventeenth century, that the first great conscious split between the aristocrats and the plebeians took place. By the middle of the eighteenth century the gap had become complete, the samurai being by law cut off from all the live gaiety of the popular theatres and tea houses. Thrown back upon their ancient stock of resources, their culture perhaps consolidated, but taking on a hardened form in the derogatory sense. It was the same with Tanyu art. Cut away from what might have been a valuable inoculation from Ukiyoye, it fell, in the hands of Tsunenobu's two sons, Chikanobu and Minenobu, Yasunobu's son Tokinobu, and Tanyu's sons, Tanshin and Tansetsu, into mère commonplace repetition, without a spark of genius. In fact this phase of it is to be regretted. It is not necessary to follow it minutely into its decay, only to notice that Minenobu founds a fourth principal branch of the Kano family. It is this tiresome weakness of Tanyuized art about the year 1750 that led to Motoori's famous diatribe against contemporary art, which Professor Chamberlain has mistakenly quoted as if Motoori were looking with our European eyes and denouncing Japanese art as a whole. He was only deploring, as every thoughtful man was deploring, that the art of the samurai had at last fallen into manufactured mediocrity ; and he was sighing for some new inspiration, a boon partly to be granted in the work soon to follow of the youthful Okio, the founder of the Shijo school. Surely Japanese art of 1750 reaches the lowest ebb it fell to, unless it be in the worst Tempei days of Kōnin Tenno.

A last revival of Kano art (fourth period) is brought about in the last half of the eighteenth century by Kano Yeisen, the grandson of Chikanobu, and his father, Furonobu, who died young. It is worth speaking of because it is a real link in the descent to us of a knowledge of Chinese art. It was part of a general Japanese revival, a sort of tonic, that went through all phases of late eighteenth century and early nineteenth century life. It was due to unconquered vitality, but without competent direction ; skill without ideals. We see it in the culmination of Okio in Kioto, of Kiyonaga in Yedo, both of 1780, and both of the popular schools. We see it in the great effort of the Shoguns to reform interior abuses, and make themselves worthy to resist the powerful disintegration of a rising democracy. Strict sumptuary laws were passed for the samurai in the early nineteenth century ;

passionate love of military exercise and of Chinese scholarship were inculcated ; every ancient Japanese ideal was stimulated by a careful censorship and encouragement of the No plays (descended from Ashikaga). It was as if the whole Shogunate gave itself a moral bracing for the world shock, within and without, which must come. In Kano court art this showed itself in the most earnest scholars by more of eclectic study than had occurred since Yoshimasa's day. Yeisen himself hardly went further back than Motonobu for inspiration ; Yosen touched Sesshu, but Yosen's son, Kano Isen, and his great contemporary, about 1820 and 1830, Kano Tanshin second (the seventh generation from Tanyu), inaugurated a careful collection, studying, re-copying, re-classifying and re-criticizing of all the original Chinese paintings owned in Japan (or at least as many as the Shogun could borrow), which made them far more conversant with the whole subject than any Japanese since Kano Masanobu, three centuries before. Motonobu first, and then Tanyu, had stood as opaque screens to shut out a real knowledge of ancient art from all Japan. It was Isen who finally broke through the screen, and made Kakei, Bayen, Mokkei and Ririomin almost as vivid realities to the anxious Tokugawa students of 1840 as they had been to Sesshu and Soami. Every daimio was then keyed up to prize his ancestral collection as the very backbone of a healthy refined society. Many of the finest copies remaining of existing or lost Chinese originals are the work of Tanshin Isen, his son, Seisen, and his grandson, Shosen, down to the forced resignation of the latter in 1868. The copies of the great Ririomin Rakan in the Fenollosa collection at Boston, for instance, were bought by me directly from Kano Tanshin, the grandson of Tanshin,* who, with his pupils, had copied them about 1840. We may say in general that Isen's and Yasunobu's earlier copies are the chief source, outside of existing originals, of our knowledge of Chinese art in Japan. Moreover, although the original art of these men was imitative, it got a certain dignity out of incorporating famous copied passages from the much-studied masterpieces. Thus in a Seisen painting we might find confiscations of bits from Kakei, Bayen, Sesshu, and Motonobu, making a very "classical" composition. Whatever the demerits of such a fourth form of Kano original art, it is clear that in their school of criticism they did an immense amount to ascertain and preserve the truth. With superior knowledge they even

* The grandson here of Kano Tanshin Morimichi must not be confounded with his ancestor Kano Tanshin Morimasa.—PROFESSOR PETRUCCI.

dared to reverse some of the judgments of Tanyu himself. No Chinese artists and critics, since the very beginning of Ming, at least, *i.e.*, for 500 years, have had anything like the insight into their own ancestors' great art, as did Kano Isen and his school. Isen's brother, indeed, specially imbued with this scholarship, is the author of the great Kokwa Biko, MSS. notes on Japanese art and artists, which has only recently been printed. The certificates of Isen are the basis of Chinese criticism.

It is worth while to note, for this book, how its work, my own work, is related to those fortunately belated and scholarly eclectic sources. Isen's second son, Tosen, became adopted as successor to the Minenobu line, and his son, the living Tomonobu,* has been one of my chief teachers. Isen's third son, Kano Yeitoku Tatsunobu, was adopted as patriarch of the Motonobu-Yasunobu main Kano line—main, that is, rather in name, than in power. The real Shogunal headship remained to the end with the Naonobu-Tsunenobu branch. Now this third Yeitoku, brought up in the very centre of the eclectic movement of 1840, was my personal teacher in criticism of ancient Chinese and Japanese art from 1878 to 1890. From him I have received by letters patent the name of Kano Yeitan Masanobu, as Koi received the Kano name from Takanobu. I consider it one of the greatest fortunes of my life to have reached Japan while the direct tradition of this renaissance Tokugawa scholarship was in full memory. It is largely through it that I dare to write this book. Let me add that Kano Tomonobu to-day is the only blood descendant of this already forgotten school who is alive, and practising his family art as he learned it in the Shogun's great academy before 1868. He stands absolutely alone. All the others are dead.†

I am glad thus to trace the real descent of the line of Tang and Sung Chinese tradition to its close in Japan. I deny that modern Chinese art since middle Ming has anything to do with this line of descent. I assert that it died out of the world in the sixteenth century, with the one exception of the island of Japan, where it maintained a carefully separated and guarded life for three centuries, due to the fortunate isolation of Tokugawa institutions. I trust that later research in both

* ED. NOTE.—It is this same Kano Tomonobu, now a very old man, who, with Dr. Nagao Ariga, gave priceless and untiring assistance upon the manuscript of this book, in Tokio, during the spring of 1910.—M. F.

† ED. NOTE.—Since the writing of this book, 1906, so much has come out of China, that there is no doubt this assertion would be greatly modified, if not utterly changed.— M. F.

China and Japan may eventually produce a still greater restoration ; but even if so, it will be cold knowledge, cut off from the present heat. The line from Godoshi to Kano Tomonobu breaks for ever at the death of the latter.

Let me now speak briefly of other minor phases of Tokugawa aristocratic art that flowed on parallel with the main line of the Kano. One is a revived school of Buddhist hierarchical painting of altar-pieces in gold and colours ; a real revival of Yeishin Sozu and the old Kose, which did good work about the year 1700. The finest specimens are in such temples as the third Shogun's temple at Nikko, the Kuhon-ji Jodo temple of North-East Kioto, and the temple of Kofuku-ji on the west slope to the north-west of Nara. Some of the work in the latter is as late as the nineteenth century.

A much more important movement was an attempted revival of the Tosa family and national art in the seventeenth century, a revival which lasted on side by side with the Kano down to 1868. The very reaction of the Tokugawa age against the mediævalism and excessive classicism of Ashikaga ought to have been a violent return to Japanese tradition and subject. And so it would have been but for the novel need of the yashikis and the genius of Tanyu. Even so, it was strong enough to lead to as real an eclectic re-study of the Kose, Kasuga, Tosa secular painting, as the Kano's re-study of Hangchow and Ashikaga. Two phases of this revived Japanese move-ment arose in the middle and latter half of the seventeenth century. One was the work of Tosa Mitsuoki, an alleged descendant in the fifth or sixth degree from Tosa Mitsunobu. I have already given my reasons for considering such a real connection unfounded. Mitsuoki, however, became a favourite artist with the Imperial Court at Kioto. We may say that he represents specially the Mikado's Court, as his contemporary, Kano Tanyu, does the Shogun's. Mitsuoki's work is delicate, and his colouring rich, but without any close relation to ancient Tosa. It is just pretty drawing of Japanese subject with a considerable Kano sub-flavour in it. It is Tosa permeated with Tanyu, as Mr. Freer's beautiful Benten shows. He and his descendants continued to live in Kioto.

The other movement was started by a Tosa style of painter about 1650, named Sumiyoshi Jokei. He was much more of an eclectic Tosa scholar than Mitsuoki. He deliberately studied and copied all

the makimono of Keion, Toba, Mitsunaga and Nobuzane he could get his hands on. His son Gukei developed a microscopically minute style, something like Kasuga Takachika's manner. From here the Sumiyoshis moved to Yedo, and became to the Shoguns, on a minor scale, critics and painters where Tosa tradition was needed, quite as the Kano were critics and painters for Chinese tradition. In this way the later Sumiyoshis came to be almost as good scholars in their narrower line, as the Kanos in theirs. Sumiyoshi Hirosada was the contemporary of Kano Isen. He travelled among temples all over Japan to study examples, and copy, of the ancestral Tosa work. It was his grandson Hirokata who was my personal teacher, also the teacher of Yamana, the last great Tosa critic. Both are now dead.

In so far as we have considered Tokugawa aristocratic art, it has been, even the Kano, only survival with modification. No doubt the personal genius of Tanyu makes him a great figure, and the whole daimio world was stamped with his design. And yet one other movement, and quite separate, took place in early Tokugawa art, which though in a minor sense was also a survival, is so modified, so original, so splendid, that it overshadows Tanyu and the whole Kano school, and becomes one of the three new keynotes of the fifth Japanese period. I refer to the school commonly spoken of as the " Korin," but which should be headed more properly with the name of Korin's teacher, Koyetsu.

The national significance of this school as a whole has only been recently understood, since indeed Mr. Freer, of Detroit, has brought together so many of its striking pieces, and especially of the work of Koyetsu. Masterpieces of this school have always been highly prized by Japanese collectors, especially men of the Kugè class ; but they had become so scattered by the nineteenth century, and almost forgotten, that little was seen or said of them when I first visited Japan in 1878. Korin's lacquer was of course well known in Europe, and Koyetsu's known by name ; also Kenzan's pottery was celebrated ; but that the work of all these men—connected with a fourth, almost unknown name, Sotatsu—had founded a great centralized school of design based upon mural painting, and that their industrial design is only an offshoot from this, was not at all suspected. In truth the school had suffered from possessing no historian who had preserved biographical and other facts striking to the popular

DESIGN ON A FAN. By Koyetsu.

IVY SCREEN—TWO PANELS. Koyetsu.
Mr. Charles L. Freer.

imagination. Little tradition of technique or account of studio experiences remained. In short, a large part of what is vital in its history has got to be made up out of the only original documents, their works, themselves. When I wrote my review of Gonse's "L'Art Japonais" in 1884, I, too, was ignorant that Koyetsu had been a great painter, because I had never seen an undoubted example of him. His paintings were neither in temple nor daimio collections. And we have since found that many of them were passing under the better known names of Korin and Kenzan. To rehabilitate the fame of Koyetsu, as the founder of the school, and by far the greatest artist of Tokugawa days—in fact one of the greatest artists of any race—is one of my satisfactions in writing this book.

The Koyetsu-Korin school of design—painting and industries—is, first of all, a prime sign of that natural return to Japanese subject, after the Ashikaga debauch of idealism, which otherwise Tanyu so nearly frustrated by his Chinese renaissance. Only grudgingly did the Kanos yield to a growing demand for Japanese landscape; only weakly, and in a cold scholastic imitation, did the Tosa and Sumiyoshi pupils revive the makimono forms of Kamakura art. Taking all their productions in a single mass, we could hardly regard it as any vital return to nationality in the art of the *yashiki*. But the Koyetsu-Korin school was specifically grounded in a study of Japanese forms, first of all in a profound re-study of all the great work of the ancient Tosa and Fujiwara schools, and then in a restatement of this through personal genius, a clear re-adaptation to new conditions. It got far closer to the heart of the creators of 1200 than the pseudo-Tosas could do, because its purpose was not scholastic but creative. We may say in general that what it does is to translate motives and even much of the technique of ancient Tosa art—the miniature art of the makimono— into the great new scale demanded for palace mural decoration. The great broad landscapes, in gold and colours, of Koyetsu are only supremely great "enlargements" of microscopic gardens seen in the old Tosa panoramas. But this change of scale of course implies enormous changes of execution, of massing, of colouring, of outline. It may be called the true Japanese school of "impressionism;" for what Besnard's glowing walls are to modern French art, Koyetsu's and Korin's are to Japanese. It is neither realism nor idealism, as we ordinarily misuse these words; it attempts to give an overmastering impression, a feeling vague and

peculiarly Japanese, as if the whole past of the race with all its passions and loves surged back in a gigantic race memory inwrought in the inheriting nerves—a patriotism as gorgeous and free and colossal as one's grandest dreams. In this line played a part, but line as far removed from Chinese or Kano line as can well be conceived—always a wavy curve, often soft, even lighter in tone than the mass it bounded, line often executed in colour rather than in ink. Then came colour, as the great body of the impression ; rocky trees, clouds, figures, masses of blooming shrubs, all became magnificently placed spots of scarlet, purple, orange, olive, yellow—and a thousand unnameable modifications of those—as if they were the panes of a stained-glass window. It was this supreme decorative use of the Tosa line and colour that shocked scientific Englishmen like Dr. William Anderson. He denounced Korin's style as a most vicious mannerism, the farthest removed from nature, as if it were a kind of childish toy. But as a purely artistic school of impressionism adapted to great mural decoration, future critics will doubtless place it ahead of anything that the world has ever produced. Greek, Florentine and even Venetian wall painting, however gorgeous, is just a bit too tangible, just a bit too much like coloured sculpture. Magnificent orchestrations of line and colour, which only suck up as much of natural suggestion as they care to hold, here show for the first time what art of the future must become. Even Besnard is too conscious of being a kind of *negative pole to nature, a kind of bravura defiance of realism. Koyetsu is both as naïve, as positive, as sumptuous, as Shakespeare. Perhaps Whistler, if he could have had opportunity to develop along the mural line, would also have worked in that sphere. As for Hangchow, it lacks the full orchestration of colour ; it is great church music. The school of Yeitoku comes nearest to Koyetsu in purely decorative value, but in subject it is far more insincere and alien. Yes, we may call this Korin school *the* Japanese school of impression.

But now, on the other hand, we have to note that it becomes Japanese in the special sense of making a more profound and true study of Japanese objects, particularly vegetable forms and flowers, than any other school, a truer study of such subjects than any school of any race. Here we may seem involved in a contradiction ; but we gladly court it. Do we say that this school is at once the most impressionistic and the most true ? Yes ; and this only brings into

relief the false antinomies of our popular phrase. The strongest impression is got from truth ; but this does not mean that a mass of unrelated photographic truths give the strongest impression. *They* kill each other; they produce no unified truth. Art is first of all unity of impression ; but into this unity can be thrown and melted every serviceable form that generous nature can supply. This infinite beauty and "chemical affinity" (so to speak) of lines and colours in nature only a supreme genius—a soul already soaked with line and colour—can see. When such an one, like Koyetsu, *does* see them, we get at once a depth of impression and a revelation of truth that transfigure the world. It is in this sense that we can call the chief masters of this Korin school the greatest painters of tree and flower forms that the world has ever seen. With them, these by us somewhat despised subjects rise to the dignity and divinity with which Greek art revealed the human figure.

The rivalry between this more sensuous school and the contemporary severity of Tanyu's art concerns a certain contradiction within the make-up of the *yashiki* life itself. On the one hand, a million of aristocrats, with all the money of the land and all the time of their lives at their disposal, would naturally weave about themselves an environment of gorgeous luxury. But, on the other, Iyeyasu's policy of training the whole bukè * world to a Spartan hardihood, simplicity and soldierly honour—a cross between Chinese and Shinto ethics— required that luxury should be sternly suppressed. It was between these two poles of tendency that Tokugawa life oscillated. In the seventeenth century perhaps the sharpness of the contradiction was not realized. Tanyu and Koyetsu were rival contemporaries. There were sudden reactions against luxury and colour and art in the early eighteenth century, and again in the early nineteenth. The ministrations of the Korin school, in so far as it affected the daimio, always belonged to the more generous living. Korin himself belongs to the rococo age of Genroku (1688—1704).

But another antagonism brought out by these two leading schools concerns the duality of the two Courts, Shogun's and Mikado's. It is true that the Kanos, even Sansetsu, painted in the imperial palace ; and it is true that the daimios loved Korin's lacquers and Kenzan's

* " Bukè "—" bu "—house—and " kè " clan. Used as a feudal term in opposition to " kugè "—the Kioto Court daimios.

tea-bowls. Yet, roughly, it can be said that the Koyetsu-Korin movement specifically reflects the thought of the imperial nobles, the Kano movement that of the feudal. It is true the poor kugè had little wealth to expend in splendour ; on the other hand they had no moral prejudice against it. A Fujiwara descendant assumed a life of gold and colour as a natural environment. He was immersed in Japanese literature, not in some Chinese philosophy. In short he was a cavalier, and no roundhead like the conservative wing of the samurai. Thus we can see the Korin school to favour Japanese subject, imperial prestige, daimio luxury, a return to nature, and a genius for bold impressionism. All this is one side of the Tokugawa soul.

The founder of the great aristocratic school is Honnami Koyetsu, of whose life we know little from documents, beyond that he was a master of lacquer painting. What I say here is inferred almost solely from his works. It is from these that I now trace his derivation from preceding forms, and his growth into self-consciousness, for the first time.

That his mural quality, his use of rich deep colour, and of clouding in gold and silver leaf, grow naturally out of the second stage of Kano Yeitoku's school is made perfectly clear by several of the specimens in Mr. Freer's collection. First among these we have the magnificent ivy screen, in which dull red and olive and silvery vine leaves (of the ampelopsis) fall down over a ground of silver leaf. Here there is almost nothing of Tosa suggestion, only the taking of the sort of colouring used by Yeitoku in his gorgeous flower screens, omitting the use of line in the drawing, and making the play of ground colour and over glazing more free and decorative. Nothing more splendid than the grace of these falling leaves was ever achieved by Hangchow Chinese. We should compare this with the Yeitoku Fuji vine and grape vine screens. Most of his work in the semi-Kano line is found upon fan screens, that is, the same sort of gold leaf or colour fan, sprinkled about on a ground often itself gold, and painted in flowers and landscapes, mostly in rich colours, by all the Kano pupils of Yeitoku, between 1600 and 1620, perhaps to 1630. Such screens, to meet just the same early Tokugawa taste, were devised by Koyetsu, and sometimes combine in the thirty or more fan paintings of a single screen, colour designs of Kano quality and of Tosa quality, and even ink designs of Kano quality. Such fans are wonderfully grouped, at

DETAIL OF SCREEN WITH WIND-TOSSED INDIAN MAIZE ON GOLD. By Koyetsu.
Collection of Mr. Charles L. Freer.

MAGNOLIA SCREEN. By Koyetsu.

infinitely varying angles, over a ground of gold or silver, sometimes cut itself into a broadly-painted design with water, boats and bridges. Such a coloured Kano design, really much in the earlier style of Kano Takanobu, and even with outline, is the white lilies with olive-coloured leaves. Quite Yeitoku-ish, too, are spotted leaves of maple in gold raised to relief, or in clouded masses of red ; like the Yeitoku gold and coloured maples in Boston. Somewhat more Tosa-ish is the fan design of a great purple iris, where, however, a little Kano-ish outline remains. It is the freedom of the petal drawing here, and the solid impasto colouring that Korin copies later ; Korin's irises look as if they might be Tosa, but this is really not Tosa : rather a realistic study of the flower and the leaf in something like Kano pigment. Really Tosa-ish is the fan with raised white chrysanthemums, below which flows dark Tosa water breaking into bubbles. Another fine pair of Mr. Freer's screens which shows a mixture of Kano and nature study, combined with a feeling like lacquer decoration, is the symphony in gold, of delicate grasses and strong chrysanthemums, all in relief and in gold paint, over a ground of soft gold leaf. Among these flowers are sprinkled square " shiki-shi," or forms upon which Japanese poems are to be written. The grounds of these are tinted, and then over-painted in broad flower designs of thin tone in gold and silver. Over these delicate paintings, which are hardly more than cloud-films, Koyetsu has written out Japanese poems in his own magnificent and inimitable handwriting. In the chrysanthemum panel which we reproduce, the stiff relieved flowers and the hagi bush are again like the work of Kano Takanobu, Tanyu's father, below the *shiki-shi* a softer blurry *hagi* design is studied from nature on paper that soaks up the diluted gold pigment. The glossy purple-black of the poem's words blends incredibly with those leaves. Such a unique feeling for spacing, placing and spotting has never elsewhere been exhibited in the world's art. Koyetsu's is as new a species in spacing as Shakespeare's is a new species in drama.

But it is evident that Koyetsu was not satisfied· with this derivation of his art from Kano pigment and natural motive combined. He wanted a characteristically Japanese feeling to enter into his style ; and for this purpose deliberately went back, before Mitsuoki, to study the greatest masterpieces of figure and tree painting among the old Tosas. In the midst of much degenerate Tosa work, which would be more

plentifully offered for his inspiration, he evidently chose only the greatest creators—namely, Mitsunaga, Keion, Nobuzane and Tsunetaka. In the small Tosa-ish figure drawings he probably copied outright some passage of the old original ; but in most cases he made a new composition, in the style of the older men. This new drawing and colouring are so vigorous, so full of genius, that they do not fall below the originals themselves. Here Koyetsu appears as a fifth sporadic Tosa, creating in the grandest manner four hundred years after the originators. What Sesshu is to Kakei, so is Koyetsu to Keion. Here, as in the flower fans, appear early forms of nearly all the kinds of composition treated later by Korin. The thunder god descends in a cloud, as in Nobuzane's Kiteno panorama ; Emperors ride among cherry trees in bull carts ; crowds of men and women listen to a Buddhist service on temple steps, as in Nobuzane ; warriors prance upon turning horses as in Keion. The attitude of the armoured chief on a white horse who stops and turns backward in his saddle, is something that only Nobuzane or Keion (besides himself) could do. Here the horse's head has been so violently jerked as to disappear behind the warrior. The spotting of the colour and the clouding of the gold are most broad and picturesque. The greatest piece in this line is the capture of an aide who seems trying to swallow his despatches. Five rough soldiers of the enemy cling to the plunging horse. The violence and vigour are so like Keion that we are inclined to believe this to be a copy of some lost original ; a Fujiwara noble on a verandah is like Mitsunaga. The young man poling a boat through rapids we can recognize for a Tsunetaka. Here the big waves at the bottom of the whole screen come against the small ones of the fan.

But if these are the three derivations of Koyetsu, what unites and expands them is the splendid taste of his own decorative invention. Kano colour, Tosa line and feeling, and nature impressions, these shall be unified and enlarged to mural scale.

Probably this sort of experimental work of Koyetsu, and his following of the Kano taste for fan screens, was completed before the date 1640. His culmination then would be simultaneous with Tanyu's. Among the greatest and most original of his finished works are the two great " Corn " screens in Mr. Freer's collection, which are perhaps fragments of large mural compositions. Indian corn, a food plant of American origin, had been introduced into Japan by the Spaniards in the

preceding century. But what artists of any race have ever divined its extraordinary suggestion of line and motion in wind, as this alien Asiatic ? The more defaced screen shows over a ground of tarnished silver a great mass of cornstalks and sweeping leaves which the wind has beaten over into great curves. Up through the pale olive stems clamber the blue and pink faces of morning glories. Shooting like a rocket into the corn tangle on the right is a great monster scarlet cox-comb, with leaves mottled into claret and amber. The incredible suggestion of the colour we cannot hope to convey ; but the unheard-of spacing and line rhythm of the corn massing can only be compared with the greatest Greek work, or with the lines of Sesshu's wild stork and tangled Jurojin. Here are mere vegetable forms elevated to Parthenon dignity. It is an ultra symphony of corn, every quality being based upon actual suggestion, yet combined into pure line splendour.

The swathing leaves of the left panel are as perfectly decorative in their use as a Greek acanthus, yet as free as nature. The veining of their darker olive sides are in fine gold lines. But the tangle of the panel on the right is like bursting bombs. Here four silvery cornstalk tips, beaten almost flat by the wind, cross together at zig-zag angle, the fiery uplift of the coxcomb. A few small morning glory fireballs dare to touch off the explosion. In the largest reproduction of this bomb corner we can see that the crown of one of the coxcombs has itself almost been split to pieces. The opaque scumblings of the creamy paint would have delighted Whistler.

The other corn screen, also two-panelled, is on gold, and more brilliantly preserved in colour. Here the line-unity and the wind-destruction are neither so violent nor complete. The upright drum-major wand of the enormous crimson coxcomb centres the composition. The corn tassels are here more gracefully flung, and through the leaves we can see grain in the ear. The morning glories are in pink scumbled over pale blue. We can see from the left panel enlarged that Koyetsu kept his infinite tangle as clear in notan passage as in line. This is supreme free spotting, to which no Greek mosaic or Velasquez reaches. The great crimson-dark ball of the upper comb on the right panel contrasts wonderfully with the lower one in lemon cadmium, spattered with water-melon red. The close juxtaposition of this latter with the broken corn tassel makes a splendid passage.

But one of the finest existing screens by Koyetsu is that bought by Mr. Yamanaka at the 1904 sale of the Gillot collection in Paris. It had always been listed in France as a Kenzan, for it is unsigned. On seeing it in New York, after a recent study of Mr. Freer's Koyetsu, I immediately declared it to be a fine Koyetsu, and it has recently been exhibited under that name at the Boston Museum. It represents the lateral flow across the six panels of a river in low-toned cream and silver. The lines of this flow are conceived on the grandest scale. The ground through which the river flows is warm brownish paper spotted with tarnished silver. A note of accent is given near the centre of the lower edge by a rock in dull tones of olive and copper. Across this ground ascend, nearly vertically, two chief masses of growth : on the right a strong magnolia tree in deep browns, olives, and dark warm yellows, and soft river grasses in a scumbled cream lighter than the river ; on the left an icho tree with its autumn fan-leaves of cadmium, combined with a full-leaved maple that shades into dull scarlet and cream. A few very softly massed shrubs in pale brownish-olive arise in the centre of the middle distance from the river border, and right in the centre of this mass a single large wild carnation blooms of an indescribable low pink. This one little spot centres the whole muffled autumn colouring of the screen. The line tangle on the right, of magnolia, carnations, river and grasses, though simpler than the corn screen, rises in grandeur of pure spacing to Phidias, Godoshi and Sesshu. The æsthetic purity and loftiness of both line and colour come out in perfect combination.

We have given so much time to Koyetsu as a painter, for in this line grew and had its being his universal power of design. In his well-known lacquer, whether plain or inlaid, we have the most perfect use of material to express the forms and colour of his conception. He loved to work on small boxes, particularly suzuri bako, or ink stone boxes. Here some scene from Fujiwara reminiscence fell quaintly across the space, or one of the same perfect suggestions of the flower world which rise to grandeur in his great screens. One of the most brilliant of his boxes shows a group of painted shells, in which part of the outline is made by an actual inlay of pearl in Korinnish line. In other parts the design is an inlay of shell ; in other parts of gold pigment raised in lacquer. The designs of flowers and trees in the shells show how the grandeur of a great design is equally realizable

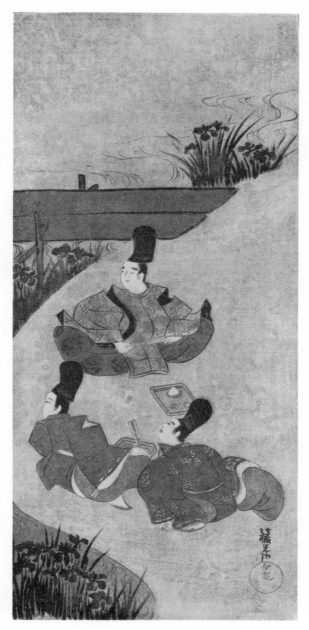

THREE NOBLEMEN IN IRIS GARDEN.
 By Korin.

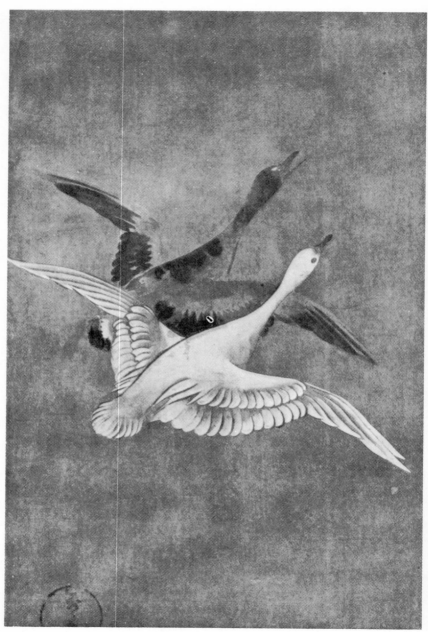

TWO GEESE FLYING.
By Sotatsu.

on a small scale, the shore with pine trees being the most beautiful vague suggestion of such a subject in art.

But though European collectors and translators of Japanese books know Koyetsu chiefly as a lacquerer, he was an equally stupendous adapter of nature design to artistic pottery. The finest example is a keramic box owned by Mr. Freer, on the cover of which lies, in rough raised glazes, a landscape worthy of Hangchow. This is thrown in as if with one of our palette knives in solid glaze pigments which come out in tones of brown and green over a light dull strawberry ground. The sun blazes in a slightly brighter paint. This is probably the greatest piece of pottery painting in Japanese art. It will possibly develop, as investigation proceeds, that Koyetsu was also an architect, an interior decorator, and a designer for hammered iron and bronze. But his supreme work is as a painter.

We come now to the second of the four giants of this school, Tawaraya Sotatsu. Kano tradition has it that he was at first a pupil of Sansetsu, and, indeed, some of his early flower pieces, like Koyetsu's, have a hard outline which directly relates them to the style of the Yeitoku period of the Kano. Sotatsu's work matures somewhat later than Koyetsu's, and there is little doubt that he received his second and strongest influence from Koyetsu's work. He, too, took his subjects from a combination of Tosa suggestion and nature study of flowers in rich impressionistic colour. He is solely a painter, no work in lacquer or pottery having yet been attributed to him. He paints on screens, too, of mural scale ; but a larger part of his work than Koyetsu's is upon medium or small kakemono, such as could have been hung in modest apartments or diminutive tea-rooms. He is less creatively imaginative than Koyetsu, less forcing nature to subserve his gigantic schemes of line and colour. He is more passive in his study of nature, letting his compositions take just the groupings which stem, leaves and blossoms would assume. He is thus less splendidly decorative in his total conceptions than Koyetsu, yet capable of the most wonderful minor passages in form of stem and leaf, and the opposition of their unconventional lines and masses. Occasionally he indulged in semi-Tosa figure work. Far more of his work remains than of Koyetsu's.

Among the finest Sotatsus owned in Japan is the great pair of wave screens, formerly in a private collection in Sakai.* Here in

* EDITOR'S NOTE.—Now among the chief treasures of the Freer Collection.

the splash of water against rocks and in the decorative arrangement of the tree we have probably an early composition in which there is a trace of Sansetsu's influence. It is almost as grand as a Koyetsu. How much Korin must have derived from this is seen in Korin's great wave screen in Boston. Sotatsu's finest pieces in Boston are a small kakemono showing two wild geese flying upward, and the great pair of flower screens on gold which once formed the treasure of the collection of Yanagisawa Keija, the famous artist daimio of Kazusa, near Nara. The colour is here applied in impasto over the gold ground, and is thus different from the majority of his flower screens where the colour has been used in semi-transparent washes, allowing the gold to show through. Mr. Freer has several screens of the latter kind. But in the Keija screens of the Fenollosa collection the firm drawing of the leaves and flowers in solid colour without line shows us one of the most rich examples of nature study in the world. Even the most minute plants have lavished upon them a wealth of loving care which we ordinarily reserve for our portraits. The wealth of colour in the great deep crimson and scarlet double poppies is indescribable. Of Sotatsu's later manner we must say that his composition gets slightly monotonous. Free as it is it consists of too many leaves drawn all in one free way. One of the most beautiful passages in Mr. Freer's gold screens is a small bush of pink *fuyo* flowers. But the finest of all his flower screens is the large four-panelled flower piece painted on dull gold, in which a great branch of mimosa in blossom overhangs a row of garden flowers in set clumps. Here the light branches of the pale malachite mimosa leaves sway in the breeze like light feathers, fringing daintily the very substance of the air. No lines of greater buoyancy can be conceived. Of the flowers below, the passage of roses with iris and hollyhocks, and that of pale blue hydrangea are most beautiful. This screen reaches the height of sweet natural impressionism in the decoration of the Korin school.

Another screen owned by Mr. Freer is noticeable for its great garden landscape impression in golds and silvers, among which walk Japanese Court ladies in ancient Fujiwara costume. These have been enlarged to mural size. The robes and veils of the ladies are painted in opaque passages (pottery glazes as it were) of greys, creams and silvers. The head of one fine figure is

wearing a wide garden sun-hat. The flesh tints are soft and very beautiful. The large cherry pattern of the dress is in tones of silver. This figure seems indeed as direct and full of poetic feeling as a Nobuzane.

In Sotatsu's latest manner is the pair of screens showing gourd vines, fuyo bushes and chrysanthemum clumps, done in golden browns in free wash, sold in Mr. Bing's private collection this spring (1906). The paper ground was sprinkled with gold, like nashiji lacquer. These screens were lent for exhibition in Boston in 1893. Of Sotatsu's finest flowers on kakemono Mr. Freer's scarlet and white poppies, built up into a splendidly pyramidal composition, like a fountain playing, is one of the finest. This comes nearest to a Korin and the strong play of colour thrown in wet upon the leaves of another colour, as of gold made to soak into green, or yellow into brown.

The great Korin, the third of the four chiefs of the school, and from whom its generally-accepted name is derived, was in a sense the official successor of Koyetsu, especially as a lacquerer. But as a painter he is only a little inferior in that his line systems are not quite so stupendous and original. In his more formal style he is more rounded and Tosa-ish than anybody. But he can do flowers and grasses with great firmness and naturalness over gold, and much as in the Kizen Sotatsu screen. Fine examples of his pines, hollyhocks and hagi are upon Mrs. Gardner's screens in Boston. Mr. Freer has a pair of screens, gold clouded, upon which Korin has painted nothing but free clumps of chrysanthemums in relief. A blue river (Korin convention derived from Tosa) winds among the spotted gold heads. The leaf masses are enormously free in their brown, gold and green. Another two-panel screen of Mr. Freer's upon paper shows a rich line design of rocks, chrysanthemums and fuyo bushes, the top being brightened with blood-red spots of maple leaves.

In Japan great Korin screens are many, but among the finest are the great iris screens on gold, shown in 1882 by the Nishi Honganji temple at the first loan exhibition of the art club. Count Inouye has his whole library decorated in a continuous design of fine coloured flowers by Korin. To get a conception of the wealth and complexity of Korin design we must refer to the

Japanese printed transcripts from his pictorial designs issued by Hoitsu about the close of the eighteenth century. The greatest piece by Korin in Boston, and one of the finest in the world, is the great six-panel wave screen, bought by me in 1880 from a dispersed daimio collection. This has curved rocks in copper reds and stone blues and greens arising out of a boiling sea of gold and cream. The foam is done in leaping masses of solid white. The body of the waves gets a "winy" tone like Homer's seas, from lines of gold and grey crossing the warm yellow paper. Great bands of solid gold mist play in from the left. This is one of the greatest pieces of impressionism in the whole school.

Of Korin as a lacquerer, pieces are to be found in all the world's notable collections. They are frequently inlaid in pearl and lead, like the old Kamakura pieces, but with a more realistic design. The box decorated in this manner with a daimio on horseback gives also a typical impression of Korin's manner in figures. A pottery box done in monochrome landscape over cream is Mr. Freer's.

The fourth of the great men is Korin's younger brother, Kenzan, who is known to collectors chiefly as a designer of freely-decorated pottery. But he is also a great painter, as witnessed by his splendid poppies on a kakemono in Boston, and by his snow-covered pine branch of Mr. Freer's. His style is generally the loosest and most spotty in the Kano manner. A fine pottery square box decorated with pines is shown on the plate facing page 114, and three pieces in coloured glaze, owned in Japan, of poppies and snow on pines. Kenzan is wonderfully varied and original in his treatment of small, sometimes almost microscopic, pottery pieces, always most charmingly adapted to material and use, and full of bits of nature fancy; but he is never as grandly constructive as Koyetsu, or even as Korin. He lived to 1743.

These four men must have had many pupils whose names are mostly lost. A third brother of Korin and Kenzan, Kuchusai, was a good painter, potter and lacquerer. Weaker corn screens in the Koyetsu manner I have often seen in the sales in Japan. At the end of the eighteenth century a priest named Hoitsu tried to revive the Korin school, which had almost become extinguished. His work is more formal and rather Kano-ized.

If now we review the aristocratic schools as a whole, we see that only two rise to any special greatness, the Kano and the Korin. Both

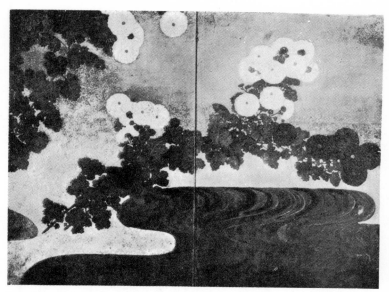

Two Panel Screen of Chrysanthemums.
 By Korin.

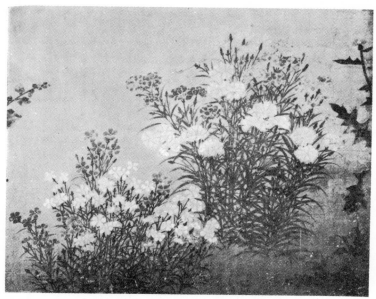

Study of Wild Pinks (detail).
 By Sotatsu.

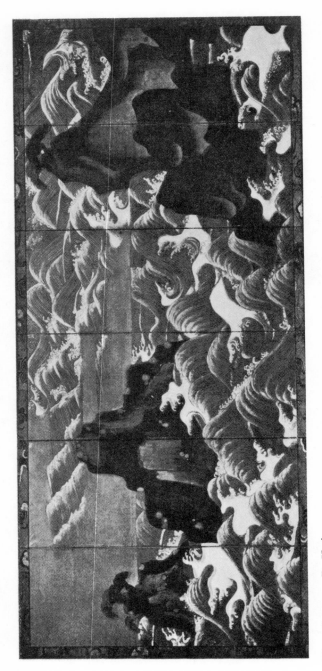

WAVE SCREEN. By Korin.
Fenollosa-Weld Collection

are mural in scale, but also adapted to tea-rooms, and to the decoration of all kinds of rich utensils used by the daimios and samurai. Metal work and embroidery specially fall to the Kano, lacquer and pottery to the Korin. Kano, however, influences all industries.

Of both schools the great period comes almost simultaneously. Both are offshoots from the Kano-Yeitoku school of Hideyoshi, the Kano through modifying the ink style of Yeitoku, the Korin by modifying the colour style. Of the several generations in time, we can say that Tanyu and Koyetsu, the creators and greatest geniuses, are nearly contemporary, and reach their zenith about 1660. Korin is to Koyetsu quite as Tsunenobu to Tanyu, and contemporary with Tsunenobu, both reaching their height about 1700. Lastly Kenzan in his old age (most of his work in collections is late) is to Korin like Chikanobu to Tsunenobu—that is, the two contemporaries are working in 1730. Of both schools as a whole, the periods from 1640 to 1700 can be considered those of the great strength of both schools. Later aristocratic work is eclectic and feeble, but the Kano work of the nineteenth century is most valuable for its critical knowledge and its copies of old Chinese.

Great as is this art, the importance of it to the whole Tokugawa period is not so great as the plebeian art which we have now to study ; though individually Koyetsu, and perhaps Tanyu, overtop Okio and Kiyonaga in the quality of their general geniuses.

CHAPTER XV.

MODERN CHINESE ART.

The Tsing or Manchu Dynasties.

IF I were to follow strictly the standard of æsthetic value, which I have for the most part set up for myself in this brief account of brilliant epochs, I should probably consider modern Chinese art to lie below the level of mention, as I have considered so many of the minor individualities in preceding periods to lie. The whole picture should be consistent, like a map of some one geologic age in the islands of a sinking continent. A full history would trace the roots of the mountain chains in what were once valleys, now deep sea troughs. But if in art we were studying only the regions of elevation, they would be grouped in time quite as Polynesian archipelagoes upon waters of the South Pacific. Finally an essay upon supreme geniuses would appear like a chart of active volcanoes, spotted in red about an ocean. It all depends upon the base level one assumes.

Having in this book deliberately chosen very high-grade work for my subject, I can defend my determination to touch upon the art of the Tsing dynasty, partly upon the really great value of some of its decorated industries, such as porcelains, but chiefly on account of keeping in view certain chains of causation, continuous with forces already noticed in Chinese history. The fall of modern Chinese culture is in some sense an organic part of the history of its rise. Moreover the thought is of special importance when we come to consider in the next chapter the whole bearing of modern plebeian art in Japan toward contemporary Chinese. It will be perhaps equally true that some of my late Japanese phases also should properly fall below the level of mention. It is mostly true that the concentration of interest in any design falls away toward the edges.

The decay of modern Chinese art, already foreshadowed by the middle of the Ming dynasty, is most conspicuous in pictorial art—in all forms of art, in fact, that involve high imagination. In early Chinese and Japanese art the industrial patterns were offshoots from the central art of sculpture. In both arts after the eighth century, design is chiefly conditioned by causes that affect its parent, painting. But in recent centuries in China, and equally for certain wide-spaced phases of modern art in Japan, we can say that for the first time design becomes separated, in part, from high creative motive, depending rather upon prettiness than upon large constructive line relations. This is not true of the Korin school, as we have just seen in the preceding chapter. But it is true conspicuously of Tokugawa architecture, especially that of temples ; and it is still more universally true of the great bulk of modern Chinese *bric-à-brac*. It is this work, however, which foreign collectors have hitherto mostly acquired, and so their standard of Chinese design starts far too low. In much the same way, as I have already shown, European scholars of any subject in China have come to adopt the low intellectual key of the modern mandarins, and are quite ignorant of the magnificent imagination and power of early centuries. It is to vindicate those higher levels that we must look up from the lower, even if they sink below our proper horizon.

Professor Hirth has to some extent protested against this view of a great decay in modern Chinese pictorial art, which Professor Giles had asserted. No doubt there have been great hosts of modern Tsing painters with elaborate school traditions and bibliographies over minute, quite as to-day we naturally know so much more about the life of any popular modern playwright than we do of Shakespeare. But if we adopt any high universal test of æsthetic attainment, great spacing, great characterization, and the structural use of great colour ; we shall find modern Chinese painting to have fallen almost to the childish point of awkward weakness and ineffective symbolism, the same point to which European Christian art fell to in the poorest of Byzantine mosaics. Art begins in hopeful childishness, and falls back to hopeless childishness. The only hope for the hopeless is to perceive itself to *be* hopeless. We may then come to discard it and begin anew. The moment we notice, coddle, and over-praise it, we do injury to all past and possible future creation. Let us not really lower our critical standards to suit a degenerate present.

The real break between China's past and present came with the sixteenth century of the Ming dynasty, after the transmission of its best traditions to Ashikagan Japan, and when the turmoil of local strife in Japan was paralleled by approaching strife between a weakened empire and the Tartars of the North. China and Japan had really done with each other.

What had happened in China was the complete loss of the early attempt in Ming to revive the anti-Confucian or Southern genius, a genius which had seen its illumination at Hangchow and its antithesis in Yuen. There was not enough ideality left in Ming to stand the strain. As early as 1421 the Ming renaissance was doomed to failure when it was decided to remove the capital from the Yangtse valley to the far North-east Tartar capital of Peking. Peking had never been the capital of China before the days of the Kins and Mongols. It had no great art monuments or collections of ancient work. Its people were largely of Tartar blood. Its traditions of brief Mongol supremacy were all of a materialistic splendour that ignored idealism.

For all these reasons Peking offered a far more effective field for the conservative Confucian *literati* to work in. Put on the defensive by Northern Sung, reformed against their will by Southern Sung, they had leaped unchecked to the head of the Tartar horses, and guided the course of their alien masters in statecraft. It is strange that both Mongols and Manchus should have lent ready ear to the repressive propaganda of both Confucian atheists and Christian scholars, but should have thrown down between them all that poetic Taoist and Buddhist idealism which has been the core of Chinese imaginative life. Of the more honest of those Confucians, it was no doubt a definite desire to make China into a moral machine, where every rite, ceremony, industry, and even thought should be conducted along pre-established formulæ. Their ideal is uniformity ; their standard is not insight but authority ; their conception of literature is bounded by the dictionary ; what they hate most is any manifestation of human freedom. Free thought with them was as horrid an anathema as with an eighteenth century New England Calvinist. Of the less honest, the motive was doubtless to further that method of absorbing all local official patronage by which tax lists became legitimate prey for extortion. The modern Confucian government of China is a government of corrupt Puritans ;

a ring more closely monopolistic than Tammany's, and worse than Tammany's because of its moral hypocrisy. Even Wu Ting Fang we see to-day giving up his efforts for reform in despair. The Mandarin class is China's Old Man of the Sea, a parasitic growth that chokes the life out of any effort at readaptation. It was this hideous, cold, reptilian monster, hidden beneath the formalism of his Confucian contemporaries, that Oanseki divined in 1060, and fought as if he foresaw the death crunch that it would eventually give to the Chinese soul. The whole Sung dynasty was a Chinese passionate protest against its crystallizing tyranny ; the whole Sung dynasty has been contemned and misrepresented by the histories of the enemy's triumphant ranks. To-day we have a China boasting of the cold poison that has killed it, as the very sign of its genius ; the stillness of its death as its divine changelessness. Truly when human nature becomes a slave it may last for ever. But even the solid strata of the mountains bend and crush and shake down cities. So China itself is now bending, so may her very dynasty be crushed ; so shall the ancient fallacies of Confucian impudence and imbecility be shaken down. And then it will be recognized by the world that the core of the new China lay in Sung !

But what has all this to do with modern art ? Everything. The Tammany Mandarins hated every sign of life involved in early Ming success. Hangchow art was a red flag to them. It must be part of their policy to decry it and all its Kakeis and Mokkeis on the one hand, and to put in some kind of substitute for it on the other. It was the last half of Ming, in short, that tried to develop a superseding school of Confucian art, utterly subversive of all Hangchow ; and it succeeded. It is this Confucian art, practically conterminous with what we call "bunjinga" and mixed with a barbarous Tartar and Thibetan Buddhism on the one hand, and with a Tartar realism and a Tartar love of crude ornament on the other that has imposed itself upon the whole Manchu dynasty.

What should be taken as the distinctive art of Ming Confucian scholars, the new lights of the empire ? Something with tradition of course. They could not quite go back to Confucius in art, for there was not any art in his day. They looked back first to the Yuen dynasty that preceded Ming, and there they found a scholarly style that had stood out against both materialism and Sung-ism, the free, blurry landscape art of the four great men who revelled in

shapeless but brilliant masses of cloud and mist. This style, indeed, threw over all accurate knowledge of form, of varied effect in nature, to record only one style of feeling. That, however, was enough, for simplicity and uniformity were dear to scholars. Certain platitudes about old nature poetry were enough to quote. In such art and literature it was as if because Shelley wrote a poem on a cloud, all future poets worthy of the name should do the same thing. This fine but narrow style of the Yuen poet - painters among the Confucians had really been developed from germs sown by the scholar Beigensho and his son in Northern Sung. Indeed the whole hated work of Sung reform was made by the Ming patriots to centre about the " traitor " Oanseki the friendly foe of Beigensho, Toba, Bunyoka, and all the strictly Confucian scholars of Kaifong in the eleventh century ; and therefore they wished to erect into a kind of saint-ship a solemn canon, the thoughts and art of the men who had opposed Oanseki (Wang An-shih).

There were many writers and artists towards the end of Ming to try to formulate this theory, and to show that the only really " true " art of China was the spotty Yuen school. New histories, new canons, new schools of criticism now arose, having about as much relation to truth as would a passionately defended French thesis that St. Luke was an impressionist. A leading man among the writers is Tokisho (Tung Ch'i-ch'ang), whose ideas have vitiated all Chinese criticism since his day. He was not content to carry his derivation of the style as far as Beigensho in Sung ; he undertook, against all evidence, to push it back to Tang, and father it upon poor Omakitsu (Wang Wei), because, in sooth, Omakitsu had been the first of the great landscape painter-poets. He then had to give a name for this universal Chinese school, and chose the term " Southern." This was probably done because the real source of landscape poetry and art had been in the South. The tradition reached back to Toemmei in the fifth century. It was a bold bid to sweep the whole nature movement in China into their—the Confucian—ranks. In contradistinction to this alleged orthodox movement Tokisho set up a " Northern " school, which was supposed to be the tradition of the Tartar Buddhists of the Northern provinces, and of the heretical academy of Kiso Kotei in Northern Sung. By this chain of reasoning, Mokkei, Kakei, and Bayen, though dwellers in the South, were

pioneers of the "Northern" school, because derived from Kiso's academic formulæ. These men had no "principle," no "soul," they were mere "hangers-on of Imperial favour." The great soulful independent art was the non-academic, nay, the lamentably "amateurish" work of the opposition scholars. For it is most un-Confucian to be a professional; you should toss these things, these paintings and poems, off for mere amusement. Lastly, Tokisho either invented or re-adapted for use in his new technical sense, a special term for this kind of art which characterized its Confucian holiness, "bunjinga"— "literary men's painting." Expanded, this means such paintings as late Ming Confucian scholars should approve, namely, such as was done by literary men in Sung and Tang, and could be dashed off without great effort by moderns.

The historical error in all this modern Chinese theory of art was stupendous. It tried to win for itself in the name "Southern," the whole prestige of Liang and Hangchow, which were the central seats of Zen Buddhist, its bitterest enemy. The whole great land-scape school of China, really southern derived, but whether produced North or South—by Omakitsu (Wang Wei), Godoshi (Wu Tao-tzu), Risei (Li Ch'eng), Kakki (Kuo Hsi), or Kakei (Hsia Kuei)—was the exact opposite to all that Tokisho loved, was really what he despised as the "Northern" school. Even the Kiso landscape of Northern Sung was what it was because it had sprung from the South. Thus in Tokisho's theory what he called "North" was essentially "South"; what he called "South" was really derived from Northern Kaifong Confucianists.

Moreover, the distribution which he alleges down through the ages *did not exist*. Beigensho indeed established a personal style, but it was not shared by his Confucian contemporaries, nor made the basis of a school method before Yuen. There is no reason to suppose that his Sung fellows, such as Toba and Bunyoka and Sanboku, thought of themselves as doing anything essentially opposed in their landscapes to Kakki and Ririomin, their other group of friends. The only difference was that they were amateurish, and very much limited in their subjects. But Toba's bamboo, for instance, is in no essential different from Mokkei's, Bayen's, and the whole great Southern Sung school. Finally, the very phrase *bunjinga*— "literary men's painting "—sufficiently characterizes and condemns it.

It was rather a matter of thought and evolution than of visual imagination. It was as if we should write "horse" under a child's drawing of a horse. To the merely literary mind, pictures are "signs" of ideas—that is, another kind of "word." Of all that is involved in original line creation they know and care nothing. All that to them, as in some of our modern lectures on art, is "mere technique."

But how about the evidence of the real old masters, which it would seem ought to have refuted this precious theory? Be patient, the evidence could be manufactured! The old were largely known by copies of copies; it was only necessary to re-copy them once or twice more into the "bunjinga" style, to prove that the old masters were *bunjin* painters themselves. I do not mean to assert that in all or even in most cases this process was deliberately fraudulent. The account of the honest artists of their process, combined with a view of what they actually did, makes clear the whole matter. They openly claim it as an advantage in their way of copying that they do not try to follow the exact lines and touch of the originals, but that they "translate" it into the creative style of themselves, just as a poet has to use his own alien genius in translating a foreign masterpiece. In other words, they saw in the original only those features which seemed more or less adapted to their own manner of work. Now their manner of work was "bunjinga," formless and woolly. Therefore, in several re-copyings, all the stiff, hard, fine drawing of the originals would vanish, and nothing be left but an extravagant exaggeration of their woolliest features. This is the reason why, in the large number of Tsing alleged copies of old masters—certified by the handwriting to be copies of copies—we find little but the most childish kind of modern work, a trivial unimaginative pen-play which has absolutely no likeness to any of the old great masters of preceding dynasties, except of a few Yuen. It is exactly as if the manufacturers of Greek altar-pieces at Mount Athos, not content with their hieratic tradition, were to assert that their little gold line dolls were the only authentic copies of lost masterpieces by Apelles and Parrhasius.

The enormous evil of this impudent "bunjinga" hypothesis, that soon stamped itself as orthodox in the belief of all Chinese scholars, was a degeneration of art so rapid that by the end of

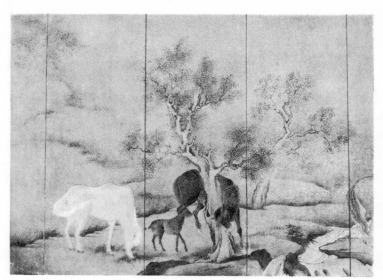

LANDSCAPE WITH HORSES. By Buson.

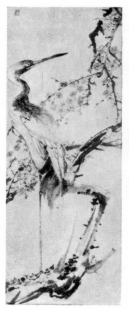

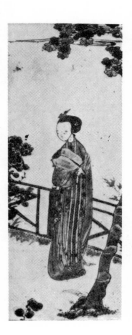

MODERN RICE-PAPER
TRIVIALITIES.

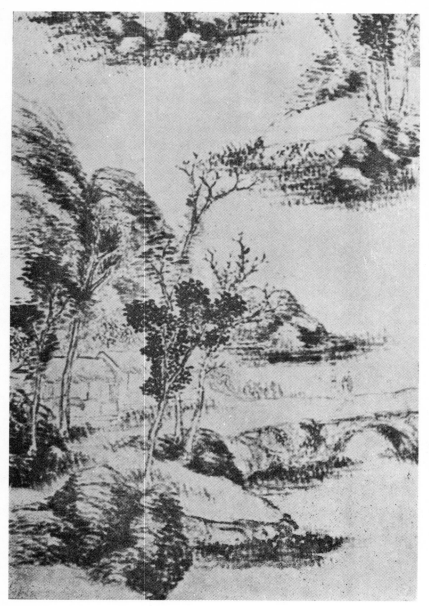

EXAMPLE OF A " BUNJINGA " LANDSCAPE.

Ming hardly a respectable piece of work could be done except in a weak sort of pretty flower painting. Figures had become dolls ; round-shouldered, backboneless, with empty idiotic faces, where proportion, grand spacing, and intricate line feeling were no longer even sought for. It is like the fall from Wagnerian opera to "ragtime." To one who likes "rag-time," classical music is a bore, quietly ignored. So to a bunjinga lover of late Ming, or of Tsing, all the great qualities that have made Chinese art are either ignored or travestied. It becomes an absolute dulling of the senses, and this should be clear to any European artist who compares side by side what they boast is their greatest Tsing masterpieces with even the poorest of the original Sung. It becomes dotage, second childhood. For though the Yuen predecessors were only great men in their limited line, and would be recognized as such by the artists of all nations, their would-be Tsing followers, having hopelessly lost the eye for proportion, could not see even in Yuen masterpieces that which made them great. To the followers of Tokisho it was the absurd piling of shapeless peak on peak—a kind of Chinese Pelion on Ossa—that was essential, not the magnificent notan of the mists that enshrouded them ; the fact that each dead tree had its broken branches done with a little manufactured spiky touch that the same artists and a hundred enrolled followers would apply to all dead trees, rather than that the lines of Yuen trees gave a sort of accent to the cloudiness that redeemed it for purposes of texture. In short, notan for modern Chinese, as well as real form, ceased to exist. Notan, the actual spotting of the dark and light upon their pictures, ceased to have any relation to the beauties of dark and light in nature, and became admired in proportion as it looked like the repeated variations in the spotting of ink upon a written manuscript. In fact it can be said that the natural effect of the bunjinga theory is to obliterate the distinction between painting and handwriting. The drawn horse and the word "horse" may be equally unpictorial.

But it was not only art history and art production that were ruined by fifty years of this Confucian triumph ; art criticism took such a tumble that the comments of those who wrote, after 1550 at least, have no more relation to the thoughts of the great early critics than the writings of modern anarchists have to Aristotle. And yet in the great Tsing compilations from all available Chinese literature upon art the words of recent critics are quoted side by side with those of ancient, in

complete unconsciousness of the infinite intellectual and imaginative gap that divides them. In this way European scholars are utterly deceived who quote a modern bunjinga critic as equally good " evidence " about art with an ancient. The whole mass of what at least bunjinga critics have to say is mostly " rot."

And the very drivelling of this modern criticism is even quoted sometimes as evidence of perspicuity, as for instance the modern Chinese illustrated books which pretend to say that Kakki's style of tree touch was such an one, Risei's this, and Randen's that. Some silly little childish scratching is produced for the alleged styles, the difference in which concerns some little trick of curve or the number of " prickles " on each side of the central stem. Not one of them has much resemblance to the styles of the really artistic originals. How childish criticism finally becomes in these modern schools is seen in the inveterate categorizing which a parrot-like education must foster, where, for instance, mountains are classified as having one tree on the top, two trees on the right slope, three trees and two rocks on the left, and trees with five long branches on the left side, with three short on the right, and so on *ad nauseam* through the whole round of mathematical permutations. When thought has fallen to the level of mere narrowing, art does likewise, and the final pleasure a connoisseur takes in a picture is the mere recognition of a category that has some artificial flavour of old association. The whole paraphernalia of this school of modern exposition serves only the most unimaginative minds. It has absolutely nothing to do with either the thought or the art of old China.

The movement of this school of bunjinga over China in the sixteenth and seventeenth centuries, was like a flashing fire that left a waste of ashes in its wake. The whole great universe of Chinese art was not only superseded, but obliterated. In the intellectual and æsthetic fields it was as disastrous as the movements of the later Taiping armies over the actual provinces. It seems at first hard to believe that a mental revolution so absolute could take place in a great consolidated people ; but we have a somewhat parallel European example in the utter transformation of Greek art feeling in the schools of Byzantium, through which, though great original statutes still existed to refer to, the paralysed taste of the day prescribed and preferred dead effigies and childish dolls.

The Tartar Manchus had been fighting with a degenerate Ming for forty years, when the last Emperor of the old line was defeated in 1660, captured and sent North to the seats of his captors. In the next year he was banished to Formosa. In 1662, Kanghi, the second Emperor of the Manchu line, came to the throne, and ruled down to 1722, a notably long reign of sixty years. After the short reign or Yun Ching, Kienlung, Kanghi's grandson, ruled also for sixty years, 1736 to 1796. These two long reigns of these two wise Tartars really occupy not only the centre but most of the bulk of the Tsing dynasty. Whatever is epochal, whatever is vital in Manchu civilization, comes from their combined reigns. Modern China became absolutely fixed by their methods.

On the accession of Kanghi it seemed as if a new glorious world might be dawning for China. Elements of the new were on every hand. Not only were the Manchus a fresh race with a strong, if uncultivated, intelligence ; but the power of the Jesuits from Europe, already laid in late Ming, grew to great influence under this first long Manchu reign. Great was the hope of the Christians, who remembered the friendliness to them of the Mongol predecessors three hundred years before. A new world of commercial intercourse was springing up with Europe. Macao was a Chinese port of the Portuguese, Canton and Whampoa were freely open to all Europeans. Kanghi allowed the Jesuit missionaries to build their cathedral near the palace in Peking, and adopted them as tutors for his children. What a tremendous contrast with Japan, who had shut herself off from the great advancing Christian world, and was striving with all her might to keep out the new ! How certain it seemed that while Japan in her persistent isolation would wither to weakness and decay, China, coming into lines of world-culture, would soon surpass her island rival ! And yet, look at the result ! Japan using her conservatism to foster mental and moral strength ; China using her world-freedom to rivet her own fetters of formalism ! What an anti-climax ! How shall we explain it ?

The answer given here can only be outlined. It is that the reign of Kanghi, which started out most hopefully for Christianity and for China, ended in the gloom of the first Christian persecution. This was due to the pigheadedness of the Papal Court and its advisers, who were jealous of Jesuit success. The Jesuits had politically and broadmindedly tried to identify as much as possible of what was vital in Chinese life

and thought with Christianity. Their Franciscan and Dominican opponents wished to down all Chinese thought and rite as the work of the devil. On the side of Europe it was the problem of tolerance or intolerance. But we will not here attempt to go into this old well-worn controversy. Enough to say that the Jesuit policy of tolerance led to the rapid conversion of many Chinese Court nobles and their families, and even the Emperor offered on certain conditions to become a Christian. He held friendly correspondence with Louis XIV. of France. French scholars were all powerful at Kanghi's Court. Some of them, who were artists, introduced European oil painting. But when Papal intolerance declared that a Chinese, in order to be a Christian, must virtually renounce all his institutions, ancestor worship, Confucianism, the reverence for the Chinese heaven, etc., all China, even that most radical part of it most friendly to the Christians, rose in revolt. Kanghi solemnly warned Europe of the colossal mistake it was about to make. But idiotic Europe made it, and effected by her stupid intolerance a practical exclusion from China nearly as effective and with even more friction than that which Japan had decreed. In the year 1700 China was almost becoming a part of Europe. By 1720 the Emperor Yung Ching had, for mere self-preservation, to fulminate almost cruel edicts against all Christians, native and foreign. The great breach then made by Rome has widened since to almost antipodal scale. The opportunity of Western civilization to incorporate China peacefully was for ever lost.

But the real effect on China was more far-reaching than this negative statement. What remained for China to build on if not Christianity ? What was the issue in the Chinese world when Christianity stood on the verge of success ? It is hardly enough to say that it was Christ *versus* Confucius ; it was the whole method of European thought *versus* the whole method of Confucian thought. It was the same old bigoted conservatism which had fought mystical Buddhism in Tang, idealistic Buddhism in Sung, and the Hangchow renaissance in Ming. It now had a new antagonist, that was all—a new kind of religious idealism more emotional than Zen, a new scheme of administration and education more radical than Oanseki's. No doubt the patriotism of these Chinese was genuine. They were strong enough to persuade even Kanghi, the Manchu friend of Europe, that " Chinese institutions " must not be subverted. To China the problem was the same old one, with the

disadvantage of having the factor of freedom now alien. The stupid ignorance of Europe, which ignored the enlightened appeal of the Jesuits, merely joined forces with the Confucianists.

The reign of Kanghi had been brilliant in many other ways. It was an age not of creators but of book scholars, men who knew words rather than thoughts. Hence its splendid compilations, of extant Chinese letters on all important subjects ; its monster cyclopædias, its splendid dictionaries. In all this work, Kanghi, the Manchu, was more really Chinese than Confucians themselves would have counselled. His mind was untarnished by formalism. He tried to think for himself. He honestly wished to awake Chinese self-consciousness at the same time that he would cautiously introduce European reforms. It was the best anti-Confucian policy possible, for it kept the scholars so busy on their endless researches and compilations that they had little time for political intrigues. Doubtless they would have wished to dominate the Court, and bind the Emperor in their cobweb net, as they had done the alien Emperor of Yuen. Kanghi knew how to steer his way between their pitfalls and Confucian dangers.

But after Europe had made its disastrous move of the Papal Bull of 1702 ; after Kanghi, still regretfully friendly to the Jesuits, had died ; after Yung Ching had been forced to raise about him the whole army of Chinese conservatism in order to grapple with the insidious Christian influence ; the Confucianists found themselves suddenly in a position of influence never intended by the wise Kanghi. China had to fall back upon herself, and who could tell the wise Kienlung in 1736 that the real China had been something far nearer to European acuteness and Christian idealism than the Confucians alleged. They had the game in their hands. They had only to enforce the most narrow and certain of their formulæ in order to inspire the patriots. Thus the whole reign of Kienlung, keen scholar as he was, and far finer in spirit than the average mandarin, could see no outlook but to follow their propaganda. Therefore the age of Kienlung is not like Kanghi's, one of hope and experiment, but one of shrinking into the shell, and finally confirming the tyranny of type as against the needs of readjustment. No new form of Buddhism or Taoism was conceivable. Chinese inspiration had worn itself out. Nothing but repetition suggested itself. Only Europe offered a clue, and Europe had failed. It was the final triumph of the Chinese Bourbons.

Since Kienlung's abdication in 1796 the History of China has become one not of internal development, but of stubborn and bitter opposition to growing European inroads. It was no longer exactly the Jesuit problem, but one hardly less bigoted, the Protestant missionary problem, and one politically more dangerous and more demoralizing, the European commercial problem. We need not enumerate the English treaties, the prohibition of opium in 1838, the enforcement of opium upon China in 1860, Hongkong, the encroachments of France, Germany, and finally of Russia. Distracted China saw herself about to be dismembered at the end of the century. She fought like an armadillo in a corner. The wonderful new fact which makes her emancipation still possible is the rise of her Japanese champion. But to-day the self-same mandarins who have throttled China like Li Hung Chang, who would sell his country for $50,000,000, and exploited her civil service, are as jealous of the veritable reforms that Japan will introduce as they were afraid of Europe, as they were afraid of Oanseki.

But now to go back to our special subject of art. Chinese art of Tsing divides itself into three sub-epochs : the Kanghi epoch of hope and experiment ; the Kienlung period of self-hardening ; the nineteenth century of despair and loss.

The art of the Kanghi age is rather a compound of many movements than a single natural impulse ; in that respect paralleling the Japanese art of Tokugawa. The chief of these movements may be said to be five. One was a thin stream of influence, not quite choked out, from the ancient styles of Chinese art revived in early Ming. But it was very narrow in subject. Strong individual figure painting had ceased to exist ; landscape had been monopolized by the Confucians. There was left only the prettiness of coloured bird and flower painting (a remote flavour of Joki and Chosho), which had been the most conspicuous feature in early Ming renaissance. The re-echoes of Rioki and Henkeisho, stiff and uninspired Ming flower painters, had been softened up into delicate decorative panels for Tsing, whose rich colouring tried to make up for lack of drawing. In so far as Court figure painting persisted, it degenerated to still more doll-like round-shouldered men and women than are to be found on the lacquered screens. The last stage of the doll degeneration are the aniline-tinted " rice-paper paintings " of the nineteenth century.

The second movement was one of Reibun, one not unlike that of Shunkio and Chosugo, arch realists of Tartar Yuen. Here, again, drawings of flowers and birds played the principal part. But the lack of real feeling

for line and proportion—crushed out of the Chinese mind in late Ming, and never a part of the Manchu mind at all—kept these studies from having much more than a certain botanical value. This movement would naturally blend with the first, as Shunkio's Yuen realism had blended with Joki's idealism. It is not worth while to give names to this triply-weakened flower art, any more than we care to quote names of Italian mosaic workers through the eighteenth century.

A third movement is the Christian or European influence, due often to actual tuition by Jesuit favourites at the palace, who had more or less skill at oil painting. It is rather pathetic to think of their probably amateurish daubs being admired as "illumination" by descendants of Kakei. But some new elements of richness and depth in colouring may have entered modern Chinese art from this source and blended with the nature movement of realism already mentioned.

A fourth movement, still pictorial, concerned the perpetuation, in very weakened form, of Tartar styles in Northern Buddhist art. We have seen samples of this powerful sacred figure work in Tang (Enriuhon) and in the Kin contemporaries of Sung. These Tartar forms prevailed also in Mongolia and Manchuria, even up to the banks of the Amoor, and are preserved in the few rare and degenerate modern Corean Buddhist works. They were known in the work of Rikushinchu of Yuen, already losing fine and natural proportions ; and in Northern Ming Buddhist work where the figures have become so wiry in line, so doll-like in curve, and so dumpy in proportion, as to make gods and devils equally hideous. Now a new form of this more "Indian" style was coming in with the Lamaistic faith that followed home the Tsing conquerors of Thibet. Eventually Thibetan Buddhism became the Court religion at Peking ; and its art, a minutely finished but hard and unfeeling school of sacred figure painting, close to the Greek traditions of Mount Athos, came in to modify Court style. The two sacred schools, the old Tartar and the new Thibetan, naturally blended in modern Peking, but without real regeneration or any power to react on Chinese design except in the way of stiffness and mere gorgeousness of colour. This doll-like religious style, and the doll-like secular style, mentioned under the first movement, confirmed each other's weakness.

The fifth movement was, of course, that "bunjinga" of the Confucian party—now in opposition—a school of feeble landscape monochrome

inherited from Ming. No longer understanding anything about line, its drawing is a travesty. Knowing nothing about notan its spotting is cold and monotonous like the scrolls of written characters that were equally venerated. It is not unnatural that to the " literary man " his poetical scroll and his symbolistic scrawl should hang side by side on the same wall. There is no distance, no foreground ; mountains and figures stand on each other's heads. There is no sizing of the paper or silk with glue so that ink washes may be manipulated—that would be too vulgarly "professional." The ink touches must soak into unprepared paper, and the skill will lie in letting them so soak as to look like the similar soaking of the edges of a written word. No doubt a certain dexterity in making these superposed soakings blend into a faint resemblance of Yuen clouding has a certain, if the only, merit in this work. But after you have seen the trick accomplished for the hundredth time, on mountains and grasses utterly uninteresting in themselves, you see that it is literature, not art. This work sometimes borrows a certain prettiness of colouring in birds and flowers from the first movement ; on the other hand it lends a degenerating " mossiness " and wriggling worminess to the first movement's drawing of its stems. There is thus some tendency for the first and fifth movements to coalesce. For, for the most part, the extreme bunjinga school remained during Kanghi's reign "in opposition," and only came out to full fruition, its final triumph in the murder of Chinese art, and in the deification of the dead bones of formalism, in Kienlung's and subsequent reigns.

But now we have to speak of a sixth movement in Kanghi's reign, not unrelated to some of the preceding, which contains the only really vital element in early Tsing art—and that is the adaptation of eclectic design to modern Chinese industries.

As is natural in all great industrial movements, the most of it is architecture. It is not that the main constructive features in Tsing architecture are radically different from previous styles, nor even that the structural element is not on the whole richer. In leaning to a greater wealth of decoration it but follows in a measure the downward trend of Tokugawa architecture. Still there is more positive grandeur and splendour about it—with its marble terraces, railings and even arches, and its splendid superstructures in glazed faience—as notably in what we may call the great triumphal

arch of Confucius at Peking. Across the lakes of the imperial
gardens, too, fine arched bridges of marble or other stone arise in
a gentle total curve, avoiding all our hardness of straight lines. The
circular structure of the Temple of Heaven, though of modern rebuild-
ing, shows the most splendid panelling in its ceilings, æsthetically
if not structurally corresponding to Gothic vaulting. In the central
rooms of the Imperial Palace that was carefully studied by Japanese
architects during the foreign occupation of 1901, the most elaborate
use of all materials contributes to the over-rich effect, metals,
ceramics and textiles lending variety to marble and gilded carving.
In the throne room itself the wealth of carved wall panels, done in the
richest lacquers, and working into intertwisted patterns of cloud and
dragons, is only surpassed by the gem of the throne itself, whose
back is a Lacoon-like openwork carving of dragons so rich that it
challenges comparison with the whole world's work. This is the
awful "dragon-throne" of China; but it must be confessed that
with all its marvellous intricacy it cannot stand for great propor-
tion, large spacing and noble rhythm. If we compare it with the
intricate patterns upon Ririomin Rakan's garments the inferiority
is at once seen. Or compare it with the architecturally ordered
intricacy of the design upon the early Japanese Trinity with a
screen. It does not lead and finally submerge the eye in a satisfactorily
noble curve system. This failing is true of most, even the most
splendid, Tsing decorative art. In such elaborate carvings as the
panels in decoration of the "Cho Sing" temple of Canton, we get
this same overloading and overcrusting, with the little doll-like
figures of contemporary painting becoming solid little mannikins in
space of three dimensions. In some of the more elaborate shops
and tea houses we get fine spacing, particularly in the use of the
characters carved into rich signs, coloured and gilded. I have always
held that the Chinese script is capable of as noble architectural
treatment as Arabic texts from the Koran in Mohammedan temples.

If now, at this period so near the end of Chinese art, we ask
where this varying mass of motive comes from, we have to refer,
among other things, back to some ancient bronze vessels with which
we began our history of Chinese art in Chapter I. In every period
of Chinese art, since the Sung (So) dynasty at least, there has been a
persistent copying of the earliest forms and patterns, generally taken not

from originals, but from the prints of the Po ku t'u lu. Han (Kan) and Tang (To) had their own styles, but Tang was a little antiquarian. The porcelains of Sung were all copied from Shang (Sho) or Chow (Shu) bronzes. Most alleged ancient bronzes are really imitation of Yuen, Ming and Tsing. But beside this actual copying of designs from early bronzes, the element of Pacific art, which formed the chief fabric of pre-Han motives, never quite died out of certain forms of Chinese ornament, and was specially rehabilitated in modified form for Ming and Tsing ornament. Just as the whole scheme of Persian rug design is only primitive realistic pattern generalized and squared off into appropriate spacing—just as this truth explains all early convention arts such as those of the North American Indians—so in Chinese inlay, and embroidery, and weaving especially ; and even on carved woods we find abstract squarish forms that seem at first to suggest keys, but are only generalized versions of dragon, face and cloud forms that were first found upon the Pacific bronzes. The Chinese seal character, itself product of conventional squaring, is derived from the inscriptions on bronze utensils of early date. Such openwork in modern rectangular lines as we see above the balcony of the Canton shops is only a modification of Pacific dragons and bands—of just about the same degree of remoteness as the almost identical patterns upon Aino dresses and Alaskan blankets. All three have descended through millennia of Northern darkness from a common source, to blend at last in simplified rectangular pattern. These square cloudings are often reduced to curves, both on rugs and garments ; and a most interesting collocation is furnished by my photograph of the splendid Shang bronze in contrast to its modern carved wood Tsing stand. The patterns on the bronze above are Pacific art, genuine, as it was in China some 1,500 years before Christ. The patterns on the stand below are modified Pacific art, such as has come down by conventional paring and simplification to the China of to-day. It should be noticed again that the Mongolian pyramidal forms at the bottom of the dragon wall panels in the throne room are only conventional relics of Han mountains, as seen on bronzes and glazed pottery of the time of Christ. Combined with these venerable forms we shall see everywhere in modern China flower passages of weak drawing which are the last echo of Sung art, and in the temples stunted effigies of gods which are the last declination of Tang sacred art. Thus the past hands down its small proportion of legacy to the present.

But by far the most interesting use of this generalized patterning finds its place in modern China's master art, porcelain. Here I care not so much to dwell on the solid coloured pieces, upon the colouring generally, so much as upon the legitimate use for mere decoration of patterns which have lost their pictorial value. To realize this divorce between painting and design in Tsing, we have only to notice how an utterly spaceless and puttyish bunjinga scroll is hung up against dignified carved walls, or behind beautiful blue and white vases. The bunjin painting has become an art divorced from architectural spacing, and becomes a formless inscription. The really vitally used elements are only those motives which have lost their early pictorial meaning, and have not been adapted into fine spacings upon the side of well-shaped vases. Structurally this art is like that of North American Indians and early Egyptians upon pottery and baskets ; but it is much finer in quality. Elements of Pacific scroll, Han curve, Tang dragons, Sung flowers and Ming landscapes "pool their issues" and fall into order as finely-placed spots. A most splendid illustration is the photograph of a choice small collection of porcelains made at Peking during the occupation. The perfection of the photograph in preserving local values makes us almost see the colours of the originals.

More especially into the porcelain art of Kanghi entered those coloured styles of which I have spoken in the first four Tsing movements. Almost realistic drawings of flowers, birds and fruits were reproduced upon the sides of pale green vases, with brilliant colourings derived from nature study. Upon others branch forms that more recall Sung painting appear ; such rather characterize Ming porcelains. Another range of Kanghi porcelains gives us the little doll-like Chinese figures in blues and pinks, and surrounded by architecture and gardens, which are found in the album paintings of the day, and come down to us as a kind of transcript of the rice paper trivialities. The so-called willow pattern in blues is a Tsing modification of Ming garden paintings, as of Kiuyei—become stiff and prescribed. So we could trace the derivation of every kind of design that enters into Chinese modern porcelain to an antecedent in some of the pictorial or sculptural styles already described in this book. But, of course, this does not detract from the fine intelligence which suggested their perfect adaptation to this exquisite art of porcelain.

The transition from the Kanghi period of Tsing to the Kienlung is marked in the main by the sudden great preponderance of "bunjinga." This is due to the final triumph of the Confucian party after the extinguishing of the Christians, and the full unquestioned adaptation of later Ming bunjinga, and all its false theories, with the added weakness of a new formalism. The tendency of all the decorative arts is toward either quietness or weak repetition of Kanghi. No new creative influence appears, unless it be more specious ways in which bunjinga enters into porcelain pattern. The vague forms and scratchy masses of the Confucian paintings are now sometimes frankly reproduced on the vases. The pictorial art itself grows thinner, and almost without a gleam of creative meaning. The round-shouldered, thin-necked, long-headed ladies of Ming have become the little rice paper lay figures ; independent flower painting, even for pretty colour, has almost ceased ; bunjinga inanities have eaten up all healthy tissue like a cancer. Roughly, and going back to our high standard, we may say that there has been no great art in China since early Ming, except the late Ming and early Tsing porcelains, and no *very great* art since Sung and early Yuen. The long line of fall of Chinese art has not been exaggerated. The end may be seen to-day in any Chinese house or shop, where the most trivial brush scratches appear to deck the walls.

MODERN PLEBEIAN ART IN KIOTO.

The Shijo School.

O F all periods of Japanese art the Tokugawa is the most disturbed, cut up into minor and local effort, without national purpose, concentration or style. The first great cleavage was between the caste of the aristocrats and the rise of the people ; first the artisans in the cities, then their new culture becoming partly shared by the farmers in the country. We have already seen the art of the *yashiki,* in so far as it presents any novel features, consisting chiefly of two schools, the modification of Kano idealism under Tanyu, and the Korin school of impressionism. We come now to a necessarily brief account of other schools, in whole or in part detached from the former, which were organized by the common people of the cities for the purpose of giving expression to their new cultural life.

A cultural life of the common people of Japan was in some sense a new thing. In the older periods of art, such as the Fujiwara, the Hojo, the Ashikaga, education had not been widely dispersed among the masses ; or at least we have little remaining indication of any extensive popular intellectual life. Certainly the recognized schools of ancient art had been practised chiefly by the lords and gentlemen, either of the Emperor's Court, or of the military Courts of Shogun and daimio.

And yet it would be easy to exaggerate the novelty of a popular culture. Indications there are that the Japanese people were never a sodden, ignorant mass of labourers like the Russian Moujiks, a mere trampled foundation upon which the nobles could build their exquisite superstructures. In ancient, pre-Nara days, the order of society was relatively democratic, farmers, soldiers and gentlemen being pretty much one and the same, like the old English Yeomanry. The village popular organization still

exists to-day as the germ of the national constitution. Some of the verses in the earlier anthologies were culled from manuscripts kept as treasures in the houses of the well-to-do countrymen, some the product of their own daughters' genius. And there is plenty to show, from the fictional literature of the Fujiwara age, and from the rebuilding of this material in the *Nō* plays, that the common people, even the servants, understood much of the culture of their masters, and sympathized with it. In the thirteenth century it was the very merry-making of the farmers that led to the comic drama of Kiogen ; and the leading actors of Ashikaga days, the wonderful operatic composers, were not reckoned samurai by birth. It is rather the fact of a *distinctive* culture among the Tokugawa populace that is the new feature ; and this has already been explained in Chapter XV. as the outcome of artificial conditions, by which the samurai were forced to hold their conservation aloof from an advancing world.

No doubt in this divided culture of gentry and populace, each suffered from the separation. The art of the Kano School especially failed to avail itself of the vigorous thought and life of its neighbours in the adjoining wards. On the other hand the art of the people, uninfluenced by those who should have been its natural leaders—directing it into lines of high ideal and refined taste—often tended to fall into triviality and sometimes into vulgarity. The very evils feared and con-demned by Tokugawa censors in popular illustration and the popular drama were due largely to the very exclusive conservation that caused the fear. If Iyeyasu and his successors had not been so intent on giving their samurai a *separate* education, they might have lifted the people to a higher plane of morality. Let it be said to the credit of the latter, how-ever, that, even without such leadership, and through their own inner divination of the meaning of loyalty, they were imbibing through those very condemned popular prints, and through the novels and plays built upon samurai life, some universal conception, however rude, of Spartan morals, a conception that has shown, in recent wars, the sons of Tokugawa farmers to be as staunch patriots, with the same sacred motives, as the sons of Tokugawa bukè. Perhaps, even with all its weakness, we should thank the dualism for giving any chance at all to popular art, and for not forcing it into channels of Kano choosing. Even the school of Koyetsu was too high and "æsthetic" to be popularized. Perhaps no course in popular art but that which actually occurred is conceivable.

But an added weakness, within the lines of popular art itself, was its tentativeness and localization, through which it divided itself into small separated schools, and never approached far toward any single national style. In most places it was rather experimental and amateurish. Its local and personal attempts were mostly doomed to triviality and failure. And it is only in two out of the many experiments that such a powerful technique and such school tradition were so rooted as to make them worthy of note here as great popular academies standing side by side with Kano and Korin. These were the new schools of design that arose among the manufacturing populace of Kioto upon the one hand, and among the artisan and merchant masses of Yedo upon the other. Other local schools, like those of Nagasaki, Nagoya, Fukui, were weak or abortive. Only in the work of the two capitals could arise art which should be at once new, teachable in a clear technique, high in æsthetic character, involving large classes of pupils in several generations, and exerting its influence not only upon mural and panel painting, but throughout the whole local field of industrial design. Such breadth and depth may be said to have been reached by both the Shijo and the Ukiyoye. In the present chapter we shall confine ourselves chiefly to the Shijo, at Kioto.

It cannot be said that the break between the two strata of art in Tokugawa is a sudden one. Rather shall we see, in both this and the following chapter, that the consciousness of a difference was of such slow growth that it can hardly be said to exist earlier than the period Genroku that began in 1688. By that time the Kano and Koyetsu movements had reached their culmination ; and by the end of Genroku they were already starting into decay. The form of samurai organization had now found itself : what it implied all knew. Yedo had now become a great habitable city, and many of the artisans and most of the old school of artists had deserted the ancient seat of culture at Kioto and passed over to the new Paris. Kioto was more deserted and left to itself than ever in its history. Moreover, the Ming dynasty in China had just fallen, and the great reign of the Manchu emperor, Kanghi, was in full swing. The new literary activity in compilation of the Tsing scholars—their summarizing, as it were, of the forms and results of Chinese culture—could not be kept permanently out of Japan in spite of the embargo upon foreign commerce. Nagasaki was

already the sole cosmopolitan city of the empire; for there were allowed to come the sparse Dutch ships to the prison island of Deshima, and there, too, came the only ships that could bring letters and immigrants from China. The Chinese fared better than the Dutch in being allowed general residence in the city, with right to build their own quarters and temples. The people of Japan wanted to understand themselves, their country and the world. Hence the somewhat complex elements that entered into their movement for self-education.

It was a question largely of where new material should be found. People were tired of mystical Buddhism, of nature idealism, and of Fujiwara Court tradition. There was dawning consciousness that they were a great national people, with a great past to be re-interpreted. Hence the new popular histories that were worked out in several places, particularly Mito. It was the unique merit of the scholars of Mito, ably encouraged in this case by an enlightened daimio, that they fixed their eye upon nationality and fearlessly exposed the false position of the shogunate. In Yedo, self-consciousness was being further developed by the popular theatre which had grown up, not so much out of the Nō dramas as of the popular puppet shows. Motoori was about to conduct his important investigations into the nature of pure Shinto, and its relation to the Emperor and nationality. Moreover, there was a great growing desire for facts in the natural sciences; collections of birds, plants, insects were made, geological studies for mining purposes attempted; better methods of medicine and surgery desired. This movement implied a fresh realistic study of the details of Japanese nature on the one hand, and an attempt to derive as much universal scientific information through Dutch sources as possible on the other. We must remark that this eighteenth century is a great era of scientific development in Europe. The people of Japan, though shut out from that Europe by exclusion laws, were eager to share in the universal knowledge, and ready to risk everything to become servants in Dutch families even, if they could get down to Nagasaki, and learn from the foreign factors or learn to read from the few books which they imported.

But some uplifting element, some transcendental standard, some scholarly and intellectual ideal at least—from what quarter could this

be derived? The samurai had their Hangchow idealisms and their codes of honour. But some great inspiration should lie for the people beyond mere facts. All but the most ignorant classes distrusted Buddhism. Christianity was forbidden, and fear of it was the chief discouragement to the Nagasaki movement. Japan had never been rich in original philosophers who can devise great speculating systems or found new fanatical religions. All Japanese-founded sects have been practical simplifications for the people. Could anything come from China? Was there any phase of culture in that strange neighbour race, now so separated as to become an object of curiosity, any line of idealistic standard which Japan had never tried?

This was a momentous question, and it was answered by the bands of Chinese merchants and scholars who now began to pour into Nagasaki, partly as Ming refugees from the new Manchu domination, partly as the general expansion of China's growing population. Yes, there was one form of Chinese culture which Japan had never yet tried—the ultra-Confucian scholarship conception of life and art, which had been matured for the first time in late Ming. Japan, through its very hatred of Kanghi's friends, the Jesuits, became a natural asylum, a sort of Plymouth Rock, for those Chinese puritans who hated all that was new in Kanghi's movements. They brought over their porcelain vases, their teak-wood stands, their ink cakes cast in wooden blocks and gilded, their table weights of marble, crystal and jade, their books hitherto unknown in Japan, and their precious bunjinga and other forms of Chinese-painted scrolls which they hung upon their walls. A new actual type of Chinese cultural life was being lived before the eyes of the Japanese who came down to Nagasaki; and it thrilled them with its evident standards of impersonal devotion. The high literary calm of these Confucian scholars, the novel charm of their surroundings, struck a new ideal. The Japanese scholars saw, were conquered, and went home to Kioto or Yedo laden with treasures to set up little imitation mandarin libraries for themselves.

Without attempting to describe this movement along any other line than that of art, we must declare it at once to have been a combined fortune and misfortune. The actual worth of what it introduced was small. Japan had been, up to this moment, fortunately preserved from the intellectual perils of Confucianism. Ming destruction by the bunjinga

heresy of early Ming art had not touched Nippon. Now the torch began
to kindle, and the fire to start, and the national traditions of Japanese art
over nine-tenths of the popular fields to burn down to cold ashes !

Yet it is not true that only bunjinga came in with this Chinese
movement to Nagasaki. All forms of Kanghi art pressed through the
commercial gap, especially the last remains of pure late Ming bird and
flower painting, and the painting of animals, not yet strongly touched
by bunjinga, was introduced. With them came the coloured flower-
decorated forms of Chinese porcelain. Chinese porcelain, the so-called
Hizen ware, is still the great product of that Japanese province of which
Nagasaki is the capital. Besides the porcelain, at least two contemporary
schools of Chinese art came in at Nagasaki. Several Chinese masters of
the old bird and flower painting actually came on to that city and taught
Japanese pupils in special academies. Among those, one of the greatest
was Chin Nan-p'ing, whom we have already mentioned in the preceding
chapter. There is little of bunjinga in his style, which is highly coloured
and given to the drawing of birds and animals. Although not powerful
in line, it reaches considerable charm of realism. His careful drawing of
rabbits at the foot of a gnarled plum tree is a true relic of pure Ming art,
a Tsing successor of Rioki. There are many flower pieces of his in Japan.
The school of bird and flower painting inaugurated by him in Japan is
a large and persistent one, and soon spread to both Kioto and Yedo.
Such Japanese names as Yuhi, Sorin, Soshiseki and Shunki belong to it.
The whole range of pretty Japanese flower pieces in colour which the
foreign traveller buys for the decoration of his home comes chiefly from
this source. One of the last masters of this same branch, Wunkin, I knew
in Japan before his death in 1880. He was the son-in-law of Shunki.
But we do not consider the school important enough to illustrate.
Another similar school was started by a Chinese painter named Hosaigan,
who seems to have penetrated as far as Kioto. His style runs more to
black-and-white and thin colour. It is not necessary here to differentiate
him from the Nagasaki school as a whole.

But after Kienlung's accession to the Chinese throne in 1726, and the
final defeat of the Jesuit party, the kind of influence his taste had in art
that flowed over into Japan through the channel of Nagasaki was out and
out "bunjinga." The enthusiasm for this new washed-out style of work
knew no bounds ; and Japan, except the work of the aristocratic schools,
became for art purposes, between 1730 and 1760, an outlying province of

"bunjin" China. Province after province was swept by the fire, and to-day, even, travelling over a great part of the interior of the islands, everywhere outside of the castles of the daimios and of the Buddhist temples, we find no ornament in houses and in inns, but the modern Chinese litter, cold bits of jade, and the single undecorative bunjinga kakemono of a monotonous landscape, or a feeble spray of orchids, hung up on the wall. All knowledge of, or care for, Buddhist art, old Tosa art, Ashikaga art (Sesshu included), Kano art, and Koyetsu art, were swept away and destroyed as utterly as if they had never existed. Even to-day the great mass of well-to-do country people, particularly in the central and southern provinces, if shown any of such old works, would shrink away from them, as from the defilement of "vulgarity." When I first went to Japan in 1878 there were many representatives of such views in Tokio, who used to say "nothing but ink rocks and black bamboos are refined enough for a gentleman to paint." It was for such Japanese enthusiasts that the really great Yuen "bunjinga" works were imported in the eighteenth century. Even after the restoration, when the master-pieces of the great Kano artists could be bought for a song, there was never a period when a fine Chinese bunjinga kakemono would not bring several thousands of yen. My praise of the dethroned Kanos caused, at first, considerable surprise and resentment among educated classes.

A great school of Japanese "bunjinga" fanatics now grew up in Japan, whose style in following the most misshapen cows, gentlemen with trepanned skulls, and wriggly-worm branches of their masters shows even in its deliberate distortion a certain distinction. Such is the work of Taigado and Buson, to give conspicuous example. Great specimens of their work are valued to-day by countless Japanese at exorbitant sums. And yet from any universal point of view their art is hardly more than an awkward joke. A Kano painting was anathema to such men. We can see well what would have happened to all ancient Japanese art if these Confucians had got in their deadly work a century earlier. They would have destroyed in Japan all evidences of ancient Chinese art as well, as they had already des-troyed it in China. It was the institution of the samurai alone, and the genius of Tanyu and his Kano followers in particular, that stood out as a great promontory against the mad storm of Confucianism that now beat upon the past. But for the Kano academy and eclecticism at Yedo, and the Shogun's passive patronage of Buddhist

temples, all the Godoshis, Ririomins, Kakeis, Bayens and Mokkeis in Japan would have been swept away and burnt up as old lumber ; this is the literal truth. In Yedo itself, where Kano influence was strong, the Chinese influence mixed itself to some extent with aristocratic technique, and so we have the eclectic school of Tani Buncho, about 1800, which thus resembles the style of the Ming landscape artists who lived from 1500 to 1550. It sometimes resembles Kano, sometimes bunjinga, sometimes the Nagasaki of Nanping—and there were frequent combinations, particularly in Kioto, between the strict schools of Nagasaki and of Bunjinga.

About the central city of Kioto, with its population of non-samurai but cultivated artisans, were surging and raging about the year 1750 every variety of these complex Chinese movements, with an infinity of individual experiments. Here was an answer to the question, What should the people seek for an ideal ? or rather it has a hundred partial answers, given at once. Buson had practically established there a great bunjinga school. Other men, like Shuikei, were introducing a revived kind of Taoist figure drawing, like some of the middle Ming figure painters. Even a descendant of Sogo Shiubun and Jasoku, named Shohaku, was perpetrating extravagant reproductions of old Chinese groups and landscapes in forms about as crazy as Buson's. There were such strange hybrids as a cross between bunjinga and revived Tosa ! No combination was too outlandish for a trial.

It was just then that into this *mêlée* of confused attempts fell a native Kioto genius willing and able to bring some kind of order and style out of contradictory chaos. This man was Maruyama Okio, one of the same educated artisan rank as the majority of the Kioto populace who worked at silk weaving and fine bronze casting. The derivation of his style shows the complexity of the forces that had played upon him, and his power to surmount their confusion. He had been educated at first as a pupil in a modified Kioto branch of the Kanos. Tanyu's own pupil, Tsurugawa Tanzan, had a competent son, Tanyei, who educated into fine decorative work a pupil named Ishida Yutei ; this Yutei had a son, Yutei 2nd, who in the rapid changes of 1740–50 had chosen to go to Nature for fresh feeling, and was painting delicate‑coloured flower, bird and animal screens, in a style half Kano and half Tosa, with a dash of Chinese realism

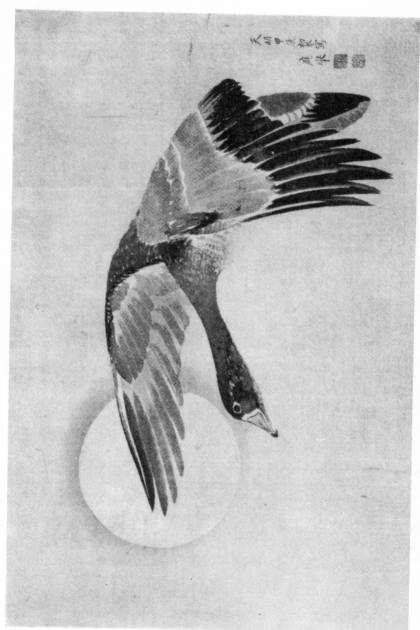

天明甲辰松冬写
応挙 [seal] [seal]

WILD GOOSE AND MOON. By Okio.

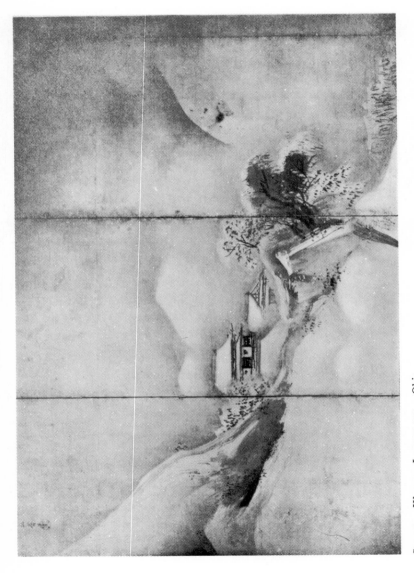

SCREEN—WINTER LANDSCAPE. Okio.

thrown in. This second Yutei was the teacher of Okio. But in literature and in handwriting Okio's master was a prince of the bunjinga, Watanabe Shiko, whose work must have strongly influenced him ; indeed Okio occasionally essayed the pure bunjinga manner, and he was well acquainted with many of the Buson extremists. But Okio kept his head, and to give himself prestige in the movement he had decided upon declared that he went back to China indeed, but to an earlier one, and not the Hangchow China either, but the pure realism of Shunkio in Zen. To enforce the thought he took a name in which the second character *kio* is the *kio* in Shunkio. A double realism was thus Okio's standard—the realism of Yuen, and the new realism of his master, Yutei, extended by his own minute studies of the nature surrounding picturesque Kioto. He wandered through the mountains and learned composition and the laws of tree growth from every picturesque site. He kept about him hens and monkeys and swimming fish, and loved to sketch them in every attitude of motion. The birds and flowers too of his native hills and gardens received his most careful attention.

Now this new move of Okio's has been considerably misunderstood by certain European scholars, notably Dr. Anderson, who have reproached Okio for not carrying out his realistic ideal to full shadow drawing and likeness to European style. Why did not Okio study under the Dutch in Nagasaki ? If he had, his art would have been debased, as Shiba Kokan's was. He founded a school not because he had a new kind of subject, not because realism would lead to a single universal kind of photographic accuracy, but because he had genius enough to see absolutely new kinds of possible spacing and line system in natural suggestion, because he felt new beauties of notan spotting in feathers, leaves and furry bodies, and because he had the power to invent a new technical method of expressing all these beauties. His brush-work, his quality of ink and pigment, the character of his chosen paper, the actual shapes of his strokes and washes, all these are absolutely new affairs, a special technique in which pupils would have to be trained. In the mounting of his kakemonos he mostly followed modern Chinese taste, thereby implying that he intended his school to take the place among modern scholarly people that bunjinga had been occupying. He was a new Chinese realist, if you like, far beyond anything that had existed in China since Yuen at least.

Okio's subjects were taken chiefly from the scenery and animal life of his native Kioto. He sometimes introduced Chinese groupings, but his studies were all before his eye, and had little symbolical value. It was all for new splendours of line, motion and notan. Landscape for him became a new spacing, trees a new law of growth; angles supplanted curves everywhere; textures were studied as never before, and particularly effects of atmosphere. In this way Okio actually forestalled the work of the Barbizon school of France, and outdoor notan planes of atmosphere. In his greatest imaginative atmospheric effects, as in the cloud rack of dragon's sport, he reaches heights hardly below those of Sung masters, though different. He utterly discarded Kano prejudice and generalization. His eye was a new eye, his hand a new hand. His landscapes are often grand, broad and mural—though probably too deficient in strong notan. He works chiefly for middle greys. In his birds and animals he sometimes loses force by becoming too minute. But he never puts in a stroke that does not have organic value for its shape, its tones and its colour; and every group of strokes has also these three values. With him, as with all great masters, nothing is left to chance. He foresees all his marvellous effects. In figures he is the weakest, because he allowed himself to work largely from ancient Chinese subjects where he had to follow Shunkio or some other Chinese tradition. But when he dealt with Japanese figure subjects he sometimes introduces tremendous force, and new ways of expressing notan, quite in the Tosa methods. Yet sometimes he even paints in severe Tosa manner. He paints peasants and city girls too, belles of the tea-houses, and thus forms a kind of Kioto Ukiyoye. It will thus be seen that there is no monotony in him, and that his range is very wide.

A word now upon how this art of his became so popular in Kioto. Though the Imperial Court was at Kioto, it was poor in this world's goods, and the new art could flourish, if at all, only under popular patronage. Who were Okio's patrons? Why, the silk weavers and bronze casters, the embroiderers and fine lacquerers, the æsthetic priests of Kioto temples, the great potters grouped at the foot of Arashiyama, the great merchants who sent their fine wares all over Japan, even to the daimio's *yashiki*. Kioto had been the seat of fine art manufacturers since the days of Fujiwara; and it is so to-day, even in 1906, only

the modern looms of Paris and America have supplanted the old domestic industries of Nishijin. The owners of these establishments, though not samurai, and mostly sprung from families of common artisans, had accumulated both capital and taste in their higher kind of living, and had beautiful private houses and cherry gardens surrounded with high walls. The blank walls of Kioto streets are still a feature. But once within, as I have often been, one is entertained most royally and charmingly by these merchant princes, who bring out from their godowns wonderful treasures of art, ancient and modern. Heretofore they had been patrons of Kanos and Tosas, recently some of them had gone over to bunjinga. But there was little in the latter to suit the æsthetic needs of men who were first of all business men, and not scholars. Moreover, bunjinga had no bearing on Kioto and her industries, being quite unable to furnish any adequate designs where spacing and beauty were to be the keys to success. With Okio, however, the case was different. No landscapes ever painted could work in better for the tapestries and embroidered fukusa—no flower pattern more perfect for the delicate borders of ladies' dresses, for rich fans and great sumptuous rolls of figured satins and brocades. The very dyeing of the cotton stuffs used by the common people was revolutionized by the beautiful two, three and five plate stencils that could be cut from the patterns of Okio and his pupils. No finer relief designs for bronze utensils could be found than delicately-sculptured translation in relief from Okio sketches of fish and monkeys. His grander designs made mural painting as fine as Tanyu's best. Here was indeed an art to patronize, which discharged all the functions of a great school, and yet was both new and native. For Okio made a specialty of the scenery of the neighbourhoods, the flora and fauna dear to his locality. Tosa landscape 500 years before had given a veritable impression of Kioto mountains and valleys, but none of the wonderful mists and cool silhouette effects that lie along these storm-fringed peaks. It was a landscape quiet in colour as Hangchow or bunjinga itself, but purely Japanese—not in the least like Tosa, but exactly reproducing the beautiful suburbs that were the city's pride. Arashiyama, Takano, Chionin, the valley of Tofukuji; views of Lake Biwa, the Yodogawa at Biodoin and Fushimi; delicate old gardens preserved from Ashikaga days, the fineness of snow on great pines and soft maples, the birds that flutter in the branches, the wild deer and monkeys that call from

the wild valleys about Kozanji—all these spots and subjects of fame and beauty entered into Okio's work and made of it, amid popular enthusiasm, a perfect and complete civic art.

Works of Okio are to be found in all the principal collections of the world. He is now held to be one of the great national geniuses. But when I first went to Japan in 1878, his name was hardly known to Yedo dealers and collectors. His reputation had remained local in Kioto and the neighbouring city of Osaka, to a less degree in the manufacturing centre of Nagoya. There are specimens in Japanese, English, German, French and American collections, and especially in the hands of the great Japanese merchant-princes of the new Meiji era. Most of these were derived from the old eighteenth century collections of Kioto business houses.

What seems at first most novel in Okio's work is his animal painting. Here are the furry bodies of monkeys, dogs, cats, and foxes and deer, conceived as new pictorial substances. He was specially fond of painting little fat roly-poly puppies. His great white monkeys in Boston are done by a new broad black and solid white touches on grey paper. In swimming fish he invented a new art, where the beautiful flexible curves of the slippery bodies, and the graceful lines of their motion, form the very substance of the picture. It is also beauty in convention. The finest specimen is the great carp screen owned by Prince Daté, the former lord of Sendai. Delicacy of motion drawing can no further go.

Of birds, Okio was most fond of hens and of wild ducks. The fluffy feather tones, worked in with transparent colours, were most beautiful. For birds of flight, generally wild duck and geese, Okio is as transcendent as for his fish. They are not generalized blots like the flying birds of Kano, nor are they all line like the careful birds of Sesshu. They are as alive as Toba Sojo's animals, yet finished in all their modelling, spotting and colouring. Fine examples are in Mr. Freer's collection. Especially fine is his great four-panel screen of two wild geese flying over the surf of a flat shore. The lines of breakers rolling in are hardly more than light lines upon a broad unbroken background of grey. Against this atmosphere the contrast of the dark grey and black tones of the flying birds comes with startling force. It is a daring study in values that even surpasses modern Europe, Monet and Whistler.

In landscapes, Okio's earliest style is in many respects like Kano, even Tanyu, as especially seen in the Fujiyama with cloud, in the

STORM DRAGON SCREEN. By Okio.

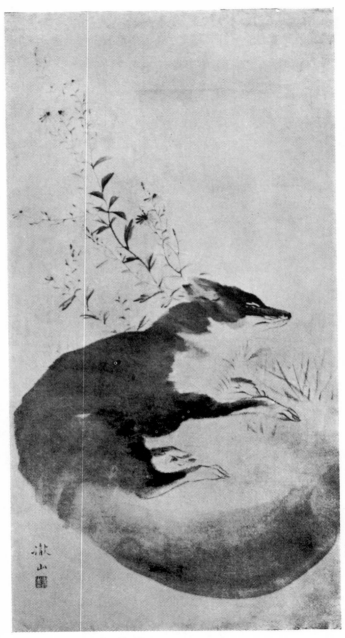

SLEEPING FOX. By R. Tetsuzan.

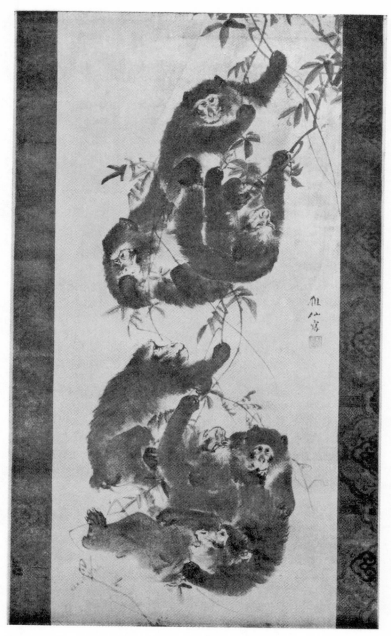

MONKEYS, SHOWING BROAD TREATMENT OF FUR.
 Sosen.

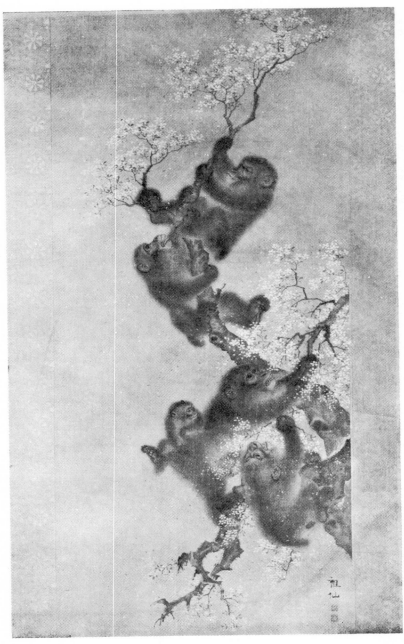

MONKEYS, SHOWING MINUTE TREATMENT OF FUR. Sosen.

Fenollosa collection. No finer treatment of soft cloud was ever done than this. In snow landscapes, as in a rough sketch on a paper screen in Boston, he reaches great heights. Snow takes utterly new forms under his precise brush. They are not so grand as the snow pieces of Sesshu and Motonobu indeed ; but they build their beauties upon modern realistic drawing and spacing. A very beautiful landscape in Okio's most tender manner is owned by Mr. Dwight F. Davis, of St. Louis. A waterfall leaps from the high level of a mountain lake, across granite cliffs, to a charming inhabited valley. No one, not even Ruskin or Turner, has ever used finer pencilling.

But Okio's greatest landscape work is mural ; finest of all the great pine and shore scenes on the walls of a room in Mr. Kawasaki's private Kobe museum. Mr. Masuda, of Tokio, has others. The greatest rock and waterfall screens in this mural manner are those owned by Mr. Nishimura, the great silk manufacturer of Kioto. His pines stand up gaunt, straight-lined and long-limbed, yet with fan-like foliage in pure flat areas of exquisite greys, for all the world like photographs of scenery in that part of the country. While scratching in individual pine needles, he does not lose the mass, as even do the great Hangchow landscapists. In short, what Okio gives us is not the old graceful and powerful conventional compositions, but new and unexpected angles of spacing, striking even if awkward, and the breadth of outdoor masses in notan. In spite of the newness and vividness of the impression, however, it cannot quite make up for the magnificent imaginative suggestiveness which it loses.

Perhaps the most stupendous efforts of Okio are when he chooses to combine motives of landscape, storm cloud and the animal forms of dragons in violent motion. Here, in his greatest pieces, almost as complicated as a Sesshu, he rises close to Hangchow, Mokkei and Chao Ch'ang. In one of his finest screens he makes a great storm dragon arise from a rocky coast, against which the tortured waves leap and boil in foam. On the left, water and cloud are swept into a single opaque mass. The body of the dragon is as realistically modelled in drawn scales as an enormous lizard in bronze. In power of form, complexity of structure and brilliancy of notan, this rises very close to the level of Koyetsu.

In his figure pieces Okio tends to become more delicate. His drawing of Chinese ladies, in full colours, is most exquisite, but a little

hard. There is a sort of wooden heaviness in Okio's mind that here shows itself most, a lack of idealism. It is a relic of his Shunkio, Yuen, proclivities. Again, in his Chinese men and women, and some of his Japanese, he falls back on stunted short-nosed types of face, such as were liked by Chinese and Japanese bunjinga. On the other hand, his cleverest figure work is done in vigorous drawing on makimono of scenes of human life. The greatest of these is his "Seven Misfortunes of Man," in famous rolls kept at Miidera of Otsu. Here crowds are shown in extreme suffering of earthquake, tempest, conflagration, murder, execution, etc. It is one of the most horrible things in the world in its excessive realism. There is no flinching from the utmost expression of horror and pain. The agonies of a man, still conscious, but being burned alive in execution at the stake, are most minute. If we compare this notable work with the tremendous torture scenes in Nobuzane's Hell, we shall divine the immense superiority of the latter, in that the splendour of the composition and colour really cast a glamour over the scene, whose awful details become a few mosaic details of the spectacle. But in Okio, there is not an æsthetic or moral justification to palliate the bare realism. Probably the least offensive passage is the lightning flash, whose foreground trees are split in the midst of an illuminated storm, and one of the fleeing figures is prostrated. This is reproduced from the original sketch or study. It is interesting that, in spite of its professed realism, no trace of imitating European style through the Dutch is found in Okio. He evidently regarded it as of bad form and unæsthetic.

One other kind of figure piece Okio occasionally did, namely, the portrait painting of certain Kioto belles, with much the same motive that actuated his contemporaries Harunobu, Koriusai and Kiyonaga, in Yedo. We may call this style Kioto Ukiyoye. Into it he sometimes threw an intensity of realism and a finish of effect that relate to his Shunkio Chinese style. His chief follower in this line of work is Nagaku.

But now the Shijo school could never have risen to its vast range and influence, had not Okio been strong enough to associate with himself other powerful artists who had also been making experiments, and had he not been able to teach to a host of able pupils the very definite technique which he had invented. Here indeed, in the long

roll of names of scions of this school through three and four genera-
tions, down to the present day, we have a splendid phalanx of original
minds, who, though never more powerful than the originator, introduced
fresh feeling and modified beauties of execution from point to point.

Of these the most important group was found by Goshun, and his two
brothers Keibun and Toyohiko. Goshun had originally been a leader
of the bunjinga artists, a follower of Buson and Taigado, and one of
real talent. His crow on a woolly tangle of branches, in Boston,
exhibits this phase. But Goshun soon fell under the influence of the
superior order and beauty of Okio's work, and went over to him,
with all his house. The group later established themselves in a
special and prolific atelier near the head of Shijo, or "Fourth Avenue"
Bridge in Kioto, and from their combined work the school took its
name, which has been generalized as applying to the whole mass of
work that derives from Okio. The more narrow of the hair-splitters
and name-riveters of Kioto would to-day condemn this wide origin,
and have it that Goshun and Keibun founded a separate school, not
under Okio, but parallel with him, and that the name Maruyama school
ought to apply to all other Okio-descended tradition than theirs. On
the other hand, every prominent teacher of each generation of the
Okio school demands the same sort of nominal exclusiveness for his
pupils, so that we should be driven to recognize some twenty different
schools in Kioto if we adopted this classification. The Ganku school
certainly more deserves a separate name than Goshun's. But there
is prime need, in speaking and writing, for some common name to
express the whole Kioto work, from 1760 to 1900, that originates
with, and grows out of, Okio. And since the name Shijo is so
generally identified with the total movement, both in Japan and in
Europe, it seems best to adopt it.

While the composition of the Goshun-Keibun school is much like
that of Okio, its execution is a little softer and more blended. Okio's
dry, often crumbly, even-breadthed outline touch hardly appears in
it. Its tones are more liquid, its colours more tender. On fine leaves
it was more of a wedge-shaped stroke. In broad leaves it gives gradation
even in single broad washes. This is its peculiar technique, developed
somewhat further than Okio's, to so charge different sides of the brush with
inks of varying tone or with distinct colours, as to be able to execute a
transition and a blending with a stroke consisting of a single sweep.

Goshun's careful landscapes are of especial beauty. His bamboo stems make a simple but very beautiful composition. Keibun is especially happy in his bird and flower pieces, whose leaves seem fairly to pulsate with modulated tint. Toyohiko has left us a finely-painted deer under a pine-tree upon a two-panelled screen in Boston.

Of Okio's direct pupils there is a great host, all celebrated men with strong individualities. Kirei is the arch-impressionist ; Genki excels in developing Okio's greys ; Okio's son, Ozui, has left us a beautiful Arashi-yama landscape, at Boston ; Rosetsu has always some humorous antic phase, even in the expression of his puppies ; Taichu became a photo-graphically minute landscape realist ; Chokken painted birds and animals in a most suave style, especially fine with snow. Among the greatest is Tetsuzan, who worked equally well in all subjects, though his sleeping fox at Boston is an exceptional masterpiece. Here, the blurring of the red tail thrown far toward the spectator in foreground enlargement, and the focussing of the eye upon the distant head, both by the unique darkness and sharpness of the touches there, and by the clear hair lines of the weeds, give an exposition of modern optical truth combined with æsthetic laws of centralization which goes far beyond what our modern photography has yet introduced into our art. Toko, the great specialist as a fish painter, merits special attention, though the limitation and same-ness of his work makes him a little monotonous. Nangaku is the chief pupil who is greatest as a figure painter, and he is best, not in his Chinese ladies, but in his Kioto Ukiyoye drawing of belles and tea-house girls.

Of this same first generation of followers, though not so closely the personal pupils of Okio, must be specially mentioned two men who have become, in spite of Okio's prestige, Japan's two best known animal painters, and both of whom have founded art schools. The better known of these in Europe and America is Sosen, the famous painter of monkeys. Fine specimens are in all the world's collections. Sosen vibrated between two extremes of execution, a minute style on silk in which he drew every hair of the coloured fur, and a rough style in which he relied upon bibulous paper to give the effect of fur by soaking up the broadly-placed washes of a large brush. Both of these styles are per-fectly exhibited by specimens in Boston. Naturally artists prefer the rougher style. But it is a great mistake to suppose that Sosen could paint only monkeys. He did all kinds of furry animals, especially

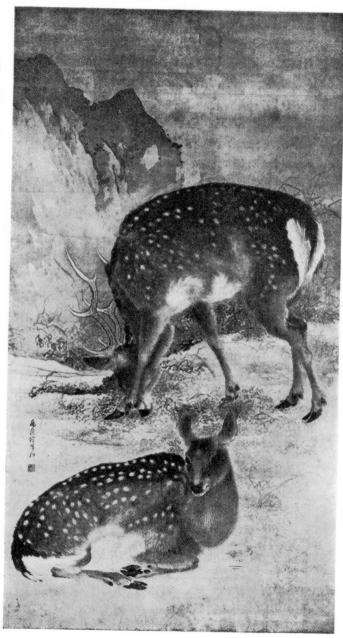

DEER. By Ganku.

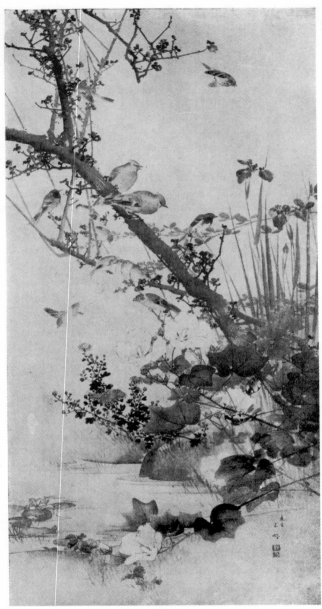

FINE STUDY OF FLOWERS, FOLIAGE
AND BIRDS. By Giokuho.
Fenollosa-Weld Collection, Boston.

cats, rats, dogs, foxes and deer ; and he was peculiarly fine in birds, Mr. Freer's peacock in colours and the fine pea-hen in glossy ink at Boston being notable examples. Sosen also occasionally painted pure landscape, and very rarely figures.

The other animal painter, and founder of the special Kioto school, is Ganku. He, like Goshun, was already a noted worker in another style, the pure Nagasaki Chinese style of Nanping, before he fell under Okio's all-dissolving influence. Even then he refused to follow Okio's touch in detail, developing for himself a rough vigorous style much more renowned than Goshun's. It consists of a kind of crumbly woolly texture, which is suggested by the very strongest of later Chinese work. It is much more pictorial and grandly spaced than bunjinga. Ganku also painted all subjects, being very strong in animals, landscape and figures. His figures, however, are a little too much like modern Chinese, and monotonous. His magnificent peacock in colours in silk is one of the greatest treasures of Mr. Nishimura's collection in Kioto. There is a fine study on paper, for a painting in similar style, in Boston. But his greatest forte was animals, and especially tigers. Ganku's tiger is almost as specialized a celebrity as Sosen's monkey. There are several fine tigers in Boston. But Ganku's greatest masterpiece is undoubtedly his elaborate painting on a large silk of two Japanese sacred deer, which was one of the greatest treasures of my collection that went to Boston. I suppose this to be one of the greatest animal paintings of the whole world. There is a European solidity of finish and motion about it that Okio did not attempt. The composition is also most beautiful, forming a kind of letter S through the two connecting heads. A fine summer landscape shines in mist behind. The fur is broadly painted in quiet colour. Here we come into comparison with the best of Rubens, Jordaens and Paul Potter, and with the animal drawings by Dürer. I acquired the work in 1879 from a picture dealer who had never heard the name of Ganku, and knew not how to place him. This picture was shown by me several times in the yearly loan exhibitions of the nobles' art club in Uyeno, from 1882 onward—it was borrowed for the Emperor, and Mr. Nishimura tried to make a cut velvet copy of it.

Among the third generation of the Shijo school, which we may consider to have reached its culmination about 1840 or 1850, were many noted names. Of Goshun's pupils, Keibun, Gito and Toyohiko,

and of Keibun's, Seiki, Giokuho and Hoyen, are all great painters. A specially fine and elaborate Giokuho in Boston shows how flower stems could be so painted as to grade from side to side (by varied brush charging), and from end to end (by varied pressure), with only a single executive sweep of the arm. Tetsuzan's son, Mori Kwansai, lived late to modern times, and I visited the dear old gentleman at his house in Kioto before his death in the late eighties. Ganku's son-in-law, Renzan, and his sons, Gantei and Ganrio, were good artists, especially the first, who has left us many birds and animals and landscapes. But among these Kioto painters of 1840 is a group who made such a special showing in original work that I feel like classing them together as the " four landscapists," and of devoting a special word to each.

One of the four was a pupil of Ganku, Yokoyama Kwazan, whose " peach-garden " on silk, and the wanderings of Tokiwa Gozen, the mother of Yoshitsunè in snow, on a screen, are important pieces in Boston. He has also left beautiful coloured paintings of maples at Takawo and Tofukuji.

Another is Ippo, the greatest pupil of Tetsuzan. His breadth of execution and daring square touch make him almost worthy to be called the " Sesshu of Shijo." It is like a photograph, or an American student's school work in two tones. There are many fine pieces in Boston, including a pine tree in snow.

The third of the great landscapists of 1840 is Bunrin, the greatest pupil of Toyohiko. His style is heavier and more muddy—more European perhaps—than that of other members of the school ; but he reaches great atmospheric effects, and is specially fond of snow and mist. The great bank of Arashiyama pines in snow is owned by Mr. Freer.

The fourth is Nishiyama Hoyen, who, though trained in Kioto under Keibun, did the greater part of his work in the neighbouring commercial city of Osaka. He was the last great all-round artist of Shijo, living down to about 1865, and being very exquisite in landscape, birds and flowers, and human figures. But perhaps he is most conspicuous in landscape. There are some sixty or seventy fine pieces of his work in the Boston museum, most of them belonging to the Bigelow collection. Dr. W. S. Bigelow made a specialty of collecting Hoyens in Japan between 1882 and 1889. The delicacy and precision of his line work and the melting tone of his colours are beautiful

beyond stating, but he has not the masculine vigour of conception that we find in Okio. But the sweetness and purity of natural effects in the Shijo manner can no further go. His greatest figure piece in Boston is a Kwannon in white, seated cross-legged on a rock by the sea. This shows the almost unique power in a Shijo artist to take a religious subject well worked by great Chinese and Japanese artists, from Godoshi to Tanyu, and produce an entirely new version of it, and adequate to the purity, if not to the grandeur of the subject. One of the most lovely flower pieces is the elaborate branch of young pink plum blossom, upon which perch two little birds in black and yellow. There are four of his Fujiyama landscapes in Boston, of which the one that shows Enoshima and the curving beach in the foreground, and sunset clouds shrouding the mountain in tinted gold mists, belongs to the Fenollosa collection. Such coloured atmospheric effects have been rare in modern Japanese art. In his earlier and often rougher works on paper we have wonderfully vigorous rustic impressions, as of an old farmer's hut with high straw ricks on the great plain behind Osaka. This is like a contemporary charcoal drawing by Millet. In effects of rain upon soaking foliage his tone is purer than · Bunrin's. Finally, in symbolism, rare among Shijo artists, Hoyen has left us his misty sun producing the first rice plants from chaos. We may regard this as his way of expressing "The Creation of Man," through human food. Its exquisiteness of drawing and tenderness of colour are charming.

Of the fourth generation of Shijo few artists attained great fame. The weakness of imitation was upon them. Many are still living, and some working, in Kioto and Osaka to-day. Hoyen's son, Shuikei, I knew intimately at Osaka. Kubota Beisen is personally known in America. But Bairei, the best pupil of Bunrin, also a pupil of Raisho, is known the whole world over, if only for his flower books printed in colours. Bairei was a dear friend of mine for many years in Kioto. Kawabata Giokosho, spoken of in the next chapter, is a pupil of Raisho. Kishi Chikundo, the adopted son of Renzan, painted the great tiger shown at Chicago in 1893. He died only a few years ago.

Of the fifth generation we have one really great man, Takenouchi Seiho, still young, pupil of Bairei, and who is the most successful teacher in the art school at Kioto.

It would not do to close this chapter without a word more upon the splendid effect this Shijo School has produced upon Kioto design, especially

in the patterns for stuffs. Even to-day, much of the finest designing done for the splendid gold-shot brocades, manufactured for the imperial household, or shown in the great Tokio shop of Mitsui, is made from Shijo drawings. A large part of the great designs for embroidery and cut velvets, done by Nishimura, Kawashima and Iida, have come out of the studios of Burin and Chikudo. We show here a typical example of a Shijo-Kioto stencil, among the hundreds of thousands from which the finely-printed cotton and silk stuffs used by the people all over Kioto have been stamped. The more special process of Yuzen dyeing has also used Shojo design. The whole life of Japan, in so far as its industries centred about Kioto, has been enormously enriched by this great line of work that Okio had the genius to originate. It gives us an absolutely new and fertile species, though late-sprung from the great genus of Chino-Japanese art.

TYPICAL STENCIL DESIGN.

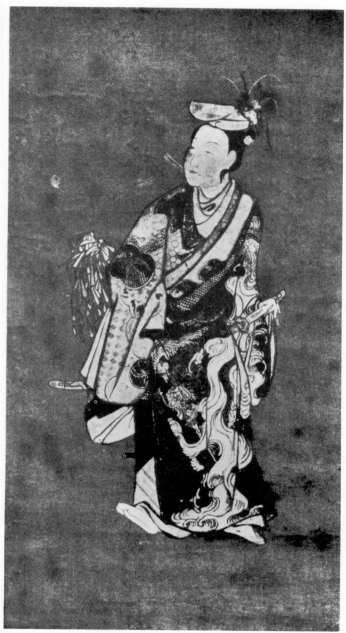

PAINTING. School of Matahei.

PLUM BRANCH AND NIGHTINGALES. By Hoyen.
Fenollosa-Weld Collection, Boston.

Fuji from Enoshima. By Hoyen.
Fenollosa-Weld Collection.

Farm Huts and Well-sweep. By Hoyen.
Fenollosa-Weld Collection, Boston.

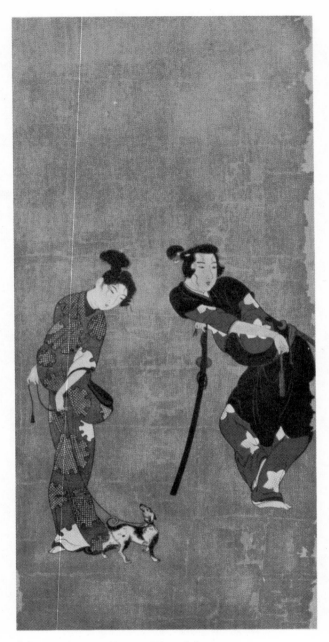

A Panel from the Famous Hikonè Screen.
By Matahei.

MODERN PLEBEIAN ART IN YEDO.

UKIYO-YÈ.

Prints—Illustration—Genre.

B UT we have not, even yet, fully exhausted the great branch varieties of Asiatic art that have grown out of the Japanese stem. There still remains one great school of popular art which has covered portions of the three last centuries with genre studies of the life of the masses, most important both for history and for æsthetics. It is this school only which European and American students as yet know much about, because its work has been so widely disseminated in printed sheets and books. Even in the 1850's, immediately after the opening of Japan, many examples were exported to America, London and Paris ; and writers such as Jarves, and artists such as Lafarge, François Millet and Whistler eagerly studied the amazing revelations of power along the very lines in which they were pressing their own innovations. It is hardly too much to say that all the new phases of European art down through the last fifty years, including all phases of "Impressionism," have been influenced more or less strongly by Japanese Ukiyoyè. Whistler, while by no means a slave to it, did not pretend to conceal the influence.

Many misconceptions have arisen, however, among foreigners with regard to this great school of Ukiyoyè. It has been declared to be the only pure form of Japanese art untainted by Chinese. This ignores the fact that the whole Tosa art of the third period, and the aristocratic art of the Korin school in the fifth, are purely Japanese in style and subject. It is also held that this genre art of Yedo is the only form of Asiatic art ever developed by the common people. That this is not true can be seen by pointing to the Shijo school of Kioto and Osaka. Again it is often made out that this Ukiyoyè is primarily a school of printed art, and is treated as

if it included all book illustration. The truth is that, on the one hand, it is as much primarily a school of painting as is the Shijo ; and that, on the other, much of Japanese book illustration belongs to Shijo art and to the work of the Kano pupils of Tanyu. This is only another illustration of the æsthetic confusion that issues from classifying through industrial methods. Any school of design may use the method of printing, but that which makes it an individual school is its manner of drawing, spacing, spotting and colouring.

It is true, however, in spite of these misconceptions and over-statements, that the Ukiyoyè school of Japanese design is foremost of those which *in modern days* have taken Japanese life for its motive ; that it is peculiarly the art of the common people of Japan's largest city ; and that Japanese colour-printing derives its most telling experiments from Yedo popular artists. Yet, though the printing may be the most striking novelty in Ukiyoyè, it must be remembered that it would still furnish us a most original school of painting, even if printing had never been invented.

We have already seen that Tokugawa art is hopelessly divided into two water-tight compartments, the art of the soldiers, and the art of the people. It was indeed in the Shogun's great capital city of Yedo that this duality grew to its strongest opposition in the eighteenth and nineteenth centuries. The two antagonistic parties were the Kano and the Ukiyoyè. And yet the Ukiyoyè, in its earlier phases, of the seventeenth century, is not at all characterized by this opposition, since it grew out of Kano art, and it worked at Kioto. These many phases of it make its history a somewhat complex thing to state.

To understand fully the origin of the movement which we now call Ukiyoyè, we must go as far back as the Kano school of late Ashikaga art, described in Chapter XIII. We saw there that a certain thin stream of Japanese style and subject in art had trickled down through the chinks in the prevailing Chinese-ism of Ashikaga, linking the ancient school of Tosa that had originated in the twelfth and thirteenth centuries with the Tokugawa revivals of the seventeenth. We saw that the link took the form of a marriage between Mitsuhisa, the daughter of Tosa Mitsunobu —last legitimate descendant of the ancient house—and Kano Motonobu ; from which union of the two schools sprang a more or less continuous translation of Tosa subjects into terms of Kano penmanship which lasted from Motonobu to Shosen. A great historical work in many rolls, and in full Tosa style and colouring, which had been ordered

by the Shogun's Court from Kano Isen, Seisen and Shosen, was still unfinished at the abdication in 1868. We have seen that Tanyu himself was often most happy in Japanese subjects, Tosa-ish or realistic. But all this phase of Kano art did not quite constitute Ukiyoyè. In most cases the Kano subjects were still the old Court scenes of Fujiwara, or the military tragedy of the Heike, or the narrations of a temple's foundation (Engi). Ukiyoyè is peculiarly a study of contemporary life, and that, too, of the more fashionable or pleasurable side of the popular life. The very name " Pictures of, or the Art of, the Floating World " means that it deals with transitory and trivial phases, contrasted in Buddhist phrase with the permanent life of moral idealism.

The lack of moral purpose in Chinese subject had crept in with the second Kano style, of Yeitoku, in building his gorgeous figure decorations in gold and deep colours for the walls of Hideyoshi's palaces. It only required that, as a relief from the monotony of Chinese Court ladies and gentlemen, the Kanos should occasionally turn to another source of gorgeous gaiety—namely, the life of the dancing girls, the wrestlers, and the humorous *contretemps* between the mighty samurai class and these vulgar pleasure-givers with whom they mingled " on the sly." It was probably not until after the death of Yeitoku, even after the accession of Iyeyasu, and before the new Yedo dynasty had acquired power to curb the dissipations of Kioto, left to itself without a military head, that excursion into this new line of Japanese subject was often tried. Yet pure examples from Yeitoku's pen will probably be found. The difference between these Hideyoshi and post-Hideyoshi experiments on the one hand, and the Kano-ish-Tosa persistence and the Tosa revival on the other, lies as much in technique as in subject. It was the use of large figures for mural work, as large as the great screen effigies of Chinese Emperors and their Courts, and of the same deep-glazed colouring over a gold ground. The lines and proportions of the drawing are essentially Chinese—Yeitoku-Chinese. The intense rich colouring of the Chinese lords forms a splendid medium to render the equally rich and gold-shot fabrics of the Japanese dancing girls' robes. The patterns outlined are large and heavy, not unlike some Chinese patterns ; indeed our knowledge of Hideyoshi design in popular costume depends chiefly upon these rare paintings.

If, then, we can imagine Kano Sanraku, about the year 1600, deliberately replacing the courtiers of Taiso of Tang upon his walls and screens, with the tall, graceful, moving figures of contemporary

dancing girls, using the same suave Kano outline, and the same deep
lapis-lazuli blues, malachite greens, and the placing of cochineal car-
mines over orange vermilions, and backing the screen with great
booming clouds of gold, and touching the threads of the dress patterns
with the gold paint formerly reserved by Yeitoku for Chinese dragons,
we shall discern the real beginnings of Ukiyoyè. It should be noticed
that the movement is exactly contemporary with the similar beginnings,
out of Yeitoku palace decoration genus, of the aristocratic school of
Koyetsu. Often the early Kano Ukiyoyè figures became smaller, between
1600 and 1620, like the smaller figures upon their Chinese screens.
Sometimes they are found even on silk kakemonos or on fans. By
1620 there was yet no separate thought or name for two diverging
movements, the girl-painting in Yeitoku colouring of Sanraku, and the
flower-painting in Yeitoku colouring of Koyetsu ; the only difference
being that Sanraku was more relying upon the realistic impression that
he could get from his living world, and Koyetsu more and more relying
upon being able to translate his subjects into a kind of impressionism
suggested by old Tosa. " Kano-ish Realism," " Tosa-ish Impressionism "
—these terms well express the germs of the coming variation. Following
Sanraku, the sons and other pupils of Yeitoku, especially Mitsuoki,
took up this fresh Kioto genre, and have left us splendid gold screens
that differ from Yeitoku's only in the new subject. It is in Mr. Freer's
collection that we have the chief chance to study this peculiar phase.

One of the most beautiful of the Sanraku pieces is the set of four
sliding doors, directly from a wall, with graceful Japanese figures of
women and children. The pine-trees are pure Kano of the Yeitoku
type. In this case there is almost no gold. The tallness of the
figures, like Yeitoku's Chinese women, and the excessive grace of
their lines of curve (to say nothing of the colouring), are all utterly
unlike anything to be found in Tosa, ancient or modern. Notice the
large simple dress-pattern, as of the wistaria branches. A very beautiful
and more careful kakemono upon silk, of a Japanese lady seated upon
a Chinese high-backed chair, is in the Fenollosa collection at Boston.
It is signed with Sanraku's name. Here the broad, heavily coloured
pattern of the waves and cherry blossoms is in pure Kano school, and
shows exactly the Kano root of Koyetsu. The lines are still almost
graceful to excess. Of Kano Mitsunobu the great six-panel screen
with gold clouding showing a Japanese interior decorated in the Yeitoku

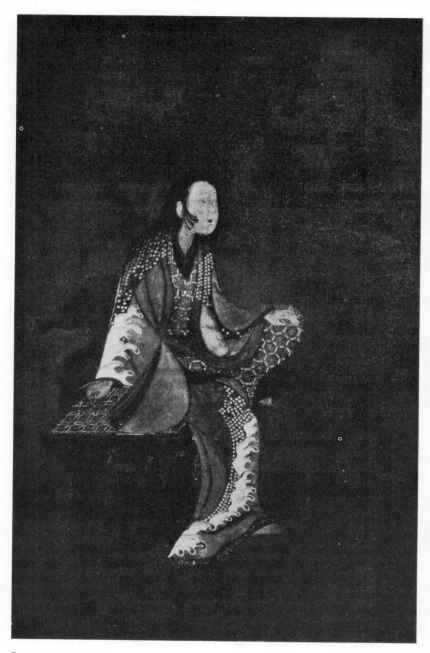

SCHOOL OF MATAHFI.

PAGE OF BOOK ILLUSTRATIONS BY MORONOBU.

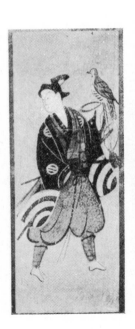

EXAMPLE OF OTSUYÈ.

manner, and very tall girls and children, is a splendid example. Here
the figures are not so graceful, inclining to stoutness at the waist ;
but the strange attitudes come evidently from close realistic study.
The dress patterns run into a still more violent cloud and wave curve,
being of deep and startling colour. The doing of the hair into great
twisted puffs at the top of the head, though hanging down the back,
is characteristic. The tallest figure is about four feet in height. The
face of the young girl in purple is Egyptian. Though unsigned, this is
surely to be attributed to Mitsunobu after comparison with his Chinese
screens, and some of his small signed kakemono. The use of snow-
covered Fuji in the house decoration is interesting, as a forerunner of the
treatment of the same subject by Korin 100 years later. The walls of the
inner room have ink landscape decoration, also of the style of Mitsunobu.

Up to this point, doubtless, the name of Ukiyoyè and the thought of
a separate school had never occurred. It was only when a new artist,
Iwasa Matahei, basing his style upon the Kano work of the Yeitoku
school, and upon the Japanese figures of Sanraku in particular, made it his
life-work to treat these subjects only, and to develop them into a manner
peculiarly his own, that Ukiyoyè, as a consciously independent movement,
can be said to begin.

About this obscure artist, Matahei, an immense amount has been
written. He has become a subject of Japanese legends, entering into
drama and romance ; and his work has been confused with that of a host
of contemporaries. We cannot go here into the unravelling of these
extreme views ; ranging from the European acceptance of any rich colour
and gold girl-painting done between 1620 and 1680 as an unquestionable
Matahei, down to the recent thesis defended in the Japanese journals that
we have no proof that such an artist as Matahei ever lived. We can trace
in existing specimens at least two great movements in this Ukiyoyè of the
seventeenth century—one apparently derived from Sanraku, and one from
Mitsunobu ; and evidently at least half-a-dozen individuals were at work
in each. Now among those individualities we can identify one so
commanding, so developing the graceful style of Sanraku toward graceful
realism, that we can say this individual—whether his name was Smith, or
Kato, or Matahei—did exactly this very thing for which Matahei has the
fame ; we shall therefore call him Matahei.

Matahei's most celebrated piece of work is the great six-panelled screen
called by all Japanese "The Hikone Biobu" (screen), because it was the great

treasure of the daimio of Hikone Castle on Lake Biwa. It was sent to the Exhibition of 1900 at Paris by the Japanese Government, which is said to have insured it for 30,000 yen. It represents graceful figures of men and girls and children in rich colours upon a gold ground, seated upon the mats in utterly unrestrained Japanese attitudes. In the centre of one screen an old blind musician is giving a lesson in samisen playing to two girls, while a party of young people near by play a game of Go. Behind those two groups a beautiful landscape screen, evidently by Kano Motonobu, is unfolded. Another group shows us tall slender girls—like those of Sanraku—walking, while a gay young samurai leans in a most unconventional attitude upon his long sword. This shows us a tendency to dissipation that may well become the degeneration of the whole bukè class, if not checked. The drawing of the drapery is less stiff and more realistic than Sanraku's. Another screen of identically the same artist is a low six-panel one of gold ground, belonging to Mr. Freer. Here, also, there is depicted an open Motonobu landscape screen behind the principal group. The exquisite rendering of the Motonobu lines and tints shows what a fundamental study of Kano art Matahei must have made, and, at a time when the eclecticism of Koi was throwing attention upon old masters. We should therefore place these works somewhere about 1630 or 1640. The lines of the young girl seated upon the bench with drawn-up knees are among the most graceful in all Japanese art. The female coiffure, with a great puffed brush behind, shows a later manner than the top coils of Mitsunobu. That in his last days Matahei went over to a still finer realism, discarding the gold surroundings, and gave us great figures of girls and children in more angular touch, and in low silvery tones more like those of Koyetsu and Sanraku, is almost certain.

Matahei's claim to have founded Ukiyoyè, taking, as it is said, the name upon himself, is confirmed by the host of pupils, mostly unnamable to-day, whom he left. It is their work, and the work of contemporaries, in part distinguishable, but without assigned names, which fills in the gap between 1650 and the work of Moronobu in 1680. It is probably Matahei's son who is figured in the first plate of my large book on Ukiyoyè. Another example of the day is Mr. Freer's exquisite little painting of a showman exhibiting a dancing monkey to some girls. Many of these unsigned paintings are to be found in every collection, but none reach to the truth and grace of Matahei's drawing. Another artist who has been confused with our Iwasa is a second

man of the same name, Matahei or Matabei, who worked in Echizen at a later date, but one which overlaps Matahei. His work is characterized by much more awkward drawing, and longer and more formless and even slighter Tosa-ish faces. The cheeks and chin have a swollen appearance. The colour is Yeitoku-ish, but of that later period when it is striving to hold itself against the new Tanyu manner, as in Kano, Sansetsu and Yeino. After Yeino, about 1650, the last trace of the Yeitoku colouring goes out, except in Ukiyoyè itself. Mr. Freer has a fine wrestling scene by this secondary Matahei. By 1770 the Yeitoku colouring has nearly reduced itself in range to a somewhat hard green, orange and gold.

The so-called " Otsu-yè " was an attempt to cheapen and popularize this new school of painting by issuing editions of rough sketches many times repeated. A firm, rapid outline was drawn in ink on all the sheets, and then the spaces were filled in with a few touches of wash in green, orange and yellow. They were sold among the poorer people for a very small sum, and are evidently the precursors of the single sheet prints. Because Matahei is supposed to have lived for a time in the city of Otsu, on Lake Biwa, where these sketches originated, it has become part of his legend that he was the author of them. Many of the Otsu-yè now seen were issued as late as 1700 ; but the earliest forms may go back to 1660 and 1670. Japanese dealers to-day frequently attach the name of Matahei to any specimen of Otsu-yè, thus helping to confuse a confusing subject.

Though Japanese book illustration began as far back as 1608, it had at first nothing whatever to do with Ukiyoyè. The first book with wood-block plates in outline was an edition of the Ise Monogatari, with Japanese figures of Tosa costume of course, yet drawn with landscape accompaniment in the pure Kano style of the Yeitoku branch. Printed illustration had been used for Chinese books for several centuries. Here the method of cutting is almost pure Chinese of Ming. But the drawings look as if they had been made by Kano Mitsunobu. Many other books of similar style were issued during the middle of the century. But it was not till about 1650 that some illustration became frankly Ukiyoyè, that is, reproducing graceful, and generally over-tall, figures of girls in outline, and drawn in the style of the Ukiyoyè painters of the Matahei school. Such experiments were rare, however, before 1670.

The temporary decay of Ukiyoyè after 1645 is accounted for by the absence of a clear technique. The school had begun with the technique of the Yeitoku period of the Kanos, but this was now extinct in the Kano

world. The revolutionary simplified and monochrome art of Tanyu had entirely superseded it for the *yashiki,* and its work stood for the principle of return to Chinese ethical purity. A second and greater period of Ukiyoyè could not be started until some one should deign to treat its subjects with the new handling of Tanyu and Tsunenobu. This was done by Hishikawa Moronobu, a designer for Kioto dress patterns, who was well versed in the light, nervous crumbly line and the gay thin colouring of the new Kano. He began about 1670 to develop Ukiyoyè along three parallel lines—painting, book illustration and a new one, single sheet printing. For the first time he adopted the composition of the Tosa panorama, giving gay scenes of picnics, street festivals and groups of girls in the fashionable quarter, more or less continuous laterally, and crowded with figures. For the second he enlarged the figures of previous Ukiyoyè books, and in very vigorous outline (purely Tanyu-ish) placed them in complicated groups, like the paintings of his makimono. For the third— an experiment fraught with incalculable importance to future art—he took a suggestion from the small editions of the Otsu-yè sketches ; and now, with his improved methods of wood-block cutting in books (quite divorced from Chinese precedent), he tried for larger and cheaper editions in which the outline should be printed in black. For this new work he took larger sheets, either long lateral pieces for scenes like his printed panoramas, or tall rectangular pieces on which should be set large, carefully-drawn portraits, mostly of women. He seems to be conscious that the beauty of the black-and-white illustration in books suggests a discarding of the Otsu-yè bad colouring ; but precedent was stronger than æsthetics, and we frequently find even his single sheets touched by hand in places with little accenting dabs of green and orange. This was really, though probably unknown to him, the last relic, like an island in the midst of the Tanyu sea, of our old Hideyoshi colouring. In his later days, during the 1680's, he generally discards even this last trace and issues pure black-and-white prints (Sumi-yè).

Moronobu's work fell at an epoch, that of " Genroku," from 1688 to 1703, but which really should include also " Tenwa " and " Teikio," from 1681. This was the day when population and arts had largely been transferred to Yedo, and both people and samurai were becoming conscious of themselves. The populace of the new great city, already interested in the gay pleasures of the tea-houses and the dancing girls' quarter, were just elaborating a new organ for expression, namely the vulgar theatre, with

PAINTING. By Moronobu.

EARLY PAINTING OF HARUNOBU.
Mr. Charles L. Freer.

plays and acting adapted to their intelligence. They had just caught hold, too, of the device of the sensational novel. Now here was an army of young samurai growing up in the neighbouring squares, who were just on the *qui vive* to slip out into these nests of popular fun. For the time being freedom for both sides was in the air. Anybody could say or do what he pleased. Fashions and costumes became extravagant. Everybody joined good-naturedly in the street dances. It was like a world of college boys out on a lark ; to speak more exactly, it had much resemblance to the gay, roystering, unconscious mingling of lords and people in the Elizabethan days of Shakespeare, before the duality of puritan and cavalier divided them. Such were the scenes that Moronobu and his pupils painted and illustrated at first in Kioto, afterwards in Yedo. Flirtation between samurai and girls of the people is shown in the accompanying book illustration of about 1680. The large single sheet of a girl is about 1688.

The æsthetic value of Moronobu's work is high, and was loved by the samurai class, from whose collections it has largely come out in modern times. This was both because it was in the popular Kano technique, and also the samuri were Genroku samurai. Thus the art is not yet pure Ukiyoyè. The figures have no such flexibility as Matahei's ; they are more hard and doll like. But for strength in black-and-white illustration his work has not been surpassed.

But such a social anomaly as the Genroku extravaganza was necessarily shortlived. It would have resulted in the rout of all Iyeyasu's plans to regulate the morals of the samurai class. Very restricting measures were passed to separate the two orders of society. The people were not to be interfered with in their own dissipations and pleasures ; but the samurai must keep to their *yashiki*, eschew the vulgar theatre and content themselves with Nō plays, buy no more of the tempting sheet prints, not go out skylarking at night, but devote themselves solely to military exercises and the study of Confucius. Thus was the actual and conscious wedge driven in between the *yashiki* and the streets, in Yedo especially ; and thus it was that from about the year 1700 the art of Ukiyoyè took on a third and decisive form, in which it soon cut itself away from class relation to any Kano canons, and produced new forms suited to its own self-expression. The three lines of work struck out by Moronobu need not be added to ; but the methods of drawing, spacing and colouring would now take on their own evolution, and though there are some mild remains of it in Kioto, from now on Ukiyoyè is distinctively the art of the Yedo populace, and single sheet printing comes to the fore as of primary importance.

Nevertheless, even in Yedo itself, the new lines could not be at once tightly drawn ; and so we find between 1700 and 1725 two somewhat opposed schools of Ukiyoyè, one, that of Miyagawa Choshun, confining itself to painting, and though in a broader form and with freer colouring, being influenced by Kano Tsunenobu. Tsunenobu himself is known to have sometimes painted Ukiyoyè on the sly ; and Mr. Freer has a splendid screen with hundreds of people done in the richest colouring, probably by Kano Chikanobu. The hair had now become flat on the top of the head, but pulled down in a narrow sloping tail behind the neck. Only one of Choshun's numerous school did prints—namely Kwaigetsudo. His lines are very powerful, whether in painting or printing, often going back to suggestions of the old Buddhist "lead lines," and in colouring to hints of Koyetsu and Korin. The finest large sumi-yè print which I have ever seen of his is in the Bigelow collection at Boston. The painting of a small girl, seen from the back, is from Mr. Freer's. Here the large and extravagant design of dress pattern between 1705 and 1715 is well shown. Choshun's pupil, Shunsui, who took the name of Katsukawa about 1740, carried the broad pictorial school of Ukiyoyè, confining itself largely to representation of young girls in home life, down to 1760.

The other school of Yedo Ukiyoyè, the Torii, gave itself up frankly to patronizing, largely through prints, the separated life of the common people, in all their gaiety, and especially scenes from plays at the recently-developed theatre. But even this movement, which quite cuts itself off from all Kano precedent, had two forms, though closely connected—the work and school of Okumura Masanobu, who devoted himself chiefly to the portrayal of romantic scenes, and the work and school of the Torii people, who devoted themselves chiefly to violent and theatrical scenes. Both did interesting painting and both illustrated popular books, chiefly scurrilous novelettes ; but the work which gives them great fame is their finest development of the single sheet print from the bare outline sumi-yè, in which form Moronobu had left it. This is Ukiyoyè in its proper and most special sense ; and the fame of these prints soon sent them out in large masses to the provinces, particularly in the North, where they were bought up by well-to-do country merchants and farmers, who chuckled over details of the capital's gaiety, the place where they intended to spend their own vacations. And thus the single sheet print of Ukiyoyè tended to become for the detached and self-conscious populace of Northern Japan what our illustrated newspapers are for America.

Masanobu, like Choshun, grew out of the Moronobu school during Genroku. Torii Kiyonobu, the founder of his line—and Kiyomasu, his friend, life-companion, and probably younger brother—came from a different, parallel and obscure source, the atelier of Kondo Kiyonobu in Genroku, whose work seems to have descended by tradition from the incipient Ukiyoyè of Kano Mitsunobu, without passing through the transformations of Matahei and Moronobu. This probably accounts for the heaviness of his colouring, very beautiful, but most distasteful to the Yedo samurai, and for the introduction of strong hand-colouring in pale olive and solid orange (redlead or *tan*) over the ink lines of many of his single sheet prints. So that still in a remote way we can consider his "tan-yè" (orange-coloured prints) a modified trace of Kano-Yeitoku influence. His forms are often awkward, striking out new line feeling, and the colours of his rougher paintings look a little like Otsu-yè. These three men, Okumura and the two Torii, though coming into prominence as early as 1700, continued their creative work through many phases, side by side until after 1750. It is this long, concentrated range of work that makes them the foundation on which the later and finer Ukiyoyè raises solidly its superstructures. We show here a strong sumi-yè by Kiyonobu, and a fine tan-yè of two women by Kiyomasu.

The second stage of the work of these three men began between 1715 and 1720, and consisted first in expanding the range of the hand-colouring upon the prints from the dominant orange through reds, blues and purples, browns and yellows; second, in putting in the hand-applied blacks and gold powders in lacquer pigment (whence the name urushi-yè); third, in making the average size of the print smaller, but composed in a triptych, three designs in one, which could be cut apart if desired; fourth, in making a specialty of developing actor prints, a movement in which even Masanobu at this time joined. This kind of work lasted down to about 1740, and the group of workers was joined by many, but especially Masanobu's pupil, Nishimura Shigenaga. A beautiful painting of a scene in a garden by Masanobu of this day is in the collection of Mr. Freer's, and an urushi-yè print by Shigenaga is of the same subject.

The third stage of the work began with these four men about 1740 and continued for about fifteen years, its primary feature being the development of colour printing. Heretofore only the black outline had

been printed, and from one block. But the process of applying colour by hand made the edition still rather expensive. If identical tints could be applied to all the sheets from cut blocks it would greatly cheapen the work. On the other hand, it would change the æsthetic effect by limiting the number of colours. At first two only were chosen, a rose-pink and a pale green. These two tones, with the black and the white spaces of the paper, made up four kinds of mosaic spots, as it were, out of the clever manipulation and juxtaposition of which magic variety and charm should be evolved. These dates of change are nowhere given in the scanty-printed records of Ukiyoyè ; and all European writers were following Dr. Anderson in asserting 1696 as about the first date for colour printing, until my Ketchum catalogue of 1896 appeared. The determination of these dates was a slow work built up by me between 1880 and 1896 solely from internal evidence and the variation of fashions and coiffure.

Hand colouring, however, was not entirely discarded at once after 1742, but retained for specially careful and expensive pieces, which now undertook to enlarge their size and scope, as they had not been enlarged since 1715. We have thus the phenomenon of the two styles working side by side—the rose and green colour prints for small pieces in triptych, mostly actors, and the large hand-coloured sheets, veritable paintings but for line, for street and country scenes, and the portraits of belles. But even those latter ceased to be used about 1750. The grand old group of four was now joined, among others, by Torii Kiyomitsu, son or grandson of Kiyomasu, Ishikawa Toyonobu, pupil of Masanobu, and Suzuki Harunobu, pupil of Shigenaga. The grandest work in both lines is done by these seven men, until Masanobu, the most suave of all in form, and most tender in colour, dies about 1752. A two-colour triptych by Masanobu belongs to C. J. Morse, of Evanston, and of about the date 1750. Kiyonobu ceased to work about 1754 and Kiyomasu about 1756.

The next stage, a short one, and transition to the culminating period that follows, concerns the introduction of a third colour block about 1758. For six years thereafter all kinds of changes were rung upon the resultant combinations. Yellow was first used with the red and green. Then, blue being substituted for the green, the so-called primary colours made it possible to get secondaries by superposition. The four remaining leaders already noticed participated in this work, and were joined by Toyoharu, pupil of Toyonobu, and Shigemasa, pupil of Shigenaga. But Kiyomasu and Harunobu were the chief rivals, the former leaning to soft tones, the

latter to superposition with primaries. During this period the use of the long narrow sheet, kakemonoyè, came in.

Reckoning the incipiency of Ukiyoyè from Matahei, the development of its form from Masanobu, and the foundation of colour handling in Yedo prints from Kiyonobu, a fourth period, and that one of rapid culmination, now comes in in 1765 with the invention by the veteran Harunobu of polychrome printing—that is, the using of as many colour blocks as one requires tints. The power to handle such complex material was already well based on mastery of two and three tones. The rise of æsthetic power was rapid. We may reckon this culminating period from 1765 to 1806. It can itself be divided into three sub-movements, the growth of the culmination from 1765 to 1780, the culmination of the culmination from 1780 to 1788, and the decay of the culmination from 1788 to 1806.

Harunobu, whose work as traced in painting goes back to 1735, effected a four-fold revolution thirty years later. He used as many blocks as he wanted tints ; he chose them from very soft tones ; he filled every part of the paper except the human faces with tone, selecting separate tints for sky, earth and parts of buildings ; and he changed his subjects from actors and street belles to domestic scenes, mostly romantic incidents of youth. This last change came from two influences—the success of such new subjects in the black outline illustrated books which he had issued since 1750, and the desire to succeed in prints to the pictorial line which Shunsui had maintained from 1725 in paintings. He called himself " Yamato artist," thus intimating that he was consciously doing what the old Tosa artists had done in 1200—studying native life in all its purer phases, and yet without retaining a trace of Tosa technique. He had the genius to divine that full-colour prints were the appropriate form for this work.

The fame of Harunobu's prints from 1765 to 1772 is upon every lip. He changed the prevailing shape of print to a small square sheet that would develop a fine pictorial composition. He also made wonderfully new and beautiful use of the tall narrow kakemonoyè, far surpassing all his predecessors in his variety of handling this different species of design. His colouring has a soft charm in its flat spacing which is more delicate and varied than Greek. He experimented month by month with new papers, pigments and solvents. At times he pressed the block so lightly that only a transparent film of tone lay on the fibres ; at others he used solid opaques ; in yet others he embossed the paper by

hard stamping with a colourless block. His colours are softest in 1765-6, richest in 1767-69, tending to strong effects of black-and-white alternating with tints in 1770-72. His figures, which are short in 1765, grow tall and slender about 1770. The wings of the women's hair over the ears begin to expand laterally, like a kind of hollow shell, from 1768. They have become much swollen and top-heavy by 1772. The use of a thin redlead mixed with white for interior woodwork begins from 1768. A predominance of green in the tinting dates from 1770. An endless charm lurks in his dainty little figures of young girls. The young girl walking in the wind, which we reproduce, is from a dove-tinted print of 1766, the two kakemonoyè from 1769 to 1771.

From 1772 to 1780 the Harunobu line of experiments was continued by his best pupil, Haruhiro, better known as Koriusai. Though not such an inspired artist as his master, Koriusai's term of original work fell upon perfected technique and changes in fashion which gave most picturesque opportunities. His *forte* lay in two directions— groups of portraits of Yoshiwara belles, for which he used a larger, squarish sheet than Harunobu's, and more elaborate designs in the difficult kakemonoyè, into which he introduced sometimes three and four figures. There is no question that he is the greatest and most prolific composer in this line. In colour he gradually introduced a stronger orange, and about 1775, as foil for it, he tended to supplement Harunobu's green with a soft blue. Figures, which were tall and slender in 1772-3 became shorter and stouter about 1776, then grow tall and stout from about 1778, when his drawing becomes most perfect and his colouring strong, sometimes enhancing its darks with pure black breaking against orange. His coloured patterns on garments are brilliant ; but on the whole he has less atmospheric tone than Harunobu. A strong kakemonoyè of his best date is here given. He has also left us a great many paintings. The wings of the female coiffure, expanding over the ears in Harunobu's day, had grown to wide falling shells in 1775 ; shells which expanded to nearly a foot in width by 1778, and began to grow more pointed at the tips in 1779. It is this great winged head, like an Egyptian scarab, which gives the type, balance and unique dignity to Koriusai's figures.

The account of this rise to full power would not be complete without considering the work of three schools parallel with Harunobu's between 1765 and 1780, all adopting his new method of colour work, but making individual applications of it. One is the school of Toyoharu already

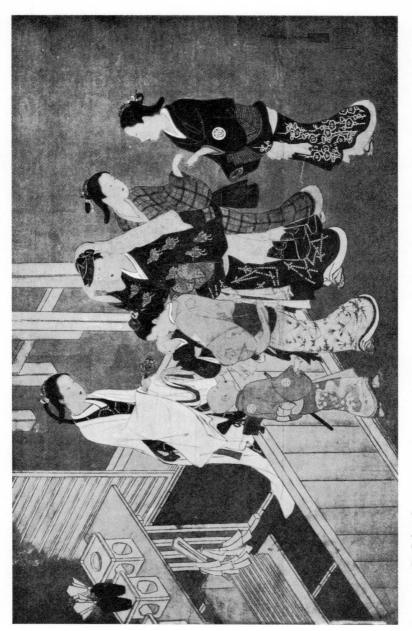

PAINTING. By Sukenobu.

PAINTING BY SHIGEMASA.
 Collection of Mr. Charles L. Freer.

FAN.
 By Shunsho.
 Monsieur G. Bullier, Paris.

mentioned, which composes exquisite groups of young girls at play. He is specially prolific as a painter. Another is that of Shigemasa, whose drawing is more powerful and accurate, using wedge-shaped brush strokes in outline, and whose colouring tends toward soft dove greys. He is specially skilful in representing motion, his dancing Nō actors being extraordinarily fine. The third school is that of Shunsho, strange pupil of Shunsui, who threw over his native school of painting women to succeed to the Torii habit of printing actors. Thus he and Harunobu in some sense exchanged places in 1765. His enormous range of actor pieces, done in separate triptychs, between that date and 1780, in drawing quite discard the old stiff manner of the Torii, and in colour strike new combinations out of the Harunobu scale ; the great bulk of them come after 1770. They hold themselves on equal level with Koriusai's prints for pure beauty, though their shape affords less room for elaborate composition. Their patterns exquisitely cut the tones of the dresses, up to 1778, when they become simpler and broader. The figures, in height, follow the fashions in Koriusai. By 1780 they are excessively tall. The whole development of the Japanese theatre can be followed in this series. Shunsho also painted, and he left most exquisite books in coloured illustration, of which the Seiro Bijin Awase, done in collaboration with Shigemasa in 1776, is the chief.

But a greater than Koriusai and Shunsho had come fully upon the scene by 1880, and ready, both by native genius and inheritance of perfected technique, to inaugurate the culmination of the culmination. Torii Kiyonaga, an adopted son of Kiyomitsu, had shown talent as a boy in the three-colour process. As a youth he had experimented with Harunobu's polychrome, though professionally forced to make cheap actor prints. By 1774 he gracefully yielded this latter field to the new school of Shunsho, and entered seriously into competition with Koriusai as master of printing scenes from Japanese life. The rapid advance in the work of both from 1775 to 1780 must be explained by this conscious rivalry. Kiyonaga, following a suggestion of Shigemasa, introduced a far greater flexibility of brush stroke in outlining his figures, and a greater breadth in handling his colours and patterns. Peculiarly fond of out-of-door groups, he inaugurated a new balance between the tones of his figures and the background by leaving out of the latter most of the sky and earth tones which Harunobu had introduced. At first sight this seems a movement backward, but Kiyonaga correctly saw that against such background tone the depth of Harunobu's figures was insufficient for atmospheric detachment, except when black could be used.

To get such relief he determined to throw all his atmosphere into high light, depending upon soft drawing in details to suggest the solidity of landscape. This also avoids the excessive falsifying of the white tones of the flesh which Kiyonaga did not care to tint, as Shunsho had sometimes done for his male actors. Thus in free drawing of movement and atmospheric impression Kiyonaga went far beyond Koriusai's powers, even in his experimental stage.

It is only from 1780 that, having distanced Koriusai and driven him from the field, Kiyonaga launches upon the career which I have marked as the extreme of culmination. He is the undisputed lord of the Temmei period, the pupils of Toyoharu, Shigemasa and Shunsho largely going over to his perfected manner. His figures are very dignified and tall down to 1786, and drawn with long sweeping modulated line that almost suggests the penmanship of Ririomin. He adopts the large square sheet of Koriusai, which gives free play for the composition of six or more figures. He appreciates the strengthening value of straight lines, and of the long " cool " curves that become tangent to them. In the colouring of garments he aims for the broad tone of textures rather than the delineations of pattern, sometimes showing both flesh and undergarment through the transparency of summer outer stuffs. He also gives us the deepening or tint in folding and sheen, yet without prejudice to the mosaic flatness of his tone. His colours are gay, often suggesting sunshine, as in the bright warm pinks of his dresses and the pure yellow used for hillside greens. In short Kiyonaga is at once the most successful draughtsman of all Ukiyoyè, and the most brilliant plein air-ist. He was the only man beside Harunobu and Koriusai who could do fine kakemonoyè. Representations of his finest prints show up well beside photographs of natural groups, and of compositions of the old Venetian masters. Kiyonaga's paintings are also magnificent, though very rare, and he did at least one exquisite illustrated book in outline.

Kiyonaga's power over motion in his Koriusai period is shown in the print of boys playing with a woman. The same, and his most perfect mastery of values, is shown by his painting of three women walking in wind on the banks of the Sumida river. This is of about 1782, and shows the raising and pointing of the hair wings. The top knot has become a small balloon, and the beaver tail, so conspicuous from 1740 to 1760, has disappeared in a mere rudimentary stump. This splendid painting belongs to Mr. George Vanderbilt. The dignity of line in prints of 1884-5 is

shown by the three tall girls at a tea-house bench, and the four women with
a child. Of 1786 is his three figures in snow, a man in a magnificent robe
of black velvet standing between two women in soft orange. For dignity of
line and power of values this is unsurpassed in Ukiyoyè. Greatest of all,
and in the same year, is his print of three girls at a window, looking out
upon the sea by moonlight. The interior is lighted in warm tones by a
Japanese lamp (andon). The scene outside is in luminous night greys,
with the half-full moon entangled in light clouds. The boats in the far
harbour show reddish torches. Such a study of three separate sources of
light, though without the expedient of cast shadows, is worthy of our
modern realistic students of forge effects. The lines, too, falling from the
standing figure, and then curling into the two crouching girls upon the
floor, are more harmonious than Botticelli, more suave and flowing than
Greek painting, and indeed suggesting the finest line feeling of Chinese
Buddhist painting, and even Greek sculpture. It is for such work that we
must put Kiyonaga—though an Ukiyoyè-shi—for absolute æsthetic height,
beside Koyetsu, Tanyu and Okio of Tokugawa days ; and even worthy of
coming into competition with Ririomin, Kiso, Masanobu, Motonobu and
Raphael.

 After 1786 Kiyonaga's style weakens by shortening the figure and a
little overdoing the curves. The point of the head-dress becomes rounder.
Fashion, too, makes the figures of girls become shorter. The type for all
contemporary artists is not so beautiful. Yet Mr. Freer's Kiyonaga
painting of a young girl in strawberry finish, arranging her hairpin with
uplifted arm, is very beautiful. He seems deliberately to have withdrawn
from active competition after 1790, though he lived down to 1815,
disdaining to take part in what he felt to be a decay of fashions and
manners and descent to picturesque extravagances which lowered his
æsthetic standard. In this again he shows himself the true artist.

 The whole range of the artists of the day were practically Kiyonaga's
followers. Closest to him was Shuncho, who had originally been Shunsho's
pupil. A proof impression from the outline block, made before the colour
blocks were cut, shows the dignity of his line and the method of work.
His prints, sometimes indistinguishable but for signature from Kiyonaga's,
range from 1782 to 1792. He has left some books, but almost no
paintings. Kitao Shigemasa himself in these days falls under Kiyonaga's
influence, as is witnessed by his splendid painting of many figures walking
along the Oji road, owned by Mr. Freer. Here the drawing, which is

exquisite, is enhanced by the most delicious colouring in Kiyonaga pinks and soft evanescent blues. Shunman, Shigenaga's greatest pupil, working into the Kiyonaga manner, becomes a veritable Whistler, as is shown by the counterpoint of his two graceful ladies gazing upon the bridged river from a balcony. The very brush strokes here, though cut from wood, have the feeling of an etching. Shunsho and Toyoharu practically give up print producing after 1782, and in their paintings are somewhat influenced by Kiyonaga's proportions.

By this time, the later eighteenth century, most of the causes which could bring about the peculiar nature of Tokugawa society were in full swing. The people themselves, apart from the samurai, already had schools of their own, historical scholars, and a growing literature. They were aware of the usurpation of the Shogunate, they were already fired with an enthusiasm for nationality, and an instinct for freedom. Motoori had built up his theory of a divine origin of the Mikado through Shinto. Seditious sheets and pamphlets were issued from secret hiding places, sometimes the depths of the Yoshiwara. The Shogun's government was all on the defensive, more prone to spying and repression, ready to hold samurai to stricter discipline. The Kano art of the nobles had now become an eclectic study of ancient Chinese ideals. The new literature, except at one or two liberal Courts like that of Mito, was tabooed. On the part of the people the movement toward light and freedom was multiform. They, too, wished to study into the past of China as well as of Japan ; and great popular romances were soon to issue based upon the tradition of both countries. A new popular poetry developed. It was the very central period of Dutch influence, which had already affected Ukiyoyè artists like Toyoharu. Science was pursued in medicine and in making collections, at least of careful drawings of birds, flowers and animals ; the curiosity of the people knew no bounds. They had become so interested in their own history that every man wished to travel all over the country to new scenes famous for their beauty or their association with great deeds. Travel became a passion, and, because it was so cheap, almost universal. For the use of pilgrims, guide books were issued, much like our European Baedekers. In art three movements were already rooted—the bunjinga through the

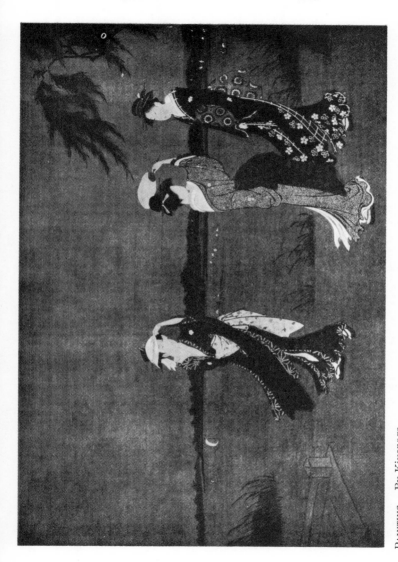

PAINTING. By Kiyonaga.
Mr. Howard Mansfield.

GIRLS UNDER CHERRY TREES.
By Utamaro.
British Museum.

southern country, and partly through the northern ; the Shijo, mostly at Kioto and Osaka ; and the Ukiyoyè, at Yedo, and disputing with bunjinga for patronage through the northern provinces. Naturally it was only the more scholarly and conservative among the people that took to bunjinga ; some of the samurai took to it also. It could do little to help popular unrest and research. For this, Ukiyoyè now opened up new resources.

What we must really call the decadence of the culminating period came in with the withdrawal of Kiyonaga, 1788 or 1790. His standard of beauty was probably too high, too abstract, too removed from the taste of a people deliberately drifting into passionate opposition to their masters, and full of new thoughts. A sort of desperate defiance was in the air, and a wild determination at least to enjoy if the alien government would furnish no real relief. But whatever the cause, there was indeed, about 1800, and after, a very real lowering of both the moral and æsthetic standards of the streets. Men and women went to the extravagances of frank vulgarity. It was a sort of Genroku carnival, on a lower plane. The Shogunate drew its line of restrictions closer.

The decay of Ukiyoyè art did not at once show itself, however. The three masters of printing who dominate the age, from 1790 to 1806, namely, Yeishi, Utamaro and Toyokuni, had all been influenced in the preceding decade by the noble standards of Kiyonaga. Yet they came from various sources. Toyokuni was indeed the chief pupil of that Toyoharu whom we saw to spring from the old Toyonobu about 1760. Utamaro had been a pupil, during Anyei,[*] of Sekiyen, and old Ukiyoyè-shi who had reverted to a kind of mixture of bunjinga and Kano. He also did some early actor prints in Shunsho's style. Yeishi had been a Kano pupil of that Yeisen who founded the eclectic school, and had seceded to the cause of popular art. But by 1786 they had all become so absorbed by the graces of Kiyonaga's drawing, composition and colouring, that their works are only a continuation of his. And for some years after his withdrawal, the power of his influence over them was strong enough to hold them to a considerable degree of dignified beauty. About 1796 Utamaro began to execute some nature-study books in specially æsthetic colour printing. This led to a soft beautifying of thousands of New Year's and other congratulatory printed cards, which collectors

* (From 1772 to 1781.)

call "Suri-mono," "printed things" *par excellence.* In the large sheet prints a simultaneous change showed itself in a gradual elongation of the figure, and an adoption of violent motion and extravagant attitudes. This came partly from a change in fashion which was building the top knot member of the ladies' coiffure into an expanding balloon. Æsthetic proportion required a corresponding elongation of the head and that of the body, and both of a different balance in attitude. The sober, finely-composed lines of Kiyonaga looked out of place. The head had to tilt, the neck, arms and legs became thin ; and the garments, no longer clinging closely to classic form, had to be thrown over the strange distortions in loose and baggy folds. The eyes were elongated and drawn upward ; the mouth reduced to a slit. No doubt a certain piquant picturesqueness accompanies these changes for a time. The extravagances of Utamaro appealed to a degenerating taste, as they appeal to-day to many modern French æsthetes. Almost no new great structural principles were introduced. Utamaro and Yeishi printed portraits in great heads ; and there are some bold domestic scenes. Toyokuni succeeded to a school of actor printing that is far coarser and more awkward than Shunsho's. Landscape accessories became wild and theatrical. Toyokuni followed his master in introducing tree drawing from Dutch prints. A violent, false perspective was built out of foreign half-teaching. By 1800 these several movements had gone to the point of giving us figures some twelve heads high, with great balloon-shaped hair almost a foot across. All trace of Kiyonaga's drawing of faces and figures had now vanished. Almond eyes, long noses and violent postures reigned supreme. Yet some striking new types are given us in angular composition and in colour. Toyokuni's tall figures of 1802-3, though not like human beings, have a wonderful new sort of æsthetic dignity that we can call again almost Greek. It is but a momentary state of passage, however, for in a year or two more all æsthetic standard seems broken up, and the degeneration passes beyond bounds.

To illustrate this rapid change we refer to Yeishi's fine figure of a girl fishing from a print of 1787 in the Kiyonaga fashion ; a painting of two women walking in snow by Utamaro (Mr. Freer's) about 1797, and Toyokuni's print of two girls coming from a bath about 1803. The extravagance of action and proportion that accompanied the balloon about 1800 are shown in Utamaro's print where a shadow profile of a girl is cast

upon a translucent *shoji*. Toyokuni's associate and younger brother, Toyo-
hiro, devoted himself partly to printing landscapes between 1800 and 1806.
There is in particular a fine landscape of ink work, looking like a Whistler
etching. The demand for landscape was a slow outgrowth from the
guide book movement.

The real degeneration, and the beginning of a fifth and last movement
of Ukiyoyè, came in with 1807. The pupils of Utamaro carried the
extravagances of their teacher to a point of ugliness. Toyokuni, who
continued to work for many years, followed the downward path. Yeishi
confined himself to careless paintings. The new artist who expressed
frankly all the hideousness of drawing and proportion between 1807 and
1820 was Yeizan. The figures became short and dumpy, sometimes only
about six heads high. The heads themselves are about five times as long
as they are wide. The two slanting slits of eyes are at first gashes across
the face, then about 1812 open into a great stare with exaggerated pupils.
The figures of girls often become as formless as the queen of hearts on our
playing cards. Patterns become generalized and coarse. Hair is drawn in
a few coarse strands. Only in the landscape backgrounds, and in the
colours of costumes considered as spotty wall-paper, is there any hint of
beauty. Following his master Yeizan in this ultra-degenerate style is
Yeisen; and following Toyokuni, his pupils, Kunisada and Kuniyoshi. It
seems incredible that the maniacal distortions of the prints of 1815
could have come by deliberate change from the perfections of Kiyonaga
only twenty-five years earlier. The fine rise from the already high
Harunobu to Kiyonaga took quite as long as this precipitation into the
depths. It is only this degenerate style of 1815, especially of Yeizan, that
the mass of foreigners in Europe and America have seen ; and from this
that they derive their low opinion of Japanese as serious art.

From 1820 something like a temporary recovery took place in
Japanese taste ; not that it went back to the purity and drawing of
eighteenth-century prints ; but that it at least tried for some order
and proportioning in the new colour. The best figure prints, say of
Kunisada, Kuniyoshi and Yeisen, between 1820 and 1830, rise much
above the caricatures of 1815. Still, the spotting remains coarse ;
and the colours tend to be cheap and modern, strong reds and
deep indigo-blues. The finest pieces have considerable feeling, but
they are mere foster decorations compared to Kiyonaga's beautiful
groups.

Now, right in between the great period of Kiyonaga, and the lower standards of 1830, comes in such an extraordinary Ukiyoyè-shi to fill up the gap, and give his own picturesque versions of the change, a man so long-lived withal, and of such marvellous versatility, that we might devote a whole chapter to him. I refer of course to Hokusai. European writers have lavished panegyric upon him, as the greatest artist of Japan. He is the best known abroad, on account of the great quantity and cheapness of his printed books. He was as prolific as Doré along all lines. Thousands of paintings and single sheet print designs came from his brush. He was always original, different from anyone else, though often taking hints from the moods of others. The whole world of the samurai lived in ignorance of him ; and it was largely the lower grades of city people who cared for his Ukiyoyè work. He was at once a great vulgarizer, and yet through his coarse, varied vigour, an æsthetic reviver. While other artists, like Toyokuni and Yeizan, were descending into the valley of the shadow of death, between 1810 and 1820, Hokusai alone was so in sympathy with the vulgarities of the popular style as to concoct a veritable æsthetic type out of it. And yet Hokusai's is the only school of Japanese drawing that never looks like anything in nature. We are so accustomed to his books from youth, that we suppose Japan to be a queer corner of the world that looks like him ; but it does not. It was his own fancy, a world translated into Hokusai-isms. And yet they are often fine as line, mass and colour. Hokusai is a great designer, as Kipling and Whitman are great poets. He has been called the Dickens of Japan ; but no one name or analogy could characterize his many phases.

Hokusai's long career is specially fascinating to study, because we can identify his changes of style through almost every year. Here we can give but the merest sketch of it. His life bridges the extraordinary gap from Torii Kiyomitsu to Kunisada. The great careers of Harunobu, Koriusai, Shunsho, Kiyonaga, Utamaro and Toyokuni he witnessed, and to some extent shared ; yet he remained always himself. Without signature or date we could identify all his prints, even the first, and separate them year from year. Of the work of no other Chinese or Japanese artist can we say so much. And yet we must not be tempted by this interest into admitting that Hokusai is even the greatest of Ukiyoyè artists. We certainly rank him below Masanobu, Harunobu and Kiyonaga. Still, through his

THE WATERFALL OF YORO (ONE OF THE EIGHT WATERFALLS).
By Hokusai.
British Museum.

BRIDGE IN RAIN (ONE OF THE HUNDRED VIEWS OF YEDO).
By Hiroshige.
British Museum.

matchless fecundity he is one of the world's notable masters. There are no
collections of his work in Japan. The richest collection of his paintings
belongs to Mr. Freer ; of his illustrated books to Mr. Morse, of Evanston ;
of his early prints at least to Mr. Lathrop, of New York. The best
all-round grouping of his three lines of work put together is in the Bigelow
collection at the Boston Art Museum.

The earliest works of Hokusai, now known, are his illustrated
novelettes and some actor colour prints in the style of his master Shunsho,
of about the date 1775, when he was fifteen years old. He made many
actor prints down to 1780. In that year he began to try kakemonoye and
square sheets in the style of Kiyonaga. His name through all these is
Shunro, though he sometimes uses Takitaro for his books. From 1790 to
1796 he is temporarily influenced by Utamaro, though his paintings still
bear strong qualities of Shunsho. From 1796 Hokusai's style, as his name,
breaks into extraordinary changes which it is hard to follow. It is clear
that it is the same vulgarising, elongating movement which brings on the
new style in Utamaro and Toyokuni; but with Hokusai it takes a different
phase.* He came under the influence of two obscure men, Torin
and Hishikawa Sori, both of whom had a coarse, broad, loose style, more
outrè than Utamaro. He seems for a time (about 1798) to have conceived
that he might find the real breadth that he wanted in the quite alien
technique of Sotatsu. He calls himself variously, Sori, Hiakurinsai Sori,
Tawaraya Sori, Hishigawa, or Hishikawa Sori, Kako, Hokusai Sori,
retaining this group of names down to about 1800. The name Hokusai,
as a pen-name, began from about 1797, but before 1800 was used only
occasionally and in company with " Sori." From 1800 to 1802 we find in
his signatures several ways of stating the fact that he had given up the
name Sori for Hokusai. Through these years from 1796 to 1802 he
executed a large number of books with coloured plates crowded with tall
figures ; and literally thousands of great coloured single sheet prints, some
of which are most delicate and broad in tint, like Whistler's, and are grace-
ful in form and movement.

From 1802 to about 1810, Hokusai called himself by that name
chiefly, though often united to other subordinate ones, as Gwakiojin,
Katsushika, Toyo. From 1798 to 1802 he occasionally used Kako
alone. His style now becomes harder, with finer wedge-shaped lines,

* Influence of Dutch 1792-1796. Some real effort to make prints look like the Dutch
etchings. Also colours in these prints of Dutch oil paintings.

and more solid colour in his paintings. From 1804 he uses much opaque red and white pigment combined with greys. In his prints his colour partakes of the Yeizan degeneration. But in books he starts on a tremendous career of illustrations for the many-volumed romances of Bakin and others. For this he develops a free-line style that shows also in his paintings. About 1810 he changes his name to Taito, which title he retains until about 1820. This period is chiefly given up to the rough encyclopædic illustrations of his well-known " Mangwa " books. Single sheet prints, in which he had been so prolific about 1802, he mostly drops. Careful paintings are also rare, and bring in a crumbly jerky line which breaks up his former dignity. His drawing soon degenerates into a wild extravagance of rough caricature. His colour at this strange period of break-up is light, careless and harsh. Many rough sketches remain.

From 1820 he again changed his name, using Tameichi as the chief. Zen Hokusai, Tameichi, is now frequently found for the next twenty years. From 1820 to 1826, he still worked in sketches largely, but softening his colours to greys, and then building up experiments in two-tone blotchy tinting of orange and blue, or red and green. Here he loved to print vegetables, fruits, flowers and landscapes. As those colour experiments went on he enlarged their range, tending toward yellow for a high light, and deep green-blue for darks (1826-30). From 1828 to 1830 he seems to have said to himself that it was time to come out from his debauch of sketches, and prove to the world that he could produce great finished paintings. He crowded his silks with carefully drawn and heavily coloured figures ; his landscape backgrounds are rich and full. In line, too, he made new experiments, utterly overcoming the broken awkward daubs of his transition period, and retiring to well-ordered sweeps of drapery so fine and new that we are almost persuaded a second Kiyonaga is coming. His finest line work is seen in the books, paintings and prints of 1830.

From 1830 to 1840 Hokusai entered into his solid inheritance of deep-toned prints and paintings, having heavy yellows and green-blues for their foundation. His mannerism is complete. Particularly he loves landscapes, as his Fuji and other sets attest. At this time he is fond of painting great screens. In line he tends to make the dignified curves of his 1830 style knot up too much into spirals.

The last ten years of his life, from 1840 to 1850, his style becomes heavier and darker, letting the big broken strokes that should be his lines become only rough depths in his massive darks. It is his strongest and broadest notan style since his Sori period, but much more blocky in texture : that is, his colour is put on crumbly and dry as if with chunks of charcoal, instead of with wet silvery washes. In paintings Hokusai always recorded his age after his 80th year. He adopted the name Gwakiojin-man ; and generally used with it a seal that depicts Fuji mountain. During the last three years of his life he changed the seal to one which shows a large character for " hundred." His single sheet prints and books are not so numerous at this day. He had countless pupils through the many periods of his life, of whom Hokkei is the best known.

A young gentleman in grey, with a straw hat, is a fine sample of his Sori paintings, now owned by Mr. Freer. The painting of six tall figures walking among cherry trees, also Mr. Freer's, is the finest example of his 1802 type, and shows from what pictorial facts in landscape detail the peculiar touches upon his many contemporary prints were taken. His interview between a scholar and a priest is about 1807. A rare example of Hokusai's painting during his Mangwa period is the very fine girl under a cherry tree, of about 1818, also Mr. Freer's. A book illustration of about 1826 shows his return to continuous decorative line ; while the great panel painting on silk, of villagers starting out across a river for a picnic, now owned by Mr. Freer, is the finest example of his highly coloured work of 1830. The patterns on the dresses are wonderfully worked out. His rich landscapes of 1835 are best illustrated by the splendid colour prints of the Fuji series (36 views). His most carefully drawn book designs in ink are of this date. His finest late work in painting is the descent of the Thunder God.

One more great artist of this school must be conspicuously mentioned. Hiroshige had been a pupil of Toyoharu's brother, Toyohiro, before 1810. He worked largely on figure prints before 1820. But after that date the growing desire for illustrated guide books led him to devote all his energies to printing large landscapes in colour, which were issued in " series of views," of the Tokaido, of Yedo, the Kisokaido, etc., from

1820 to 1840.　His first great series of the Tokaido was issued probably about 1825.　Besides these landscapes, he made countless coloured prints of flowers, fishes and birds.　His figures of 1830 are almost as dignified as Hokusai's.　Still it is as a landscapist that we must put him first in Ukiyoyè.　It is on account of the excellence in landscape of the two men, Hokusai and Hiroshige, that we must allow a subordinate æsthetic culmination to attach to the decade 1830-40. But Hiroshige's devotion to landscape is more single, and his realistic success greater.　Without any special personal deflections of line system or notan scheme, he just translated into a few simple and well-balanced tones the views which his native land presented.　Here we have a frank blue for the sky, a deeper blue for water, clear grass and tree greens, wood tones of stems and buildings, the flashing of bright costumes in small spots.　His impressions are so true that, even after the changes of sixty years, one can recognise to-day much of the topography of individual scenes.　He did not use firmly flat colours, but had learned how to grade a broad wash upon the block, thus giving modulation to sky tone, a privilege often abused by his contemporaries and his own printers of late editions.　Fine warm evening sky tones lie along his horizons.　As a painter of night he is without a rival, save Whistler.　As is well known, Whistler built his nocturnal impressions upon Hiroshige's suggestions.　In special atmospheric effects, such as moonlight, snow, mist and rain, he achieved variety of effects such as neither Greek nor modern European art had ever known.　He was an arch-impressionist before Monet.　It has been asserted by some European writers that the bulk of the Hiroshiges which we know were the product of three separate men. It has also been specifically added that all the upright designs in prints are by the second Hiroshige.　This is absurd.　For though it is true that the " wide " landscape sheet tends to prevail in his earlier work (1825-30), there is no uniformity in this respect, as any one can see by comparing his growing looseness of writing in his signature.　A complete series could be shown from 1825 to 1850 at least, in which it is evident that the same man is slowly changing his style.　We mark the same change in his paintings.　In general his drawing becomes more careless after 1835, but the truth of his colour values goes on increasing up to 1845.　His paintings of 1850 and after are weak.　Doubtless there was a second Hiroshige, but his works

comprise only a few and very bad ones done about 1860, when all colour printing was "going to the dogs." It would not be in proportion to record the names of artists who followed that date.

Of illustrations, the nearest to Toyohiro's manner is the great Riogoku bridge at Yedo, done perhaps before 1825. The cloud effect about the moon is fine. Of the first great Tokaido set, the mist effect at Mishima (between Fuji and the sea) is one of the most striking. What traveller in Japan among the Hakone mountains, or at Nikko, has not seen just such effects? The great shopping street of Honcho by moonlight, where the unseen moon throws heavy shadows of the strollers upon the ground, is an upright masterpiece of about 1835. The fox scene at night is of about 1840. His view of Tsukabayama, under cherries, of about 1845, is a perfect specimen of his late realistic drawing.

Associated with Hiroshige as a landscape printer between 1825 and 1840 is Yeisen, the pupil of Yeizan. His great night scene of the pond at Uyeno Park is like an early Hiroshige.

Such is our brief outline sketch of Ukiyoyè, a branch of Japanese art important because so near to us, and so accessible for study. But, if we take it in relation to its historical antecedents, we have to admit that, with all its merit, it is only one of several leading plebeian Tokugawa schools, which, with the aristocratic Tokugawa schools, compose only the fifth, and that probably the æsthetic lowest, of Japanese periods. Moreover, Japanese art as a whole is only a section of East Asiatic art.

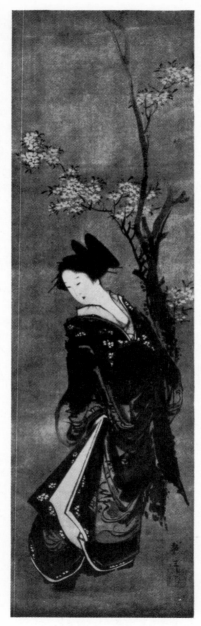

PAINTING. By Hokusai.
Collection of Mr. Charles L. Freer.

EARLY HAND-COLOURED PRINT.
By Kiyomasu.

EARLY BLACK AND WHITE PRINT.
By Kiyonobu.

EARLY "TAN-YE," HAND-COLOURED.
By Kiyomasu.

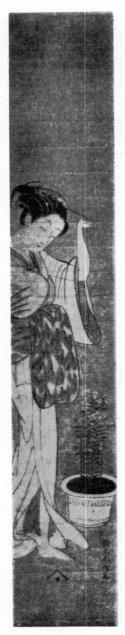

EXAMPLES OF "KAKE-MONO-YÈ."
By Harunobu.

FULL COLOUR PRINT. By Harunobu.

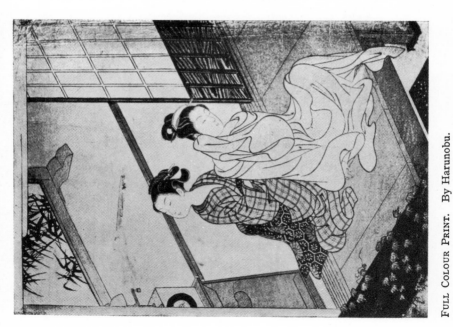

YOUNG GIRL AND WILLOW IN WIND.
By Suzuki Harunobu.

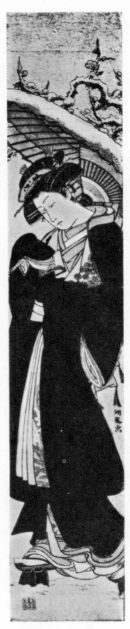

KAKÈMONO-YÈ.
By Koriusai.

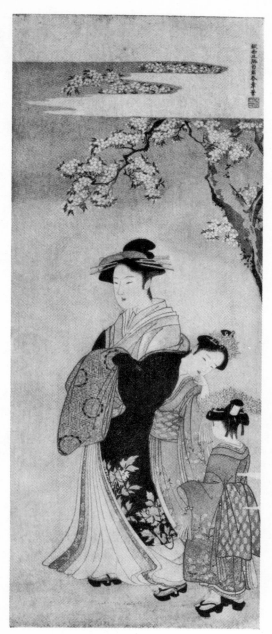

PRINT.
By Katsukawa Shunsho.

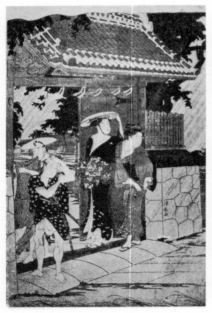

FOUR PRINTS. By Kiyonaga.

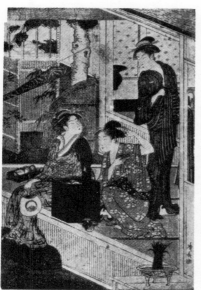
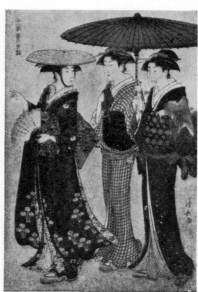

FOUR PRINTS.
 By Kiyonaga.

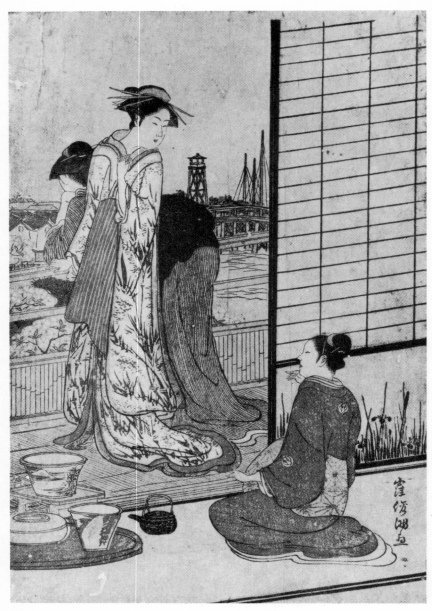

COLOUR PRINT, "ON A BALCONY." By Shunmann.

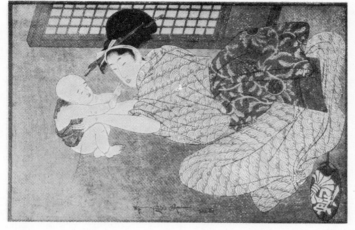

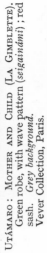

UTÁMARO : MOTHER AND CHILD (LA GIMBLETTE).
Green robe, with wave pattern (*seigaindmi*) ; red
sash. *Grey background.*
Vever Collection, Paris.

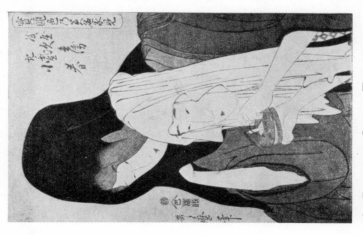

UTAMARO : AN ELOPEMENT SCENE. The paper-
dealer Jihéi, his handkerchief over his head,
extinguishing a paper lantern ; and the singer
Koháru in a black veil. *Grey ground.* Medium
size.
Vever Collection, Paris.

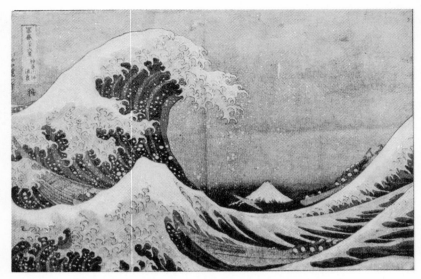

HÓKUSAI: THE WAVE. From the " Thirty-six Views of Fuji." Diptych.
Vever Collection, Paris.

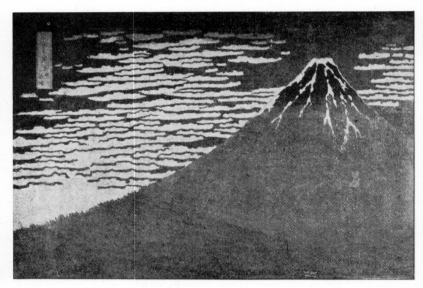

HÓKUSAI: FUJI IN FINE WEATHER FROM THE SOUTH. The red mountain,
with its snow-capped peak, melts gradually into the green of the lower
part. The blue sky, against which the white clouds are relieved, is
darkest at the top. From the " Thirty-six Views of Fuji." Diptych.
Koechlin Collection, Paris.

Night on the Kamo River, Kioto.
 By Hiroshigè.

Under Sumida Bridge. By Hiroshigè.

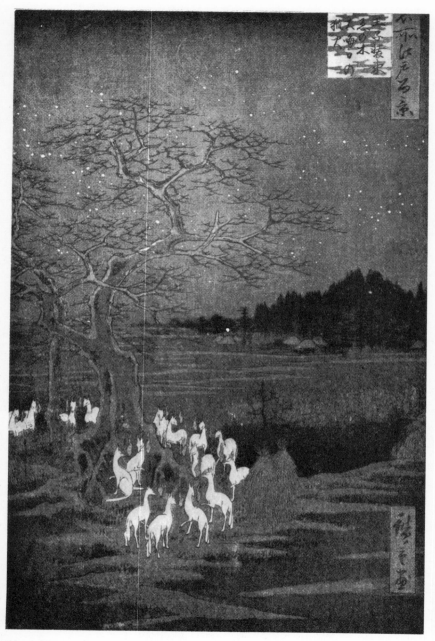

GHOST FOXES. By Hiroshigè.

NOTES

NOTES

VOLUME I.

CHAPTER I.

NOTE 1 (page 9).—The representation of the human figure is not lacking on the old vases of the Chou Dynasty, and as Fenollosa's first chapter comprises a period extending from 3000 to 250 B.C., that is to say, to the end of the Chou period, it is necessary to note that his assertion is too sweeping. Laufer, in his *Chinese Pottery of the Han Dynasty* (Leyden, Brill, 1909), pp. 150, 151, quoting from the *Hsi-Ching-ku-chien*, mentions the bronze vase known as *pai shou tou* (*tou* with a hundred animals), which is decorated with hunting-scenes, among them the subject he calls : The Hunter and the animals. Laufer's observations, and the reproduction he gives, show that at this period, human as well as animal forms had been freely treated, and that a conventional decorative type had already been evolved. This seems to indicate that the human form had been treated no less than the animal form in periods anterior to the Chou Dynasty, in the time of the Shang emperors. We know now that the decorative conventionalisation of forms follows realistic representation, and never precedes it (cf. E. Grosse, *Die Anfänge der Kunst*, Freiburg and Leipzig, 1894; Haddon, *Evolution in Art*, London, 1895 ; H. Stolpe, *Studier i Amerikansk Ornamentik*, Stockholm, 1896). It follows that Chinese decorative convention, as manifested in the *t'ao-tieh* and elsewhere, where the elements of the human figure are recognisable, conjoined with this document, which bears witness to the long persistence of a primitive motive, demonstrates the fact that the human figure was represented at a very early period, and even at the first inception of Chinese art.

NOTE 2 (page 10).—The dragon, associated with the still water of lakes, with rivers, the sea, clouds, rain, and thunder, constitutes a myth which is practically universal. Again, the long-nosed Chinese and Japanese masks are derived from the *tengu* or reptile-killing bird, as opposed to the *nāga* or the dragon. The fabulous reptile-killing bird is another universal myth. It is therefore not surprising to find in the most diverse parts of the globe representations of these types, which demonstrate the essential unity of the human mind.

NOTE 3 (page 11).—The *Po ku t'u lu* was compiled at the beginning of the thirteenth century. The *Kin shih so*, is, however, very much later. It was published in 1821 by the two brothers Fêng Yün-p'êng and Fêng Yün-yüan. These two important works are devoted to the study of Chinese antiquities, and divided into several sections.

NOTE 4 (*passim*).—The affinities established by Fenollosa in this chapter between the essential characteristics of Chinese art in the early periods and the art of Peru, of

Central America, of Alaska and of Hawaii, Micronesia and Macronesia, Formosa and ancient Japan, lead one to trace the limits of the area of dispersion of what he calls the " Art of the Pacific." These considerations are highly interesting, and the fact that they are here formulated for the first time gives a value to Fenollosa's posthumous book which will be appreciated by all scholars. It is indisputable that the decorative method, and notably a psychological tendency to distribute the elements of figures, which is characteristic of the decoration of archaic Chinese bronzes, reappears in the area of dispersion in the Pacific where Fenollosa notes it. But in the form in which he presents it to us it is impossible to accept his theory of affinity. Had Fenollosa known certain works by specialists, particularly A. de Quatrefage's book on *Les Polynésiens et leurs Migrations* (Paris, 1866), he would never have compared Polynesian art, which, in its present form, cannot date from an earlier period than the sixteenth or seventeenth century, with Chinese art anterior even to the Chou period, putting forward the hypothesis of possible influences from the Pacific exercised upon China. Of the various points in which he noted elements comparable to those of the Chinese decorative system, the earliest belonged to Central America. Now the civilisation of the Inca of Peru dated only from the twelfth century. As to the predecessors of the Mexicans, we cannot accept an earlier date than the seventh or eighth century for the period of the develop-ment of the Toltec civilisation. It was succeeded by that of the Chichimec, and the Aztec Empire did not arise till the fourteenth or fifteenth century (cf. Beuchat, *Manuel d'Archéologie americaine*, Paris, 1912). Under these circumstances, affinities between the art of the Pacific and the Chinese art of from 3000 to 250 years B.C. on the lines suggested by Fenollosa are inadmissible. If a certain relation may be traced between the art of the Pacific and the Chinese art of the early period, it is only to be accounted for by some obscure influence exercised by China on Malaysia and perhaps on Central America at a relatively late period. This, however, is merely an hypothesis which may serve as a starting-point for interesting researches, but cannot be accepted as a conclusion. It follows that what is said in the first chapter as to the origins of ornamental forms cannot be brought into harmony with the one current of influence the existence of which may be hypothetically advanced : one setting from the Asiatic continent to Malaysia, Polynesia and New Zealand. Fenollosa's æsthetic analyses are nevertheless to be retained ; they point the way to researches which may some day throw light on a complex problem by no means easy of solution.

CHAPTER II.

NOTE 1 (page 17).—The question of the origin of the name China is still in dispute. It has lately been re-examined by B. Laufer (cf. *The Name China, T'oung Pao*, December, 1912) and P. Pelliot (cf. *L'Origine du Nom de Chine, idem*). Laufer, accepting the pronouncement of Jacobi, who declares that he found the name Cina mentioned by a Sanskrit writer of 300 years B.C., completely abandons the etymology Ts'in. He compares the name Cina or Tsina, which was in use along

the maritime route of the Indian Ocean, with the names Sēres and Sērikē, by which China was known in the western regions. He concludes that there are two groups of names, one continental, the other maritime, and that the word Cīna was an ancient Malay term of the coast of Kuan-Tung, in use before the Chinese settled in this district.

Pelliot, for his part, upholds the ancient etymology of Cīna from Ts'in. He does not consider that the date of the Sanskrit text on which Jacobi relies is established beyond dispute. Further, he thinks the relation of Cīna to Ts'in should be maintained, even if the date put forward by Jacobi be accepted. And again, even were it proved that the word Cīna has been applied to populations other than the Chinese, we should have to enquire into the possibility of a fusion between a somewhat vague denomination of Himalayan tribes and the Chinese word Ts'in. Finally, there are Chinese texts which show that in the time of the Han dynasty the Chinese were known among the *Hsiung-nu* of Central Asia by the designation " Men of Ts'in."

We see therefore that the question of the origin of the word Cīna is not yet decided, and we must needs accept Pelliot's conclusion, and wait until one of the documents found on the ancient route of the Lob reveals to us the exact name borne by China there at the dawn of our era (cf. H. Jacobi, *Kultursprach und Literarhistorisches aus dem Kantilīya.—Sitzungsbericht der Kön. Preuss. Acad. der Wissenschaft*, 1911.—Laufer, *The Name China*, and P. Pelliot, *L'Origine du Nom de Chine*, in *T'oung Pao*, December, 1912). It must also be noted, with regard to Ser or Sērēs, that this is not, as Fenollosa supposes, an ethnical term. It is derived from the Chinese word *ssu*, meaning silk, and the *r* in it is justified by modern Korean, Chinese, and Manchu forms. At least, this is, so far, the derivation which seems most plausible, and is most widely accepted.

Nor, finally, is it correct to say that China, identified under her double name of Cīna or Seres, was not generally known in Europe until the seventeenth century. Marco Polo, who knew the country under the name of Khitai, indicates its unity very clearly. He had, indeed, been able to appreciate this in the course of his voyages, for he had visited the North, as well as the Southern provinces. Further, his knowledge of India enabled him to define Indian relations with this region (cf. *Marco Polo*, ed. Yule, London, 1875).

NOTE 2 (page 20).—The works published since Fenollosa wrote these pages have fully confirmed his opinion. I will merely note the results of certain of these. Salomon Reinach's study of the *Flying Gallop* (*Galop Volant*), in the *Revue Archéologique* (Paris, 1901), demonstrated the adoption in China of a method of representing the gallop which seems to have been derived from early Asia and Central Asia. M. Reinach has also pointed out that the horses of Bactria, sent to China either as tribute, or at the instance of Imperial officials, were represented on the bas-reliefs of Han times. Hirth, in *Ueber fremde Einflüsse in der Chinesischen Kunst*, Leipzig, 1896, has shown that the decoration of the Greek mirrors of Bactria was reproduced on the Chinese mirrors of the Han period. Chavannes (*Journal Asiatique*, IX., S. vol. VIII., pp. 529 *et seq.*, 1896) upholds the theory, apparently well founded, of a transformation in the fabulous type of the Chinese Phœnix, which,

in the period of the Hans, passed from the pheasant form peculiar to ancient China to a form closely akin to the Persian bird, Simurgh. Finally, Laufer, in *Chinese Pottery of the Han Dynasty*, has carefully examined all the problems presented in the study of the decoration of Chinese pottery in the Han period.

NOTE 3 (page 23).—The subject on the lids of these jars shows, in the middle, three mountain peaks, one of which rises high above the others. They are surrounded by waves, the conventionalised form of which is carried right round the lid. This seems almost certainly to be a representation of the Island of the Blest or of the Immortals, " beyond the sea." Although we know of no Chinese text which alludes to these jars, we can hardly doubt that they are funerary objects. Pages 168 to 211 of Laufer's *Chinese Pottery of the Han Dynasty* will be read with much interest in this connection.

NOTE 4 (page 25).—Here Fenollosa follows Bushell in determining the dates of the bas-reliefs of the Han period. It is now proved that Bushell's conclusions were erroneous and that the bas-reliefs date from the second and third centuries after Christ.

CHAPTER III.

NOTE 1 (page 37).—Fenollosa's opinion as to the priority of the Pāli Canon, which was generally accepted when he wrote, can no longer be maintained. The discoveries made in Central Asia during the last few years have modified the whole question. Dutreuil de Rhyns and Petrowsky brought back the two halves of a *Dhammapada* written in a very ancient alphabet, and composed in a Sanskrit dialect. After them, Sir Aurel Stein, Grünwedel, von Lecoq, and Pelliot have made contributions of the highest interest, the examination of which has barely begun. But already it has yielded Sanskrit versions of the texts which hitherto had belonged exclusively to the Pāli Canon.

This is sufficient to prove that this was no unique, privileged Canon, peculiar to the School of the South, and of the greatest antiquity, but that other Canons, no less rich and methodical, formed the basis of the texts of the Northern School, Canons showing intrinsic evidences of antiquity which make it impossible to consider them posterior to the Pāli Canon. The Sanskrit or Northern Canon, moreover, appears to be extremely complex, and can no longer be considered homogeneous ; it contains elements as ancient as the Pāli Canon, and in the present state of our knowledge, it is impossible to affirm the priority of the one to the other. Those who wish to form a clear idea of the question as rapidly as possible should read Sylvain Lévi's *Les Saintes Ecritures du Buddhisme, comment s'est constitué le Canon sacré*, in the *Conférences du Musée Guimet*, 1909, Paris.

NOTE 2 (pages 32—35).—M. A. Foucher's studies have settled the question of the iconographic type of Buddha. They show how the representation of Buddha was evolved from the combination of the monkish type and the princely type. Buddha took the robe of the monk, but he retained the head-dress of the prince, and instead of the shaven crown of the *bhikshu* he has the high chignon of the Indian noble. This

fusion took place in the Hellenistic workshops of Gandhāra, where the traditions which fettered the representations of the purely Indian workshops had not the same force. Scarcely had it been created, indeed, when the Buddha type of the Gandhāran workshops seems to have been adopted by the whole of India. (See A. Foucher, *Les Débuts de l'Art bouddhique ; Journal Asiatique*, 1912, and *L'Art gréco-bouddhique du Gandhāra*, Leroux, Paris, 1905.)

NOTE 3 (page 37).—The writing brush was invented by Meng T'ien (general under Ch'in Shih Huang-ti), who died in 210 B.C. As early as this, writing with a brush upon silk was practised. The invention and use of paper followed closely upon this important modification of the process of writing.

CHAPTER IV.

NOTE 1 (page 48).—The ancient Korean state of Paik-tjyel (in the Japanese transcription Hakusai or Kudara or Benkan, in the Chinese transcription Pai-tsi) occupied the territory which is now the province of Seoul, in the centre and on the western slope of Korea.

NOTE 2 (page 58).—The Sarson sect is a Buddhist sect introduced into Japan by the bonze Ekwan, who came from Korea in 625. His principal doctrines were based upon the writings of Maudgalyāyana and Nāgārjuña. As the sect professed to propagate the teachings of the life of Sākya Muni, it was also known as *Ichi-dai-kyō-shū*. It was eventually divided into two sections : the *Gwankōji-ha* and the *Taianji-ha*. Both have long disappeared.

NOTE 3 (page 62).—*Sōjō* is a Buddhist title corresponding to that of bishop. The work in question here is a portrait of one of the mitred abbots of Horiuji.

NOTE 4 (page 62).—The explorations in Central Asia have brought to light representations of the four Buddhist kings of the four cardinal points closely akin to that mentioned by Fenollosa. It is a type common to the whole of Eastern Turkestan. Numerous examples occur in von Le Coq's fine plates of *Chotscho* (Berlin, 1913).

NOTE 5 (page 64).—Here Fenollosa's chronology is incorrect. Kamatari was certainly born in 614. He was therefore fifteen when the Emperor Jomei came to the throne, and twenty-seven at his death. It was during the three reigns of Kotoku, Saimei, and Tenchi (*i.e.* from 646 to the year of his death, 669) that he took an active part in affairs of state, under the title of *Naijin*.

CHAPTER V.

NOTE 1 (pages 77—85).—These observations are the outcome of the period at which the chapter was written. It is obvious that Fenollosa would have completed it, had he been able to acquire an adequate knowledge of the researches which have substituted exact information for suppositions more or less well founded. First in order was the attempt of Grünwedel to establish the purely Indian character of the Hellenistic bas-reliefs of Gandhāra. His work *Buddhistische Kunst in Indien*

appeared in 1893. In 1901 Burgess published an English edition of it, to which his own very important additions gave a new character (*Buddhist Art in India*, by A. Grünwedel. Translated by A. C. Gibson ; revised and enlarged by J. Burgess, London, 1901). Finally, in 1905 A. Foucher issued the first volume of his *Art gréco-bouddhique du Gandhāra*, in which he carries the study of the problem so far, that he has left but scanty gleanings relating to matters of detail for further research.

All these works have finally solved the question of the constitution of Greco-Buddhist art in the Hellenistic workshops of Gandhāra. Further, the explorations carried out in Chinese Turkestan have shown how Buddhist preachers brought Gandhāran models to Khotan by way of the long line of oases scattered among the K'un-lun hills. Moreover, the Nestorians and Manichæans, driven eastward by Byzantine persecution, and coming into contact with China proper, brought into Eastern Turkestan a number of elements from earlier Asia. If the Hellenistic art of Gandhāra, intermingled as it was with Sassanian and Bactrian elements, made its influence felt in Northern China, in Korea and in Japan, it was at the price of transforming itself as it advanced towards the East. It is quite legitimate to speak of Hellenistic influences on the art of Northern Wei, of Korea, and of Japan in the fifth, sixth and seventh centuries, but it must be understood that these influences were already remote. Khotan seems to have been the extreme eastern boundary of Gandhāran art properly so called. We are in the presence of an artistic school, which, having created the iconographic types of Buddhism, prolonged certain influences in consequence of the immobility of religious images ; we are not face to face with a vivifying inspiration comparable to the influence of Greek art on European art. We see rather the last ripples of a distant wave, the waters of which are arrested at the limits of the oriental world.

NOTE 2 (page 79).—When the head of a Gandhāran Buddhist figure is surmounted by a serpent, there is not the slightest doubt that a *nāga* is suggested. When he speaks of those monarchs or warriors whose heads are surmounted by a serpent, Fenollosa seems to be alluding either to those *Nāga*-kings who figure so frequently in Gandhāran bas-reliefs, or to simple *Nāgas* evoked in connection with some characteristic scene. The reader will find representations and explanations of these scenes in A. Foucher's *L'Art gréco-bouddhique du Gandhāra*.

NOTE 3 (page 84).—The idea that the Byzantine Emperors were in communication with the Emperor T'ai Tsung, and proposed that he should enter into an alliance with them against the Mahometans, has no historic basis. Chinese history has preserved a record of an embassy sent in 638 to the Emperor of China by the Persian King, Yezdegerd. The latter, vanquished by the Arabs, who had invaded Persia and penetrated to the north of the Oxus, had fled to Merv, whence he implored the help of T'ai Tsung. We do not know how his request was received. When T'ai Tsung had been entreated by the inhabitants of Samarcand on several occasions to intervene against the Arabs, he had replied that they were too far away, and that he could not protect them. He probably made a similar reply to the envoys of Yezdegerd, who was definitively conquered and killed in 642. It was probably this episode of Persian history which Fenollosa confounded with Byzantine history.

NOTE 4 (page 87).—*Wadō* is the name of a *nen-gō* (708—715). *Yoro* also (717—724).

CHAPTER VII.

NOTE 1 (page 119 *et seq.*).—Fenollosa seems here not to have taken into account the constitution of the Northern and Southern Schools in China during the T'ang period. Indeed, the example on which he relies, certainly painted very much later than he supposes, sufficiently explains his error. Chinese books give us a very precise account of the constitution of the two schools, and these texts, far from being modern, date from the Sung period. Further, neither the School of the North nor that of the South was official ; they represent two tendencies rather than a firmly established tradition which would justify the use of the term School.

In its beginnings, the School of the North, as represented by Li Ssŭ-hsün and Li Chao-tao, was characterised by delicate lines and violent colours. Later, it acquired that vigour of line which, conjoined with violence of tone, gave it such individuality at the end of the Sung and during the Yüan period. As to the style of Wang Wei, it consisted of a very supple and varied line combined with a very sober use of colour. The tints were light and discreet, and the technique often became that of a monochrome in Indian ink. There was a great difference between this monochrome painting and the *Bunjingwa* or "Painting of the *literati*" (in Chinese, *Wên-jên-hua*) to which Fenollosa alludes. This painting, with its calligraphic style, is totally different in character. It summarises forms by an abstract line, which gives a very remote synthesis of things. It has never been proposed to father it upon Wang Wei, whose mind was set on problems of aërial perspective and the relative value of tones.

Wang Wei also practised the painting known as *Lü-ch'ing*. It consists in the use of a malachite green, which merges into lapis lazuli blues as the planes recede, and as the mountains, set screen-wise one behind the other, lose their individual colour and appear veiled in the blues of the atmospheric strata. The British Museum owns a fine landscape of this kind, painted in the manner of Wang Wei, and attributed to the great painter of the Yüans, Chao Mêng-fu.

I must add that the work of Wang Wei seems to be completely lost. We can form an idea of it only by means of replicas or copies. This is enough to show that the traditional attribution of certain paintings in Japan to Wang Wei is baseless. The same must be said of the attribution, accepted by Fenollosa in his book, of certain paintings to Wu Tao-tzǔ. But this chapter has nevertheless a very special interest, in that it presents to Europeans the conceptions of ancient Japanese criticism in relation to the early Chinese masters.

NOTE 2 (pages 126—129).—Here again Fenollosa reveals to us the point of view of Japanese archæologists of the old school, with whom he had been brought in contact. These data are of the greatest interest, and must certainly be taken into account. But in connection with the subject under discussion, the scepticism it betrays is not well founded. The study of certain Chinese collections, such as that of the former Viceroy, Tuan-fang, and Mr. Lö Chên-yü, of Peking, and the discoveries made by Sir Aurel Stein's mission, the Grünwedel, von Le Coq and Pelliot missions in Chinese Turkestan or at Tun-huang, have brought to light a large number of

T'ang paintings. Some few among these are very fine, and may be described as of the first rank; a great many others are of the highest interest from the archæological point of view. I may add that certain paintings of the T'ang period have arrived in Europe within the last few years. At the Exhibition in the Cernuschi Museum in Paris in 1912, M. Chavannes and the present writer were able to establish the incontestable authenticity of three examples, all of the greatest artistic merit. (See Chavannes and Petrucci, *La Peinture chinoise au Musée Cernuschi, Ars Asiatica,* premier fascicule (part i.), Van Oest, Paris and Brussels, 1913.)

NOTE 3 (page 139).—There is a mistake here which should be rectified. Dai-nichi-niorai never appears in the form of a Bodhisattva. He is a spiritual Buddha or a Dhyāni-Buddha. He is the first of the Buddhas of the Trikāya; he corresponds to Dharma, or Law, in the Triratna; he is the personification of essential intelligence and absolute purity; he is the first of the five Dhyāni-Buddhas, and has Samantabhadra for his Dhyāni-bodhisattva. In the Shingon sect he is the eternal and uncreate Buddha, of whom all the remaining Buddhas are but emanations. Here, even more emphatically than elsewhere, he held the highest rank, and was certainly never designated otherwise than as a Buddha.

CHAPTER VIII.

NOTE 1 (page 141).—The Taihō-ryōritsu, already mentioned incidentally on p. 151 of the present volume, is a code which was promulgated in the first year of the Taihō era, *i.e.*, in 701. The Emperor Tenji had taken the initiative in appointing a commission for the purpose of collecting all the laws actually in use, unifying them, and editing them in an official and definitive form. This work was completed in 670. As the capital was then Shiga, in Ōmi, the code became known as the Ōmi-ryo. It was finished in the reign of the Emperor Temmu and first promulgated in that of the Empress Jitō, in 689. The Emperor Mommu had all the earlier work recast in the form of a compact body of laws. This was accomplished in 701. On the promulgation of the code in this same year, jurists were sent into all the provinces to proclaim and elucidate it. The Taihō code was subjected to some slight modifications in the reign of the Empress Genshō (715—724). It remained in force, save for some variations in detail, until the revolution of 1868.

NOTE 2 (pages 150 and 151).—Enryaku-ji is the temple founded by Dengyō-Daishi, and is still the central seat of the Tendai sect. But here Fenollosa alludes to the part played by the monks of Hiei-zan in the history of Japan. Many other temples rose round the parent building. These were fortified, and Mount Hiei-zan became an impregnable fastness. As the Imperial power declined, the audacity of the monks increased. They armed themselves, and maintained a body of troops who became the terror of Kiōto. They also played a very important part in the civil wars of the feudal period, and it required the brutal and energetic repressive measures of Nobunaga to bring them into subjection. In 1571 he seized the temples, burnt them, and massacred all the bonzes. Some of the temples were rebuilt subsequently, but the military power of the monks of Hiei-zan had been finally destroyed.

NOTE 3 (page 167).—The secular origin of Jōcho's art is not perhaps so evident as Fenollosa believed. Jōcho was a bonze like his father Kōshō, and although they are the heads of all that dynasty of sculptors who constitute the school of Nara, their essentially Buddhist art reveals a thoroughly religious inspiration.

VOLUME II.

CHAPTER X.

NOTE 1 (page 6).—The idea that Chinese characters have two senses, one natural and realistic, the other spiritual and metaphorical, is wide-spread. It has been put forward in certain so-called translations of the *Tao-tê-king* by heterodox sinologists. It is, however, entirely mistaken, and when we see it accepted without question by a mind of such distinction as that of Fenollosa, it seems necessary to warn the reader against such theories. As a fact, the ancient Chinese poets had ideas of what they wished to say no less clearly defined than those of our own poets. Characters had a very precise sense in their minds. If their poetry has become difficult to understand occasionally, both to Chinese scholars and European sinologists, it is because the allusions, the historical conditions, all the complex elements which go to make up a poem, have been lost or forgotten. Hence it is necessary to reconstitute the meaning by a study which overloads the artist's free and precious expression with commentaries. But the characters in Chinese poems are neither more nor less evocative than the words in our own poetry.

NOTE 2 (page 8).—Chinese texts say explicitly that Fan K'uan first formed himself on the style of Li Ch'êng.

NOTE 3 (pages 12—18).—These fragments are taken from two sources. Some are from the Treatise on Landscape-painting written by Kuo Hsi, others from the Observations on Painting published by Kuo Ssŭ, his son, which are supposed to have been written for the most part from notes left by Kuo Hsi himself. In any case, they all reflect Kuo Hsi's ideas. I do not know where Fenollosa procured the Chinese text from which the translation he gives in his book was made. I have myself compared this with the original, and save for slight variations in details, which may be due to a translator's fancy, the translation is on the whole sufficiently accurate.

CHAPTER XI.

NOTE 1 (page 38).—The following are the exact dates of these three reigns:

Kao Tsung	1127—1163.
Nin Tsung	1195—1225.
Li Tsung	1225—1261.

CHAPTER XIV.

NOTE 1 (page 119).—The following is the correct form and explanation of this table:

Yeitoku (1543—1590) was the son of Kano Shoyei. Genshiro is merely a personal name of Yeitoku. These two names represent one and the same person.

Kano Yeitoku had three sons: Mitsunobu (d. 1608), Takanobu (1570—1618), and Yoshinobu.

Mitsunobu had a son, Sadanobu, who died childless.

Takanobu, brother of Mitsunobu, had three sons: Tanyu (1602—1674), the eldest; Naonobu (1607—1651), the second; and Yasunobu (1608—1683), the third.

Lastly, Tsunenobu (1636—1713) was the son of Naonobu.

GLOSSARY OF PROPER NAMES

GLOSSARY OF PROPER NAMES *

ABE-NO-NAKAMARO. Japanese writer and poet. He lived from 701 to 770, and spent the greater part of his life in China.

AHIMI, KOSE. Japanese painter of the 9th and 10th centuries. Son of Kose Kanaoka.

AKAHITO, YAMABE-NO. Japanese poet of the 8th century. He shares with Hitomaru the title of the Sage of Poetry.

AMOGHAVAJ'RA. Indian monk. He followed Vajrabodchi to China in 719, and in 732 succeeded him as chief of the Yogātchārya school.

ARIIYÉ, KOSE. Japanese painter of the Kose school. He lived in the 14th century.

ASA. Corean prince of the kingdom of Hiakusai or Kudara. He came to Japan at the end of the 6th century. The portrait of Shotoku Taishi is ascribed to him.

ASAÑIGHA. Buddhist monk and preacher. He seems to have lived in the 6th century. He was a native of Gandhara and the founder of the Yogātchārya school, and left various writings.

ASHIKAGA TAKANJI (1305-1358). The first Shōgun of the Ashikaga family. He held the Shōgunate from 1338 to 1358.

ASHIKAGA YOSHIMITSU (1358-1408). The third Shōgun of the Ashikaga family. He held the Shōgunate from 1367 to 1395. Having abdicated in favour of his son, and become a bonze, he caused the Kinkaku-ji to be built.

AWADAGUCHI TAKAMITSU, TOSA. Japanese painter of the 14th century. He was the son of Tosa Mitsuaki.

BAIREI, KONO. Japanese painter of the 19th century.

BEISEN, KUBOTA. Contemporary Japanese painter.

BODHIDHARMA. The twenty-eighth patriarch of Indian Buddhism and the first of Chinese Buddhism. He came to convert China in 520, and died about ten years later.

BUNCHO, TANI. Japanese painter of the classical school. He lived from 1764 to 1841.

BUNRIN, SHIOGAWA. Japanese painter of the middle of the 19th century. He was a pupil of Toyohiko.

BUSON, YOSA. Japanese painter. He lived from 1716 to 1783.

CHANG SENG-YU (*Chosoyo*). Chinese painter of the 6th century.

CHAO CH'IEN-LI (*Chosenri*). Chinese painter of the Sung period.

CHEN SO-UNG (*Chin Shoo*). Chinese painter of the Sung period.

CH'EN TUAN (*Kwazan Inshi*). Philosopher, alchemist and poet of the period of the "Five Dynasties." He died in 989.

CH'ENG CHUNG-FU (*Danshidzui*). Chinese painter of the Yuan period and the beginning of the Ming period.

CHIKANOBU, KANO. Japanese painter of the 18th century, the son of Kano Tsunenobu.

CHIN NAN-PING. Chinese painter of the 18th century. He worked in Japan, and exercised a strong influence on the Japanese painters of the Chinese tradition.

CHISHO DAISHI. The posthumous name of the monk Enchin, founder of the Tendai sect in Japan. He lived from 814 to 891.

* This glossary is appended by Prof. Petrucci. The Japanese transliteration of old Chinese names adopted by the late Prof. Fenollosa is given in brackets.

CH'IN YING (*Kinyei*). Painter of the Ming period. He lived in the 16th century.
CHŌ DENSU, or MINCHŌ. Buddhist priest and Japanese painter. He lived in the 15th century, and died about 1431.
CHOGA, TAKUMA. Japanese painter of the end of the 12th and the beginning of the 13th century.
CHOKKEN. Japanese painter of the 18th and 19th centuries. A pupil of Okio.
CHOKUAN, SHOGA. Japanese painter of the 16th century. He died in the first years of the 17th century.
CHOU TUN-I (*Teishi*). Philosopher of the Sung period. He lived from 1027 to 1073.
CHU HSI (*Shuki*). Philosopher of the Sung period. He lived from 1130 to 1200.
CH'U HUI (*Beigensho*). Chinese painter. He lived at the end of the T'ang period.
CHÜ YÜAN, or CHÜ PING (*Kutsugen*). One of the greatest poets of China. He was the minister of Prince Huai, in the province of Ch'u. On his disgrace, he retired into solitude and composed the Li-sao. He lived from 332 to 295 B.C.
CH'UAN SHIH (*Rinno*). Chinese painter of the Ming period. He lived in the 15th century.
CHUJO-HIME. Daughter of Fujiwara Togonari; she lived from 753 to 781. She retired to the temple of Taemadera in Yamato under the religious name of Zenohin-ni. She embroidered a hanging representing the Paradise of Amida. Legend represents her as an incarnation of Kwannon.
CONFUCIUS (*Koshi, Kung Tzŭ*). The acknowledged chief of Chinese classic philosophy. He lived from 551 to 479 B.C.

DAIGŌ. Japanese Emperor, who reigned from 898 to 930.
DO-AN, YAMADA. Japanese painter of the 16th century. Do-an is his priestly name. His secular name is Yorisada.
DŌKYŌ. A Buddhist monk, famous for his intrigues and for the part he played in the Japanese history of the 18th century. He died in 772.
DONCHO. A Corean bonze, who is supposed to have come to Japan in 610. The frescoes of Horiuji are ascribed to him, and he is also credited with having taught the Japanese to make paper and Indian ink.

EIKWAN. Bonze of the Jodo sect. He lived in the 10th century.
EN-I. *See* SAIGYŌ.
EN NO SHOHAKU. Born in 634; he was one of the first Buddhist hermits in Japan. At the age of 32 he retired to Mount Katnuagi, and lived in solitude for thirty years.

FAN AN-JEN. Chinese painter of the South Sung period. He lived in the 13th century.
FAN K'UAN (*Hankwan*). Chinese painter of the 10th and 11th centuries.

GANKU, KISHI. Japanese painter of the classical school. He lived from 1749 to 1838.
GANRYO, KISHI. Nephew and pupil of Ganku. He lived from 1798 to 1852.
GANTEI, KISHI. Son and pupil of Ganku. He died in 1865.
GEIAMI, or SHINGEI. Japanese painter, son of Noami. He lived in the second half of the 15th century.
GEMMEI. Japanese Emperor. He reigned from 708 to 722.
GENHA, KANO. Painter of the Kano family. He lived in the 16th century.
GENKI, KOMAI. Japanese painter. Pupil of Okio. He died in 1797.
GENSHIRO. *See* KANO YEITOKU.
GENSHŌ. Japanese Empress. Born in 681, she came to the throne in 715, abdicated in 724, and died in 748.
GIOGI (*En no Giogi*). A celebrated bonze, by birth a Corean. He spent the greater part of his life proselytising in Japan. He lived from 670 to 749.

GIOKUHO. Japanese painter of the 18th and 19th centuries. A pupil of Goshun Matsumura.

GITO, SHIBATA. Pupil of Goshun Matsumura. He died in 1819.

GOSHUN, MATSUMURA. Japanese painter, a pupil of Okio. He was born in 1752, and died in 1811.

HAN CH'I (*Oyoshi*). Man of letters and statesman of the Sung period. He lived from 1008 to 1075.

HAN KAN (*Kankan*). Chinese painter of the 8th century.

HAN WEN-KUNG. Canonisation title of Han Yü, a writer of the T'ang period. He lived from 728 to 824.

HARUNOBU, SUZUKI. Japanese painter, a pupil of Shighenaga. He lived from 1718 to 1770.

HENJŌ, YOSHIMINI MUNESADA. Japanese poet. Henjō is his priestly name. He lived from 816 to 890.

HIDARI JINGORŌ. Japanese sculptor. He lived from 1594 to 1634.

HIROSHIGHE. Japanese painter. He lived from 1797 to 1858.

HIROTAKA, KOSE. Japanese painter of the Kose school. He lived at the end of the 9th and the beginning of the 10th century.

HIROTAKA, SUMIYOSHI. Japanese painter of the 19th century. He died in 1885.

HITOMARO, KAKIMONOTO. Celebrated poet of Japan. He lived in the 8th and 9th centuries, and died probably in 729.

HIUAN-TSANG. Chinese Buddhist monk, famous for his pilgrimage to India and his translations of the sacred writings. He lived from 602 to 664.

HOGHAI, KANO. Japanese painter of the Kano school. He lived until the last years of the 19th century.

HOITSU SAKAI. Japanese painter of the school of Korin. He lived from 1761 to 1828.

HŌJŌ TOKIYORI. Fifth Shikken of Kamakura. He lived from 1226 to 1263, and succeeded his brother Tsunetokien in 1246.

HOKKEI. Japanese painter of the 19th century, a pupil of Hokusai.

HOKUSAI. Japanese painter, one of the great Ukiyoyé masters. He lived from 1760 to 1829.

HONEN SHŌNIN. Name given to the bonze Genkū, the founder of the temple of Chionin. He lived from 1133 to 1212.

HOYEN, NISHIYAMA. Japanese painter of the 19th century. He died in 1867.

HSIA KUEI (*Kakei*). Chinese painter of the Sung period. He lived at the end of the 11th and the beginning of the 12th century.

HSIA MING-YUAN (*Kameiyen*). Chinese painter of the Sung period. He lived in the 13th century.

HSIEH LING YÜN (*Shareiwun*). Chinese poet of the 4th and 5th centuries.

HSÜ HI (*Joki*). Chinese painter of the "Five Dynasties." He lived in the 10th century.

HUANG CH'UAN (*Kosen*). Chinese painter of the "Five Dynasties." He lived in the 10th century.

HÜAN TSUNG (*Genso*). Emperor of the T'ang dynasty. He reigned from 713 to 756.

HUANG-TI, or the YELLOW EMPEROR. A semi-legendary personage. He lived *circa* 2697 B.C.

HUI TSUNG (*Kiso* or *Kiso Kotei*). Chinese Emperor of the Sung dynasty. He reigned from 1101 to 1126.

HUI YÜAN. Buddhist priest, founder of the School of the Lotus. He lived from 333 to 416.

INDARA. This painter worked in China in the Sung period. He probably was not Chinese. He is remembered only in Japan.

IPPO, HANABUSA. Japanese painter in the 18th century. He died in 1772.

IPPO, MORI. Japanese painter of the 19th century. He was the son of Mori Tessan.

ISEN, KANO. Japanese painter of the Kano school. He lived in the 18th and 19th centuries.

ISHIKAWA TOYONOBU. Japanese painter, pupil of Shigenaga. He lived from 1711 to 1785.

I-TSING. Chinese Buddhist priest, celebrated for his pilgrimages in India. He lived from 634 to 713.

IYEYASU, TOKUGAWA. The first Tokugawa Shōgun. He lived from 1542 to 1616, and held the Shōgunate from 1603 to 1605.

JASOKU, SOGA. Japanese painter of the 15th century, the son of Soga Shiubun. He died about 1483.

JITO. Japanese Empress, widow of the Emperor Temmu. She reigned from 687 to 703.

JŌCHO. Japanese sculptor of the 11th century.

JOMEI. Japanese Emperor. He reigned from 629 to 641.

JOSETSU. Painter of the 14th and 15th centuries. He was Chinese by origin, but settled in Japan, and is now known only by his Japanese name.

K'AO KO–MING (*Jinkomei*). Chinese painter of the Sung period. He lived in the 11th century.

KAIHOKU YUSHO. Japanese painter. His personal name was Joyeki. He lived from 1533 to 1615.

KAKUYŪ. Japanese painter, better known under his monkish name Toba, accompanied by his episcopal title : Sojo. He lived from 1053 to 1140.

KAMATARI, FUJIWARA. The founder of the Fujiwara family. Born in 614. He took an active part in public affairs from 646 to his death in 669.

KAN DENSU. Japanese painter of the 15th century. A pupil of Chō Densu.

KANANOBU, KOSE. Japanese painter, of the Kose school, in the 12th century.

KANAOKA, KOSE. Japanese painter, founder of the Kose school. He lived in the 9th and 10th centuries.

KANATAKA, KOSE. Japanese painter of the Kose school. He lived in the 11th, and perhaps in the 12th century.

KANG HI. Emperor of the Ts'ing dynasty. He reigned from 1662 to 1723.

KANISHKA. An Indian King, the conqueror of the greater part of India and the patron of Buddhism. He reigned from 15 B.C. to 45 A.D.

KANSHIN. A Chinese bonze who came to Japan in 754. In 758 he received the title of Taishon-oshō, by which he is sometimes designated. He lived from 687 to 763.

KATO KIYOMASA. A Japanese general, famous for his conquests in Corea. He lived from 1562 to 1611.

KEIBUN, MATSUMURA. A Japanese painter, the pupil and younger brother of Goshun Matsumura. He died in 1843.

KEION, SUMIYOSHI. Japanese painter of the 12th and the 13th centuries.

KEISHOKI, TSUBURA. Japanese painter of the 15th century.

KENZAN, OGATA. Japanese painter and potter. He was the brother of Korin, and lived from 1663 to 1743.

KI'EN LUNG. Chinese Emperor of the T'sing dynasty. He reigned from 1736 to 1796.

KIMMEI. Japanese Emperor who reigned from 540 to 571.

KIMURA NAGAMITSU. Painter of the Kano school. He was a monk under the name of Zenryo. He lived in the 16th century.

KINMOCHI, KOSE. Japanese painter of the Kose school. He was the son of Kose Kintada and the great grandson of Kose Kanaoka, and lived in the 11th century.

KIREI. Japanese painter, a pupil of Okio. He lived in the 18th century.

KISHI CHIKUNDO. Japanese painter of the school of Ganku. He was born in 1826.

KIUHAKU, KANO. Painter of the Kano school, the father of Kano Yeitoku. He lived in the 17th century.

KIYOMASU, TORII. Japanese painter, who ranks as the second great master of the Torii school. He was born in 1679 and died about 1763.

KIYOMITSU, TORII. Japanese painter of the Torii school. He lived from 1735 to 1785.

KIYOMORI, TAIRA. The greatest of the Taira. He lived from 1118 to 1181.

KIYONAGA. Japanese painter; his real name was Sekiguchi Ichibei. He was born in 1752 and died in 1814.

KIYONOBU, TORII. Japanese painter of the Torii school. He lived from 1664 to 1729.

KOBO DAISHI. His real name was Kūkai. Kobo Daishi is a posthumous name. He was a Japanese monk, who studied in China, and on his return to Japan founded the Shingon sect. He lived from 774 to 835.

KOBUN. A Japanese sculptor of the school of Nara. He lived in the 13th and 14th centuries.

KOI, KANO. Painter of the Kano school. His real name was Matsuga Koi. He lived from 1566 to 1636.

KŌKEN. Japanese Empress, who reigned from 749 to 758.

KŌNIN. Japanese Emperor, who reigned from 770 to 781.

KONISHI, YUKINAGA. A Japanese general who commanded in Corea. He died in 1600.

KOREHISA, KOSE. Japanese painter of the Kose school. He lived in the 14th century.

KORIUSAI. His real name was Isoda Shobei. A Japanese painter, the pupil of Harunobu. He lived at the end of the 18th century.

KUAN HSIU (*Zengetsu*). Chinese painter of the period of the "Five Dynasties." He lived in the 10th century.

KUAN YÜ. A Chinese general, who died in 219. He was deified as god of war under the name of Kuan Ti.

KŪKAI. *See* KOBO DAISHI.

KU K'AI-CHIH (*Kogaishi*). A Chinese painter, under the "Six Dynasties"; he lived in the 4th and 5th centuries.

KUNISADA. The second Toyokuni. A Japanese painter of the 19th century. He died in 1864.

KUNIYOSHI. A Japanese painter of the 19th century. He died in 1861.

KUO HSI (*Kakki*). Chinese painter of the 11th century.

KUO SZE (*Jakkio*). Chinese painter of the Sung period, the son of Kuo Hsi. He lived in the 11th and perhaps in the 12th century.

KUSUNOKI MASASHIGE. A Japanese hero, the traditional type of fidelity and devotion to the Imperial dynasty. He lived from 1294 to 1336.

KWAIGETSUDO. A Japanese painter, the pupil of Miyagawa Shosun. He lived at the beginning of the 18th century.

KWAMMU. A Japanese Emperor. He reigned from 782 to 805.

KWASAN, YOKOYAMA. A Japanese painter, the pupil of Ganku and afterwards of Goshun. He lived from 1784 to 1837.

LAO-TZÜ (*Laotse*). A Chinese philosopher, the author of the Tao-té-ching. Legend has transformed him into a fabulous being. He now holds the first place in the Taoist Trinity. He was born 604 B.C.

LIANG CH'IEH (*Riokai*). A Chinese painter of the South Sung period. He lived in the 13th century.

LI CH'ENG (*Risei*). A Chinese painter of the Sung period. He lived in the 10th century.

LI CHIEN. A Chinese painter of the T'ang period. He lived in the 9th century.

LI LUNG-MIEN (*Ririomin*). A Chinese painter of the Sung period. He died at the beginning of the 12th century.

LI PO (*Rihaku*). One of the greatest poets of Chinese literature. He lived from 705 to 762.

LIN PU. Chinese calligrapher and man of letters in the 3rd century, A.D.

LI SSU-HIUN (*Rishikin*). A Chinese painter of the T'ang period. He lived in the 8th century.

LI T'ANG (*Rito*). Chinese painter of the Sung period. He lived in the 12th century.

LI TI (*Riteki*). Chinese painter of the Sung period. He lived in the 12th century.

LI TSUNG. Emperor of the South Sung period. He reigned from 1125 to 1265.

LIU SUNG-NIEN. Chinese painter of the Sung period.

MA CHE-YUNG. Chinese painter, the father of Ma Yüan and Ma Kuei. He lived in the 12th century.

MA HING-TSU (*Bakoso*). Chinese painter, the grandfather of Ma Yüan.

MA-KONG-HIEN (*Bakoku*). Chinese painter, the uncle of Ma Yüan and the elder brother of Ma Che-yung.

MA KUEI (*Baki*). Chinese painter of the Sung period, the brother of Ma Yüan. He lived in the 12th and 13th centuries.

MA LIN (*Barin*). Chinese painter of the Sung period, the son of Ma Yüan. He lived in the 13th century.

MA YÜAN (*Bayen*). Chinese painter of the Sung period. He lived in the 12th and 13th centuries.

MAO CHANG (*Mosho*). Chinese painter of the Sung period. He lived in the 12th and 13th centuries.

MASAKADO, TAIRA. One of the Taira. He died in 940.

MASANOBU, KANO. Japanese painter, the founder of the Kano school. He lived in the 15th century.

MASANOBU, OKUMURA, or GENFACHI. Japanese painter who lived from 1690 to 1768.

MATAHEI, IWASA. Japanese painter, the founder of the school which bears his name. He lived in the 16th and 17th centuries.

MICHIZANE, SUGAWARA. Son of Koreyoshi and minister of the Emperors Uda and Daigo. He lived from 845 to 903.

MINCHŌ. *See* CHŌ DENSU.

MINENOBU, KANO. Painter of the Kano school, the second son of Kano Tsunenobu. He died in 1790.

MING TI (*Meitei*). Chinese Emperor of the Han dynasty. He reigned from 58 to 76. Buddhism seems to have made its first appearance in China in his reign.

MITSUHISA, TOSA. Japanese painter, the daughter of Tosa Mitsunobu and wife of Kano Motonobu.

MITSUMOCHI, TOSA. Japanese painter of the Tosa school. He worked in the first half of the 16th century.

MITSUNAGA, KASUGA. Japanese painter of the 12th century.

MITSUNAKA, MINAMOTO. The son of Tsunemoto. He lived from 912 to 997.

MITSUNARI, TOSA. Japanese painter of the Tosa school. He died in 1710.

MITSUNOBU, TOSA. Japanese painter of the Tosa school. He was born about 1434 and died about 1525.

MITSUNORI, TOSA. Son of Mitsuyoshi. He lived in the 17th century.
MITSUOKI, TOSA. Son of Mitsunori. He died in 1691.
MITSUSHIGHE, TOSA. Son of Yukimitsu. He lived in the 15th century.
MIYAGAWA CHOSHUN. Japanese painter. He lived from 1682 to 1752.
MI YUAN-TCHANG, or MI FEI (*Beigensho*). Chinese painter of the Sung period. He lived at the beginning of the 11th century.
MORIKAGE, KUSUMI. Japanese painter of the 17th century.
MORIKUNI, TACHIBANA. Japanese painter and calligrapher. He died in 1748.
MORI KWANSAI. Japanese painter, the pupil and son-in-law of Mori Tessan. He died in 1894.
MORIYA, MONONOBE. Japanese statesman. He opposed the Soga, and showed himself the implacable foe of Buddhism. He died in 587.
MORONOBU, HISHIKAWA. Japanese painter of the 17th century. He lived from 1625 to 1662.
MOTOMITSU, KASUGA. Japanese painter, one of the founders of the Tosa school properly so called. He lived in the 11th century.
MOTONOBU, KANO. Japanese painter, the son of Kano Masanobu. He lived from 1476 to 1559.
MOTOTSUNE, FUJIWARA. Japanese statesman, writer and regent of the Empire. He lived from 836 to 891.
MU-AN (*Mokuan*). Chinese painter of the Sung period. He was a Buddhist monk, and lived in the 13th century.
MU CH'I (*Mokkei*). Chinese painter of the Sung period. He lived in the 10th century.
MU WANG (*Wa-Tei*). A Chinese Emperor, the sixth sovereign of the Chou dynasty. He came to the throne in 1001 B.C. and died in 946 B.C.
MURASAKI SHIKIBU. Japanese writer, authoress of the *Genji Monogatari*. She died in 992.

NAGARJIMA. The fourteenth patriarch of Indian Buddhism. He was the first to preach the doctrines of Amitābha. He was one of the greatest philosophers of Northern Buddhism. He lived in the 3rd century B.C.
NANGAKU, WATANABE. Japanese painter of the Shijō school. He died in 1813.
NARA KANTEI. Japanese painter and Buddhist monk. He lived in the first half of the 15th century.
NARIHIRA, ARIWARA. Poet and painter. He lived from 825 to 880. He became the hero of the *Ise Monogatari*.
NEN KAO. Japanese painter of the 15th century.
NICHIREN. Buddhist monk, the founder of the Hokke-shū sect. He lived from 1222 to 1282.
NIN TSUNG (*Neiso*). Emperor of the Sung dynasty. He reigned from 1195 to 1225.
NITTA YOSHISADA. Japanese hero and general. He put an end to the Hōjō power by taking Kamakura. He lived from 1301 to 1338.
NOAMI. Japanese painter of the 15th century. His family name was Nakao.
NOBUZANÉ, FUJIWARA. Japanese painter of the 13th century. He was the son of Kasuga Takachika. His priestly name was Jakusai. He died in 1265.

OKIO, MARUYAMA. Japanese painter, founder of the school that bears his name. He lived from 1733 to 1795.
ONO NO KOMACHI. The daughter of Yoshisada, celebrated for her beauty and misfortunes. She was one of the great poets of Japan. She lived from 896 to 966.
ONO NO TAKAMURA. Japanese writer and statesman. He lived from 802 to 852.
OTOMO YAKAMOCHI. Japanese statesman. He died in 785.
OZUI. Japanese painter, the son and pupil of Okio. He died in 1829.

RENZAN, AOKI. Japanese painter, the pupil and son-in-law of Ganku. He died in 1859.
RINKEN, SHIBA. Japanese painter of the Tosa school. He lived in the 16th century.
ROSETSU, NASAGAWA. Japanese painter. He died in 1799.
RYOGA, TAKUMA. Japanese painter, the son of Takuma Shoga. He lived in the 13th century.
RYOSON, TAKUMA. Japanese painter of the Takuma school. He worked about 1326.

SADANOBU, KANO. There were two Japanese painters of this name, both of the Kano school. One, the son of Kano Mitsunobu, died young ; the other was Matsuya Ko-i, born in 1566. The latter did not really belong to the Kano family either by birth or adoption.
SAICHO. Japanese bonze, better known by his posthumous name of Dengyō Daishi. He lived from 767 to 822.
SAIGO TAKAMORI. One of the most important leaders of the Restoration movement. He directed the revolt of 1877. Born in 1827. He died on the battlefield of Shiro-yama in 1877.
SAIGYŌ. Descendant of Fujiwara Hidesato. Poet and perhaps painter. He became a bonze under the name of En-i. He lived from 1118 to 1190.
SANRAKU, KANO. Japanese painter of the Kano school. His real name was Kimura Mitsuyori. He lived from 1559 to 1635.
SANSETSU, KANO. Japanese painter of the Kano school, a pupil of Sanraku. His family name was Chiga. He lived from 1589 to 1651.
SEISEN, KANO, or OSANOBU. Japanese painter of the Kano school, the son of Kano Isen, or Naonobu. He died in 1846.
SESSHU. Japanese painter, the founder of the school that bears his name. He lived from 1420 to 1506.
SHIGEMASA, KITAO. Japanese painter, the pupil of Shigenaga. He lived from 1739 to 1819. He often used the name Kosuisai.
SHIGENAGA, NISHIMURA. Japanese painter. He lived from 1697 to 1756.
SHINGETSU. Japanese painter of the Sesshu school. He lived in the 15th century.
SHINKEI. A Japanese painter, the pupil of Hoȳen. He lived in the 19th century.
SHINRAN. A famous bonze, the founder of the Shin-shu sect. He lived from 1174 to 1263.
SHOHAKU, SOGA. A Japanese painter. His real name was Soga Ki-ichi. He lived from 1730 to 1783.
SHŌMU. Japanese Emperor. He abdicated in 723 and died in 756.
SHOSEN, KANO. Painter of the Kano school, the son of Kano Seisen. He died in 1880.
SHOSISEKI, KUSOMOTO. Japanese painter, a pupil of Chin Nan-ping. He died in 1786.
SHOTOKU TAISHI. The second son of the Emperor Jomei. One of the most fervid devotees of Buddhism in Japan. He lived from 572 to 621.
SHOYEI, KANO. Painter of the Kano school. He lived from 1521 to 1592.
SHUBUN, SOGA. Japanese painter of the 15th century.
SHUKEI. A Japanese painter, better known by the name of Sesson. He lived in the 16th century, and was a pupil of Sesshu.
SHUN. One of the great legislators of primitive China. Chosen by the Emperor Yao to succeed him on the throne. He lived from 2317 to 2208 B.C.
SHUNKI, KATSUGAWA. Japanese painter of the 19th century.
SHUNMAN, KUBO. Japanese painter of the end of the 18th century.
SHUNSHO. Japanese painter. He lived from 1726 to 1792.
SHUNSUI. Japanese painter of the 18th century.
SOHA, KANO. Japanese painter, the brother of Yeitoku. He lived in the 17th century.
SORIN, TAWARAYA. Japanese painter of the 17th century.

SOSEN, MORI. Japanese painter. He lived from 1747 to 1822.

SOSHI, KANO. Painter of the Kano school. He lived in the 16th century.

SOTAN, OGURI. Japanese painter, a pupil of Shubun. He lived in the 15th century.

SOTATSU. Japanese painter of the 17th century.

SSU-MA KUANG (*Shiba Onko*). Chinese statesman and writer. He lived under the Sung dynasty from 1019 to 1086 A.D.

SU TUNG P'O (*So-Toba*). Chinese statesman, writer, poet and painter. He lived under the Sung dynasty from 1036 to 1101.

SU WU. Chinese statesman. He suffered a long captivity among the Huns. He lived in the 1st and 2nd centuries B.C.

SUGAWARA NO MICHIZANÉ. Japanese statesman, who opposed the Fujiwara in the interests of the Emperor. He lived from 845 to 903.

SUIKO. Japanese Empress. She reigned from 593 to 628.

SUSHUN. Japanese Emperor from 588 to 592.

SUMITOMO, FUJIWARA. An accomplice in the revolt of Taira Masakado. He was killed in 942.

SUMIYOSHI GUKEI. Japanese painter. He was the son of S. Jokei. He died in 1705.

SUMIYOSHI HIROSADA. Japanese painter of the Tosa school. He lived in the 19th century.

SUMIYOSHI JOKEI, or HIROMICHI. Japanese painter of the Tosa school. He lived in the 17th century.

SUNG KIUN-TCHE. Chinese painter of the Ming period.

SUNG TI (*Rito*). Chinese painter of the 11th century.

SUYEMASA, or KANO KUNIMATSU. Third son of Kano Masanobu. He lived in the 16th century.

TAI CHIN (*Tai Wen-chin*). Chinese painter of the Ming period. He lived in the 16th century.

TAIGADO IKÉ. Japanese painter. He lived from 1723 to 1776.

T'AI T SUNG (*Taiso*). Second Emperor of the T'ang dynasty. He lived from 627 to 650.

TAI SUNG (*Taisu*). Chinese painter of the T'ang period. He lived in the 9th century.

TAKACHIKA. Japanese painter of the Tosa school, the son of Takagoshi. He lived in the 12th century.

TAKAMOCHI TAIRA. The son of Takami-ô. He received the family name of Taira in 889.

TAKANOBU, FUJIWARA. Japanese painter of the Tosa school, the son of Fujiwara Tame-taka. He lived from 1146 to 1205.

TAKANOBU, KANO. Japanese painter of the Kano school, the son of Kano Yeitoku. He lived from 1570 to 1618.

TAKAYASU, FUJIWARA. Japanese painter of the Tosa school. He lived in the 12th century.

TAKENOUCHI, SEIHO. Contemporary Japanese painter, a pupil of Bairei.

TAMENARI, TAKUMA. Japanese painter of the 11th century. He worked about 1037.

TAMURAMARO, SAKAMOTO. Japanese general, famous for his campaigns against the Ainus. He lived from 758 to 811.

T'ANG YIN (*Ta'in*). Chinese painter of the Ming period. He lived in the 15th and the 16th centuries.

TANKEI. Japanese sculptor of the 13th century. He was the son of Unkei.

TANSHIN, KANO, or MORIMASA. Painter of the Kano school. He lived from 1653 to 1718.

TANSHIN MORIMICHI, or KANO TANSHIN. Japanese painter of the 19th century. He is often confounded with a 17th century painter, Kano Tanshin.

TANYEI. A Japanese painter, the son of Tsuruzawa Tanzan. He lived in the 18th century.

226 GLOSSARY OF PROPER NAMES

TANYU, KANO. One of the great masters of the Kano school. He lived from 1602 to 1674.
TANZAN, TSURUZAWA. Japanese painter of the 18th century.
TAO YÜAN-MING, or T'AO CH'IEN (*Toemmei*). Chinese poet. He lived from 365 to 427.
TEMMU. Japanese Emperor. He reigned from 673 to 686. He succeeded the Emperor
 Kōbun, who reigned only a year.
TENCHI. Japanese Emperor. He reigned from 662 to 671.
TETZUZAN, or TESSAN MORI. Japanese painter, the nephew and adopted son of Mori
 Sosen. He died in 1841.
TOBA. Japanese Emperor. He came to the throne in 1108, abdicated in 1123 and died
 in 1156.
TOKIMUNE, HŌJŌ. Sixth Shikken of Kamakura. He lived from 1251 to 1284.
TOKIWA GOZEN. The concubine of Minamoto Yoshitomo, then of Kiyomori, and finally
 wife of Fujiwara Nagari. Her flight with her three children in 1160, after the death
 of Yoshitomo, is a classic subject in Japanese painting.
TOKO UNKOKU. Japanese painter, the son of Unkoku Togan. He lived in the first
 half of the 17th century.
TORI. A Japanese name under which we know a Buddhist sculptor of Southern Chinese
 origin, who came to Japan towards the beginning of the 6th century.
TORI BUSSHI, or DŌSHI, the name of Kuratsukuribe no Tori. A Japanese painter and
 sculptor in the reign of Suiko (593-628).
TO-UN, KANO, or MASUNOBU. Painter of the Kano school, the pupil of Kano Tanyu.
 He lived in the 17th century.
TOYOHARU, UTAGAWA. A Japanese painter, the brother and pupil of Toyonobu. He
 worked at the end of the 18th century.
TOYOHIKO, OKAMOTO. Japanese painter. He died in 1845.
TOYOHIRO. Japanese painter, the brother of Toyokuni. He worked at the beginning
 of the 19th century.
TOYOKUNI. Japanese painter of the Utagawa school, the pupil of Toyoharu. He died
 in 1825.
TOYONOBU, UTAGAWA. Japanese painter of the second half of the 18th century.
TS'AO PU-HSING (*So Fukko*). A Chinese painter at the period of the "Six Dynasties." He
 lived in the 3rd century.
TSURAYUKI. Poet and calligrapher, one of the masters of Japanese poetry. He lived
 from 883 to 946.
TU FU (*Toshimi*). One of the greatest poets of China. He lived from 712 to 770.
TUNG CH'I-CHANG (*Tokisho*). A Chinese writer of the Ts'ing period.
TUNG YÜAN (*Kwando*). Chinese painter of the Sung period. He lived in the 11th
 century.

UNKEI. Japanese sculptor of the 12th and 13th centuries.
UTAMARO. Japanese painter of the 18th century. He died in 1788.
UTANOSUKI, KANO, or YUKINOBU. Japanese painter, the younger brother of Kano
 Motonobu. He lived from 1513 to 1575.

VASUBANDHU. The twenty-first or twenty-second patriarch of Indian Buddhism. He
 was the younger brother of Asanigha. He lived in the 2nd century A.D.
VIMALAKIRTI. A contemporary of Sakya Muni. Legend asserts that he visited China.

WANG AN-SHIH (*Oanseki*). Chinese statesman, the leader of the reform party under the
 Sungs. He lived from 1011 to 1086.

WANG HSI-CHIH (*Ogishi*). Chinese painter at the period of the "Six Dynasties." He lived from 321 to 379.

WANG WEI (*Omakitsu, Oi*). Painter and poet of the T'ang period. He was born in 699.

WATANABÈ SHIKO. Japanese painter. He lived from 1683 to 1755.

WEI YE (*Sho-o*). Man of letters and calligrapher of the Sung period. He lived in the 11th century.

WEN WANG. Hereditary prince of the state of Ch'i in the modern Shensi; the father of Wu Wang, the founder of the Chou dynasty. He lived from 1231 to 1135 B.C.

WU TAO-TZÜ (*Godoshi*). Chinese painter of the T'ang period. He lived in the 8th century.

WU TI (*Butei*). Fourth Emperor of the first Han dynasty. He died in 87 B.C., having reigned from 140 B.C.

WU WANG. The son of Wen Wang, first Emperor of the Chou dynasty. He lived from 1169 to 1116 B.C.

YANG KUEI-FEI. The all-powerful favourite of the T'ang Emperor, Hüan Tsung. She was handed over by the Emperor to the insurrectionary troops and killed in 756.

YASUNOBU, KANO, or YEISHIN. Japanese painter of the Kano school. He lived from 1613 to 1685.

YEIGA, TAKUMA. Japanese painter of the school of Takuma. He lived in the 14th century.

YEISEN. Japanese painter, the pupil of Yeisan. He lived from 1792 to 1848.

YEISHI. Japanese painter of the end of the 18th and of the 19th century.

YEISHIN, KANO. *See* KANO YASUNOBO.

YEISHIN, SOZU, or GENSHIN. Buddhist priest and painter. He lived from 942 to 1017

YEITOKU, KANO. Painter of the Kano school. He lived from 1543 to 1590.

YEN HUEI (*Ganki*). Chinese painter of the Southern Sung period. He lived in the 13th century.

YEN LI-PĒN (*Enriuhon*). Chinese painter of the T'ang period. He lived in the 7th century.

YEN LI-TĒ (*Enriutoku*). Chinese painter of the T'ang period, the brother of the above. He lived in the 7th century.

YEN TZ'U-PING (*Enjihei*). Chinese painter of the Southern Sung period. He lived in the 13th century.

YENICHIBO, TAKUMA. Japanese painter of the Takuma school. He lived in the second half of the 13th century.

YOCHIMOCHI, ASHIKAGA. The fourth Ashikaga Shogun. He lived from 1386 to 1428.

YOGETSU. Buddhist priest and painter of the school of Sesshu. He lived in the 15th century.

YORIYOSHI, MINAMOTO. The son of Minamoto Yorinobu. He took part in various campaigns against the Taira. He lived from 995 to 1082.

YOSEN, KANO or KORINOBU. Painter of the Kano school. He lived in the 19th century.

YOSHIHAKI. Fifteenth Ashikaga Shōgun. He held the Shōgunate from 1568 to 1573. He died in 1597.

YOSHIIYÉ, MINAMOTO. Japanese hero of the 11th century. He lived from 1041 to 1108.

YOSHIMITSU, MINAMOTO, the brother of Yoshiiyé; took part in the wars carried on by the latter. He lived from 1056 to 1127.

YOSHINOBU, KANO. Painter of the Kano school, the brother of Kano Yeitoku. He lived in the 16th century.

YOSHITOMO, MINAMOTO, the son of Tameyoshi. He took part in the civil war of Hōgen (1156). Born in 1123, killed in 1160.

Yu. Chinese Emperor of legendary times. Annals record that he came to the throne in 2205 B.C.

Yueh San. Painter of the Ming period.

Yuhi Komashiro. Japanese painter, the pupil of Chin Nan-ping. He lived in the 18th century.

Yukihide, Tosa. Painter of the Tosa school, the son of Yukihiro. He lived in the 15th century.

Yukihiro, Tosa. Painter of the Tosa school. He lived in the 15th century.

Yukimitsu, Tosa. Japanese painter of the Tosa School. He worked about 1356.

Yukinobu, Kano. *See* Utanosuke.

Yusetsu Kaihoku. Japanese painter of the 17th century, the son of Yusho Kaihoku He died about 1677.

Yusho Kaihoku. Japanese painter, the pupil of Kano Yeitoku. He lived from 1533 to 1615.

Yutei, Ishida. Painter of the 18th century. He was the master of Okio.

INDEX

INDEX

A CATALOGUE OF SELECTED DOVER BOOKS
IN ALL FIELDS OF INTEREST

A CATALOGUE OF SELECTED DOVER BOOKS
IN ALL FIELDS OF INTEREST

AMERICA'S OLD MASTERS, James T. Flexner. Four men emerged unexpectedly from provincial 18th century America to leadership in European art: Benjamin West, J. S. Copley, C. R. Peale, Gilbert Stuart. Brilliant coverage of lives and contributions. Revised, 1967 edition. 69 plates. 365pp. of text.

21806-6 Paperbound $3.00

FIRST FLOWERS OF OUR WILDERNESS: AMERICAN PAINTING, THE COLONIAL PERIOD, James T. Flexner. Painters, and regional painting traditions from earliest Colonial times up to the emergence of Copley, West and Peale Sr., Foster, Gustavus Hesselius, Feke, John Smibert and many anonymous painters in the primitive manner. Engaging presentation, with 162 illustrations. xxii + 368pp.

22180-6 Paperbound $3.50

THE LIGHT OF DISTANT SKIES: AMERICAN PAINTING, 1760-1835, James T. Flexner. The great generation of early American painters goes to Europe to learn and to teach: West, Copley, Gilbert Stuart and others. Allston, Trumbull, Morse; also contemporary American painters—primitives, derivatives, academics—who remained in America. 102 illustrations. xiii + 306pp. 22179-2 Paperbound $3.50

A HISTORY OF THE RISE AND PROGRESS OF THE ARTS OF DESIGN IN THE UNITED STATES, William Dunlap. Much the richest mine of information on early American painters, sculptors, architects, engravers, miniaturists, etc. The only source of information for scores of artists, the major primary source for many others. Unabridged reprint of rare original 1834 edition, with new introduction by James T. Flexner, and 394 new illustrations. Edited by Rita Weiss. 6⅜ x 9⅝.

21695-0, 21696-9, 21697-7 Three volumes, Paperbound $15.00

EPOCHS OF CHINESE AND JAPANESE ART, Ernest F. Fenollosa. From primitive Chinese art to the 20th century, thorough history, explanation of every important art period and form, including Japanese woodcuts; main stress on China and Japan, but Tibet, Korea also included. Still unexcelled for its detailed, rich coverage of cultural background, aesthetic elements, diffusion studies, particularly of the historical period. 2nd, 1913 edition. 242 illustrations. lii + 439pp. of text.

20364-6, 20365-4 Two volumes, Paperbound $6.00

THE GENTLE ART OF MAKING ENEMIES, James A. M. Whistler. Greatest wit of his day deflates Oscar Wilde, Ruskin, Swinburne; strikes back at inane critics, exhibitions, art journalism; aesthetics of impressionist revolution in most striking form. Highly readable classic by great painter. Reproduction of edition designed by Whistler. Introduction by Alfred Werner. xxxvi + 334pp.

21875-9 Paperbound $3.00

VISUAL ILLUSIONS: THEIR CAUSES, CHARACTERISTICS, AND APPLICATIONS, Matthew Luckiesh. Thorough description and discussion of optical illusion, geometric and perspective, particularly; size and shape distortions, illusions of color, of motion; natural illusions; use of illusion in art and magic, industry, etc. Most useful today with op art, also for classical art. Scores of effects illustrated. Introduction by William H. Ittleson. 100 illustrations. xxi + 252pp.

21530-X Paperbound $2.00

A HANDBOOK OF ANATOMY FOR ART STUDENTS, Arthur Thomson. Thorough, virtually exhaustive coverage of skeletal structure, musculature, etc. Full text, supplemented by anatomical diagrams and drawings and by photographs of undraped figures. Unique in its comparison of male and female forms, pointing out differences of contour, texture, form. 211 figures, 40 drawings, 86 photographs. xx + 459pp. 5⅜ x 8⅜.

21163-0 Paperbound $3.50

150 MASTERPIECES OF DRAWING, Selected by Anthony Toney. Full page reproductions of drawings from the early 16th to the end of the 18th century, all beautifully reproduced: Rembrandt, Michelangelo, Dürer, Fragonard, Urs, Graf, Wouwerman, many others. First-rate browsing book, model book for artists. xviii + 150pp. 8⅜ x 11¼.

21032-4 Paperbound' $2.50

THE LATER WORK OF AUBREY BEARDSLEY, Aubrey Beardsley. Exotic, erotic, ironic masterpieces in full maturity: Comedy Ballet, Venus and Tannhauser, Pierrot, Lysistrata, Rape of the Lock, Savoy material, Ali Baba, Volpone, etc. This material revolutionized the art world, and is still powerful, fresh, brilliant. With *The Early Work,* all Beardsley's finest work. 174 plates, 2 in color. xiv + 176pp. 8⅛ x 11.

21817-1 Paperbound $3.75

DRAWINGS OF REMBRANDT, Rembrandt van Rijn. Complete reproduction of fabulously rare edition by Lippmann and Hofstede de Groot, completely reedited, updated, improved by Prof. Seymour Slive, Fogg Museum. Portraits, Biblical sketches, landscapes, Oriental types, nudes, episodes from classical mythology—All Rembrandt's fertile genius. Also selection of drawings by his pupils and followers. "Stunning volumes," *Saturday Review.* 550 illustrations. lxxviii + 552pp. 9⅛ x 12¼.

21485-0, 21486-9 Two volumes, Paperbound $10.00

THE DISASTERS OF WAR, Francisco Goya. One of the masterpieces of Western civilization—83 etchings that record Goya's shattering, bitter reaction to the Napoleonic war that swept through Spain after the insurrection of 1808 and to war in general. Reprint of the first edition, with three additional plates from Boston's Museum of Fine Arts. All plates facsimile size. Introduction by Philip Hofer, Fogg Museum. v + 97pp. 9⅜ x 8¼.

21872-4 Paperbound $2.50

GRAPHIC WORKS OF ODILON REDON. Largest collection of Redon's graphic works ever assembled: 172 lithographs, 28 etchings and engravings, 9 drawings. These include some of his most famous works. All the plates from *Odilon Redon: oeuvre graphique complet,* plus additional plates. New introduction and caption translations by Alfred Werner. 209 illustrations. xxvii + 209pp. 9⅛ x 12¼.

21966-8 Paperbound $4.50

DESIGN BY ACCIDENT; A BOOK OF "ACCIDENTAL EFFECTS" FOR ARTISTS AND DESIGNERS, James F. O'Brien. Create your own unique, striking, imaginative effects by "controlled accident" interaction of materials: paints and lacquers, oil and water based paints, splatter, crackling materials, shatter, similar items. Everything you do will be different; first book on this limitless art, so useful to both fine artist and commercial artist. Full instructions. 192 plates showing "accidents," 8 in color. viii + 215pp. 8⅜ x 11¼. 21942-9 Paperbound $3.75

THE BOOK OF SIGNS, Rudolf Koch. Famed German type designer draws 493 beautiful symbols: religious, mystical, alchemical, imperial, property marks, runes, etc. Remarkable fusion of traditional and modern. Good for suggestions of timelessness, smartness, modernity. Text. vi + 104pp. 6⅛ x 9¼.
20162-7 Paperbound $1.50

HISTORY OF INDIAN AND INDONESIAN ART, Ananda K. Coomaraswamy. An unabridged republication of one of the finest books by a great scholar in Eastern art. Rich in descriptive material, history, social backgrounds; Sunga reliefs, Rajput paintings, Gupta temples, Burmese frescoes, textiles, jewelry, sculpture, etc. 400 photos. viii + 423pp. 6⅜ x 9¾. 21436-2 Paperbound $5.00

PRIMITIVE ART, Franz Boas. America's foremost anthropologist surveys textiles, ceramics, woodcarving, basketry, metalwork, etc.; patterns, technology, creation of symbols, style origins. All areas of world, but very full on Northwest Coast Indians. More than 350 illustrations of baskets, boxes, totem poles, weapons, etc. 378 pp.
20025-6 Paperbound $3.00

THE GENTLEMAN AND CABINET MAKER'S DIRECTOR, Thomas Chippendale. Full reprint (third edition, 1762) of most influential furniture book of all time, by master cabinetmaker. 200 plates, illustrating chairs, sofas, mirrors, tables, cabinets, plus 24 photographs of surviving pieces. Biographical introduction by N. Bienenstock. vi + 249pp. 9⅞ x 12¾. 21601-2 Paperbound $5.00

AMERICAN ANTIQUE FURNITURE, Edgar G. Miller, Jr. The basic coverage of all American furniture before 1840. Individual chapters cover type of furniture—clocks, tables, sideboards, etc.—chronologically, with inexhaustible wealth of data. More than 2100 photographs, all identified, commented on. Essential to all early American collectors. Introduction by H. E. Keyes. vi + 1106pp. 7⅞ x 10¾.
21599-7, 21600-4 Two volumes, Paperbound $11.00

PENNSYLVANIA DUTCH AMERICAN FOLK ART, Henry J. Kauffman. 279 photos, 28 drawings of tulipware, Fraktur script, painted tinware, toys, flowered furniture, quilts, samplers, hex signs, house interiors, etc. Full descriptive text. Excellent for tourist, rewarding for designer, collector. Map. 146pp. 7⅞ x 10¾.
21205-X Paperbound $3.00

EARLY NEW ENGLAND GRAVESTONE RUBBINGS, Edmund V. Gillon, Jr. 43 photographs, 226 carefully reproduced rubbings show heavily symbolic, sometimes macabre early gravestones, up to early 19th century. Remarkable early American primitive art, occasionally strikingly beautiful; always powerful. Text. xxvi + 207pp. 8⅜ x 11¼. 21380-3 Paperbound $4.00

ALPHABETS AND ORNAMENTS, Ernst Lehner. Well-known pictorial source for decorative alphabets, script examples, cartouches, frames, decorative title pages, calligraphic initials, borders, similar material. 14th to 19th century, mostly European. Useful in almost any graphic arts designing, varied styles. 750 illustrations. 256pp. 7 x 10. 21905-4 Paperbound $4.00

PAINTING: A CREATIVE APPROACH, Norman Colquhoun. For the beginner simple guide provides an instructive approach to painting: major stumbling blocks for beginner; overcoming them, technical points; paints and pigments; oil painting; watercolor and other media and color. New section on "plastic" paints. Glossary. Formerly *Paint Your Own Pictures.* 221pp. 22000-1 Paperbound $1.75

THE ENJOYMENT AND USE OF COLOR, Walter Sargent. Explanation of the relations between colors themselves and between colors in nature and art, including hundreds of little-known facts about color values, intensities, effects of high and low illumination, complementary colors. Many practical hints for painters, references to great masters. 7 color plates, 29 illustrations. x + 274pp.
20944-X Paperbound $3.00

THE NOTEBOOKS OF LEONARDO DA VINCI, compiled and edited by Jean Paul Richter. 1566 extracts from original manuscripts reveal the full range of Leonardo's versatile genius: all his writings on painting, sculpture, architecture, anatomy, astronomy, geography, topography, physiology, mining, music, etc., in both Italian and English, with 186 plates of manuscript pages and more than 500 additional drawings. Includes studies for the Last Supper, the lost Sforza monument, and other works. Total of xlvii + 866pp. 7⅞ x 10¾.
22572-0, 22573-9 Two volumes, Paperbound $12.00

MONTGOMERY WARD CATALOGUE OF 1895. Tea gowns, yards of flannel and pillow-case lace, stereoscopes, books of gospel hymns, the New Improved Singer Sewing Machine, side saddles, milk skimmers, straight-edged razors, high-button shoes, spittoons, and on and on . . . listing some 25,000 items, practically all illustrated. Essential to the shoppers of the 1890's, it is our truest record of the spirit of the period. Unaltered reprint of Issue No. 57, Spring and Summer 1895. Introduction by Boris Emmet. Innumerable illustrations. xiii + 624pp. 8½ x 11⅝.
22377-9 Paperbound $8.50

THE CRYSTAL PALACE EXHIBITION ILLUSTRATED CATALOGUE (LONDON, 1851). One of the wonders of the modern world—the Crystal Palace Exhibition in which all the nations of the civilized world exhibited their achievements in the arts and sciences—presented in an equally important illustrated catalogue. More than 1700 items pictured with accompanying text—ceramics, textiles, cast-iron work, carpets, pianos, sleds, razors, wall-papers, billiard tables, beehives, silverware and hundreds of other artifacts—represent the focal point of Victorian culture in the Western World. Probably the largest collection of Victorian decorative art ever assembled—indispensable for antiquarians and designers. Unabridged republication of the Art-Journal Catalogue of the Great Exhibition of 1851, with all terminal essays. New introduction by John Gloag, F.S.A. xxxiv + 426pp. 9 x 12.
22503-8 Paperbound $5.00

DESIGN BY ACCIDENT; A BOOK OF "ACCIDENTAL EFFECTS" FOR ARTISTS AND DESIGNERS, James F. O'Brien. Create your own unique, striking, imaginative effects by "controlled accident" interaction of materials: paints and lacquers, oil and water based paints, splatter, crackling materials, shatter, similar items. Everything you do will be different; first book on this limitless art, so useful to both fine artist and commercial artist. Full instructions. 192 plates showing "accidents," 8 in color. viii + 215pp. 8⅜ x 11¼. 21942-9 Paperbound $3.75

THE BOOK OF SIGNS, Rudolf Koch. Famed German type designer draws 493 beautiful symbols: religious, mystical, alchemical, imperial, property marks, runes, etc. Remarkable fusion of traditional and modern. Good for suggestions of timelessness, smartness, modernity. Text. vi + 104pp. 6⅛ x 9¼. 20162-7 Paperbound $1.50

HISTORY OF INDIAN AND INDONESIAN ART, Ananda K. Coomaraswamy. An unabridged republication of one of the finest books by a great scholar in Eastern art. Rich in descriptive material, history, social backgrounds; Sunga reliefs, Rajput paintings, Gupta temples, Burmese frescoes, textiles, jewelry, sculpture, etc. 400 photos. viii + 423pp. 6⅜ x 9¾. 21436-2 Paperbound $5.00

PRIMITIVE ART, Franz Boas. America's foremost anthropologist surveys textiles, ceramics, woodcarving, basketry, metalwork, etc.; patterns, technology, creation of symbols, style origins. All areas of world, but very full on Northwest Coast Indians. More than 350 illustrations of baskets, boxes, totem poles, weapons, etc. 378 pp. 20025-6 Paperbound $3.00

THE GENTLEMAN AND CABINET MAKER'S DIRECTOR, Thomas Chippendale. Full reprint (third edition, 1762) of most influential furniture book of all time, by master cabinetmaker. 200 plates, illustrating chairs, sofas, mirrors, tables, cabinets, plus 24 photographs of surviving pieces. Biographical introduction by N. Bienenstock. vi + 249pp. 9⅞ x 12¾. 21601-2 Paperbound $5.00

AMERICAN ANTIQUE FURNITURE, Edgar G. Miller, Jr. The basic coverage of all American furniture before 1840. Individual chapters cover type of furniture—clocks, tables, sideboards, etc.—chronologically, with inexhaustible wealth of data. More than 2100 photographs, all identified, commented on. Essential to all early American collectors. Introduction by H. E. Keyes. vi + 1106pp. 7⅞ x 10¾. 21599-7, 21600-4 Two volumes, Paperbound $11.00

PENNSYLVANIA DUTCH AMERICAN FOLK ART, Henry J. Kauffman. 279 photos, 28 drawings of tulipware, Fraktur script, painted tinware, toys, flowered furniture, quilts, samplers, hex signs, house interiors, etc. Full descriptive text. Excellent for tourist, rewarding for designer, collector. Map. 146pp. 7⅞ x 10¾. 21205-X Paperbound $3.00

EARLY NEW ENGLAND GRAVESTONE RUBBINGS, Edmund V. Gillon, Jr. 43 photographs, 226 carefully reproduced rubbings show heavily symbolic, sometimes macabre early gravestones, up to early 19th century. Remarkable early American primitive art, occasionally strikingly beautiful; always powerful. Text. xxvi + 207pp. 8⅜ x 11¼. 21380-3 Paperbound $4.00

ALPHABETS AND ORNAMENTS, Ernst Lehner. Well-known pictorial source for decorative alphabets, script examples, cartouches, frames, decorative title pages, calligraphic initials, borders, similar material. 14th to 19th century, mostly European. Useful in almost any graphic arts designing, varied styles. 750 illustrations. 256pp. 7 x 10. 21905-4 Paperbound $4.00

PAINTING: A CREATIVE APPROACH, Norman Colquhoun. For the beginner simple guide provides an instructive approach to painting: major stumbling blocks for beginner; overcoming them, technical points; paints and pigments; oil painting; watercolor and other media and color. New section on "plastic" paints. Glossary. Formerly *Paint Your Own Pictures.* 221pp. 22000-1 Paperbound $1.75

THE ENJOYMENT AND USE OF COLOR, Walter Sargent. Explanation of the relations between colors themselves and between colors in nature and art, including hundreds of little-known facts about color values, intensities, effects of high and low illumination, complementary colors. Many practical hints for painters, references to great masters. 7 color plates, 29 illustrations. x + 274pp.
20944-X Paperbound $3.00

THE NOTEBOOKS OF LEONARDO DA VINCI, compiled and edited by Jean Paul Richter. 1566 extracts from original manuscripts reveal the full range of Leonardo's versatile genius: all his writings on painting, sculpture, architecture, anatomy, astronomy, geography, topography, physiology, mining, music, etc., in both Italian and English, with 186 plates of manuscript pages and more than 500 additional drawings. Includes studies for the Last Supper, the lost Sforza monument, and other works. Total of xlvii + 866pp. 7⅞ x 10¾.
22572-0, 22573-9 Two volumes, Paperbound $12.00

MONTGOMERY WARD CATALOGUE OF 1895. Tea gowns, yards of flannel and pillow-case lace, stereoscopes, books of gospel hymns, the New Improved Singer Sewing Machine, side saddles, milk skimmers, straight-edged razors, high-button shoes, spittoons, and on and on . . . listing some 25,000 items, practically all illustrated. Essential to the shoppers of the 1890's, it is our truest record of the spirit of the period. Unaltered reprint of Issue No. 57, Spring and Summer 1895. Introduction by Boris Emmet. Innumerable illustrations. xiii + 624pp. 8½ x 11⅝.
22377-9 Paperbound $8.50

THE CRYSTAL PALACE EXHIBITION ILLUSTRATED CATALOGUE (LONDON, 1851). One of the wonders of the modern world—the Crystal Palace Exhibition in which all the nations of the civilized world exhibited their achievements in the arts and sciences—presented in an equally important illustrated catalogue. More than 1700 items pictured with accompanying text—ceramics, textiles, cast-iron work, carpets, pianos, sleds, razors, wall-papers, billiard tables, beehives, silverware and hundreds of other artifacts—represent the focal point of Victorian culture in the Western World. Probably the largest collection of Victorian decorative art ever assembled— indispensable for antiquarians and designers. Unabridged republication of the Art-Journal Catalogue of the Great Exhibition of 1851, with all terminal essays. New introduction by John Gloag, F.S.A. xxxiv + 426pp. 9 x 12.
22503-8 Paperbound $5.00

A HISTORY OF COSTUME, Carl Köhler. Definitive history, based on surviving pieces of clothing primarily, and paintings, statues, etc. secondarily. Highly readable text, supplemented by 594 illustrations of costumes of the ancient Mediterranean peoples, Greece and Rome, the Teutonic prehistoric period; costumes of the Middle Ages, Renaissance, Baroque, 18th and 19th centuries. Clear, measured patterns are provided for many clothing articles. Approach is practical throughout. Enlarged by Emma von Sichart. 464pp. 21030-8 Paperbound $3.50

ORIENTAL RUGS, ANTIQUE AND MODERN, Walter A. Hawley. A complete and authoritative treatise on the Oriental rug—where they are made, by whom and how, designs and symbols, characteristics in detail of the six major groups, how to distinguish them and how to buy them. Detailed technical data is provided on periods, weaves, warps, wefts, textures, sides, ends and knots, although no technical background is required for an understanding. 11 color plates, 80 halftones, 4 maps. vi + 320pp. $6\frac{1}{8}$ x $9\frac{1}{8}$. 22366-3 Paperbound $5.00

TEN BOOKS ON ARCHITECTURE, Vitruvius. By any standards the most important book on architecture ever written. Early Roman discussion of aesthetics of building, construction methods, orders, sites, and every other aspect of architecture has inspired, instructed architecture for about 2,000 years. Stands behind Palladio, Michelangelo, Bramante, Wren, countless others. Definitive Morris H. Morgan translation. 68 illustrations. xii + 331pp. 20645-9 Paperbound . $3.00

THE FOUR BOOKS OF ARCHITECTURE, Andrea Palladio. Translated into every major Western European language in the two centuries following its publication in 1570, this has been one of the most influential books in the history of architecture. Complete reprint of the 1738 Isaac Ware edition. New introduction by Adolf Placzek, Columbia Univ. 216 plates. xxii + 110pp. of text. $9\frac{1}{2}$ x $12\frac{3}{4}$.
21308-0 Clothbound $12.50

STICKS AND STONES: A STUDY OF AMERICAN ARCHITECTURE AND CIVILIZATION, Lewis Mumford.One of the great classics of American cultural history. American architecture from the medieval-inspired earliest forms to the early 20th century; evolution of structure and style, and reciprocal influences on environment. 21 photographic illustrations. 238pp. 20202-X Paperbound $2.00

THE AMERICAN BUILDER'S COMPANION, Asher Benjamin. The most widely used early 19th century architectural style and source book, for colonial up into Greek Revival periods. Extensive development of geometry of carpentering, construction of sashes, frames, doors, stairs; plans and elevations of domestic and other buildings. Hundreds of thousands of houses were built according to this book, now invaluable to historians, architects, restorers, etc. 1827 edition. 59 plates. 114pp. $7\frac{7}{8}$ x $10\frac{3}{4}$
22236-5 Paperbound $4.00

DUTCH HOUSES IN THE HUDSON VALLEY BEFORE 1776, Helen Wilkinson Reynolds. The standard survey of the Dutch colonial house and outbuildings, with constructional features, decoration, and local history associated with individual homesteads. Introduction by Franklin D. Roosevelt. Map. 150 illustrations. 469pp. $6\frac{5}{8}$ x $9\frac{1}{4}$. 21469-9 Paperbound $5.00

THE ARCHITECTURE OF COUNTRY HOUSES, Andrew J. Downing. Together with Vaux's *Villas and Cottages* this is the basic book for Hudson River Gothic architecture of the middle Victorian period. Full, sound discussions of general aspects of housing, architecture, style, decoration, furnishing, together with scores of detailed house plans, illustrations of specific buildings, accompanied by full text. Perhaps the most influential single American architectural book. 1850 edition. Introduction by J. Stewart Johnson. 321 figures, 34 architectural designs. xvi + 560pp.
22003-6 Paperbound $5.00

LOST EXAMPLES OF COLONIAL ARCHITECTURE, John Mead Howells. Full-page photographs of buildings that have disappeared or been so altered as to be denatured, including many designed by major early American architects. 245 plates. xvii + 248pp. 7⅞ x 10¾.
21143-6 Paperbound $3.50

DOMESTIC ARCHITECTURE OF THE AMERICAN COLONIES AND OF THE EARLY REPUBLIC, Fiske Kimball. Foremost architect and restorer of Williamsburg and Monticello covers nearly 200 homes between 1620-1825. Architectural details, construction, style features, special fixtures, floor plans, etc. Generally considered finest work in its area. 219 illustrations of houses, doorways, windows, capital mantels. xx + 314pp. 7⅞ x 10¾.
21743-4 Paperbound $4.00

EARLY AMERICAN ROOMS: 1650-1858, edited by Russell Hawes Kettell. Tour of 12 rooms, each representative of a different era in American history and each furnished, decorated, designed and occupied in the style of the era. 72 plans and elevations, 8-page color section, etc., show fabrics, wall papers, arrangements, etc. Full descriptive text. xvii + 200pp. of text. 8⅜ x 11¼.
21633-0 Paperbound $5.00

THE FITZWILLIAM VIRGINAL BOOK, edited by J. Fuller Maitland and W. B. Squire. Full modern printing of famous early 17th-century ms. volume of 300 works by Morley, Byrd, Bull, Gibbons, etc. For piano or other modern keyboard instrument; easy to read format. xxxvi + 938pp. 8⅜ x 11.
21068-5, 21069-3 Two volumes, Paperbound $12.00

KEYBOARD MUSIC, Johann Sebastian Bach. Bach Gesellschaft edition. A rich selection of Bach's masterpieces for the harpsichord: the six English Suites, six French Suites, the six Partitas (Clavierübung part I), the Goldberg Variations (Clavierübung part IV), the fifteen Two-Part Inventions and the fifteen Three-Part Sinfonias. Clearly reproduced on large sheets with ample margins; eminently playable. vi + 312pp. 8⅛ x 11.
22360-4 Paperbound $5.00

THE MUSIC OF BACH: AN INTRODUCTION, Charles Sanford Terry. A fine, nontechnical introduction to Bach's music, both instrumental and vocal. Covers organ music, chamber music, passion music, other types. Analyzes themes, developments, innovations. x + 114pp.
21075-8 Paperbound $1.95

BEETHOVEN AND HIS NINE SYMPHONIES, Sir George Grove. Noted British musicologist provides best history, analysis, commentary on symphonies. Very thorough, rigorously accurate; necessary to both advanced student and amateur music lover. 436 musical passages. vii + 407 pp.
20334-4 Paperbound $4.00

JOHANN SEBASTIAN BACH, Philipp Spitta. One of the great classics of musicology, this definitive analysis of Bach's music (and life) has never been surpassed. Lucid, nontechnical analyses of hundreds of pieces (30 pages devoted to St. Matthew Passion, 26 to B Minor Mass). Also includes major analysis of 18th-century music. 450 musical examples. 40-page musical supplement. Total of xx + 1799pp.
(EUK) 22278-0, 22279-9 Two volumes, Clothbound $25.00

MOZART AND HIS PIANO CONCERTOS, Cuthbert Girdlestone. The only full-length study of an important area of Mozart's creativity. Provides detailed analyses of all 23 concertos, traces inspirational sources. 417 musical examples. Second edition. 509pp. 21271-8 Paperbound $4.50

THE PERFECT WAGNERITE: A COMMENTARY ON THE NIBLUNG'S RING, George Bernard Shaw. Brilliant and still relevant criticism in remarkable essays on Wagner's Ring cycle, Shaw's ideas on political and social ideology behind the plots, role of Leitmotifs, vocal requisites, etc. Prefaces. xxi + 136pp.
(USO) 21707-8 Paperbound $1.75

DON GIOVANNI, W. A. Mozart. Complete libretto, modern English translation; biographies of composer and librettist; accounts of early performances and critical reaction. Lavishly illustrated. All the material you need to understand and appreciate this great work. Dover Opera Guide and Libretto Series; translated and introduced by Ellen Bleiler. 92 illustrations. 209pp.
21134-7 Paperbound $2.00

BASIC ELECTRICITY, U. S. Bureau of Naval Personel. Originally a training course, best non-technical coverage of basic theory of electricity and its applications. Fundamental concepts, batteries, circuits, conductors and wiring techniques, AC and DC, inductance and capacitance, generators, motors, transformers, magnetic amplifiers, synchros, servomechanisms, etc. Also covers blue-prints, electrical diagrams, etc. Many questions, with answers. 349 illustrations. x + 448pp. 6½ x 9¼.
20973-3 Paperbound $3.50

REPRODUCTION OF SOUND, Edgar Villchur. Thorough coverage for laymen of high fidelity systems, reproducing systems in general, needles, amplifiers, preamps, loudspeakers, feedback, explaining physical background. "A rare talent for making technicalities vividly comprehensible," R. Darrell, *High Fidelity*. 69 figures iv + 92pp. 21515-6 Paperbound $1.35

HEAR ME TALKIN' TO YA: THE STORY OF JAZZ AS TOLD BY THE MEN WHO MADE IT, Nat Shapiro and Nat Hentoff. Louis Armstrong, Fats Waller, Jo Jones, Clarence Williams, Billy Holiday, Duke Ellington, Jelly Roll Morton and dozens of other jazz greats tell how it was in Chicago's South Side, New Orleans, depression Harlem and the modern West Coast as jazz was born and grew. xvi + 429pp.
21726-4 Paperbound $3.95

FABLES OF AESOP, translated by Sir Roger L'Estrange. A reproduction of the very rare 1931 Paris edition; a selection of the most interesting fables, together with 50 imaginative drawings by Alexander Calder. v + 128pp. 6½x9¼.
21780-9 Paperbound $1.50

AGAINST THE GRAIN (A REBOURS), Joris K. Huysmans. Filled with weird images, evidences of a bizarre imagination, exotic experiments with hallucinatory drugs, rich tastes and smells and the diversions of its sybarite hero Duc Jean des Esseintes, this classic novel pushed 19th-century literary decadence to its limits. Full unabridged edition. Do not confuse this with abridged editions generally sold. Introduction by Havelock Ellis. xlix + 206pp. 22190-3 Paperbound $2.50

VARIORUM SHAKESPEARE: HAMLET. Edited by Horace H. Furness; a landmark of American scholarship. Exhaustive footnotes and appendices treat all doubtful words and phrases, as well as suggested critical emendations throughout the play's history. First volume contains editor's own text, collated with all Quartos and Folios. Second volume contains full first Quarto, translations of Shakespeare's sources (Belleforest, and Saxo Grammaticus), Der Bestrafte Brudermord, and many essays on critical and historical points of interest by major authorities of past and present. Includes details of staging and costuming over the years. By far the best edition available for serious students of Shakespeare. Total of xx + 905pp. 21004-9, 21005-7, 2 volumes, Paperbound $7.00

A LIFE OF WILLIAM SHAKESPEARE, Sir Sidney Lee. This is the standard life of Shakespeare, summarizing everything known about Shakespeare and his plays. Incredibly rich in material, broad in coverage, clear and judicious, it has served thousands as the best introduction to Shakespeare. 1931 edition. 9 plates. xxix + 792pp. 21967-4 Paperbound $4.50

MASTERS OF THE DRAMA, John Gassner. Most comprehensive history of the drama in print, covering every tradition from Greeks to modern Europe and America, including India, Far East, etc. Covers more than 800 dramatists, 2000 plays, with biographical material, plot summaries, theatre history, criticism, etc. "Best of its kind in English," New Republic. 77 illustrations. xxii + 890pp. 20100-7 Clothbound $10.00

THE EVOLUTION OF THE ENGLISH LANGUAGE, George McKnight. The growth of English, from the 14th century to the present. Unusual, non-technical account presents basic information in very interesting form: sound shifts, change in grammar and syntax, vocabulary growth, similar topics. Abundantly illustrated with quotations. Formerly Modern English in the Making. xii + 590pp. 21932-1 Paperbound $3.50

AN ETYMOLOGICAL DICTIONARY OF MODERN ENGLISH, Ernest Weekley. Fullest, richest work of its sort, by foremost British lexicographer. Detailed word histories, including many colloquial and archaic words; extensive quotations. Do not confuse this with the Concise Etymological Dictionary, which is much abridged. Total of xxvii + 830pp. 6½ x 9¼. 21873-2, 21874-0 Two volumes, Paperbound $7.90

FLATLAND: A ROMANCE OF MANY DIMENSIONS, E. A. Abbott. Classic of science-fiction explores ramifications of life in a two-dimensional world, and what happens when a three-dimensional being intrudes. Amusing reading, but also useful as introduction to thought about hyperspace. Introduction by Banesh Hoffmann. 16 illustrations. xx + 103pp. 20001-9 Paperbound $1.00

POEMS OF ANNE BRADSTREET, edited with an introduction by Robert Hutchinson. A new selection of poems by America's first poet and perhaps the first significant woman poet in the English language. 48 poems display her development in works of considerable variety—love poems, domestic poems, religious meditations, formal elegies, "quaternions," etc. Notes, bibliography. viii + 222pp.

22160-1 Paperbound $2.50

THREE GOTHIC NOVELS: THE CASTLE OF OTRANTO BY HORACE WALPOLE; VATHEK BY WILLIAM BECKFORD; THE VAMPYRE BY JOHN POLIDORI, WITH FRAGMENT OF A NOVEL BY LORD BYRON, edited by E. F. Bleiler. The first Gothic novel, by Walpole; the finest Oriental tale in English, by Beckford; powerful Romantic supernatural story in versions by Polidori and Byron. All extremely important in history of literature; all still exciting, packed with supernatural thrills, ghosts, haunted castles, magic, etc. xl + 291pp.

21232-7 Paperbound $3.00

THE BEST TALES OF HOFFMANN, E. T. A. Hoffmann. 10 of Hoffmann's most important stories, in modern re-editings of standard translations: Nutcracker and the King of Mice, Signor Formica, Automata, The Sandman, Rath Krespel, The Golden Flowerpot, Master Martin the Cooper, The Mines of Falun, The King's Betrothed, A New Year's Eve Adventure. 7 illustrations by Hoffmann. Edited by E. F. Bleiler. xxxix + 419pp. 21793-0 Paperbound $3.00

GHOST AND HORROR STORIES OF AMBROSE BIERCE, Ambrose Bierce. 23 strikingly modern stories of the horrors latent in the human mind: The Eyes of the Panther, The Damned Thing, An Occurrence at Owl Creek Bridge, An Inhabitant of Carcosa, etc., plus the dream-essay, Visions of the Night. Edited by E. F. Bleiler. xxii + 199pp. 20767-6 Paperbound $2.00

BEST GHOST STORIES OF J. S. LEFANU, J. Sheridan LeFanu. Finest stories by Victorian master often considered greatest supernatural writer of all. Carmilla, Green Tea, The Haunted Baronet, The Familiar, and 12 others. Most never before available in the U. S. A. Edited by E. F. Bleiler. 8 illustrations from Victorian publications. xvii + 467pp. 20415-4 Paperbound $3.00

MATHEMATICAL FOUNDATIONS OF INFORMATION THEORY, A. I. Khinchin. Comprehensive introduction to work of Shannon, McMillan, Feinstein and Khinchin, placing these investigations on a rigorous mathematical basis. Covers entropy concept in probability theory, uniqueness theorem, Shannon's inequality, ergodic sources, the E property, martingale concept, noise, Feinstein's fundamental lemma, Shanon's first and second theorems. Translated by R. A. Silverman and M. D. Friedman. iii + 120pp. 60434-9 Paperbound $2.00

SEVEN SCIENCE FICTION NOVELS, H. G. Wells. The standard collection of the great novels. Complete, unabridged. *First Men in the Moon, Island of Dr. Moreau, War of the Worlds, Food of the Gods, Invisible Man, Time Machine, In the Days of the Comet.* Not only science fiction fans, but every educated person owes it to himself to read these novels. 1015pp. (USO) 20264-X Clothbound $6.00

LAST AND FIRST MEN AND STAR MAKER, TWO SCIENCE FICTION NOVELS, Olaf Stapledon. Greatest future histories in science fiction. In the first, human intelligence is the "hero," through strange paths of evolution, interplanetary invasions, incredible technologies, near extinctions and reemergences. Star Maker describes the quest of a band of star rovers for intelligence itself, through time and space: weird inhuman civilizations, crustacean minds, symbiotic worlds, etc. Complete, unabridged. v + 438pp. (USO) 21962-3 Paperbound $3.00

THREE PROPHETIC NOVELS, H. G. WELLS. Stages of a consistently planned future for mankind. *When the Sleeper Wakes,* and *A Story of the Days to Come,* anticipate *Brave New World* and *1984,* in the 21st Century; *The Time Machine,* only complete version in print, shows farther future and the end of mankind. All show Wells's greatest gifts as storyteller and novelist. Edited by E. F. Bleiler. x + 335pp. (USO) 20605-X Paperbound $3.00

THE DEVIL'S DICTIONARY, Ambrose Bierce. America's own Oscar Wilde— Ambrose Bierce—offers his barbed iconoclastic wisdom in over 1,000 definitions hailed by H. L. Mencken as "some of the most gorgeous witticisms in the English language." 145pp. 20487-1 Paperbound $1.50

MAX AND MORITZ, Wilhelm Busch. Great children's classic, father of comic strip, of two bad boys, Max and Moritz. Also Ker and Plunk (Plisch und Plumm), Cat and Mouse, Deceitful Henry, Ice-Peter, The Boy and the Pipe, and five other pieces. Original German, with English translation. Edited by H. Arthur Klein; translations by various hands and H. Arthur Klein. vi + 216pp.
20181-3 Paperbound $2.00

PIGS IS PIGS AND OTHER FAVORITES, Ellis Parker Butler. The title story is one of the best humor short stories, as Mike Flannery obfuscates biology and English. Also included, That Pup of Murchison's, The Great American Pie Company, and Perkins of Portland. 14 illustrations. v + 109pp. 21532-6 Paperbound $1.50

THE PETERKIN PAPERS, Lucretia P. Hale. It takes genius to be as stupidly mad as the Peterkins, as they decide to become wise, celebrate the "Fourth," keep a cow, and otherwise strain the resources of the Lady from Philadelphia. Basic book of American humor. 153 illustrations. 219pp. 20794-3 Paperbound $2.00

PERRAULT'S FAIRY TALES, translated by A. E. Johnson and S. R. Littlewood, with 34 full-page illustrations by Gustave Doré. All the original Perrault stories— Cinderella, Sleeping Beauty, Bluebeard, Little Red Riding Hood, Puss in Boots, Tom Thumb, etc.—with their witty verse morals and the magnificent illustrations of Doré. One of the five or six great books of European fairy tales. viii + 117pp. 8⅛ x 11. 22311-6 Paperbound $2.00

OLD HUNGARIAN FAIRY TALES, Baroness Orczy. Favorites translated and adapted by author of the *Scarlet Pimpernel.* Eight fairy tales include "The Suitors of Princess Fire-Fly," "The Twin Hunchbacks," "Mr. Cuttlefish's Love Story," and "The Enchanted Cat." This little volume of magic and adventure will captivate children as it has for generations. 90 drawings by Montagu Barstow. 96pp.
(USO) 22293-4 Paperbound $1.95

THE RED FAIRY BOOK, Andrew Lang. Lang's color fairy books have long been children's favorites. This volume includes Rapunzel, Jack and the Bean-stalk and 35 other stories, familiar and unfamiliar. 4 plates, 93 illustrations x + 367pp.
21673-X Paperbound $2.50

THE BLUE FAIRY BOOK, Andrew Lang. Lang's tales come from all countries and all times. Here are 37 tales from Grimm, the Arabian Nights, Greek Mythology, and other fascinating sources. 8 plates, 130 illustrations. xi + 390pp.
21437-0 Paperbound $2.75

HOUSEHOLD STORIES BY THE BROTHERS GRIMM. Classic English-language edition of the well-known tales — Rumpelstiltskin, Snow White, Hansel and Gretel, The Twelve Brothers, Faithful John, Rapunzel, Tom Thumb (52 stories in all). Translated into simple, straightforward English by Lucy Crane. Ornamented with head-pieces, vignettes, elaborate decorative initials and a dozen full-page illustrations by Walter Crane. x + 269pp.
21080-4 Paperbound **$2.00**

THE MERRY ADVENTURES OF ROBIN HOOD, Howard Pyle. The finest modern versions of the traditional ballads and tales about the great English outlaw. Howard Pyle's complete prose version, with every word, every illustration of the first edition. Do not confuse this facsimile of the original (1883) with modern editions that change text or illustrations. 23 plates plus many page decorations. xxii + 296pp.
22043-5 Paperbound $2.75

THE STORY OF KING ARTHUR AND HIS KNIGHTS, Howard Pyle. The finest children's version of the life of King Arthur; brilliantly retold by Pyle, with 48 of his most imaginative illustrations. xviii + 313pp. 6⅛ x 9¼.
21445-1 Paperbound $2.50

THE WONDERFUL WIZARD OF OZ, L. Frank Baum. America's finest children's book in facsimile of first edition with all Denslow illustrations in full color. The edition a child should have. Introduction by Martin Gardner. 23 color plates, scores of drawings. iv + 267pp.
20691-2 Paperbound $3.50

THE MARVELOUS LAND OF OZ, L. Frank Baum. The second Oz book, every bit as imaginative as the Wizard. The hero is a boy named Tip, but the Scarecrow and the Tin Woodman are back, as is the Oz magic. 16 color plates, 120 drawings by John R. Neill. 287pp.
20692-0 Paperbound $2.50

THE MAGICAL MONARCH OF MO, L. Frank Baum. Remarkable adventures in a land even stranger than Oz. The best of Baum's books not in the Oz series. 15 color plates and dozens of drawings by Frank Verbeck. xviii + 237pp.
21892-9 Paperbound $2.25

THE BAD CHILD'S BOOK OF BEASTS, MORE BEASTS FOR WORSE CHILDREN, A MORAL ALPHABET, Hilaire Belloc. Three complete humor classics in one volume. Be kind to the frog, and do not call him names . . . and 28 other whimsical animals. Familiar favorites and some not so well known. Illustrated by Basil Blackwell. 156pp.
(USO) 20749-8 Paperbound $1.50

MATHEMATICAL PUZZLES FOR BEGINNERS AND ENTHUSIASTS, Geoffrey Mott-Smith. 189 puzzles from easy to difficult—involving arithmetic, logic, algebra, properties of digits, probability, etc.—for enjoyment and mental stimulus. Explanation of mathematical principles behind the puzzles. 135 illustrations. viii + 248pp.
20198-8 Paperbound $2.00

PAPER FOLDING FOR BEGINNERS, William D. Murray and Francis J. Rigney. Easiest book on the market, clearest instructions on making interesting, beautiful origami. Sail boats, cups, roosters, frogs that move legs, bonbon boxes, standing birds, etc. 40 projects; more than 275 diagrams and photographs. 94pp.
20713-7 Paperbound $1.00

TRICKS AND GAMES ON THE POOL TABLE, Fred Herrmann. 79 tricks and games— some solitaires, some for two or more players, some competitive games—to entertain you between formal games. Mystifying shots and throws, unusual caroms, tricks involving such props as cork, coins, a hat, etc. Formerly *Fun on the Pool Table*. 77 figures. 95pp.
21814-7 Paperbound $1.25

HAND SHADOWS TO BE THROWN UPON THE WALL: A SERIES OF NOVEL AND AMUSING FIGURES FORMED BY THE HAND, Henry Bursill. Delightful picturebook from great-grandfather's day shows how to make 18 different hand shadows: a bird that flies, duck that quacks, dog that wags his tail, camel, goose, deer, boy, turtle, etc. Only book of its sort. vi + 33pp. 6½ x 9¼.
21779-5 Paperbound $1.00

WHITTLING AND WOODCARVING, E. J. Tangerman. 18th printing of best book on market. "If you can cut a potato you can carve" toys and puzzles, chains, chessmen, caricatures, masks, frames, woodcut blocks, surface patterns, much more. Information on tools, woods, techniques. Also goes into serious wood sculpture from Middle Ages to present, East and West. 464 photos, figures. x + 293pp.
20965-2 Paperbound $2.50

HISTORY OF PHILOSOPHY, Julián Marias. Possibly the clearest, most easily followed, best planned, most useful one-volume history of philosophy on the market; neither skimpy nor overfull. Full details on system of every major philosopher and dozens of less important thinkers from pre-Socratics up to Existentialism and later. Strong on many European figures usually omitted. Has gone through dozens of editions in Europe. 1966 edition, translated by Stanley Appelbaum and Clarence Strowbridge. xviii + 505pp.
21739-6 Paperbound $3.50

YOGA: A SCIENTIFIC EVALUATION, Kovoor T. Behanan. Scientific but non-technical study of physiological results of yoga exercises; done under auspices of Yale U. Relations to Indian thought, to psychoanalysis, etc. 16 photos. xxiii + 270pp.
20505-3 Paperbound $2.50

Prices subject to change without notice.
Available at your book dealer or write for free catalogue to Dept. GI, Dover Publications, Inc., 180 Varick St., N. Y., N. Y. 10014. Dover publishes more than 150 books each year on science, elementary and advanced mathematics, biology, music, art, literary history, social sciences and other areas.